ART TREASURES OF THE WORLD

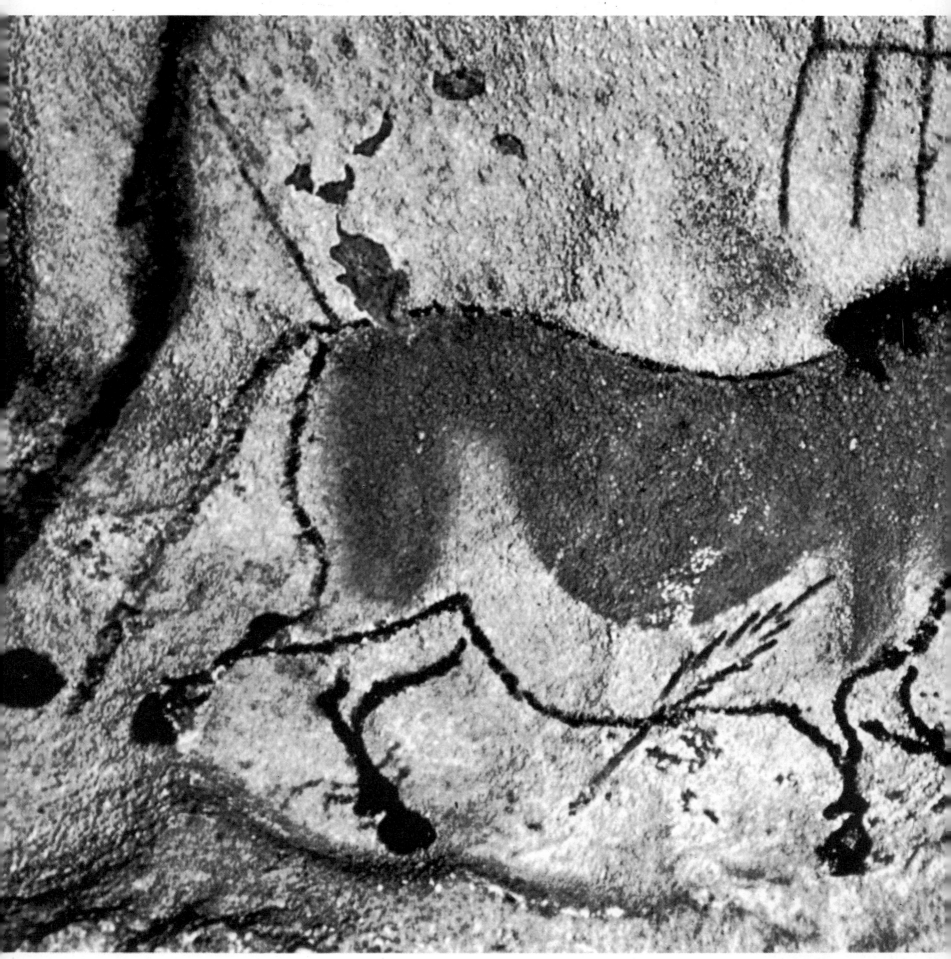

Palaeolithic art: *Running horse*, Lascaux

ART
TREASURES
OF THE WORLD

An illustrated history in colour

With short biographies of artists

PAINTING, SCULPTURE, ARCHITECTURE,
AND ORNAMENT, FROM PREHISTORIC
TIMES TO THE TWENTIETH CENTURY

HAMLYN
LONDON / NEW YORK / SYDNEY / TORONTO

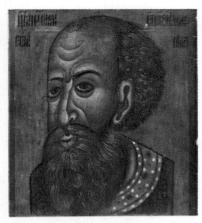

1. Russian art: *Portrait of Ivan the Terrible*, 16th century

ACKNOWLEDGMENTS

The publishers express their deep gratitude to the people and institutions who have helped to assemble the illustrations.
Special thanks are due to the following:

Dr. Alfred Frankfurter, of Art News, New York.

John Clark, of Scala, Laboratorio Fotografico, Florence.

Mrs. A. K. Coomaraswamy, Cambridge, Massachusetts.

Richard Okamoto, Tokyo.

Hanna Gunther, of Frederick A. Praeger, Publishers, New York.

Earleen Field, of Skira Inc., New York.

Milton Fox, of Harry N. Abrams Inc., Publishers, New York.

Mildred McGill, Photograph Sales Department, Metropolitan Museum of Art.

Lnor West, Freer Gallery of Art, Washington, D.C.

G. W. Atkins, of the National Gallery, London.

Pearl Moeller and Willard Tangen, Museum of Modern Art, New York.

Anselmo Carini, Art Institute of Chicago.

First edition 1964 – Tenth impression 1975
Published by The Hamlyn Publishing Group Ltd., Astronaut House, Feltham, Middlesex
London, New York, Sydney, Toronto
by arrangement with Golden Pleasure Books Ltd
© Copyright 1961 by Golden Press Inc. All rights reserved
This edition © Copyright The Hamlyn Publishing Group Ltd 1964
ISBN 0 601 07007 0
Phototypeset by Filmset Limited, Crawley, Sussex
PRINTED IN ITALY

tees, The National Gallery, London. (*Arborio Mella*)

PAGES 192–193

1. Prado, Madrid. (*Scala*)
2. (*Scala*)
3. Pinacoteca, Modena. (*Scala*)

PAGES 194–195

1. Prado, Madrid. (*Scala*)
2. Reproduced by courtesy of the Trustees, The National Gallery, London
3. Reproduced by courtesy of the Trustees, The National Gallery, London
4. Allen Art Museum, Oberlin College

PAGES 196–197

1. Metropolitan Museum of Art, N.Y., Dick Fund, 1946

PAGES 198–199

1. (*Giraudon*)
2. (*French Cultural Services*)
3. From Album Charles Lebrun, Vol. I. Louvre, Paris. (*Pierre Belzeaux—R.G.*)
4. (*French Cultural Services*)

PAGES 200–201

1. Rijksmuseum, Amsterdam
2. Prado, Madrid
3. Fogg Art Museum, Harvard University, Charles A. Loeser Bequest

PAGES 202–203

1. Royal Academy of Fine Arts, Stockholm. On loan to Nationalmuseum, Stockholm

PAGES 204–205

1. Musée d'Art Ancien, Brussels. (*Scala*)
2. Boymans van Beuningen Museum, Rotterdam
3. Kunsthistorisches Museum, Vienna

PAGES 206–207

1. Louvre, Paris (*Carlo Bevilacqua*)
2. (*British Information Service*)
3. Burndy Library, Norwalk, Conn.
4. (*British Information Service*)
5. (*F. S. Lincoln*)

PAGES 208–209

1. Ehem. Staatl. Museen, Berlin-Dahlem. (*Camera Clix*)
2. (*French Cultural Services*)
3. Metropolitan Museum of Art, N.Y., Rogers Fund, 1920
4. Kunsthistorisches Museum, Vienna

PAGES 210–211

1. National Gallery of Art, Washington, D.C., Samuel H. Kress Collection

PAGES 212–213

2. (*Roy Bernard—Internationes*)
3. Uffizi, Florence. (*Scala*)
4. The Museum of Fine Arts of Houston, Texas

PAGES 214–215

1. Metropolitan Museum of Art, N.Y., Dick Fund, 1917
2. Reproduced by courtesy of the Trustees of the Tate Gallery, London
3. Metropolitan Museum of Art, N.Y., Rogers Fund, 1920
4. Metropolitan Museum of Art, N.Y., Catherine D. Wentworth Fund, 1949
5. Louvre, Paris. (*Giraudon*)

PAGES 216–217

1. Louvre, Paris. (*Scala*)
2. Fogg Art Museum, Harvard University, Grenville Lindall Winthrop Collection
3. The Smithsonian Institution, Washington, D.C.
4. Metropolitan Museum of Art, N.Y., Gift of Bayard Verplanck, 1949
5. Metropolitan Museum of Art, N.Y., Bequest of William K. Vanderbilt, 1920

PAGES 218–219

1. (*French Cultural Services*)
2. (*French Cultural Services*)
3. Comédie-Française, Paris. (*Giraudon*)
4. Louvre, Paris. (*Scala*)
5. Louvre, Paris. (*Robert Doisneau—R.G.*)
6. Museum, Besançon. (*Bulloz*)

PAGES 220–221

1. Prado, Madrid
2. Prado, Madrid
3. Prado, Madrid
4. Courtesy, Museum of Fine Arts, Boston

PAGES 222–223

1. Louvre, Paris. (*Giraudon*)
2. Louvre, Paris. (*Giraudon*)
3. Louvre, Paris. (*Giraudon*)
4. Louvre, Paris. (*Scala*)
5. Louvre, Paris. (*Giraudon*)

PAGES 224–225

1. Louvre, Paris. (*Scala*)
2. Louvre, Paris. (*Giraudon*)
3. Reproduced by courtesy of the Trustees, The National Gallery, London
4. Louvre, Paris. (*Scala*)

PAGES 226–227

1. Victoria and Albert Museum, London
2. The Collis P. Huntington Memorial Collection, California Palace of the Legion of Honor, San Francisco, California
3. Reproduced by courtesy of the Trustees, The National Gallery, London
4. Louvre, Paris
5. Musée Marmottan, Paris. (*Arborio Mella*)

PAGES 228–229

1. Private Collection. (*Held*)
2. Louvre, Paris. (*Pizzigoni*)
3. Durand-Ruel Collection, Paris. (*Mercurio*)

PAGES 230–231

1. Rodin Museum, Paris. (*French Cultural Services*)
2. Galleria Borghese, Rome. (*Scala*)
3. Coll. Richard L. Davisson, Jr., Westwood, Massachusetts
4. The Art Institute of Chicago, Arthur Heun Fund
5. Metropolitan Museum of Art, N.Y., Abrams Collection
6. Rodin Museum, Meudon. (*Roger-Viollet*)

PAGES 232–233

1. Phillips Collection, Washington, D.C.

PAGES 234–235

1. Coll. Dr. and Mrs. Harry Bakwin, N.Y. (*Francis G. Mayer, N.Y.*)
2. Solomon Guggenheim Museum, New York. (*Mercurio*)
3. Hermitage, Leningrad

PAGES 236–237

1. The Minneapolis Institute of Arts, Dunwoody Fund

PAGES 238–239

1. Helen Birch Bartlett Memorial Collection, The Art Institute of Chicago

PAGES 240–241

1. Coll. Mrs. Albert D. Lasker, N.Y.
2. Stedelijk Museum, Amsterdam
3. Museum of Modern Art, N.Y., Lillie P. Bliss Bequest

PAGES 242–243

1. Courtauld Institute of Art, London

PAGES 244–245

1. Louvre, Paris. (*Scala*)
2. Courtesy of The Smithsonian Institution, Freer Gallery of Art, Washington, D.C.
3. Louvre, Paris. (*Pizzigoni*)

4. The Art Institute of Chicago, Helen Birch Bartlett Memorial Collection

PAGES 246–247

1. Coll. Stephen C. Clark, Sr., N.Y.
5. Musée d'Art Moderne, Paris. (*Scala*)

PAGES 248–249

1. Coll. Mr. and Mrs. Donald S. Stralem, N.Y.
2. The Baltimore Museum of Art, Cone Collection
3. From Le Chef-d'Oeuvre Inconnu, by Balzac. Albert Skira, Publishers

PAGES 250–251

1. Museum of Modern Art, N.Y., Mrs. Simon Guggenheim Fund

PAGES 252–253

1. National Gallery of Art, Washington, D.C. Rosenwald Collection
2. Coll. Mr. and Mrs. John Hay Whitney, N.Y.
3. Kunsthaus, Zurich. (*Arborio Mella*)
4. Coll. Museum of Modern Art, New York, Mrs. Simon Guggenheim Fund
5. (*Hélène Adant*)
6. Coll. Alex. L. Hillman, N.Y.

PAGES 254–255

1. Museum of Modern Art, N.Y., Lillie P. Bliss Bequest
2. By permission of Marcel Duchamp
3. Museum of Modern Art, N.Y., Lillie P. Bliss Bequest
4. Private Collection, Milan (*Scala*)
5. Museum of Modern Art, N.Y., Benjamin Scharps and David Scharps Fund
6. Private Collection, Basel
7. Guggenheim Museum, N.Y. (*Mercurio*)

PAGES 256–257

1. Museum of Fine Arts, Antwerp
2. Museum of Modern Art, N.Y.
3. Private Collection, Milan. (*Scala*)
4. Private Collection, Milan. (*Scala*)
5. Coll. Mr. R. Sturgis Ingersoll
6. Penrose Collection, London. (*Mercurio*)

PAGES 258–259

1. The Solomon R. Guggenheim Museum Collection, N.Y. (*Francis G. Mayer, N.Y.*)
2. National Museum of Modern Art, Paris. (*Scala*)
3. Tate Gallery, London
4. Karsten Gallery, Amsterdam. (*Mercurio*)

PAGES 260–261

1. Private Collection, New York
2. Paul Kantor Gallery, Beverly Hills, California
3. (*François Bucher*)
5. (*Lucien Hervé, Paris*)

PAGES 262–263

1. General Motors, Detroit. Photographic
2. The Solomon R. Guggenheim Museum Collection, N.Y.
3. Hamilton Collection, New Haven, Connecticut
4. (*Lucien Hervé, Paris*)

PAGES 264–265

1. (*Roy Bernard—Internationes*)
2. Cement and Concrete Association, London
3. (*Hedrich-Blessing*)
4. By permission of McGraw Hill Inc., New York
5. TWA Public Relations Department
7. Sydney Morning Herald, Australia

The text of this book has been written by Eleanor C. Munro and Raymond Rudorff. The short biographies have been edited by Kate Vandegrift.

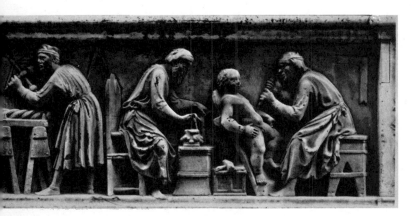

1. Nanni di Banco: *Stonemasons and sculptors at work.* Bas-relief about 1408.

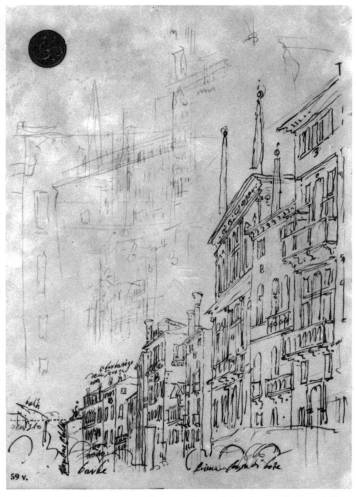

2. Antonio Canaletto: *View of Venice*, from "Quaderno di Venezia".

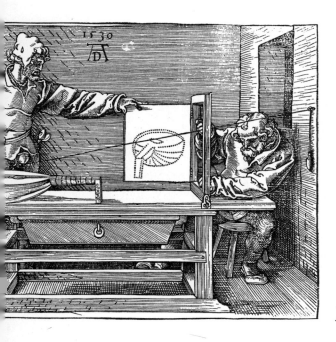

3. Albrecht Dürer: *The painter studying the laws of foreshortening.* Wood-engraving, 1530.

CONTENTS

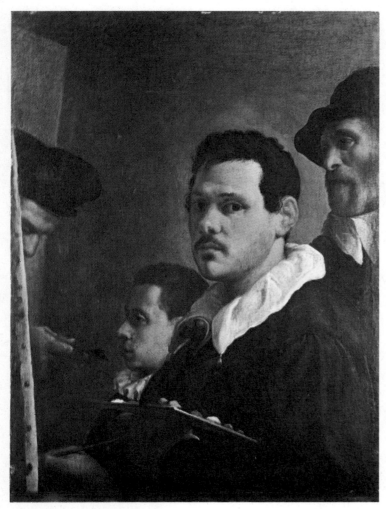

1. Annibale Carracci: *Self-portrait*.

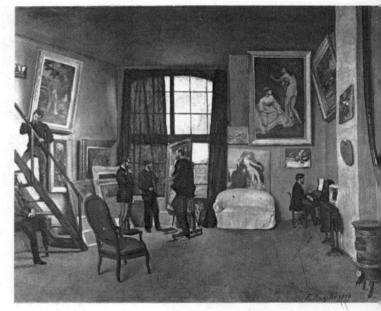

2. Jean-Frédéric Bazille: *Studio in the rue de la Condamine*.

Painters at work at their easels, sculptors carving in their workshops—this is how we often picture artists in our minds. We think of art as something separate from the lives of ordinary people, as an occupation only for those lucky enough to have special artistic gifts.

But art means much more than this. Art is part of life, an activity that has meaning for all human beings. Art has existed from the time there were human beings in the world. That is why the first men of whom we have traces were already natural artists who produced large numbers of brilliant paintings on the walls of their caves and rock shelters. That is why children are instinctive artists, whose uninhibited work holds lessons for adult, professional artists. That is why our records of lost civilisations often consist so largely of works of art—pottery, statues, jewellery, temples.

Art, in fact, has always been one of our ways of creating order out of the experience of life. The activity of making works of art —painting, shaping, writing, singing, dancing—is in some ways more important than the thing that is finally produced. It satisfies a deep human need. So, too, we learn something about ourselves every time we encounter a work of art.

Every material enforces its own discipline. Things can be made in metal and stone which would be impossible in wood. Not content with using the materials around him, the artist has

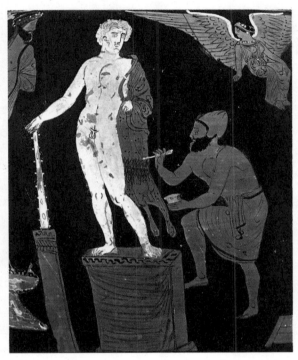

3. *Artist painting a statue of Hercules*, detail of vase painting, 4th century B.C.

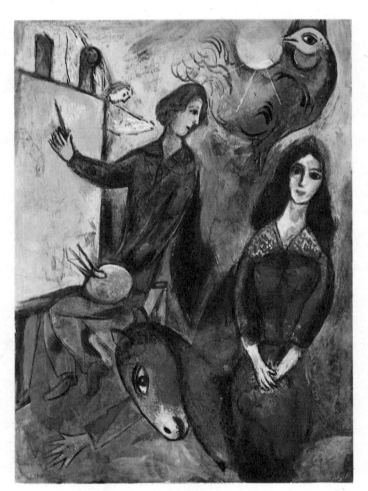

4. Marc Chagall: *The artist and his model.*

invented or perfected new ones to further his artistic purpose. Three of the pictures above show the artist painting on canvas, yet many of the pictures reproduced in this book were done on wood or plaster. The Greek artist depicted on the vase is seen painting a marble statue with colour. Today, many painters handle their materials as if they were sculptors, while sculptors work in wire and transparent plastics.

Works of art are found in many forms and in every part of the world. We look at the stained-glass windows in a Gothic cathedral, or at a twentieth-century railway terminus, or we may see in a museum Chinese porcelain, African wood-carvings, Islamic manuscripts. Art has many styles, it reflects different kinds of society, it is affected by people's different ideas of what is expected of art. It is influenced by different climates and by traditional local skills. Because of the way it records for all time these outside influences on man, the world's art is a treasury of humanity's past. Because it is always produced by the human need to shape and to express in visual forms, art is our continuing link with the future.

The purpose of the 550 reproductions with which this book is illustrated is to open a panorama of human life, all the way from the beautiful animals painted by our ancestors in their caves 40,000 years ago to the adventurous experiments of the space-age painters, sculptors and architects of our own time.

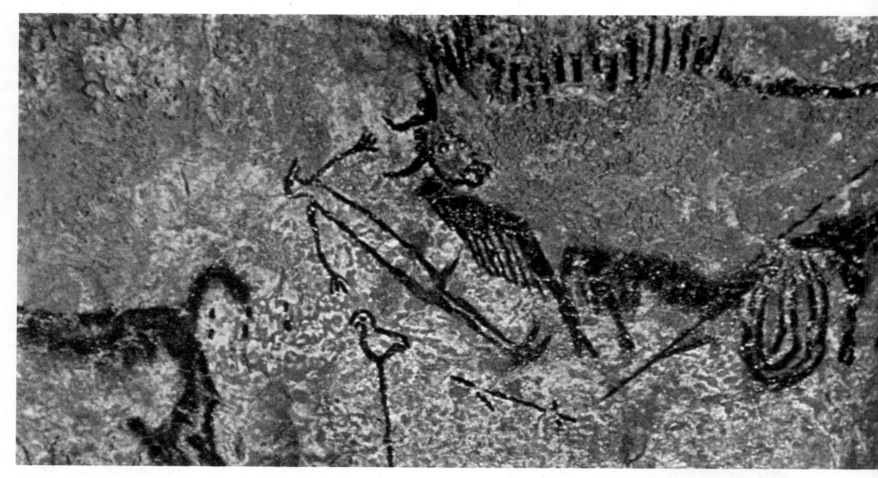

1. Palaeolithic art: *Hunting Scene*, Lascaux.

PREHISTORIC AND PRIMITIVE ART

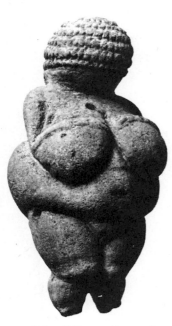

2. Palaeolithic art: *Venus of Willendorf*.

Men began to make objects which we call works of art roughly twenty-five thousand years ago in the Palaeolithic, or Old Stone Age. Early men were hunters and the pictures they drew were of wild animals and hunting scenes. These paintings probably played a part in a kind of magic, for by reproducing the shape of an animal, or the form of a human body, the artist may have felt he had power over the subject he was painting.

Ten to fifteen thousand years later, in the Neolithic, or New Stone Age, tribes banded together to build villages, and hunting partly gave way to primitive farming. Men were occupied with clearing their settlements and with planting and harvesting their crops. The changing seasons and the powerful forces of the sun, wind, and rain became matters of almost terrifying concern. Instead of drawing pictures of leaping bison and deer, these early artists now built the earth itself into monuments of stone and clay. They began to use symbols and abstract patterns. Simplified animal and human stick-figures were used to decorate their tools and domestic implements, especially pots and bowls. In many parts of Europe and Asia archaeologists have found traces of early human communities who knew the technique of modelling and decorating earthenware pottery.

Some primitive peoples still draw pictures and make sculptures much like those which were made in the Stone Age, and the symbols and god-figures they create are intended to placate the evil spirits and bring good fortune. Their simple, basic forms have fascinated and influenced later artists, even those who have inherited a long tradition of sophisticated cultures. Some of the most revolutionary movements in modern art were deeply influenced by the works of prehistoric and primitive peoples.

Prehistoric drawings of animals were usually correct in their proportions, for animals were the source of all food and clothing and, if the hunt was to be successful, palaeolithic men needed accurate knowledge of an animal's anatomy. Paintings were rubbed on the walls (1, 4) of caves with red and yellow earth mixed with animal fat. The artists usually drew single animals, although sometimes they portrayed a dramatic scene, like the one on the left (1), of a hunter being gored by a mortally wounded beast. However, when the artist painted or carved the human body, he was concerned less with correct anatomy than with his own feelings about it. So it was often only sketched in, as is the stick-figure of the fallen hunter. Sometimes, parts of the body were exaggerated for magical reasons. The so-called "Venus" (2), carved with excessively heavy breasts and abdomen was probably a charm to ensure fertility.

Neolithic artists no longer made such dramatic paintings and sculptures. They now decorated things like clay pots, painting them in bold and very satisfying geometric patterns (3). Representations of the human body were even sketchier than in some Palaeolithic art (5). These fluent, repeated images were probably early steps towards the invention of picture-writing and have been found in almost every part of the world.

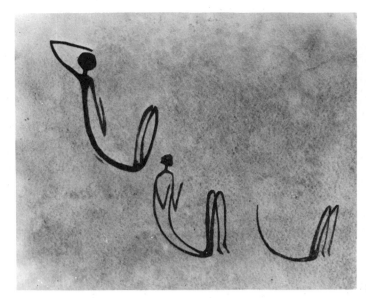

4. Neolithic art: *Three figures*, 4000–3000 B.C.

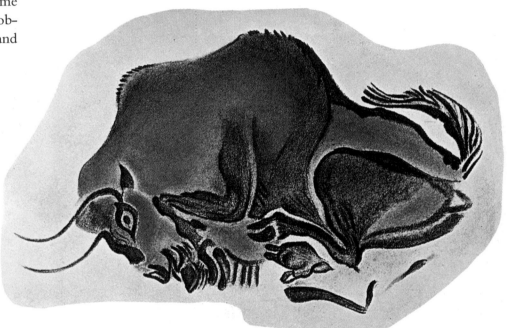

5. Palaeolithic art: *Bison, charging*, Altamira.

3. Neolithic art: *Painted vase*, about 3000 B.C.
From Susa, Persia.

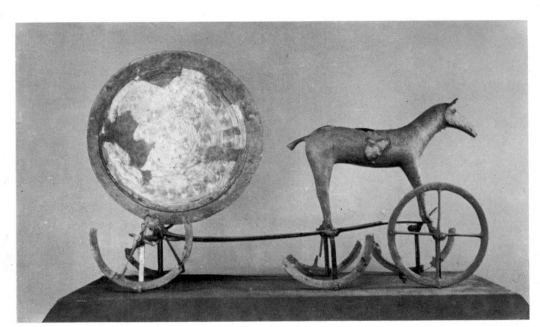

6. *Sun chariot*. From Trundholm

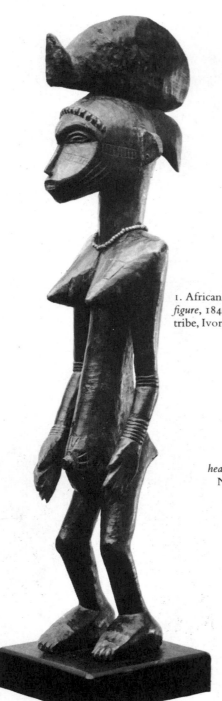

1. African art: *Human figure*, 1840–1850. Senufo tribe, Ivory Coast.

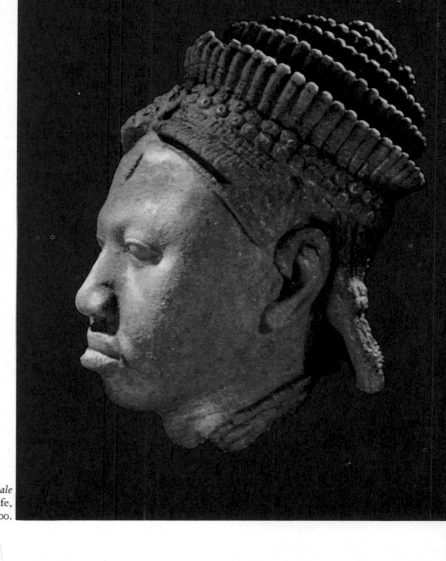

2. African art: *Female head*, terra-cotta. From Ife, Nigeria. A.D. 1100–1400.

3. Art of the Tlingit Indians of North America: *Painted Ceremonial Shirt*.

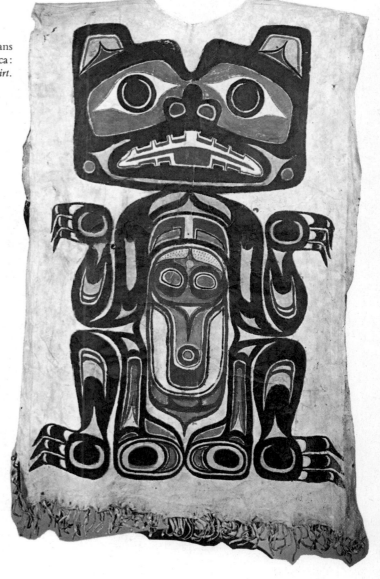

The people we call "primitive" today have changed very little from the ways of their and our earliest ancestors. They use only the most elementary tools and materials, for example, a loom, a knife, a pot of earth colour, a block of wood, shredded palm leaves, but their arts may be as accomplished in design and feeling as any in what we think of as the civilised world. The modern primitive, like his Palaeolithic ancestor, takes a recognisable shape—animal or human—and then transforms it into a pattern of sharp angles or curves, or lines and circles.

Indian artists of the American north-west coast still decorate their houses, clothing and utensils with carved and painted figures of animal spirits, called "totems" (3). The original families of each tribe are thought to descend from such animal spirits, like the Bear or the Lynx.

The sculptors of Africa were, until quite recently, among the most intense and imaginative artists of the world. (1) and (4) are examples of typical carvings by tribal artists. They represent

the spirits of ancestors which were believed to hover about the huts and sacred places of the tribe. In each case, the artist has selected a particular visual idea—a springy standing posture or a slanting, crouched position—and made it the basis for a clear-cut pattern.

The artists of the Polynesian and Melanesian island-chains were like those in Africa, brilliant carvers in wood. Sometimes they added cowrie shells, bits of coral, or fringes of palm leaves to enhance their wiry patterns, as we may see in the mask (5) which is made up of such different materials as canvas, feathers and leaves.

The artists of the Solomon Isles have a very strong sense of colour as well, as we can see in the black tattooed head (6), decorated with shells encrusted in the wood.

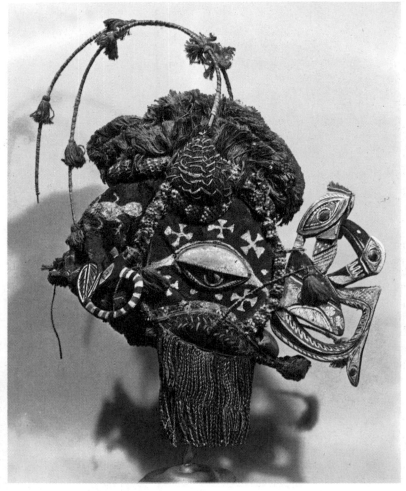

5. *Mask of vegetable fibre*. From New Britain.

6. *Human head modelled in black gum and ornamented with mother-of-pearl inlay*. From Solomon Islands.

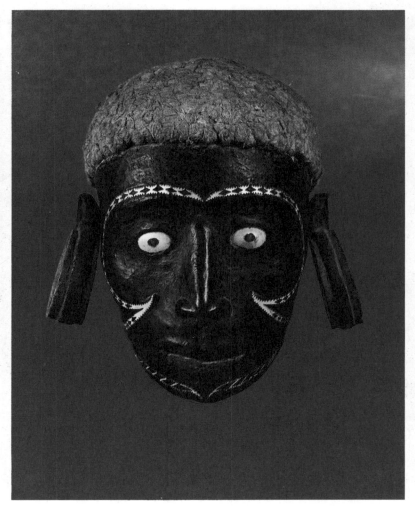

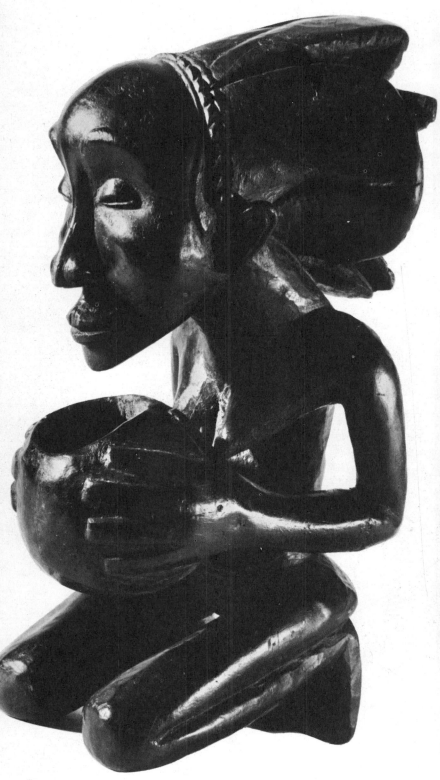

4. African art: *Female figure*. Baluba tribe.

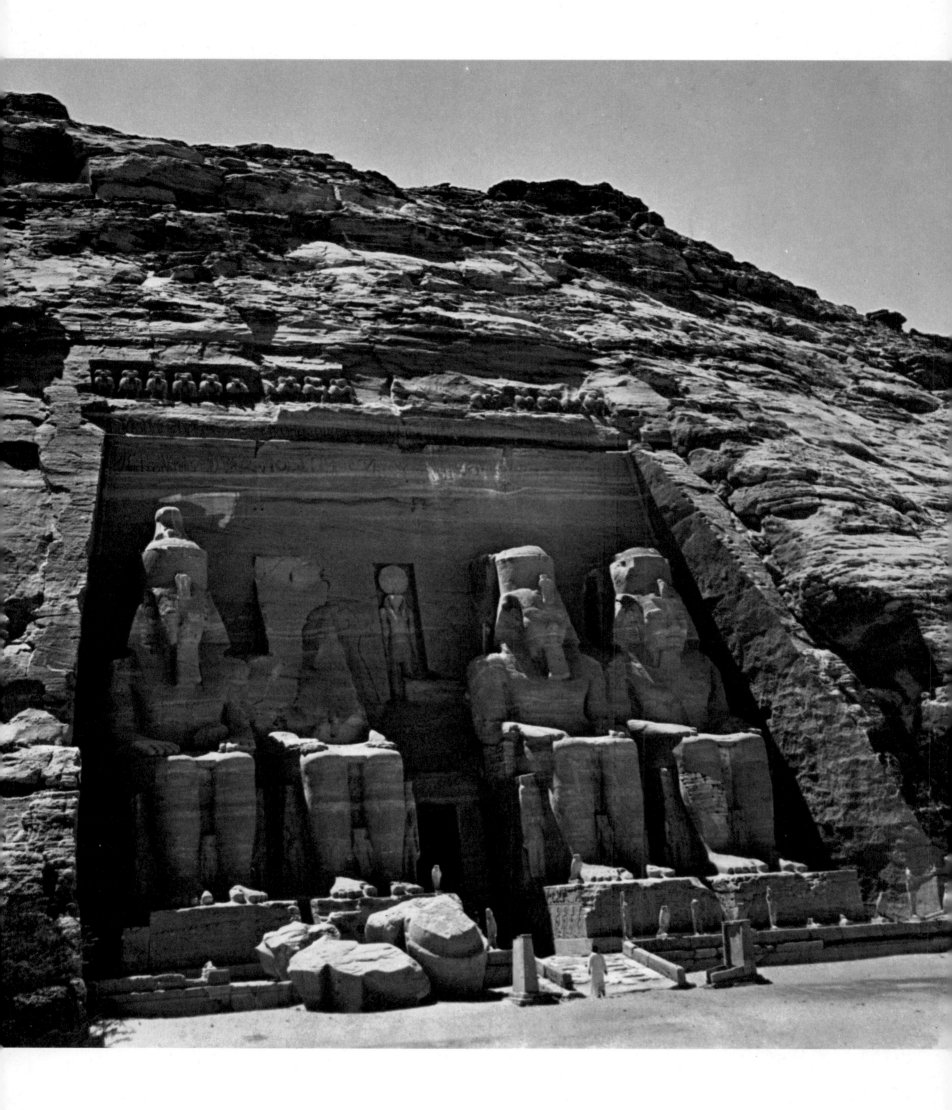

1. *Temple of Rameses II* at Abu Simbel. XIX dynasty, about 1250 B.C.

EGYPT

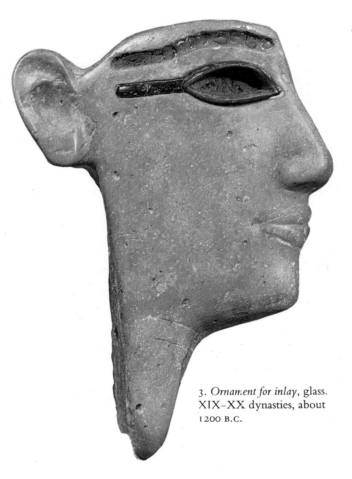

2. *Ritual figure*, terra-cotta. 4000 B.C.

By 3500 B.C., Stone Age settlements around the Mediterranean Sea had advanced to a new stage of civilisation. The world's first great art style, stamping all artistic expression with its unmistakable forms, was born in Egypt. It was thought out and preserved by the priests and kings of the land, and was carried out by the labour of tens of thousands of slaves from Asia, Africa, Phoenicia, and every other part of the ancient world.

There were three kinds of art in ancient Egypt. Art used in the home—in furniture, jewellery, dishes, musical instruments, and many household furnishings. Art made for the dead—in tombs, on masks, mummy cases, and wrappings for the body. Models were made of all the things that the dead person had owned in his lifetime, and were buried with him, for the Egyptians believed they would need them on their journey to the westward "Underworld". Finally, art was created for the gods and their priests and kings—in temples, paintings, and statues.

An Egyptian artist respected the strict and almost religious conventions or rules already laid down by their pre-historic ancestors before Egypt became a single nation. For example, figures were shown in a rigid pose, gazing forward with expressionless faces, and even in profiles the eye is shown as it appears from the front. The sculptors worked in hard stone, such as granite or diorite, or upon difficult surfaces like the great cliffs of the Nile, or else they used fragile materials like glass and gold. Because these materials were hard to shape, the Egyptian artist learned to turn his surfaces simply and to shape the outline of the body in long, taut, unbroken lines. Technical reasons lie behind the highly stylised forms with their extremely refined simplicity that are so characteristic of all Egyptian art. Each work of art made in Egypt, from the towering massive pyramid to the tiniest glass vessel, had the same fine-ground smoothness of surface.

Stone Age settlers in Egypt modelled the figurine (2) of a woman with upraised arms. Perhaps she represents a priestess in a sacred dance. If so, then the earliest Egyptians may already have been sun-worshippers like their descendants, whose greatest god was Amen-Ra, sailing his way across the sky in the sun-boat. The Egyptians became master craftsmen in every material and used glass for many delicate works of art. The glass head, right (3), was coloured to look as if made of precious lapis lazuli and turquoise. But however brilliant their techniques became, Egyptian craftsmen repeated over and over again the same images which had been handed down through the centuries.

One of the greatest monuments of ancient Egypt is the colossal carving opposite (1), a row of statues of the Pharaoh Rameses II, cut in the sheer cliff that towers 65 feet over the Nile at Abu Simbel. This and other huge monuments were the last colossal works of ancient Egypt, for no one could continue to spend such vast amounts of manpower and money on a personal cult and still defend the country against invaders. The simple outlines of Rameses's giants show how little style had changed from Neolithic times, for the rigid Stone Age priestess (2) has the simple profile of these monuments made centuries later.

3. *Ornament for inlay*, glass. XIX-XX dynasties, about 1200 B.C.

When the first dynasty began its rule in Egypt five thousand years ago, a civilised and elaborate way of life had already begun to develop throughout the length of the country. The worship of gods and godlike pharaohs played a basic part in Egyptian history, and especially in art. It was in their honour that the pyramids were built, and the whole style of painting, sculpture and decoration was laid down. The Egyptians worshipped the sun and the stars, the moon, the night and sacred animals that stood for the powers of nature, and they reproduced them all as powerful symbols in their art.

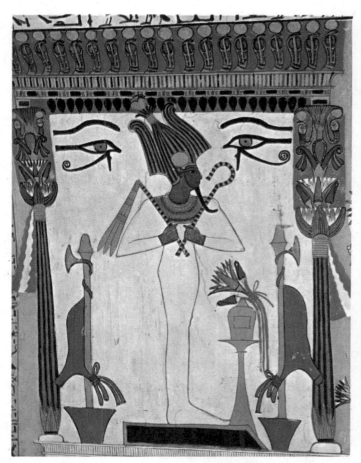

2. *The god Osiris.* XX dynasty. Fresco from the tomb of Sennedjem. Thebes.

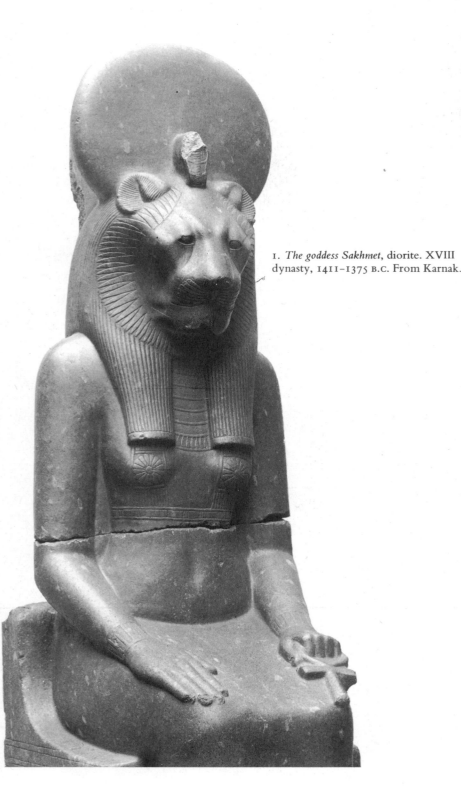

1. *The goddess Sakhmet*, diorite. XVIII dynasty, 1411–1375 B.C. From Karnak.

3. *The goddess Hathor*, diorite. XVIII dynasty. 1570–1465 B.C.

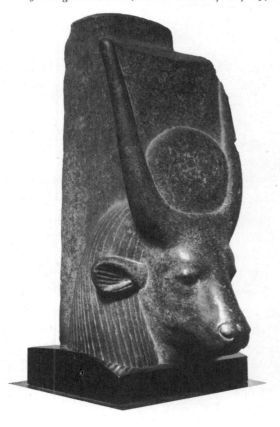

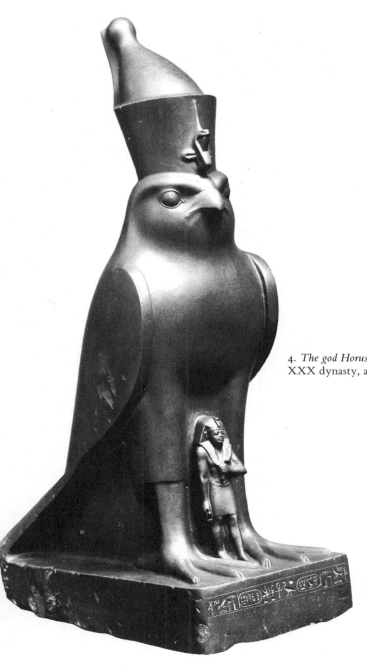

women. Her image often adorned the handles of their hand-mirrors.

Thoth, the ibis with a curved beak and round eyes (5), was the god of writing and the protector of scribes. His powers were vast for he was ruler over all mental activities from law to mathematics. Each pharaoh of Egypt was believed to change mysteriously on his coronation day into a descendant of Horus, the hawk, who then protected him in life and in battle. Above, Horus shelters the Pharaoh Nectanebos (4), who reigned about 350 B.C.

4. *The god Horus with the Pharaoh Nectanebos at his feet*, basalt. XXX dynasty, about 350 B.C. From Heliopolis.

5. *The god Thoth*, bronze. XXVI dynasty, 663–525 B.C.

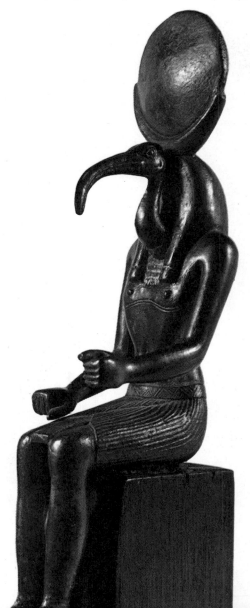

Here are some of the gods of Egypt that sculptors and painters portrayed in the same shapes for over three thousand years. Some had human forms, while others had the heads or whole bodies of animals. These curious images had already taken shape in the earliest days of Egypt's religion when the first kings, noble families, and professional groups believed they could trace their ancestry to animals whose qualities seemed like their own. For example, the lion's courage and strength was said to have been passed to the king, and the ibis's prying intelligence seemed suited to the scribe.

Foremost among the man-like gods was Osiris (2), ruler of the Underworld and god of the fields and harvests. With each autumn he seemed to have been killed, and each spring, when they said his sister Isis was putting his dismembered body together again, life was brought back to the dry fields. Sakhmet, the lioness, was the goddess of war (1). She holds in her left hand the Egyptian symbol of life. Hathor, the cow, bearing the full moon between her curved horns (3), watched over beautiful

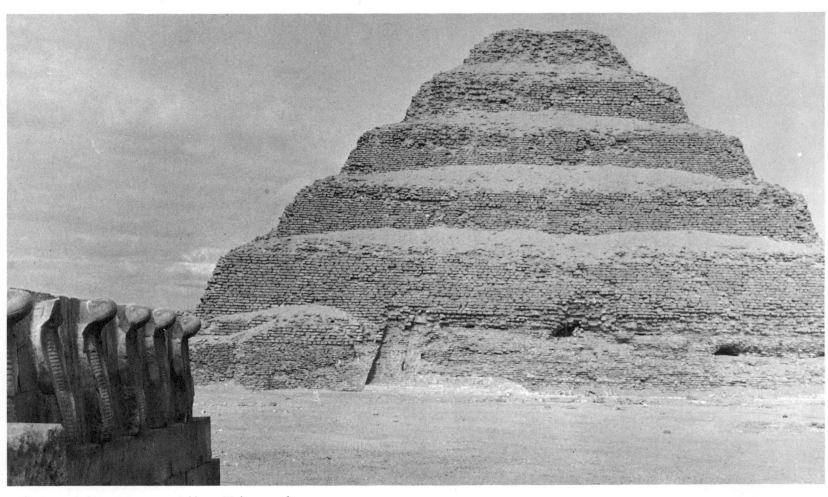

1. *The Pyramid of King Djoser*, near Sakkara. III dynasty, about 2900 B.C.

2. *Temple of Queen Hatshepsut*, XVIII dynasty, 1504–1483 B.C. Thebes.

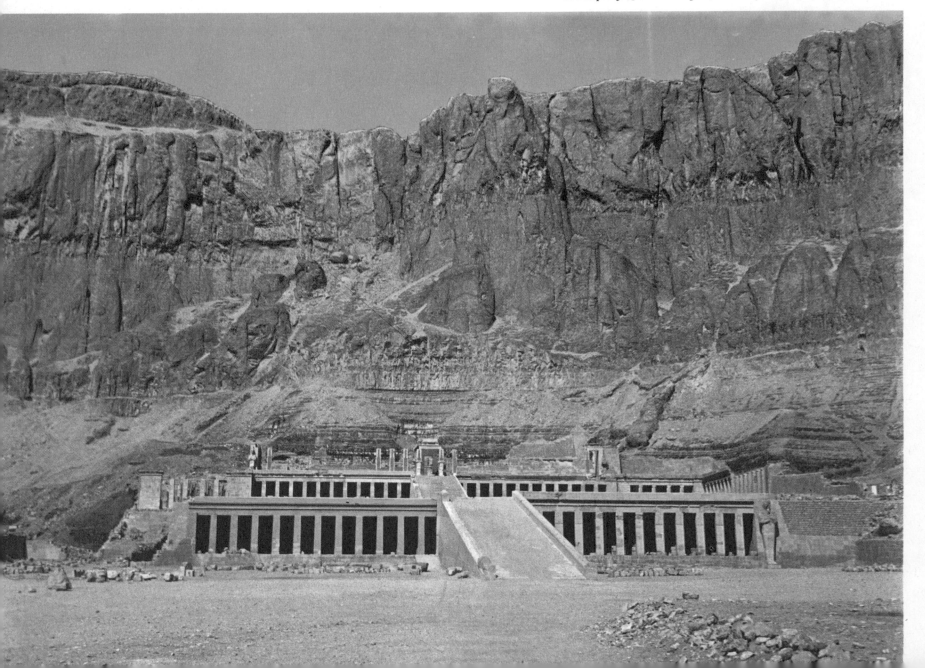

In Neolithic times, the first kings were buried in pits dug in the earth and lined with rocks. Later, rectangular tombs called "mastabas" were built above ground, with tunnels and rooms within, where religious rituals for the deceased took place. During the reign of the Pharaoh Djoser, around 2650 B.C., the architect Imhotep conceived the idea of setting one mastaba on top of another to make the colossal pyramid shape opposite (1). Later pharaohs like Khufu (Cheops) and Khafra (Chephren) outdid Djoser by building even larger pyramids with the sides smoothed off and faced with polished stone. The builders had neither pulleys nor wheels, but they had thousands of slaves and abundant stone in the Nile quarries. Millions of blocks of stone, each weighing tons, were cut, floated across the river on flat barges, dragged over the sands, and finally knocked into place.

Not until a thousand years after the end of the Old Kingdom (about 2660-2180 B.C.) did building again make vigorous progress. Then, for a while, the pharaohs built more delicate structures—temples and tunnel tombs in the Nile cliffs. The most elegant of these was built for Queen Hatshepsut (2).

Egyptian temples were built on the same plan for over two thousand years. They were walled and gloomy places with an open courtyard where the common people gathered. Inside were dark, protected sanctums for the nobles and priests. The heavy gateway was flanked by ponderous "pylons" (3), decorated with relief sculptures of the gods and kings. At the gate, tall obelisks with metal tips flashed in the sunlight, and coloured flags fluttered in the river breeze. The inner hall of the temple was often filled with great columns (4).

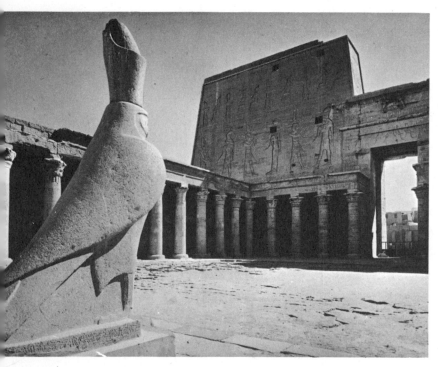

3. *Temple of Horus at Edfu*. View of the inner courtyard and gateway.

4. *Pillars*. Detail of the interior of the Temple of Horus at Edfu.

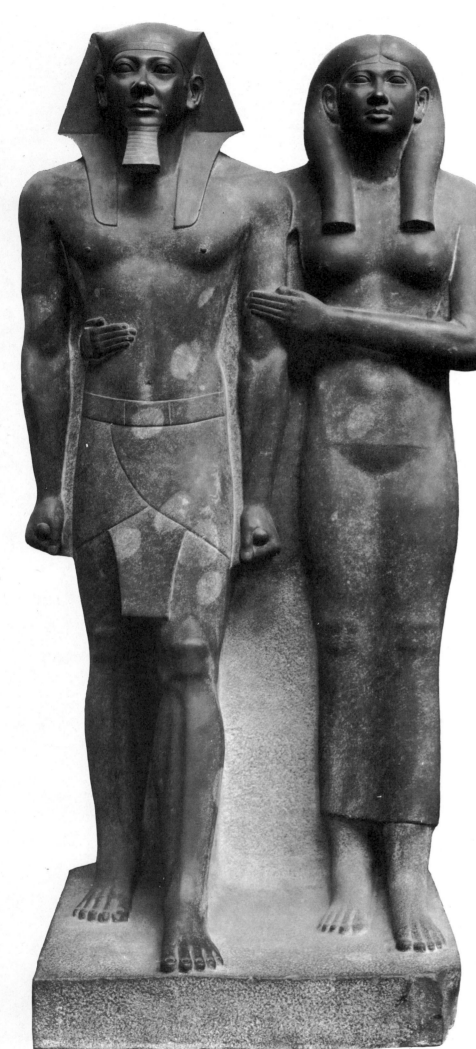

Portrait sculpture developed into a great art in Egypt, together with the belief that the *Ka* or spirit of a man could live for ever if a recognisable portrait statue were kept in his tomb. In the Old Kingdom, portraits were always presented in rigid postures, and were simple and powerful, with very little show of private emotion. King Menkawara and his wife, portrayed in this sculpture (1), reigned at the end of the Fourth Dynasty (2680–2565 B.C.). Later, in the Middle Kingdom (2080–1640 B.C.), portraits became more personal and the faces showed more of the individual moods and character of the model. The queen Hatshepsut had a statue carved of herself as a sphinx, to express the power and dignity of her reign (2).

Within his narrow conventions, the Egyptian sculptor managed to express the spirit of his subjects. He marked off simple areas of rectangles and squares on a block of hard stone to begin with, and then transformed them into the body, legs, and arms of a rigid figure, with a jutting beard and crown, all in perfect balance.

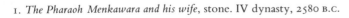

1. *The Pharaoh Menkawara and his wife*, stone. IV dynasty, 2580 B.C.

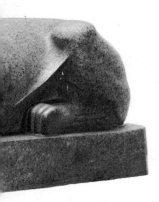

2. *Sphinx with portrait of*
Queen Hatshepsut, red granite.
XVIII dynasty, 1504–1483 B.C.

4. *Colossi of Memnon,* XVIII dynasty, 1411–1375 B.C. Reign of Amenhotep III.

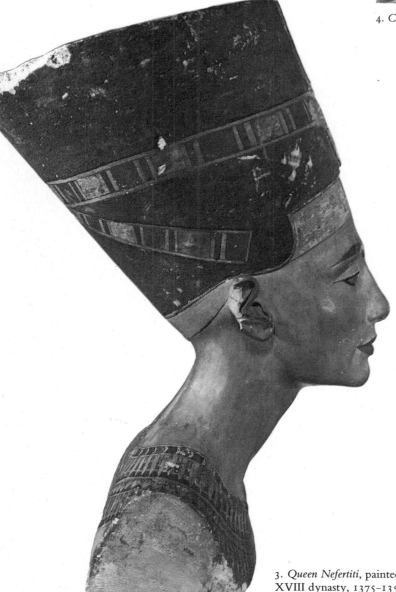

3. *Queen Nefertiti,* painted limestone.
XVIII dynasty, 1375–1357 B.C.

The traditional Egyptian style of portrait sculpture reached a climax in these colossal statues of Amenhotep III, which tower 63 feet over the empty desert (4). A later successor to the throne of Egypt obliterated the faces of these high statues, perhaps hoping thereby to wipe the memory of his rival from the face of the earth.

It was Amenhotep III's immediate successor, Amenhotep IV, who brought about Egypt's first revolution in art and ideas. Brilliant, poetic, and visionary, Amenhotep banished the thousands of animal gods which had always been worshipped in Egypt. In their place he substituted a single god of the sun called Aton and changed his own name to Ikhnaton in the new deity's honour. For the first time, artists were urged to show figures in natural positions, dancing, moving about, and conversing. The king even permitted himself to be portrayed with a wide-hipped, soft body, unlike the stern, taut-skinned pharaohs of tradition. His beautiful queen Nefertiti was also shown realistically, with her heavy-lidded eyes, slender neck, determined chin and pure profile under her heavy crown (3).

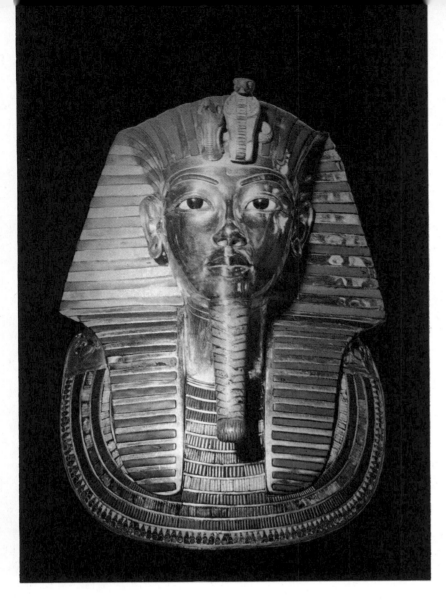

1. *Gold mask of the Pharaoh Tutankhamen*, XVIII dynasty,
1362–1253 B.C.

2. *Sarcophagus of Tutankhamen*, XVIII dynasty, 1362–1253 B.C.

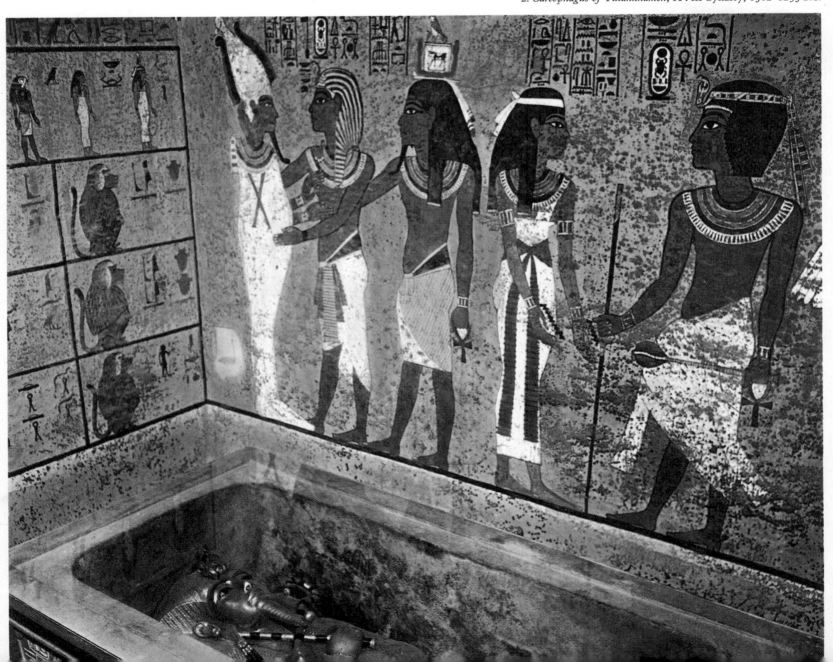

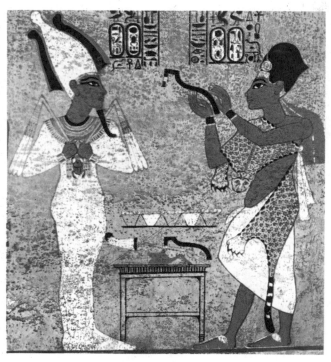

3. The priest Ai and the Pharaoh Tutankhamen. Fresco from
Tutankhamen's tomb. XVIII dynasty, 1362–1253 B.C.

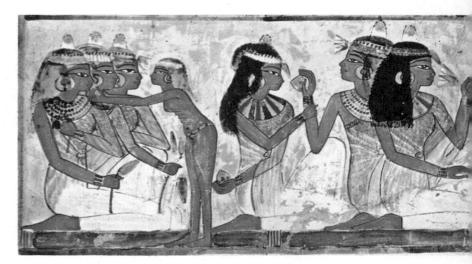

4. Funeral banquet scene. Tomb of Nakht, Thebes. Mid-XVIII dynasty.

When for political and economic reasons the age of pyramid-
building ended, the pharaohs built smaller tunnel-tombs into
the hills in the Valley of the Kings, a desolate ravine west of the
Nile at Thebes. Unfortunately, by the time archaeologists had
discovered these well-hidden tombs, almost all the contents had
long ago been stolen by robbers. The discovery of the untouched
tomb of the young king Tutankhamen in 1922 was therefore an
extraordinary event. Like the other royal tombs, that of Tutan-
khamen consisted of a series of passages and ante-chambers
which led to the sepulchral chamber itself. Next to the tomb,
the treasure chamber was found, still closed by the royal seals
on the door. There were found Tutankhamen's furniture, his
throne, his tables and chairs, and provisions for the long,
dangerous journey through the winding caverns of the Under-
world. The objects were made of precious woods and covered
with gold and were all perfectly preserved. Inside a sarcophagus
of yellow quartz, resting on a massive gold plinth, the royal
mummy was found. The head was covered with a mask of gold
inlaid with precious stones and enamels (1).

The life of the youthful king Tutankhamen can be recon-
structed thanks to the perfectly preserved condition of the tomb
and its treasures. He was the son-in-law of Ikhnaton, the artistic
and religious revolutionary. After Ikhnaton's death, the priests
of Amen quickly put a stop to the worship of Aton and the new
art style but a few artists continued to work in the more lifelike
manner. The paintings on the walls of the tomb show events in
the life of the King on earth and the scenes he expected to
encounter in the Underworld after his death (2, 3). They still
appear to have been drawn with a livelier and freer hand and
show an extreme refinement in their style (4, 5).

5. Portrait of a lady. Fresco from the tomb of Menna, Thebes. Mid-XVIII
dynasty.

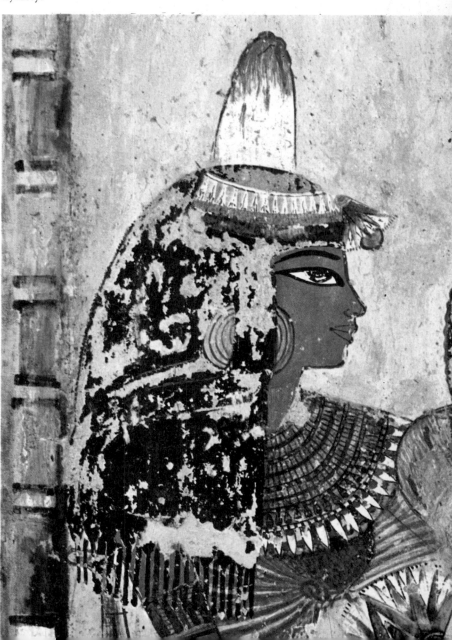

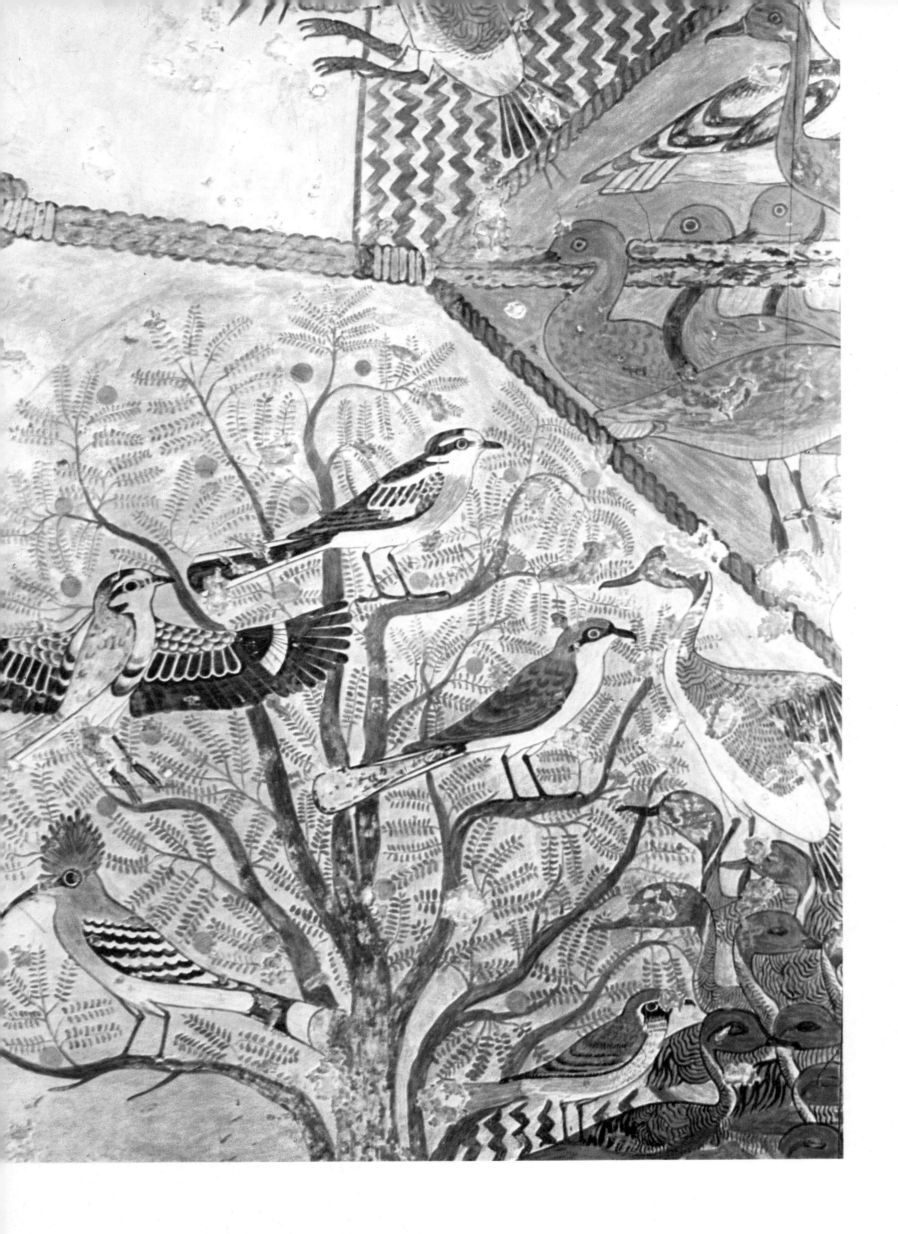

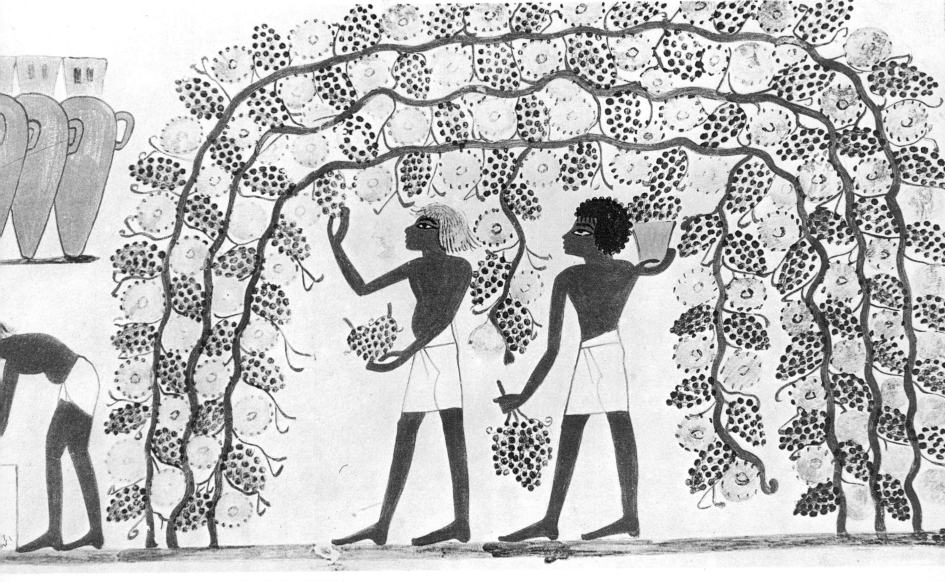

2. *Vintage scene*, from the tomb of Nakht, Thebes. XVIII dynasty, 1420–1411 B.C.

1. *Birds*, detail. From the tomb of Khnum-Hotep at Beni Hassan.
XII dynasty, about 1900 B.C.

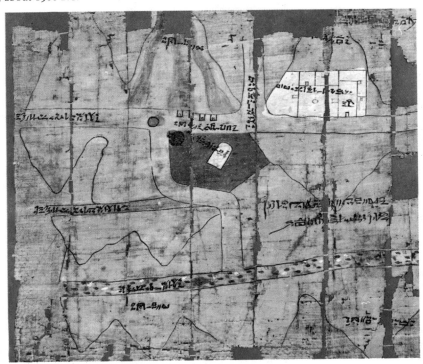

3. *Map of gold mines and quarries*. Papyrus fragment of the epoch of the Rameses.
The names of the mountains and roads are written in hieratic characters.

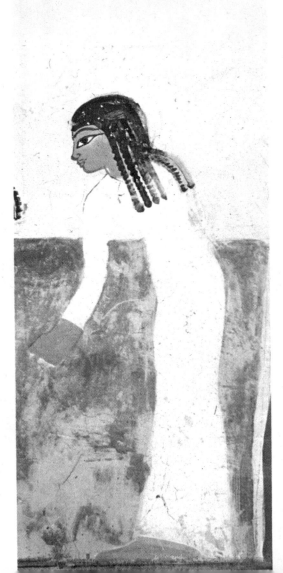

4. *Girl picking flax*. Detail from the tomb of Nakht, Thebes.
XVIII dynasty, 1420–1411 B.C.

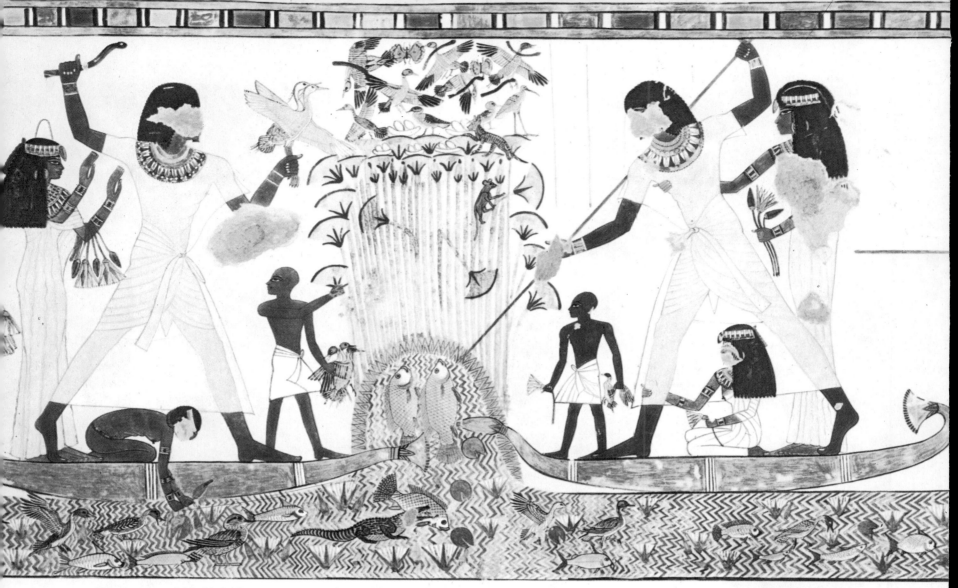

1. *Menena accompanied by his family on two outings in the marshes.* Fresco from the tomb of Menena, an official in the service of Thutmosis IV; Thebes. About 1415 B.C.

2. *Two bulls fighting.* From Thebes. New Kingdom, 1567–1005 B.C.

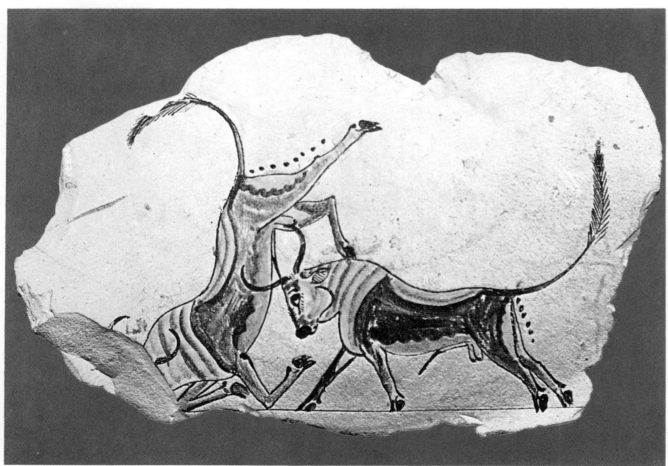

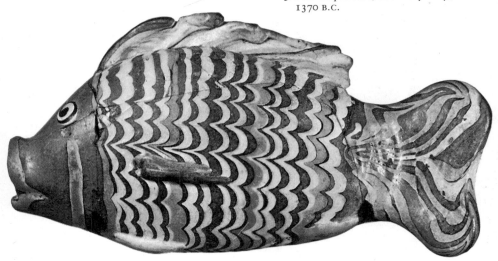

3. Fish-shaped vase, XVIII dynasty,
1370 B.C.

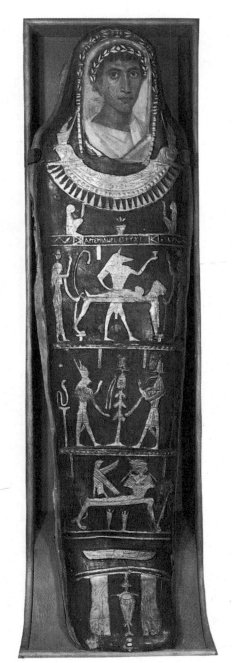

The Egyptians were unsurpassed masters
at capturing the fluid lines of an animal's
body in the smooth-finished materials
they worked. While the religious and
royal art of Egypt conformed to strict
conventions of style, art in the home, and
paintings depicting the pleasures and
labours of men and women, were drawn
with a rather freer hand.

Yet the conventions of Egyptian art
were so strong that they persisted into the
Roman and even the Christian eras.
Under Roman rule, embalmers con-
tinued to bury the dead in mummy cases
decorated with scenes from the ancient
traditions, they often painted portraits on
wood in a style that was half their own and
half Roman, and placed them on the
mummy case in place of the old masks of
gold. In (5) we can see a portrait of the
deceased wearing a wreath of olive leaves
in Graeco-Roman style.

*5. Mummy, with mask painted in the
Roman style.* 2nd century A.D.

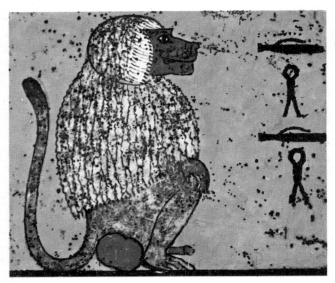

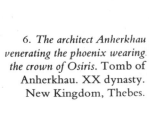

*4. Divine baboon witnessing
the solar journey.* Tomb of
Tutankhamen in the Valley
of the Kings. XVIII dynasty.
New Kingdom or the
Second Theban Kingdom,
Thebes.

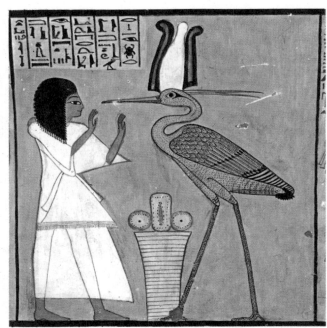

*6. The architect Anherkhau
venerating the phoenix wearing
the crown of Osiris.* Tomb of
Anherkhau. XX dynasty.
New Kingdom, Thebes.

1. Akkadian sculpture: *Head of a priest or ruler*. From Nineveh, 2270–2233 B.C.

MESOPOTAMIA AND IRAN

After about 3500 B.C., many great civilisations succeeded each other in the river-watered plain of Mesopotamia. Each produced an art somewhat influenced by the style of nearby Egypt, although it was more varied and less conventional. Unlike Egypt, wrapped up in itself and steadfast to its traditions, the peoples of Mesopotamia had no strong religious faith in an afterlife, nor in the divine power of long dynasties of rulers; rather, the people believed in various animal gods, human god-heroes, and in superstitions based on the stars and sorcery.

The Mesopotamians had little stone, so they built in sun-dried brick, and invented the arch and the dome, two architectural devices which were to influence most later building throughout the world. Since they lacked granite or marble, they turned to bronze, gold, and silver, and excelled at small, fragile carvings, in ivory and bone. It was here, in the melting-pot of many races, languages, religions, and art styles, that much of Western civilisation was born.

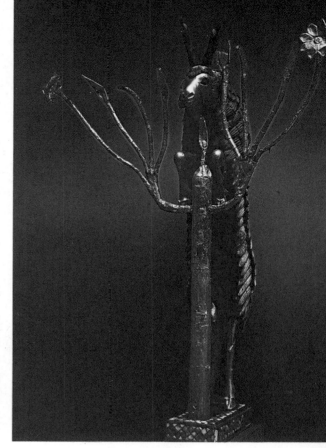

3. Sumerian art: *Ram in a thicket*, lapis-lazuli and gold. From Ur, about 2500 B.C.

2. Sumerian art: *Bull's head on a harp*, gold and mosaic. From Ur, about 2500 B.C.

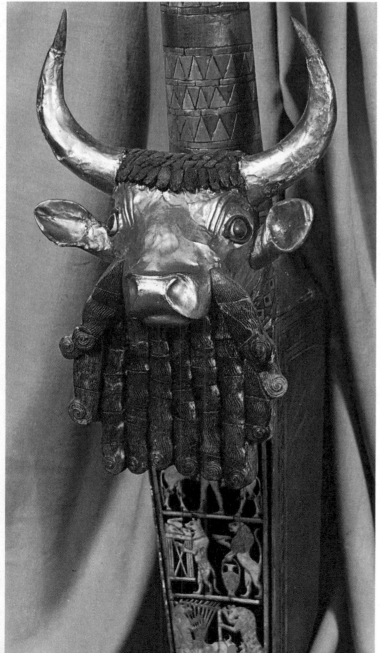

The art of Mesopotamia did not have a continuous and uniform development for it grew out of the crossing of different traditions in the rich country by the rivers Tigris and Euphrates.

The earliest Mesopotamian cities to achieve a high degree of civilisation were Ur and its neighbours, which flourished around 3000 B.C. They were built by a pastoral people called the Sumerians. Economic life depended upon raising great herds of cattle, so the soft-eyed bull became one of the favourite subjects in the art of the Sumerian gold-workers and sculptors. Around 2500 B.C. the Sumerians came under the domination of a northern Semitic people, the Akkadians, whose art was more lively and intense. In time, however, these invaders absorbed Sumerian culture and a second great Sumerian age dawned, with gentle priest-kings like Gudea of Lagash (4). This culture merged into that of Babylon, the capital of the long-remembered lawmaker Hammurabi, who united the country.

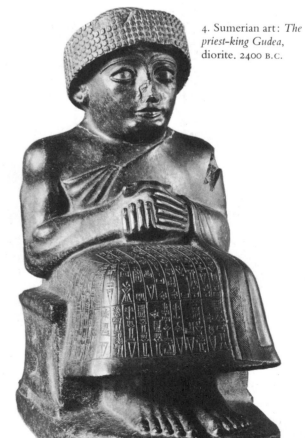

4. Sumerian art: *The priest-king Gudea*, diorite. 2400 B.C.

29

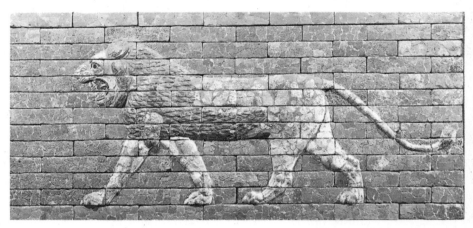

2. Babylon art: *Lion*. From the gate of the goddess Ishtar, 6th century B.C.

1. Assyrian art: *Assurnasirpal II*, amber, 883–859 B.C.

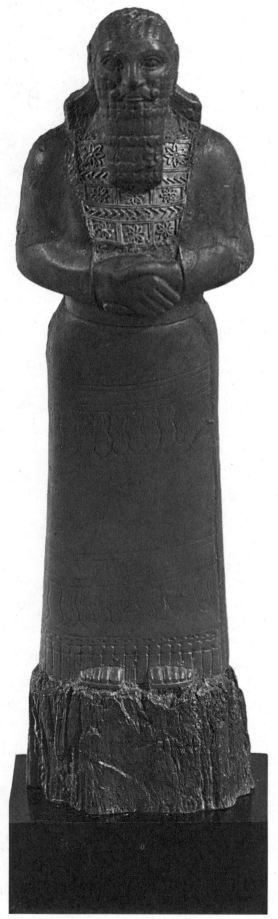

In the 10th century B.C., Southern Mesopotamia fell to the Assyrians, a warlike people from the north who worshipped a fierce sun-god, Ashur, and hunted lions with bows and arrows. The Assyrians built great cities, like Nimrud and Nineveh, and lined the walls of their palaces with huge stone reliefs. These showed their kings hunting and at war, and processions of grim, winged monsters, whose feathers, beards, robes, and muscles were fashioned into patterns somewhat like the less violent Akkadian sculptures. The Assyrians excelled all their neighbours in carving the free, wild action of animals. Perhaps their love of sport and the hunt sharpened their sight and made them as bold with a chisel as with a sword. They were also refined gold-workers, as is seen from the jewellery of Assyrian origin found to the south-east of lake Urmia in Iran.

In the 8th century B.C., Assyrian civilisation began to decline, and a new empire arose. Babylon was rebuilt in the 6th century B.C. by Nebuchadnezzar. The single gate-way to the city was dedicated to the chief religious deity of the Babylonians, Ishtar, the goddess of love, and covered with turquoise-blue enamelled tiles and adorned with golden lions (2) and griffins. Far behind the gate rose a great temple-tower or "ziggurat", the Tower of

3. Assyrian art: *Assurnasirpal II storming a city*, 883–859 B.C. Bas-relief from the Palace at Nimrud.

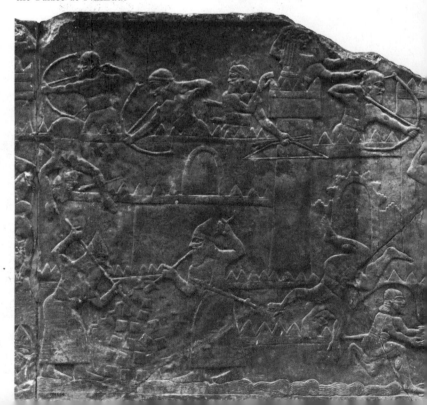

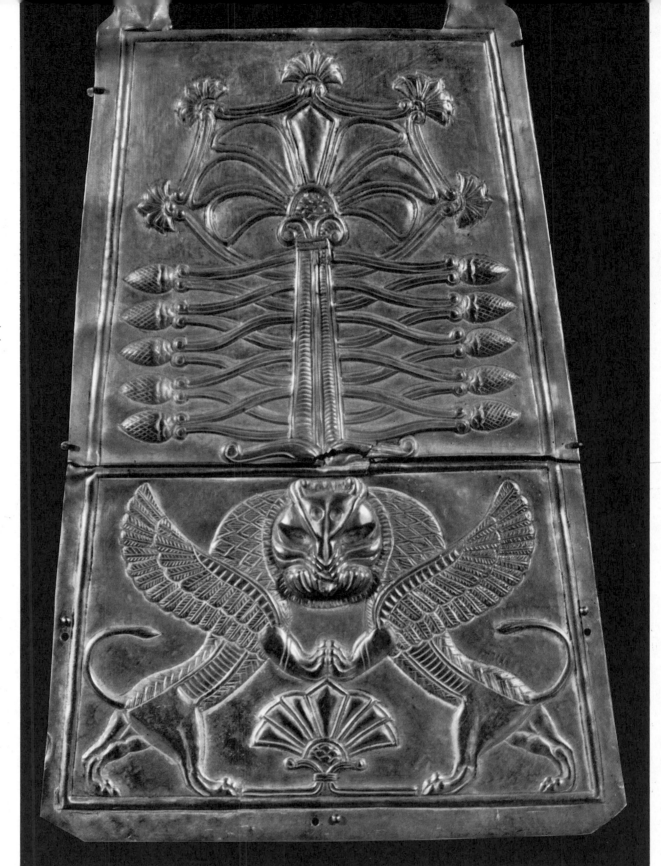

4. *Gold plaque from Ziwiye.*
7th century B.C.

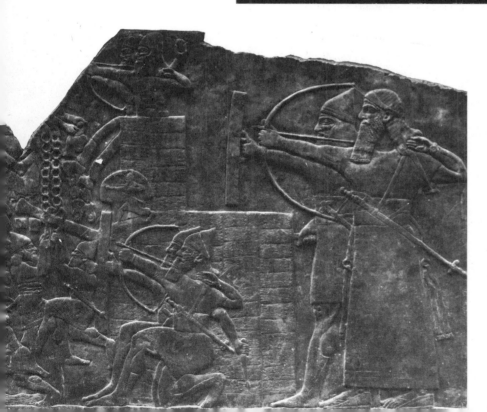

Babel of the Old Testament. Like all other temples in Mesopotamia, it was built high upon a pyramid of stepped-up brick platforms, as the country was constantly menaced by floods.

Although Babylon was a very luxurious and cosmopolitan city, it was also heavily fortified. Within the walls splendid palaces were built and a profusion of vines and flowers, drooping from the famous "hanging gardens", were irrigated with water from the Euphrates by means of an advanced hydraulic system. These gardens counted as one of the wonders of the world, for they could not have been built as they were without the invention of the arch, which allowed the beds to be placed high over brick or stone vaults.

31

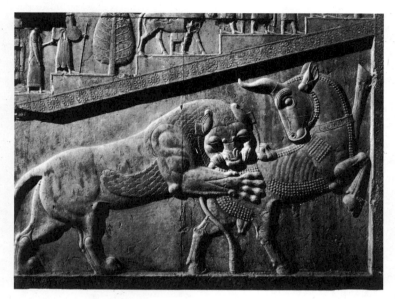

1. Persian art: *Detail of the Audience Hall (Apadana) of the Temple.* Persepolis.

In 539 B.C., Babylon fell to the Persian King Cyrus. His successors, Darius and Xerxes, built their own capital city of Persepolis, the ruins of which are among the best preserved in Iran today. Here are some of the carved scenes and details from the terraces and audience hall of the palace: sacred processions (5), robed shepherds and kings, merchants and farmers, bearing gifts of grain (2), deer (3), gold, and other riches. The sculptors and architects of Persepolis had surely seen the art of Greece, now entering its greatest period, for the figures of these reliefs obviously owe much to the Greek interest in drapery, and are carved with an easy grace seldom achieved by Mesopotamian artists. The columns which once arose from this platform also suggest Greece in their slender proportions, although their capitals were not patterned after plants or trees, but instead were the figures of rams, or fantastic animals, set back to back. Greek culture was soon to sweep over all the Near East, including Mesopotamia and Iran. In 480 B.C. the Greeks defeated King Xerxes; a century and a half later, Alexander the Great carried Hellenic culture as far as the borders of India, after defeating Darius III, the last Achaemenid king of Iran and Babylonia.

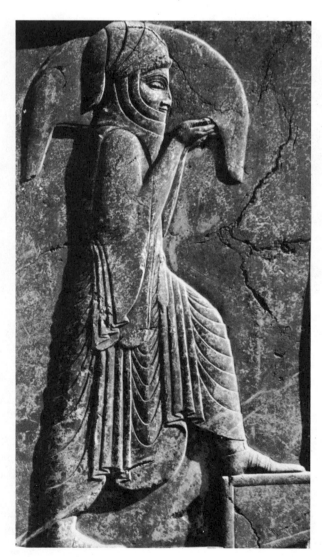

2. *Detail* of the Audience Hall of the Temple.

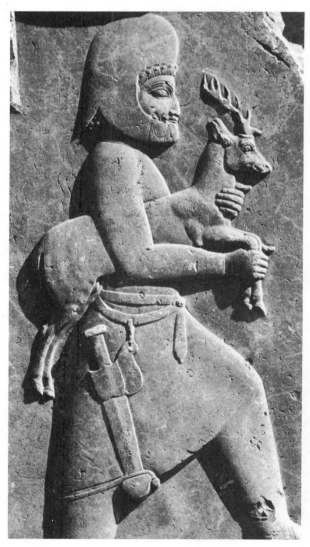

3. *Detail* of the Audience Hall of the Temple.

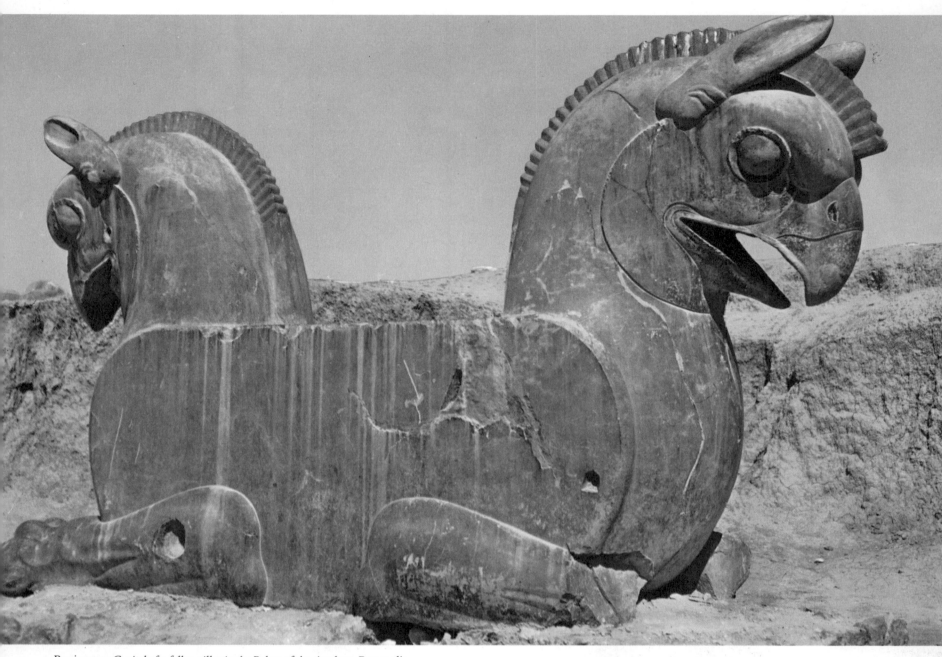

4. Persian art: *Capital of a fallen pillar in the Palace of the Apadana*. Persepolis.

5. *Detail* of the Audience Hall of the Temple.

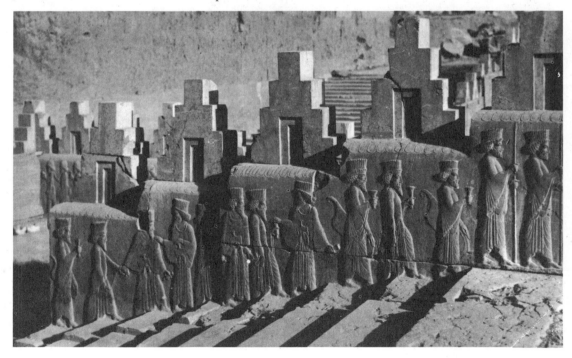

33

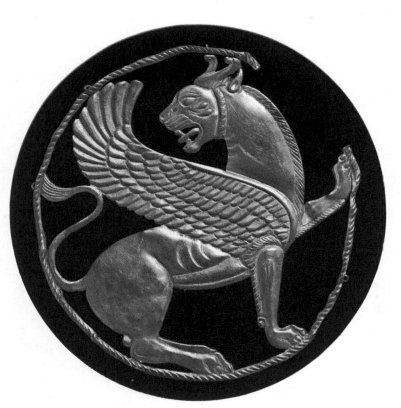

1. Art of Luristan: *Bronze bit plate from horse's harness*, about 1200 B.C.

In the 3rd century A.D., Iranian civilisation revived, and, throwing off the influence of Greece and Rome, it restored the old Persian religion and arts. The Sassanian Persians were brilliant artists, like their ancestors under the kings of Persepolis, and their inventions and styles spread throughout the civilised world. In their capital city, Ctesiphon on the Tigris, the Sassanians built the soaring arched palace (3) from which the later architects of Byzantium took inspiration for their own domed buildings, while Sassanian silverware deeply influenced the potters of T'ang dynasty in China. Their silver and textiles had a strong artistic influence on both Byzantine and Islamic civilisations and, through these, all Europe was influenced by Sassanian techniques and designs. One Sassanian pattern, a double figure inside a round medallion (5), is still used today on many satins and brocades.

The metalwork of Persia traced its style to the workmanship of the wandering steppe peoples who came out of south Russia, and ranged over Iran and central Asia. These nomadic people

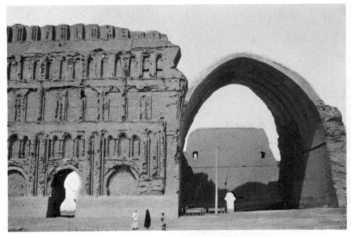

3. Sassanid-Persian art: *Palace of Ctesiphon*, 3rd century A.D.

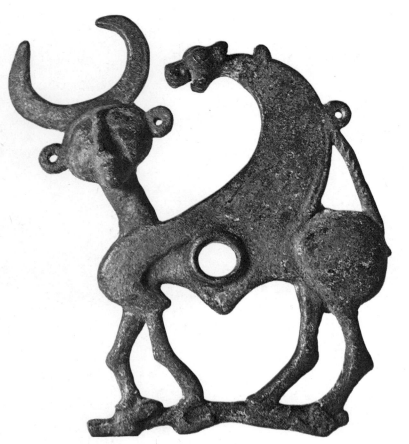

2. Achaemenid-Persian art: *Lion Roundel*, 6th-5th centuries B.C.

made their battle costumes and horse trappings in the shapes of elegant, prancing animals or imaginary, winged beasts (1), which have been unearthed in Luristan. Persian artists perfected the techniques of metal casting, and turned out marvellous objects in silver, gold, and bronze (2, 4). But however sophisticated their techniques, they always preferred the ancient images of the steppes, with their flying, winged beasts and prancing horses. The style spread through the Near East and even in late Roman times it produced such masterpieces as the rearing horse from southern Arabia (6). Such images are still alive today, for the modern flag of Iran bears a striding lion with a rising sun over its back.

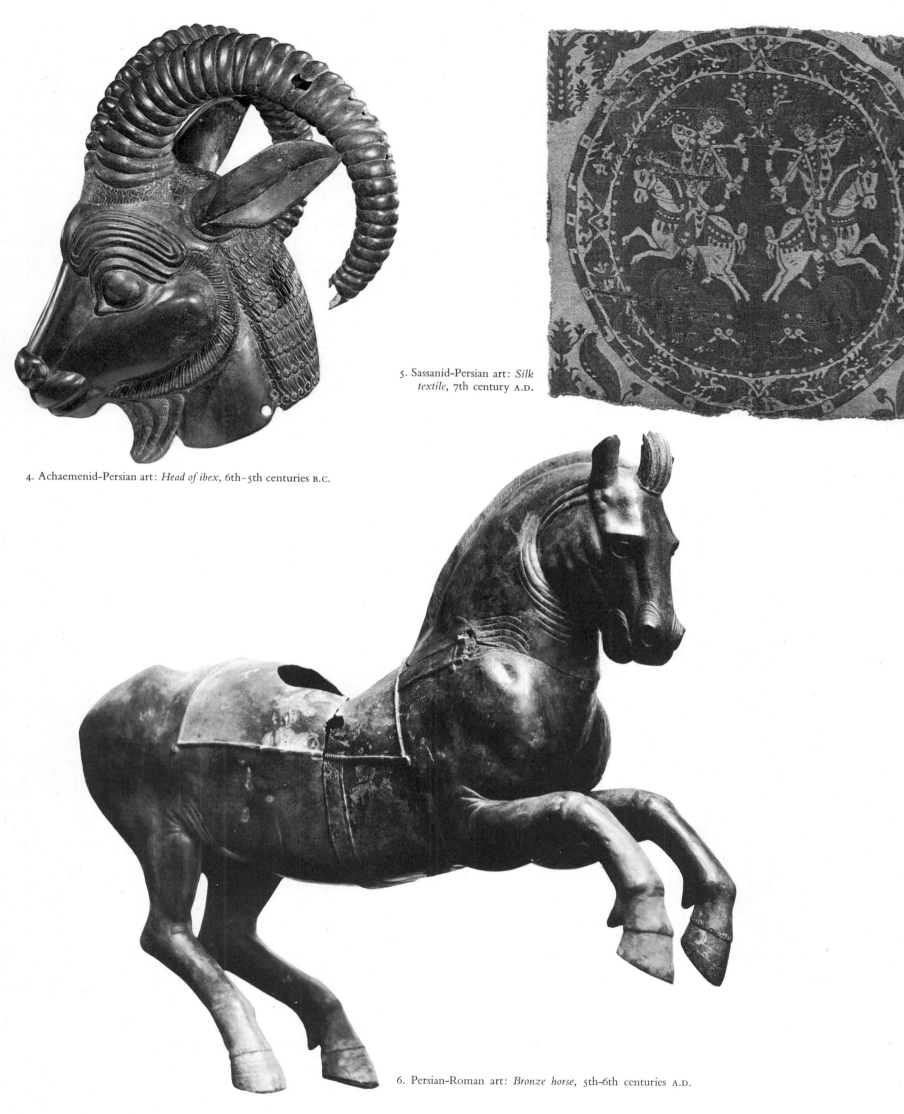

4. Achaemenid-Persian art: *Head of ibex*, 6th–5th centuries B.C.

5. Sassanid-Persian art: *Silk textile*, 7th century A.D.

6. Persian-Roman art: *Bronze horse*, 5th–6th centuries A.D.

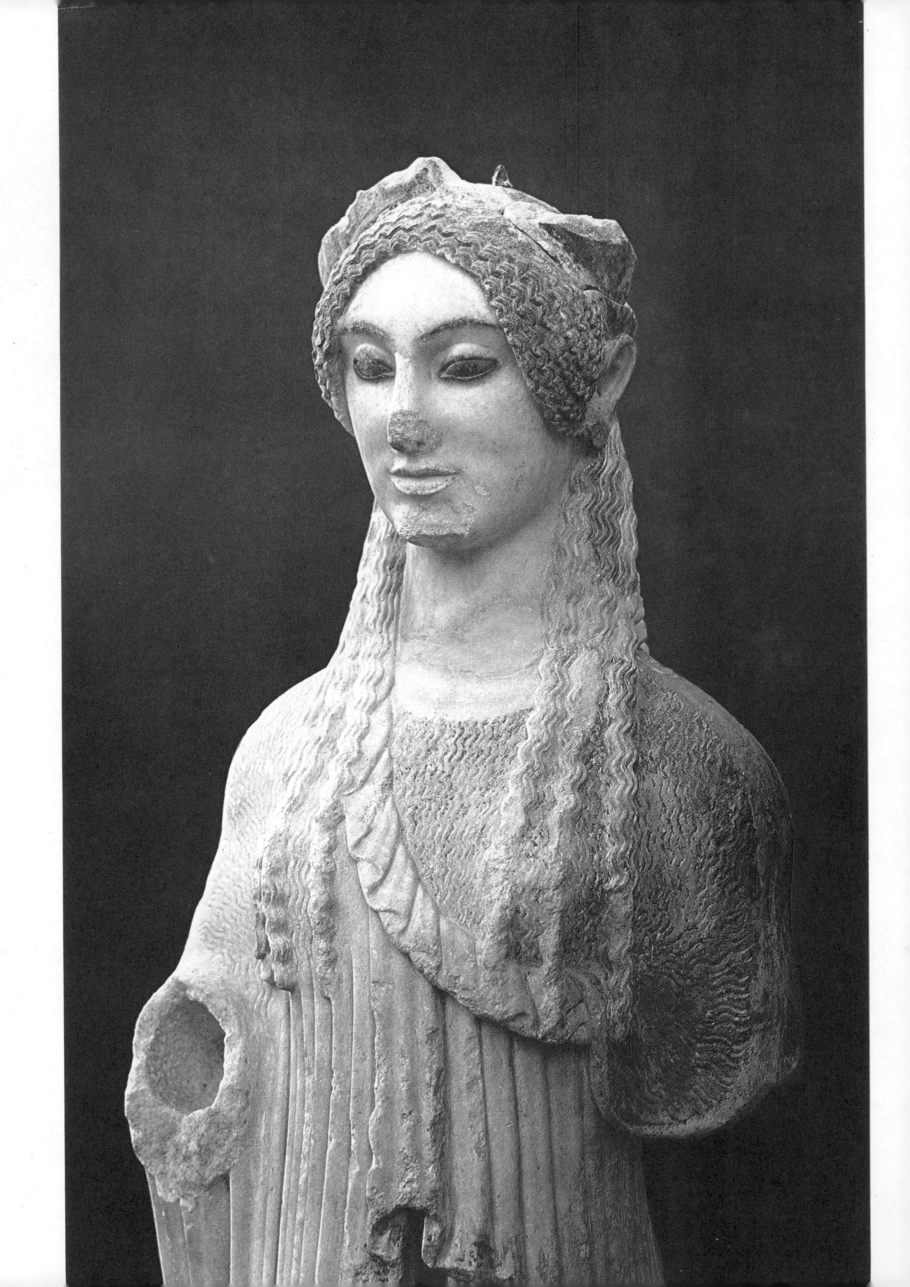

THE CLASSICAL WORLD

GREECE

The Western taste for realism or "naturalism" in art was born in Greece. Greek statues and paintings of the Archaic period began by showing similarities with the stiff designs of Egyptian and Mesopotamian art. They then became more natural and lively as the artists, no longer employed only by the priests for the supply of cult-objects, began to share in the great intellectual exploration then beginning in Athens, and searched for absolute standards of beauty. Greek artists seem to have studied anatomy, physics, and optics, as well as the techniques of carving, painting, building, gold-working and ceramics. They were familiar with the Homeric myths and the more ancient and compelling nature myths of the Aegean world. All the peoples of the Aegean worshipped many gods who were regarded as the protectors of the fields and harvests and as the rulers of the seasons. In ancient Crete the most important divinity seems to have been a serpent-goddess. In the Greek classical period the cult of nature-gods gave way to the worship of deities thought of as being like humans, and living above the clouds on the summit of Mount Olympus. When the Greeks made images of these gods, they gave them the most perfect human forms they could imagine and create, with bodies as lithe and controlled as athletes, and still with all the gravity and reserve of a priest.

This same spirit of gravity, control and naturalness infused Greek architecture as well. The Cretans building the royal palaces of Phaistos and Knossos, the Mycenaeans building the fortified cities of Tiryns and Mycenae, and the classical architects building the temples of the age of Pericles, all used the simplest of architectural forms—the post and lintel which had originated in Egypt but was refined to its most beautiful form in Greece. With her smooth brow and reflective air, the figure on the left (1) is a masterpiece of Greek style, and was, as can be seen, once painted in lifelike colours. The enigmatic idol from the Cycladic islands (2), was made over a thousand years before the elegant girl flute-player (3), yet in the simple crossing of its arms, and the slight tilting of its face, it seems to foreshadow the feeling of the Classical style.

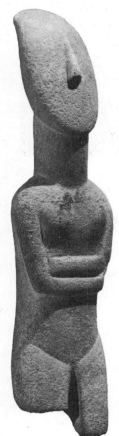

2. Cycladic art: *Female idol*, about 3000 B.C.

1. Archaic art: *Kore*, 350 B.C. From the Acropolis, Athens.

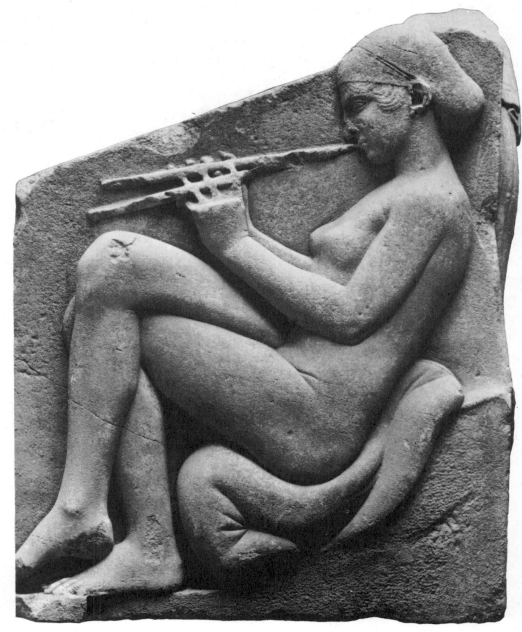

3. Classic art: *Flute player*. Detail from the Ludovisi Throne, 460 B.C.

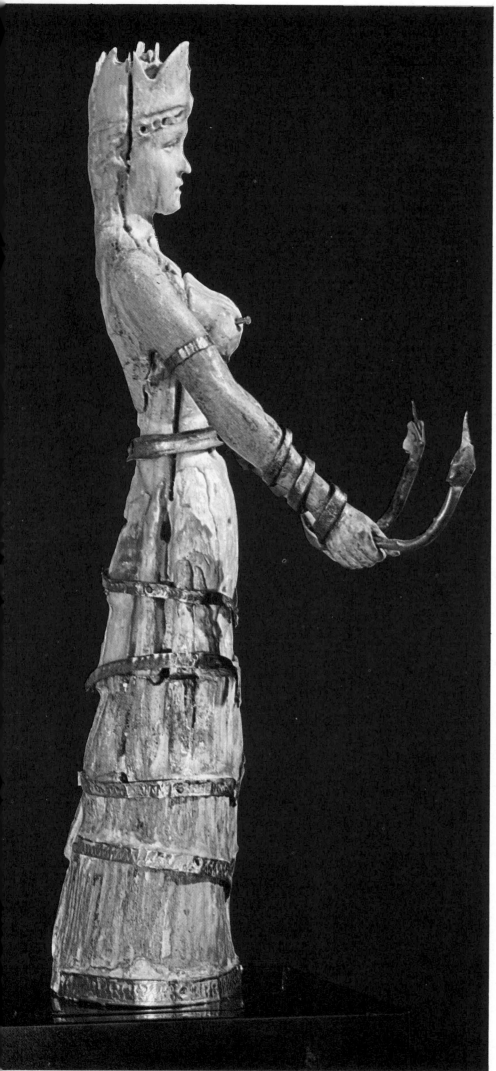

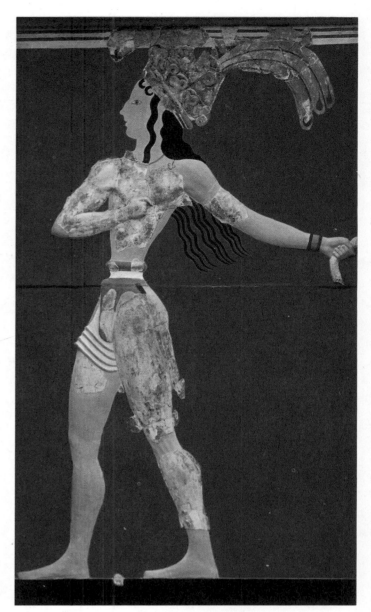

2. Cretan art: *Young prince*. Restored fresco.

Greek civilisation arose on the ruins of two great earlier civilisations in the Aegean world. One flourished in the second and third millennia B.C. on the island of Crete, about 1500 B.C., when the Egyptian empire was also at the height of its splendour, power passing to the mainland city of Mycenae. Four centuries later, this civilisation fell before invaders from the north, the Dorians, who ushered in Greece's Dark Ages. During these unsettled centuries, the story-loving Dorians embroidered and handed down myths and legends, based on half-remembered details of earlier civilisations. Consolidated in the Iliad and the Odyssey by Homer, the great poet of the 8th century B.C., these epics became the cornerstone of Greek literature and have survived undimmed to be part of the world's literary heritage. However, for centuries our ancestors believed, as the Athenians did, that the cities of Kings Minos and Agamemnon had only

1. Cretan art: *Minoan goddess*, 1500 B.C.

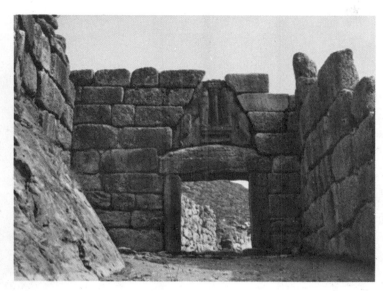

3. Mycenaean art: *Gate of the Lions*, 1350–1300 B.C. Mycenae.

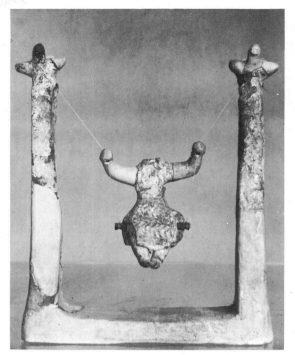

5. Cretan toy: *Girl on a swing*, 1550–1400 (?) B.C. Found near Phaestos.

existed in legends. It was not until our own century that archaeologists uncovered their actual astonishing ruins, bringing to light the pottery statues and paintings shown on these pages.

There was probably much sea-traffic between the ports of the Nile and the rocky Cretan harbours. The Cretans exported olive oil and wine to the entire Mediterranean world in decorated pots with wonderfully elegant designs like the one on the famous lotus jar (4).

Judging from their art, the Cretans were a gay and playful people. They made swings and toys for their children (5). One of the central religious events was a bull-leaping ritual, in which nimble dancers teased the bull by vaulting between its horns.

The freedom of the slim-waisted youths in these paintings (2, 6) is obvious evidence of a different world from that of the theocratic empires of Egypt and Mesopotamia.

Architecture and vase-painting reached great heights in Tiryns and Mycenae. There, the arts served above all to depict scenes of warfare and to honour the dead. The walls of Mycenaean cities were built with gigantic stone blocks, and the great gateway with the carving of two confronted lions (3), symbolising the city's power, is famous. Kings and heroes were buried in domed underground crypts with arched passageways. Beaten gold masks were laid over the dead faces of Agamemnon's countrymen.

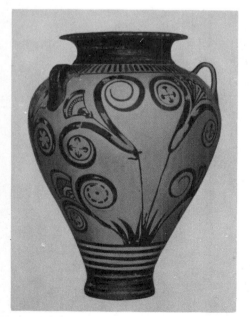

4. *Cretan vase* in the "Palace Style".

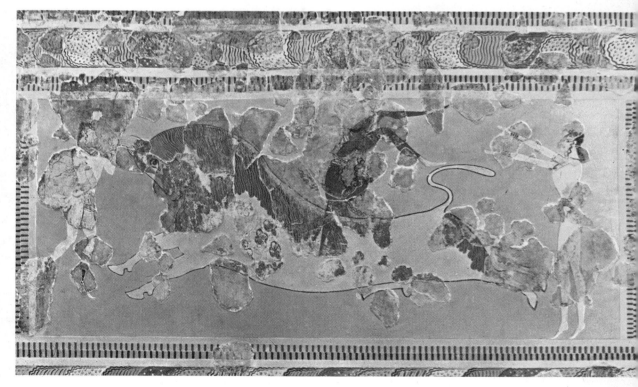

6. Cretan art: *Bull-leaping*, fresco, about 1500 B.C. From the Palace of Cnossos.

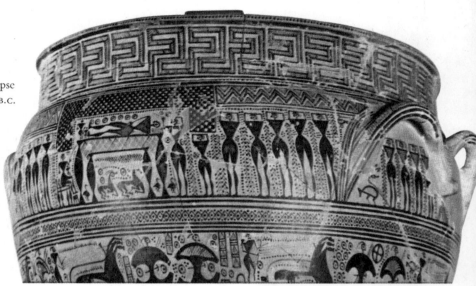

1. *Ritual vase*, terra-cotta, with painting of corpse
and funeral procession, 8th century B.C.

The Greek Dark Ages buried all the traces of Cretan and Mycenaean art, and when the new Greek world evolved in the late 9th century B.C., artists had to learn their craft again, and gradually rediscover their artistic freedom. On the 4-feet-high vase seen above (1) every detail of the funeral procession is crammed into a stiff pattern, a reversion to the designs on Neolithic pottery. Early in the 6th century B.C., artists achieved a style now called "Archaic", which was a step towards greater

plasticity but was still based on the stiff geometrical patterns which controlled the brush of the great Greek vase-painter Exekias, and the chisel which shaped the marble horseman's head (5). Tight curls, like those on Mesopotamian carvings, frame almost triangular eyes, showing a preference for geometric forms, and the mouth is drawn up tensely into the expression we call the "Archaic smile".

The first standing statues in Greece were probably carved

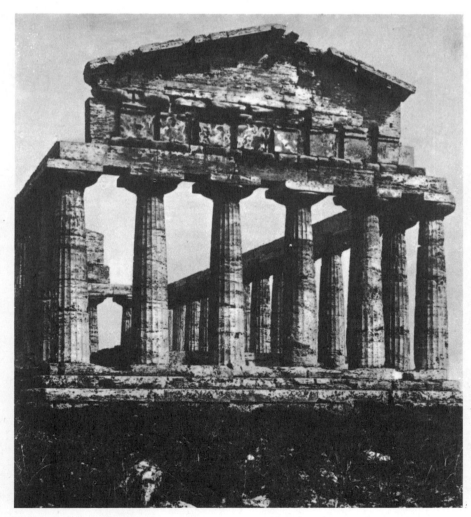

2. *Temple of Ceres*, Paestum.

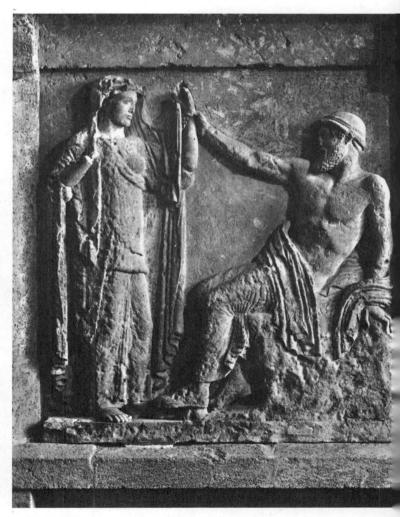

3. *Zeus and Hera*, metope from Selinunte, 627–409 B.C.

from tree trunks, and had to be made straight and stiff to fit the piece of timber. Egyptian models may also have had an influence. Little by little, the sculptors learned to divide the human body into geometric areas, to show how clothing falls in geometric patterns, and how even the bent body of an archer falls into an almost square pattern. Despite the strictness of the rules and the long established conventions, very great artists emerged, like the sculptor of the superb *Hera of Samos* (4). The mathematician Pythagoras was at that time drawing his figures in the sand and proving that the harmony of the whole universe is based on geometry.

The sculpture on an Archaic temple (2) was fitted stiffly into place in the triangular pediment and along the frieze. The same sculptural plan was used on later temples, but the figures were placed with greater freedom.

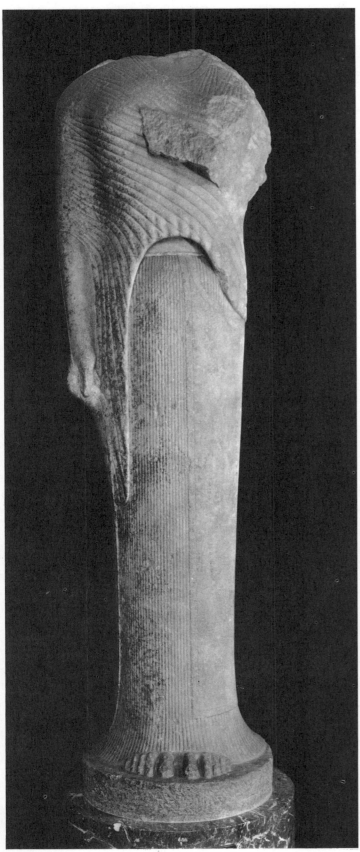

4. Hera of Samos.

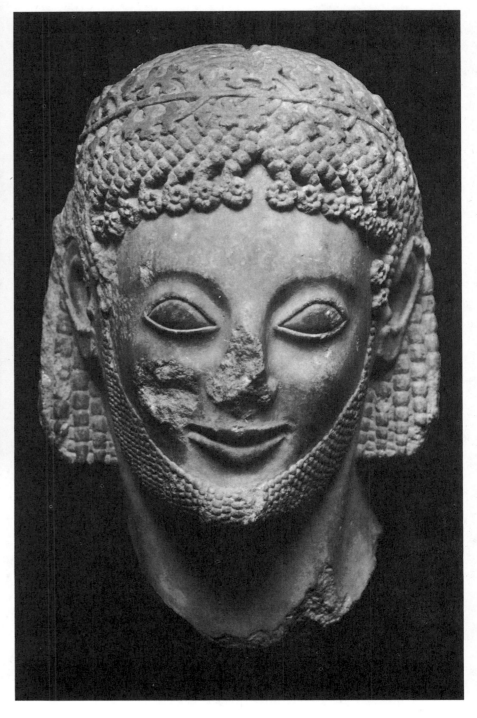

5. Head of a horseman, about 560 B.C.

This gallery of gods and heroes from Greek myths and life makes visible the evolution of style from the late Archaic to the Hellenistic periods. Early 5th-century figures (1) were still tense and stiff, their bodies hidden within enfolding robes, but bold innovators like Myron began to break with the old formula and to show figures in freer action. A famous example of the new style is *The Discobolus*, shown in an attitude of maximum tension, full of compressed energy, and about to explode into action (4). The art of bronze casting was now perfected and the charioteer (2) was cast in six sections, the eyes being added with coloured inlay.

In 483 B.C. Greece had defeated the invading armies of Persia; soon after, the brilliant Athenian leader Pericles commissioned his friend, the sculptor Phidias, to carve the sculptures of the Parthenon, where "Classical" Greek style is represented at its

2. *Charioteer*, about 470 B.C.

1. *Enthroned goddess*, about 480 B.C. From Taranto.

purest. After three centuries of experiment, Greek sculptors had finally mastered all the points of human anatomy and proportion and set out to create perfect forms.

The age of Pericles, however, was short-lived. Within sixty years, Pericles was dead, and Athens was defeated by Sparta. Thinkers, poets and artists looked inward, in a mood of questioning meditation. Praxiteles was a master of the new style of sculpture which reflected it. Apart from his *Hermes with the infant Dionysus* (5) his works (like most other Classical Greek sculptures) are only known through later Roman copies, but even in these we can see the extreme refinement of his style in the harmonious lines and delicately balanced composition of the figures. The bodies appear soft-skinned and pliable, their contours undulate like sea currents. They stand slightly off-balance, as if leaning against a tree-stump for support. Hermes and Venus are not the energetic young gods of Olympus any longer, but have become dreamy and mysterious. They are revived forms of the ancient nature deities of Aegean civilisation.

In 338 B.C. Greece fell to Alexander of Macedonia, whose marching columns were spreading his rule across the ancient world. From this time to the 1st century A.D., Greek style is usually called "Hellenistic". This is a general term covering various tendencies which it is hard to define exactly. It denotes a preference in sculpture for more elaborate patterns, a mannered arrangement of figures and groups, and an emphasis on the representation of movement for dramatic effect.

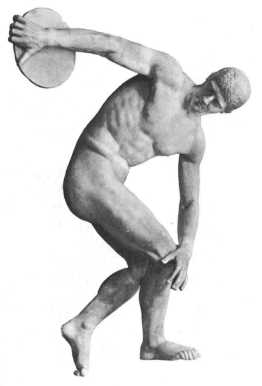

3. *The Venus de Milo*, 2nd century B.C.

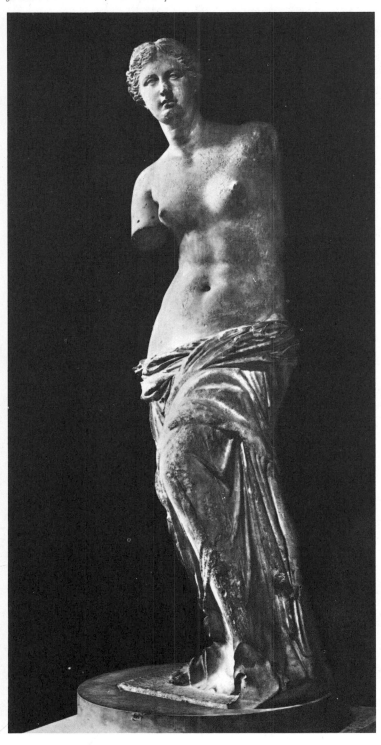

4. Myron: *The Discobolus*, about 450 B.C.

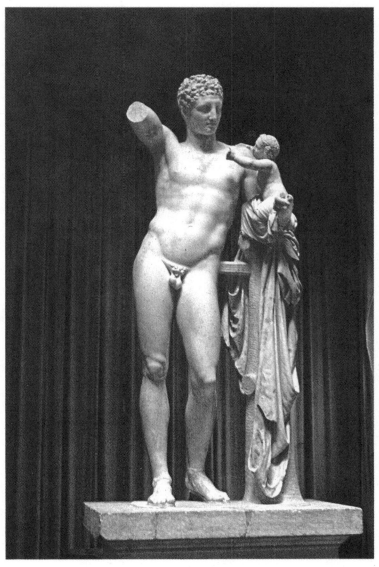

5. Praxiteles: *Hermes with the infant Dionysus*, 340 B.C.

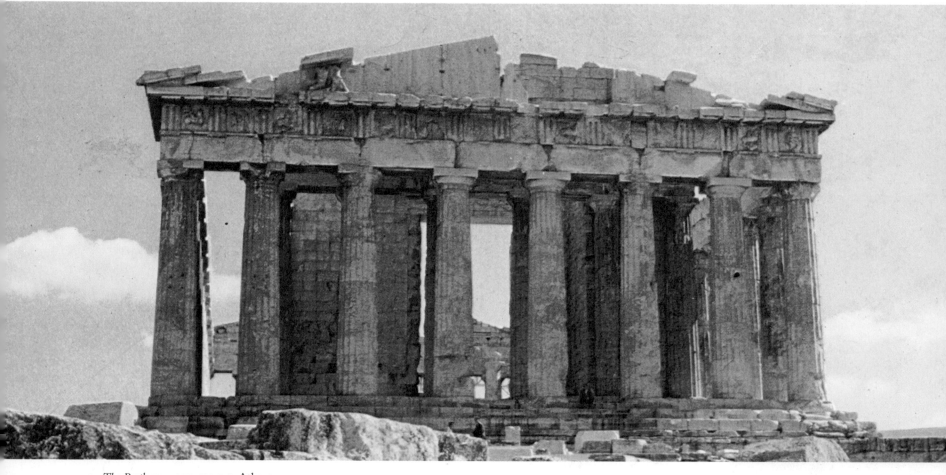

1. *The Parthenon*, 447–432 B.C. Athens.

The Acropolis ("High Town"), rebuilt under Pericles by the great master Phidias, is the grandest and most important complex of buildings ever built in ancient Greece. It is a great example of carefully thought-out planning. To accentuate the marvellous architecture of the temples on the summit, a causeway lead the visitor from the imposing Propylaeum to the very front of the Parthenon. This causeway was devised to give a series of successive views of the various buildings from different points along the route: the little temple of Athena Nike (4), the now vanished temple of Athena Promachos, the Erechtheum (2), and finally as a grand climax, the Parthenon itself.

Greek temples consisted of a central shrine or room in an aisle surrounded by rows of columns. The relationship of the column to the structure it carries was of great interest to Classical builders. Since there is a similarity between the form of a human figure standing upright and a column, it was not surprising that an architect thought of carving human bodies to bear the lintel. The slightly staggering bodies of these caryatids (2), called after the priestesses of Diana's temple at Caryae, bear their burden with the same assurance as the powerful Parthenon columns (1).

The Parthenon (1), the greatest Classical temple, was ingeniously engineered to correct an optical illusion. Its columns were slightly contorted, swollen at the centre and leaning inward, to correct what would otherwise have been an impression of deadness and top-heaviness.

Each Greek temple was designed in one of three architectural styles: the Doric (1), the Ionic (2, 4), and later the Corinthian. These styles were called the "orders". An order consisted of the base, its column, and its capital, and the roof which it supported.

As in all Greek sculpture, the proportion of the parts determined the design. A thick Doric column, like those of the Parthenon, had to bear a sturdy cross-beam divided up into simple alternating blocks of sculpture and blank stone. The taller, slimmer Ionic column carried a more delicate beam, carved with a

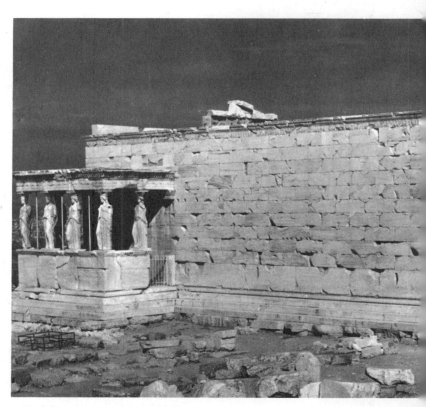

2. *Erechtheum, portico of the caryatids*, 421–405 B.C.

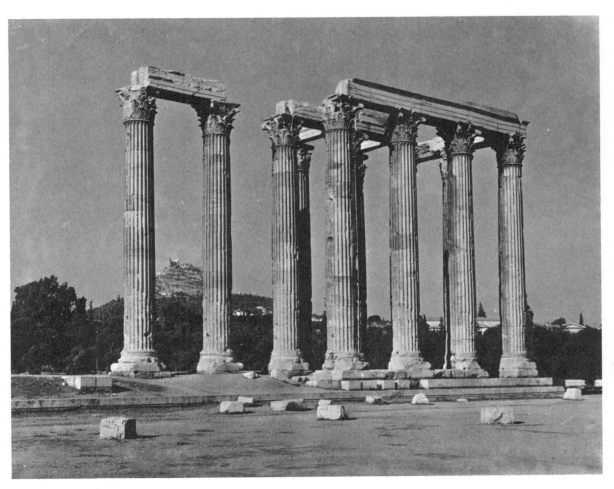

3. *Olympeium*, Athens. A.D. 131.

moulding, or strip of darts and ovals, or leaves. The Doric capital ended in a sturdy, flat slab. The Ionic capital was a graceful double spiral.

The richest and most elegant of all, but also the least original and expressive, was the Corinthian Order, invented around 420 B.C. in the rich merchant city of Corinth. The design may actually have originated in Egypt, becoming more naturalistic as it passed into Greece. The Greek orders were perfectly proportioned and so well suited to their purpose that they have inspired Western architecture ever since.

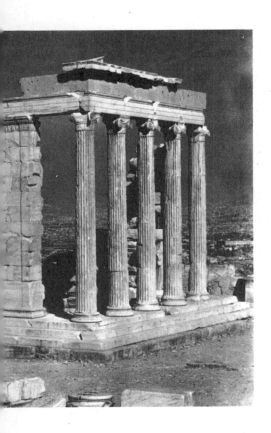

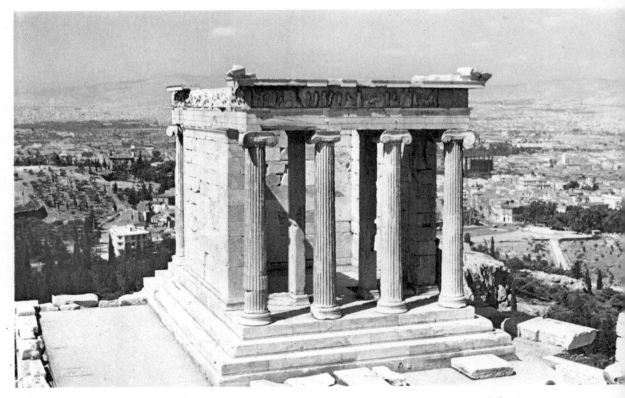

4. *Temple of Athena Nike*, about 426 B.C.

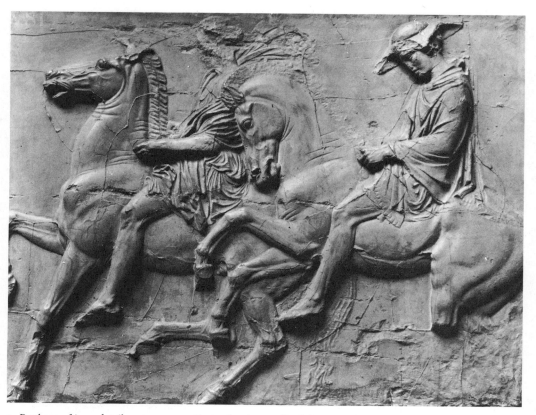

1. *Parthenon frieze*, detail, 447–432 B.C. From the Acropolis, Athens.

3. *Old woman at market*, 2nd century B.C.

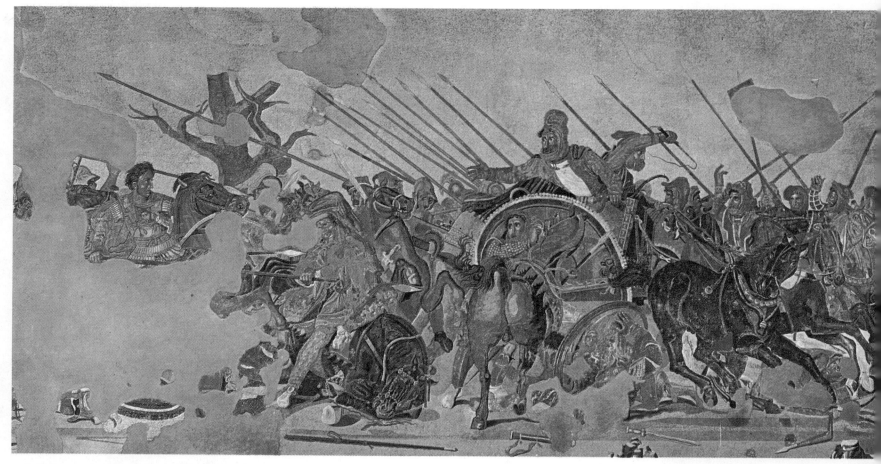

2. *Battle between Darius and Alexander*, mosaic, 4th century B.C.

46

The predominant direction of Western art until the 20th century had been towards the creation of a greater illusion of life with the lifeless materials of art. In this, Western art long differed from primitive and Oriental arts, which aim less for the illusion of reality, and more for a symbol to suggest an image in the mind. The Western school of realism could only develop when artists had mastered their techniques and increased their knowledge of the physical world. They had to study anatomy and proportion, and the laws of motion and perspective.

Sculptors gradually learned to suggest realistic space and anatomy, and a sense of individual personality (1, 4). Later they strove to copy every detail of the human body and all the changing expressions of the human face, thus giving up the principle of ideal beauty (3, 6). Faces and figures like these, which were made in abundance in the late Hellenistic world, would not have appealed to the artists of Archaic or Classical Greece, who chose to represent the serenely beautiful and almost symbolical forms of heroes and gods (5). Greek painters in the Hellenistic city of Alexandria carried their style to a climax. They learned to splash on colours with a loose wrist: a quick stroke

5. *Silver coin*, obverse and reverse, about 400 B.C. From Syracuse.

for the head, a speck of white for a glancing eye. This manner of painting gave the impression of a swift, flickering action. This style was carried to Rome, where it became the basis for a great school of copyists, original painters, and workers in mosaic. The mosaic of a battle scene, the *Alexander mosaic* (2), is a copy, made near Rome, of a lost Greek painting.

4. *Veiled and masked dancer*, about 200 B.C.

6. *Head of a philosopher*, 3rd century B.C.

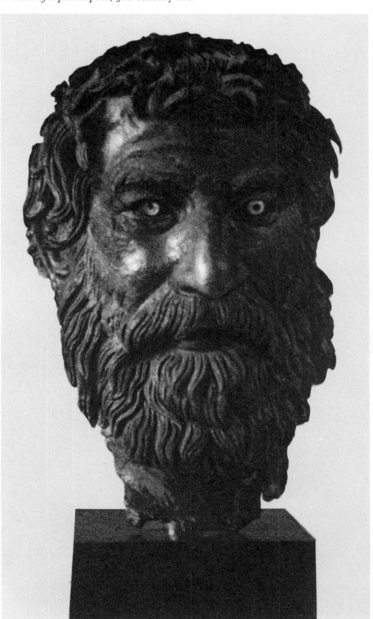

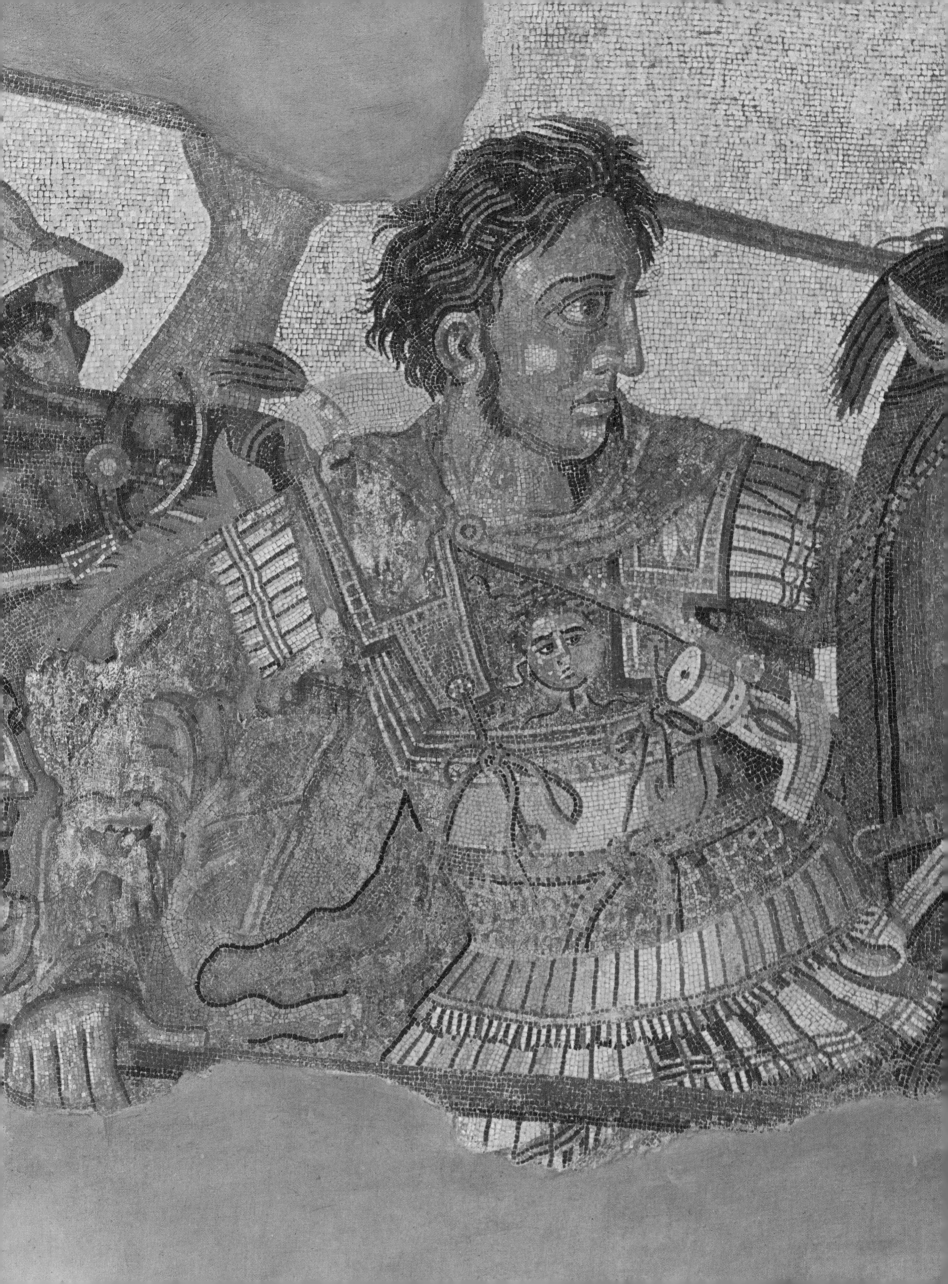

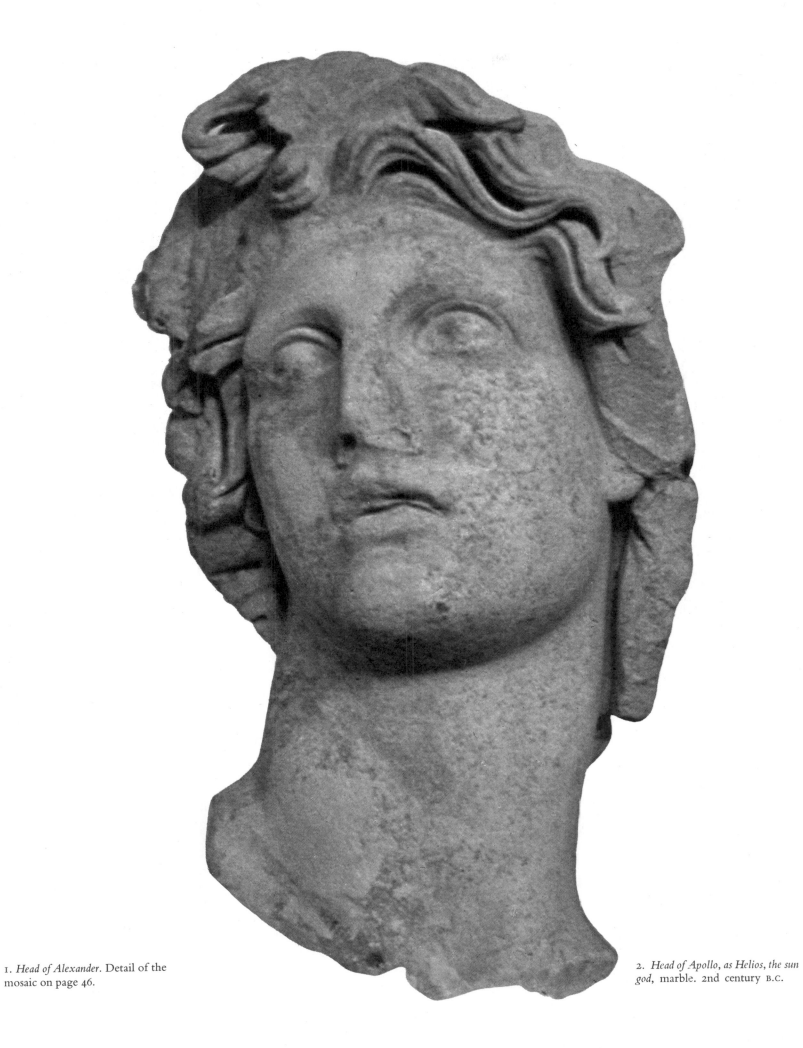

1. *Head of Alexander.* Detail of the mosaic on page 46.

2. *Head of Apollo, as Helios, the sun god,* marble. 2nd century B.C.

The creator of the *Alexander mosaic* (page 46:2—detail, page 48:1), used many of the same devices that sculptors used to suggest an illusion of deep space and the personality of the famous conqueror. The mosaic representation of Alexander is no longer based on any set pattern, but instead has all the individuality of a portrait from life. In the same way, the mythical figures of Mount Olympus became less detached and remote in their representation.

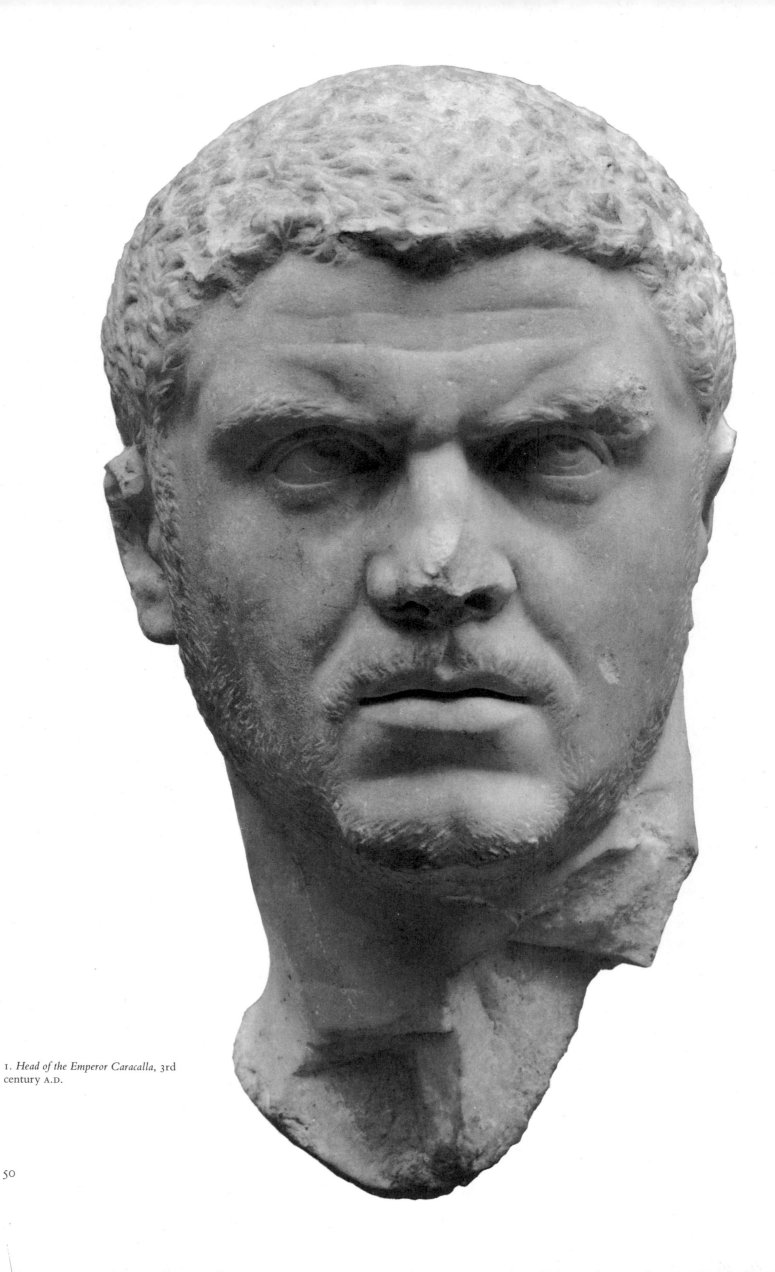

1. *Head of the Emperor Caracalla*, 3rd century A.D.

50

THE
CLASSICAL WORLD

ROME

Roman artists strove to reproduce the world around them as realistically as they could, and to give an illusion of life itself flickering in the stone wrinkles of a portrait bust or in the painted glint of an eye. On the other hand, Roman architecture was often consciously designed to reflect the power of the City, and to create in all people an awe of its imperial power. While Roman painting and sculpture traced its roots to Greece and the advanced technical inventions of artists, Roman architecture went back beyond Athens to the towering brickwork arches, vaults and ramparts of Mesopotamia. Roman art reflected a mixture of borrowed cultures fused together with local traditions (such as the Etruscan) to form the basis of the Italian tradition. It was not until the reign of the emperors Trajan, Hadrian and Marcus Aurelius (2nd century A.D.) that Roman art developed any real originality of its own. Eventually, as the empire fell apart, an awesome, supernatural kind of art prevailed, and the ideals of naturalistic Classical art were abandoned before they had had time to die out, with the fervent and anti-worldly vision of the early Christians.

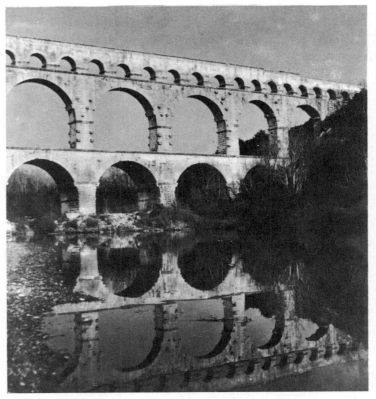

2. *Pont du Gard*, aqueduct, 27 B.C.–A.D. 14. Nîmes.

3. *Arch of Trajan*, A.D. 114. Benevento.

As long as Rome was the centre of the civilised world she transmitted artistic ideas and styles throughout the world that held good for centuries to come. They can still be seen in her great monuments, and many cities in Europe and North Africa still show traces of the geometrical layout of Roman army camps in their planning.

Romans built sturdy stone structures both for use and to perpetuate their glory (2, 3) wherever they went, and the result was that all their subject peoples, far and wide, had the same architecture as the citizens of the City of Rome.

On the left (1) is a penetratingly realistic portrait head made in the 3rd century A.D. of the Emperor Caracalla, who murdered hundreds of Roman citizens in his paranoia: and then built the splendid public baths called after him, to placate the frightened and angry populace.

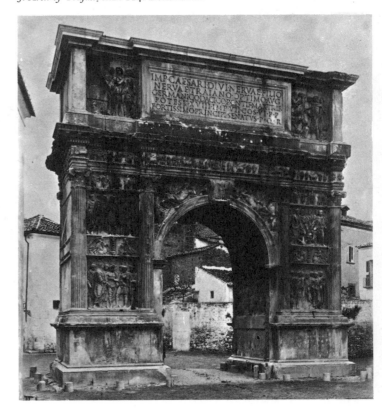

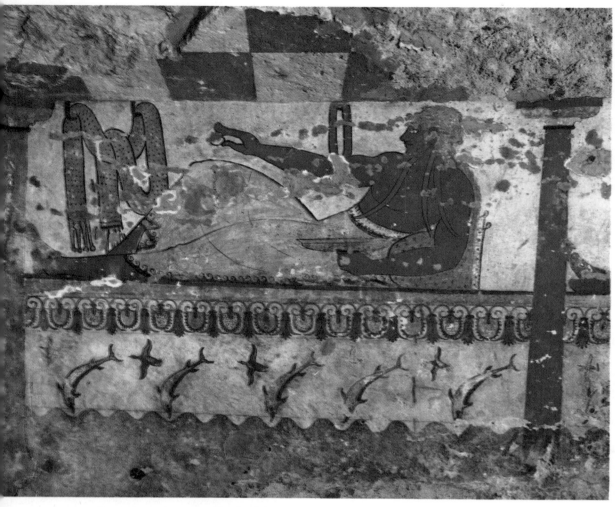

The Etruscans occupied west-central Italy from the 8th century B.C. until they were conquered by the Romans in the 3rd century B.C. No one knows exactly where this people came from, but their arts seem to link them with an east Mediterranean culture. Like the Minoans and Myceneans, they were builders, mainly using wood and baked bricks for their temples, and reserving stone for the walls of their cities and tombs.

As in Egypt, funeral arts were important in Etruria. Their coffins were shaped like banqueting couches; see, for example, the famous sarcophagus from Cerveteri (2), with life-sized figures of the deceased, smiling like the Apollos and maidens of the Archaic Greeks. The whole composition is a magnificent example of the high degree of expression the Etruscan artists put into their works. The tombs were painted with birds, flowers, and dancing figures, in freer postures and more realistic anatomical details than in Egyptian or Cretan paintings (1, 6).

1. Etruscan art: *Banqueter*. Tomb of the Lionesses, Tarquinia.

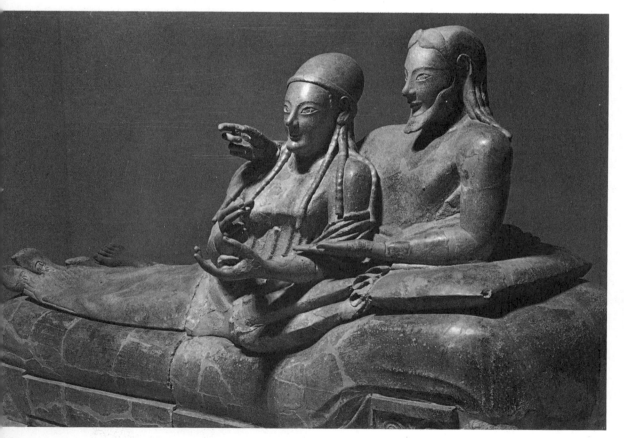

2. *Sarcophagus from Cerveteri*, terra-cotta. 6th–5th centuries B.C.

3. *Apollo*, from Scasato.

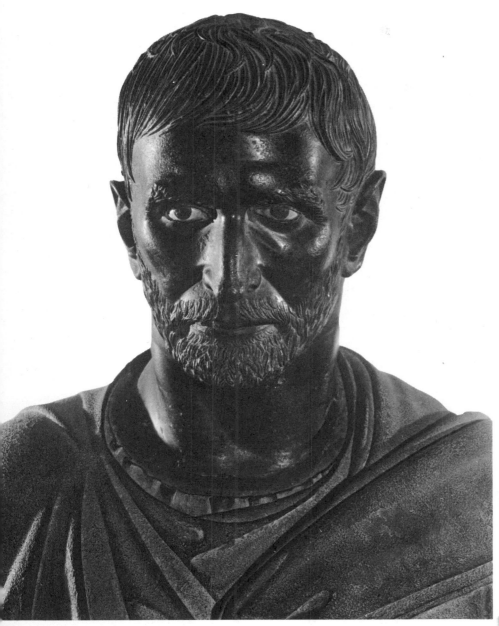

4. *Brutus*, by an unknown artist. Bronze. 3rd century B.C.

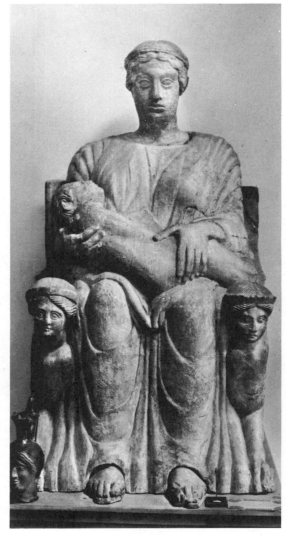

5. *Mother goddess*, 5th century B.C.

The Etruscans excelled in bronze casting as well as in stone carving. Travelling Greek artists certainly visited Etruria and influenced sculpture there, but an even greater influence was their gloomy cult of the dead, which manifested itself in figures of monsters and death-goddesses more like those of Mesopotamia than of Greece.

Cast in bronze, like the Greek bust of a philosopher on page 47, the Etruscan portrait shown here (4) is even more realistic in detail and expression. Much later, in Republican and Imperial Rome, this kind of fascination with the personality of the subject produced the world's first great style of portraiture. The Etruscan mother and child (5), with its echoes of the Greek Classical style, is an example of the idealised representation of motherhood that was to find its greatest expression centuries later in Christian images of the Madonna.

6. *Pipe-player*, about 475 B.C. Tomb of the Triclinium, Tarquinia.

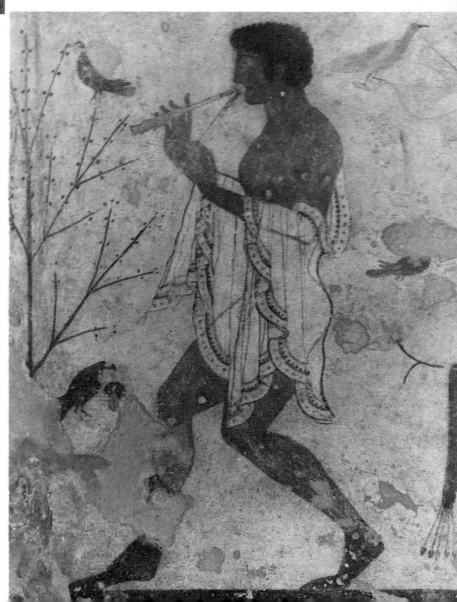

1. *Bust of Julius Caesar*, marble. 48–44 B.C.

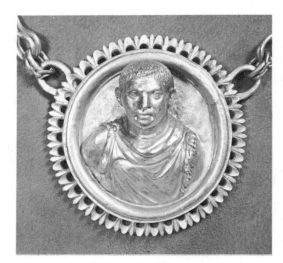

2. *Pendant with portrait of a Roman consul*,
A.D. 238–243.

3. *Equestrian statue of the emperor Marcus Aurelius*,
bronze. A.D. 161–180. Rome.

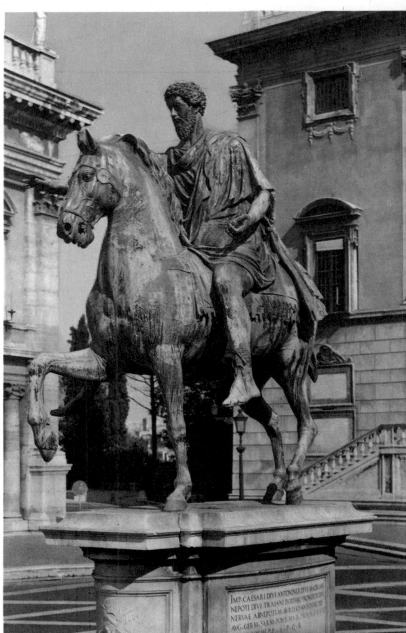

The Romans of the Republic, who conquered and assimilated
the Etruscans and started the course of world-conquest, por-
trayed themselves without trying to glamourise or idealise their
faces (2). One of the most powerful of such portraits was the
bust of Julius Caesar (1) whose conquest of Gaul opened a gate-
way linking the whole western world to Italy.

The Emperor Augustus brought to an end the civil wars which
had ravaged the Roman dominions since Caesar's assassination.
He loved Greece, and had statues of himself made in the Classical
fashion, but with much greater emphasis on facial detail and
individual expression. Some of Rome's greatest poetry, philo-
sophy, and art was created during his reign. Architecture,
especially, made great progress. Much of Rome was rebuilt, so
that later the Emperor was able to boast that he had found the
city made of brick and left it built in marble. The greatest build-
ing of this period was the Forum of Augustus in the traditional
centre of the city's public life, where the city fathers met, the
tribunals were held and public officials had their offices.

Imperial Rome had changed greatly compared with Republi-
can days when pure, Greek-style temples lined her forums and

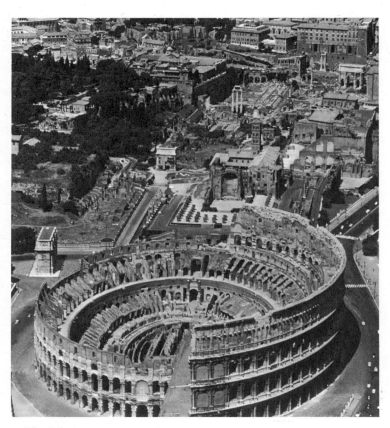

4. *The Colosseum*, A.D. 70–82. Rome.

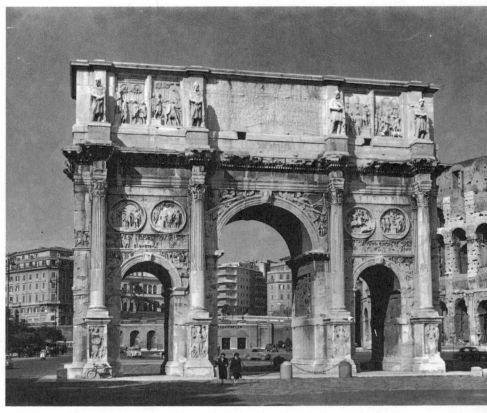

5. *Arch of Constantine*, A.D. 312. Rome.

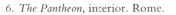

6. *The Pantheon*, interior. Rome.

there was little else of importance in the city. In order to deflect the discontents of the growing populace, the emperors erected huge halls and arenas for public games, baths, and processions—they built them of gigantic arches of stone, brick and concrete, or with barrel vaults as in the arcades under the Colosseum (4). The new architectural systems had a deciding influence on the resulting styles. For the first time in history, it was possible to create wide expanses under roofs by means of a highly planned layout of the various architectural sections, and also due to the perfecting of Italian building techniques using stone and cement in varying combinations (6). The Greek orders still dominated, but on the whole as columns laid decoratively against walls, instead of to hold up the structure (5). The Greeks had made equestrian portraits, showing a figure astride a horse, but none of these has survived. The Roman one of the emperor Marcus Aurelius (3) stood untouched by Christians and barbarians throughout the Dark Ages, spared only because people thought it portrayed the first Christian emperor, Constantine. It later inspired artists of the Italian Renaissance and the equestrian statue became one of the most popular subjects of western art.

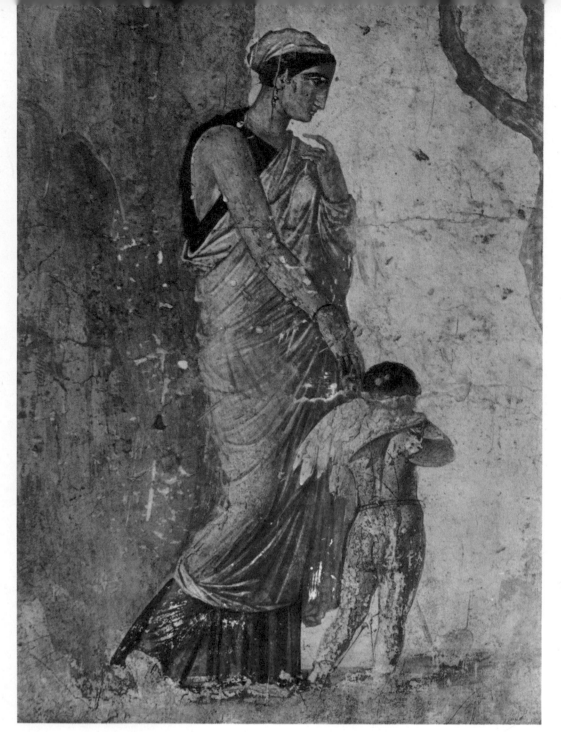

1. *Venus chastising Cupid.* Fresco from Pompeii.

The artists of Rome, like those of Hellenistic Greece, tried to create the illusion of reality, showing man at the centre of the world surrounding him. In the days of Augustus, artists still worked in the Classical fashion; the figures carved upon the *Ara Pacis*, an altar celebrating the long period of peace secured for Rome by the emperor Augustus (2), stand gracefully and serenely, gently shouldering each other. But there was already a departure from Classical ideals, for the individual features of each personage were depicted as true to life as possible. A century later, the sculptor who carved the reliefs immortalising the feats of the emperor on the Arch of Titus had made a complete break with the Classical serenity of Greek art.

2. *The Priests,* 13–9 B.C. From the *Ara Pacis*, Rome.

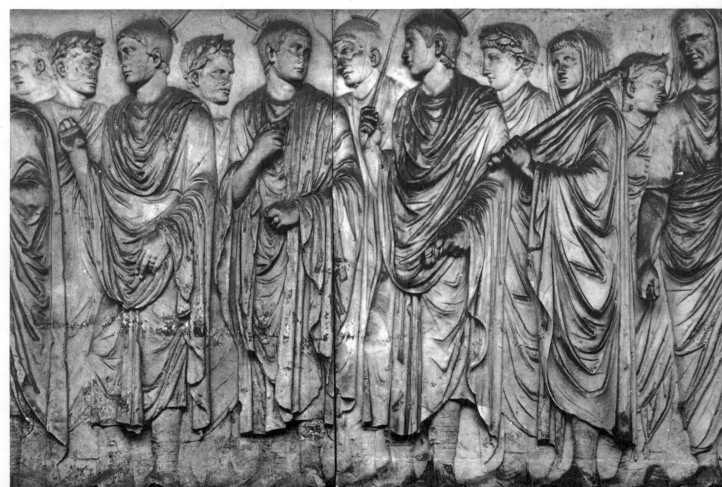

Sometimes the artists let their imaginations play over entire walls, covering them with mazes and webs of slender columns and painted architecture as though, like modern interior decorators, they were trying to give the room an extra dimension of space (3). Elsewhere, they used a solid, sculptural style to depict scenes of gods and heroes from their own, and Greece's, myths and legends (1, 4). Although they sometimes copied Greek originals of an earlier date, the Romans themselves succeeded in mastering the technique of creating an illusion of deep space, filled with light and swift movement. Among the surviving masterpieces of this style are many fragments from Pompeii of a long series of scenes from "The Odyssey" (page 59).

4. *The infant Hercules strangling the serpents.* Fresco in the House of the Vettii, Pompeii.

1. *Landscape with man and goats*, fresco from Pompeii.

2. *Idyllic sacred landscape*, from a series of frescoes depicting scenes from the *Odyssey*. Pompeii.

1. *Coptic tombstone*, limestone, 7th century A.D. Egypt.

3. *The original basilica, St. Peter's, Rome*. Fresco in the Vatican grottoes.

2. *Colossal statue of Constantine*, fragments. A.D. 306-327.

The weakening of the empire and the spread of Christianity gave Roman art a radically new direction. As the empire had expanded, incorporating many eastern Mediterranean peoples, various religious cults spread throughout the Classical world. Christianity gradually became the most popular, although, for three centuries, official Rome held fast to her old Classical gods and persecuted the Christians. In the catacombs, tunnelled in the soft lava around the city of Rome, the Christians buried their dead and awaited the arrival of their bishops to conduct their own rites. On the walls, between niches and arches, the early Christians painted religious symbols and depicted scenes taken from the old and new testaments.

In the year 313 A D., the emperor Constantine officially recognised Christianity and the Christians were allowed to build public places of worship. The plans of the first churches were based on those of the old *basilicas* (meeting and market-halls). These were straight, with side aisles and a sloping wooden roof (3). The first great basilica was St. Peter's in Rome, which was rebuilt several times, finally taking its present form between the 15th and 17th centuries. Until the invasions and ravages of the Barbarians, similar basilicas were built throughout the whole Christian world and decorated with sculptures and pictures in

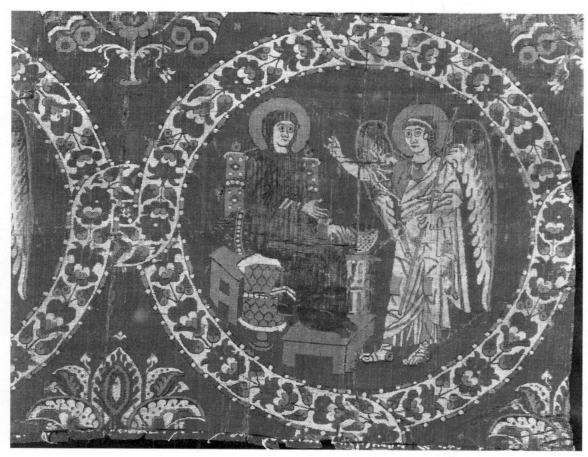

4. *The Annunciation*, painted on silk. 7th-8th centuries A.D.

5. *The Good Shepherd.* Early Christian sculpture.

6. *Detail of the Gate of the Roman Forum*, 2nd century A.D. Sabratha, north Africa.

fresco and mosaic in a style often rich in symbols taken from the ancient motifs, showing the long-lasting influence of Hellenistic style.

The art of early Christian Egypt, called Coptic, greatly influenced later Christian art, owing to the importance of the church of Alexandria. The Egyptians inherited from their ancestors a love of flat patterns, of staring figures with large, dark-rimmed eyes, and the ancient taste for intertwined plant and animal decorations, all of which spread throughout the eastern Christian world (1). With Christianity, a new attitude towards art spread westwards. Even at the height of the Empire, sculpture throughout Egypt, Syria and Asia Minor had copied the details but not the careful proportions of Classical art (2, 6). But converts to Christianity, who were afire to express their new love of Christ, cared less for satisfying form than for a clearly expressed message. *The Good Shepherd* is one of the last Christian works of art made in the West whose forms are correctly modelled according to Classical rules (5). At first, Christ was seen as an ideal youth. Later, in the 5th century, as more near-eastern believers came west, Christ was pictured as a dark-bearded man with haunting eyes, like a shepherd from Syria.

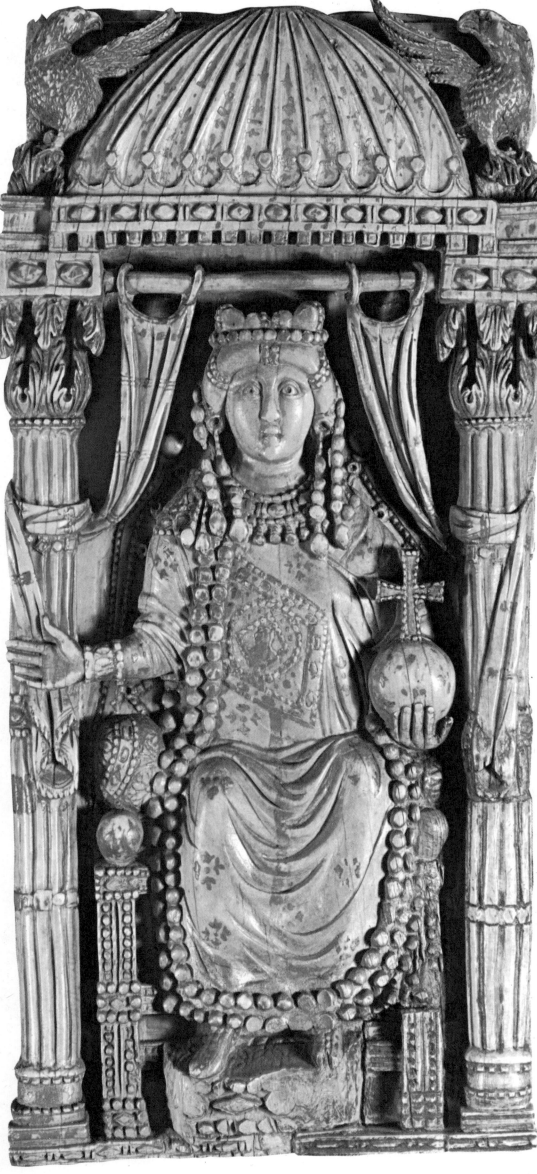

One of the last centres of Classical art
in the ravaged west was Ravenna, an
outpost of the Byzantine Empire, and
many works of art, which bridge east
and west, were created there. One of
these is a tomb decorated with mosaics
(3) showing Christ as a Greek shepherd
among his flock.

The ivory plaque of an empress (part
of an insignia for officials of the late
Roman empire) is carved in Byzantine
style (1): part Greco-Roman, part
Oriental. Roman eagles and debased
Corinthian columns flank her. She
holds an orb surmounted with the
Christian cross to show that she was a
Christian monarch, but her jewels and
her stiff staring pose remind one of a
near-eastern idol.

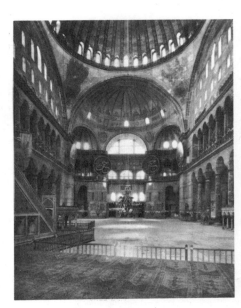

2. *Interior of Hagia Sophia*, A.D. 532-537.
Istanbul.

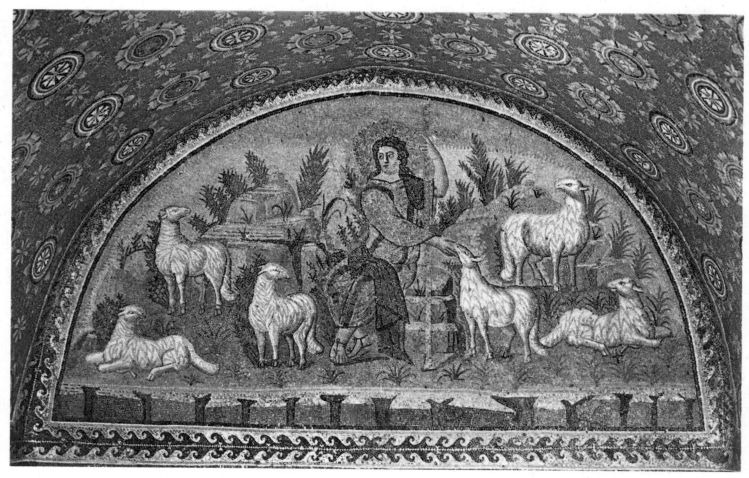

3. *Mosaic of the Good Shepherd*. Mausoleum of Galla Placidia, 5th century A.D. Ravenna.

THE EASTERN EMPIRE
BYZANTIUM

Constantinople, formerly Byzantium, was established in A.D. 330 by the Emperor Constantine as the new capital of the whole Roman empire. It stood at the junction of east-west trade and pilgrimage routes and was the meeting place for Greek and Oriental culture. Byzantine art served the eastern Christian church, always more resplendent than its western counterpart. It also served an Asiatic taste for the expression of mystical revelation, and the need of the eastern emperors to appear in an oriental and quasi-divine ceremonial. The demand was for brocades, silk, ivories, and richly painted manuscripts. Yet it was at Constantinople that the heritage of Classical Greek art was maintained and preserved during the Middle Ages.

The power of the Byzantine empire reached its peak in the reign of Justinian in the 6th century. In the 15th century Constantinople fell to the Ottoman Turks and many of her artists took refuge in the west, together with poets, philosophers, and men of letters who spread a direct knowledge of original Classical works and Greek thought as preserved in Christian writings.

The cathedral of Constantinople, called Hagia Sophia ("The Holy Wisdom"), is the greatest monument of Byzantine architecture (2, 4). The dome rests on the four pendentives (triangular corner pieces), see (4). This device allowed the builders to lift the vast dome upon a square base of columns and arches, like the groined vault of the Romans. The whole interior was covered with shining mosaics, but when the church was transformed into a mosque by the Turks, these were plastered over. They have now been uncovered, while the original structure of the building stands intact.

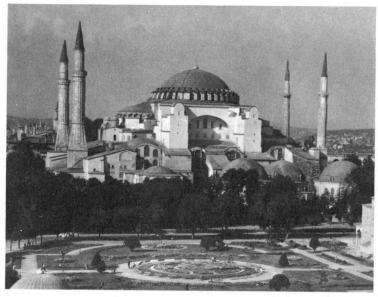

4. *Church of Hagia Sophia*, A.D. 532–537. Istanbul.

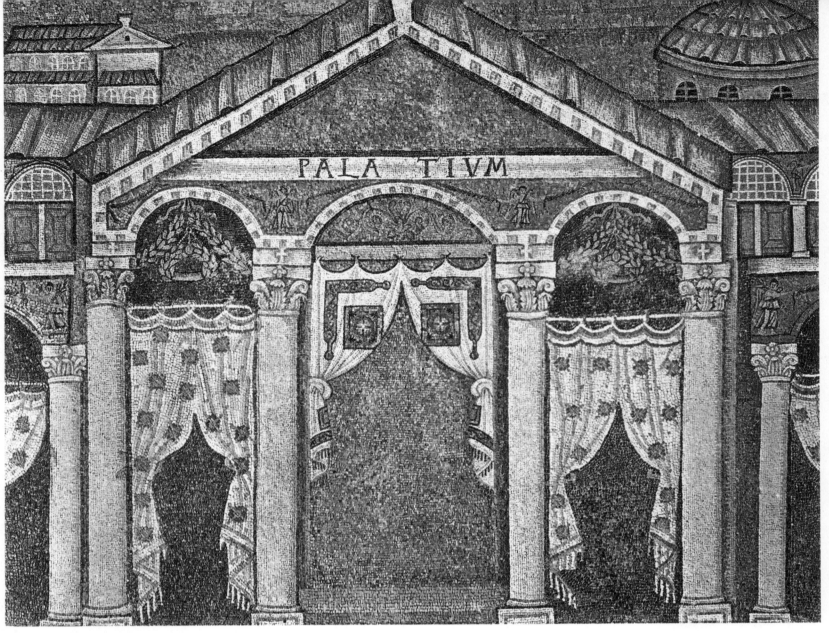

1. *The Palace of Theodoric*, mosaic. Saint Apollinare Nuovo, Ravenna.

The works on these pages illustrate the two differing tendencies of Byzantine style; the Greco-Roman or Classical (1) and (3), and the Oriental (2) and (4). The lively style of painting which had been invented by Hellenistic artists and later transmitted to Rome, lived on in Byzantium, although now used for Christian subjects. The illustration from a Christian book of psalms (3) might be a Classical scene of any shepherd boy among his animals. Objects of silver and ivory were made in the same style with gracefully proportioned figures in free action.

Works of art like these were brought into Western Europe from time to time where they kept the Classical tradition alive during the Dark Ages.

During these same centuries, the Oriental tradition slowly began to infiltrate into Byzantium, especially in the form of styles and techniques of artists and craftsmen who had learned their trade in the Near East. Only one century after the tomb of Galla Placidia was decorated in Ravenna (see page 63), the emperor Justinian commissioned a series of mosaics showing his wife, himself, and their retainers, for another church in the same city (see pages 66-67). Theodora was an Asian queen, with dark eyes and hair, and a fierce expression; she wears jewels like the ivory empress (see page 62), and her servants are clothed in heavy brocades and silks. By the 11th century, Greek and Oriental styles seem to blend together in magnificent, imposing images (4), which adorned the churches, large and small, from Armenia to Italy.

2. *Ivory casket*, 11th century A.D.

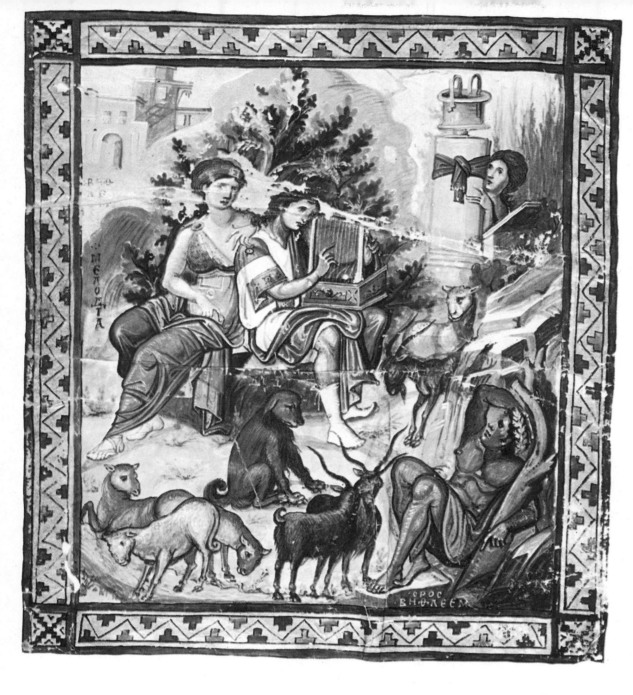

3. *David the harpist*. 7th century A.D. Page of a Byzantine manuscript painted at Constantinople by an Alexandrian artist.

4. *The Virgin with Apostles*, apse mosaic. 11th century. Torcello Cathedral.

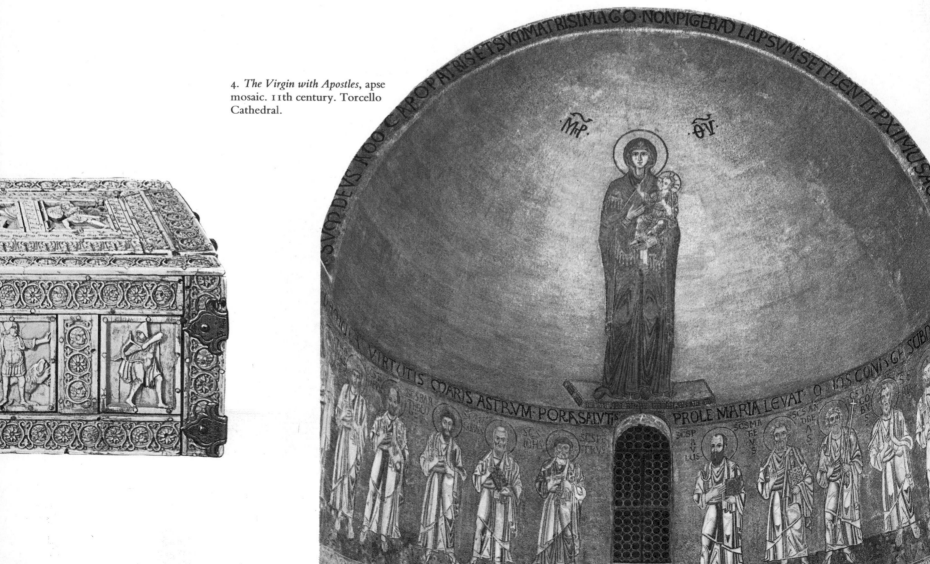

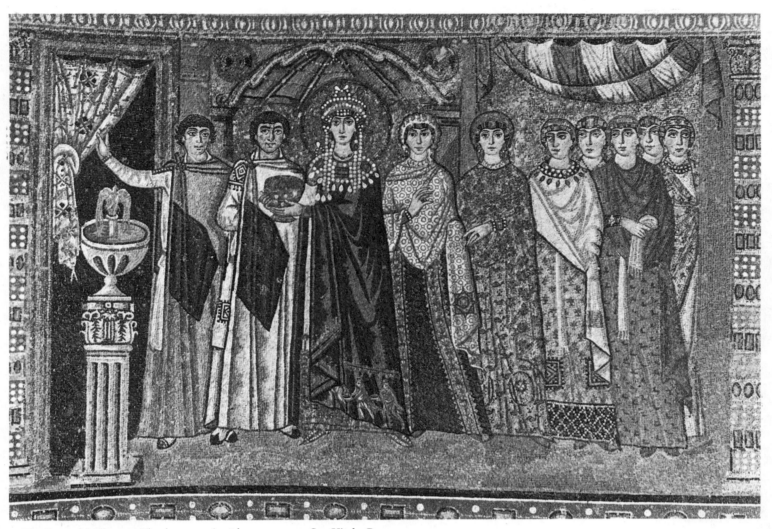

1. *The Court of the Empress Theodora*, mosaic. 6th century A.D. San Vitale, Ravenna.

2. *The Court of the Emperor Justinian*, mosaic. 6th century A.D. San Vitale, Ravenna.

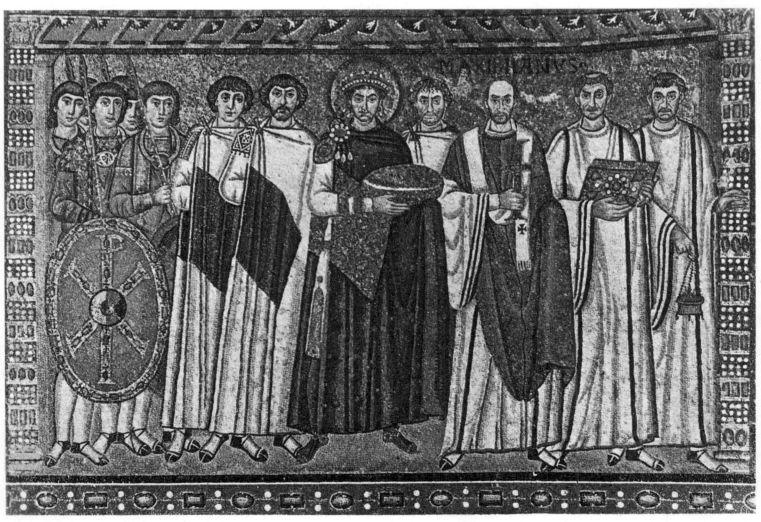

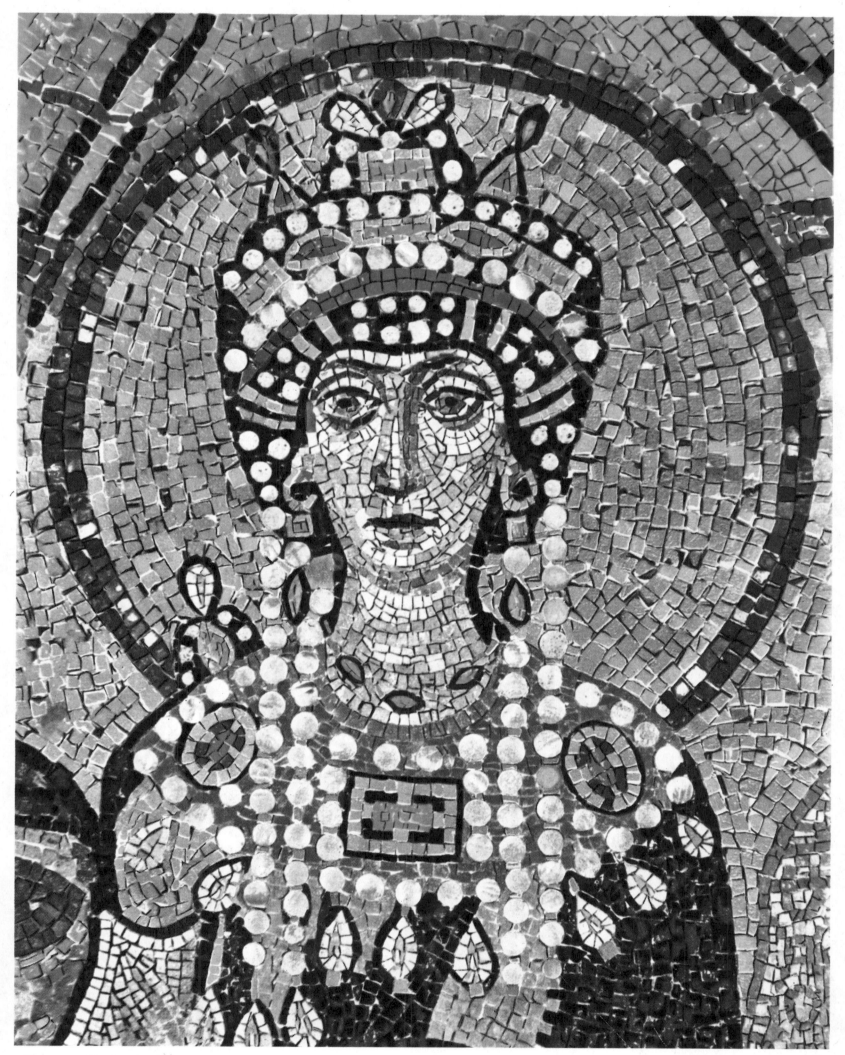

3. *The Empress Theodora* (detail of illustration on opposite page). San Vitale, Ravenna.

Two centuries after Justinian, a bitter controversy divided the Byzantine church on the question whether artists should be allowed to make pictures of Christ, his mother and the saints. The result was a victory for the pro-icon party, and a greater importance attached to these holy pictures. An icon is a painting on a wood panel of Christ or the holy family, or of angels and saints, and was intended to be revered, as much as the cross on the altar. Artists began to decorate the icons with pure gold leaf or gold paint to increase their preciousness. This style of painting spread east and west, to Russia and into parts of Italy like Siena, a centre of unusually devout artists. In the painting from a remote outpost of Byzantium (1), the artist was obviously more interested in making a precious object of gold paint and bright colours, almost like a jewel, than in giving an impression of

2. St. George and the Dragon, 16th century. Icon.

1. Enthroned Madonna and Child, 13th century.

3. Church of the Transfiguration, 18th century. Kizhi, Lake Onega.

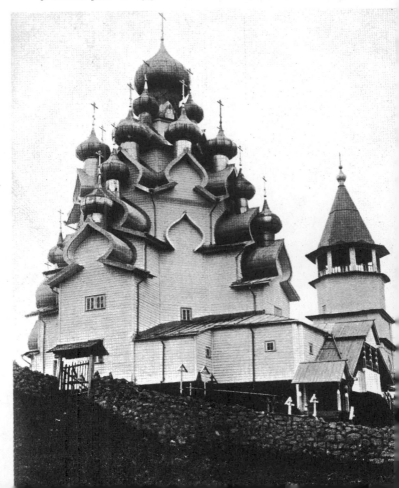

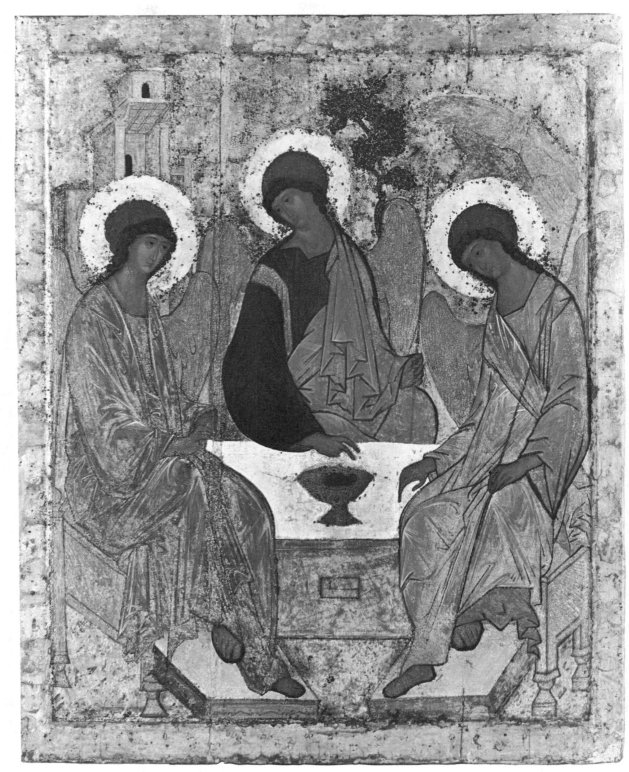

5. Andrei Rublev: *The Trinity*,
about 1410.

4. School of Novgorod:
St. George, about 1400.

reality. Since icons were often worshipped in dark, incense-filled churches, they were painted in bold, strong shapes and colours which could easily be seen.

This particular phase of Byzantine art influenced the arts of Russia. In the 10th century, King Vladimir I of Kiev was baptised into the Christian faith by missionaries from Byzantium. Churches were soon being built throughout Russia and filled with icons in the Byzantine style. The greatest master of this art, which lasted for centuries, was Rublev (5); other icon painters seem to have been more influenced by an ancient native style, based on the curling shapes produced by Scythian metal-workers. Such figures are bent and twisted as though formed

with tongs over hot flames. Before Byzantine missionaries penetrated the North, Russian art was mainly produced by two nomadic tribes, the Scythians and Sarmatians. These brilliant metal-workers roamed the steppes between about 700 B.C. and A.D. 400. The influence of their art was felt by many great civilisations—China to the east, Greece and Persia to the south, and by the barbarian Goths and Franks in the west.

In the deep forests far from the Russian cities, there was little or no possibility of communication with the great art centres of the Mediterranean. In these rural communities, church builders made curious buildings of great timbers, rising to a cluster of fanciful, onion-shaped domes (3).

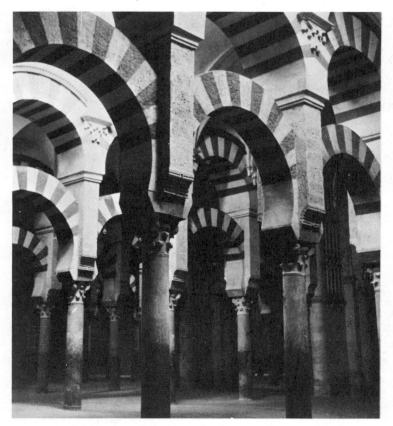

1. *Interior of the Mosque of Cordoba*, 8th-9th centuries.

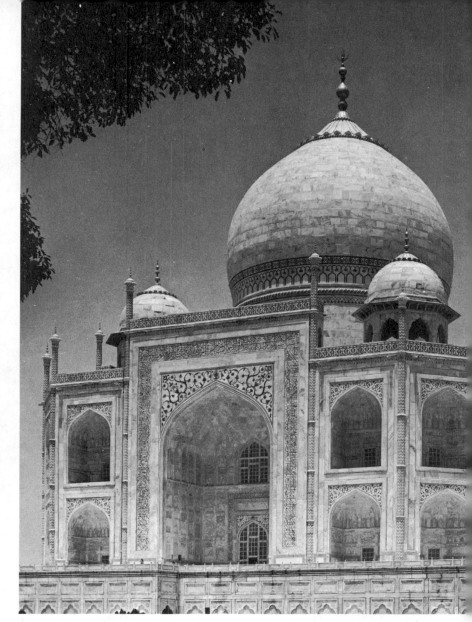

2. *Taj Mahal*, 1630-1650. Agra, India.

3. *Wall Decoration in the Alcazar*, 14th century. Seville.

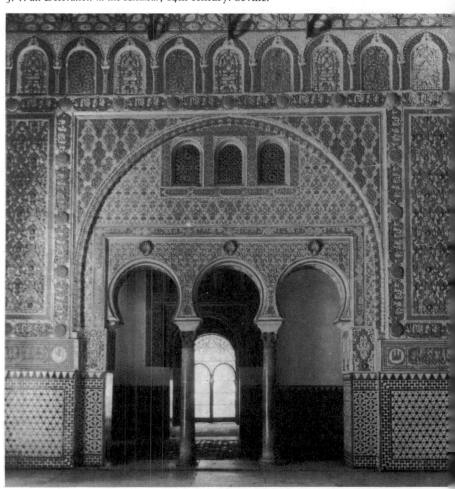

THE
ISLAMIC EMPIRE

The Islamic Empire, which at its height extended from Persia and Mesopotamia to North Africa and Spain, was established in the 7th century A.D. by the Arabian prophet Mohammed. This vast empire was, with Byzantium, a treasure house of artistic knowledge and culture during the western Dark Ages. The Arabs loved both the bright designs of the ancient Sumerians and the harmonious flowing lines of Greek and Coptic Egyptian art, and they combined lacelike ornamentations with sharp contrasts of colour and shadow. But Mohammed, like the Hebrew prophet Moses some 1,500 years earlier, had forbidden the making of images, so early Islamic religion had no use for figurative art. Instead, the Islamic artists became great builders and decorators. European Crusaders brought back many Islamic architectural ideas—the horseshoe and pointed arches, pierced battlements and ornate brickwork—which later found their way into Gothic and Renaissance structures. By the 15th century Mohammed's taboo against portraying human images had lost its force and a great school of manuscript painting was born.

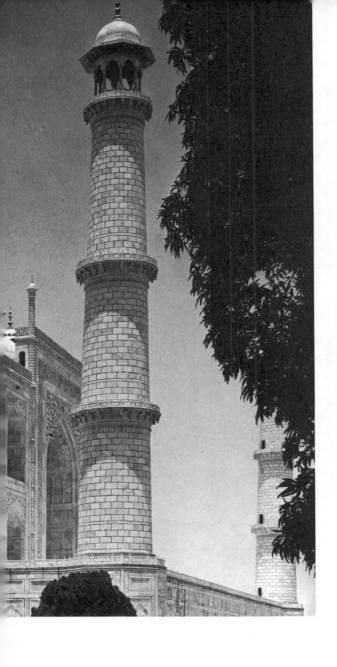

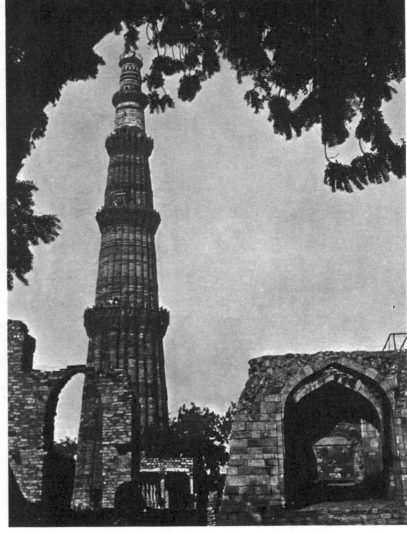

4. *Kutub minaret*, 1200. Delhi, India.

5. *Puerta del Sol*, 1200. Toledo.

When these miniature Islamic paintings were eventually brought west by travellers from the Dutch East Indies to Holland they caught the eye of artists like Vermeer and Rembrandt, and thus had some impact on modern western art. Although the Islamic culture is still alive today, its once high standards of craftsmanship have been lost.

The major kinds of Islamic building were mosques and minarets for worship, fortifications, and palaces for the sultans. The dome and the arch were favourite architectural devices, and ornament was used lavishly, according to the spirit of the different countries. The robust pillars and arches of the mosque of Cordoba in Spain (1) have a sombre and enclosing effect, while the airy Taj Mahal in India (2), built in the Moghul period, is lace-like, its dome almost as light as a bubble.

Islamic culture was brought to Spain by the invading Moors; the battlement, right (5), is in typical Moorish style, with horse-shoe arches and brickwork, which was often copied by Christian Spaniards, and later adapted in some buildings in France.

Islamic art flowered in Persia under the patronage of the sultans of Baghdad, who were among the greatest connoisseurs of art and learning in the world. At first, art styles were borrowed from the Sassanian Persians, whose brilliant culture the Islamic artists had absorbed. Later, they made illustrations for scientific treatises and books of legends (2, 3, 5). By the 16th century A.D., the Islamic style of book illustration reached its height and was carried into India with the conquering Islamic armies. Such manuscript pages showed patterns as bold and as refined as those of a Persian carpet. Their artists did not try to imitate reality. When they drew a group of figures, they did not set them one behind another in receding perspective, but instead made elegantly drawn images just as a mosaicist might set his stones into a pattern. Nevertheless, these pictures give a fascinating view of life in the sumptuous Persian and Indian courts, hung with rugs, filled with tulips, roses and lilacs, peopled with deer-eyed dancers and polo-playing princes. In the 13th century A.D. Baghdad was captured by the brother of Kublai Khan, ruler of China; its art grew more and more Oriental in spirit. In the 15th century its place was taken by Samarkand in central Asia, a capital city even nearer to China. Here stands the Gor-Emir, the tomb of Tamerlane, built in 1405.

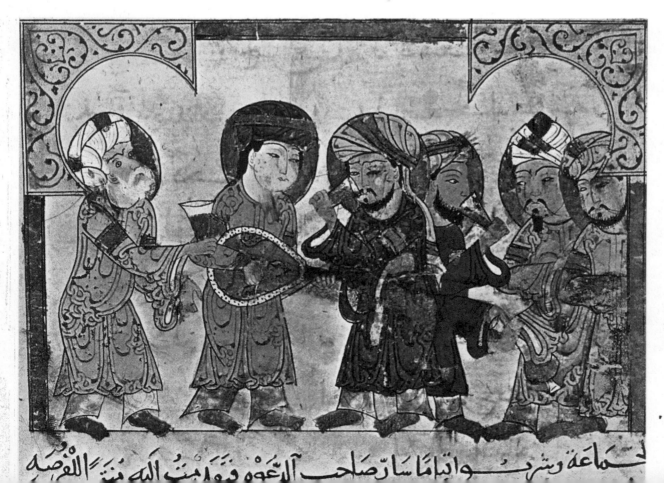

2. *Arab miniature*, from the Codex of Avicenna.

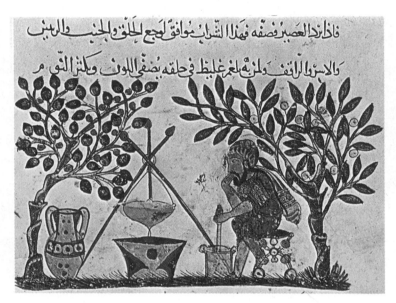

3. School of Baghdad: *A physician preparing medicine*, about 1520.

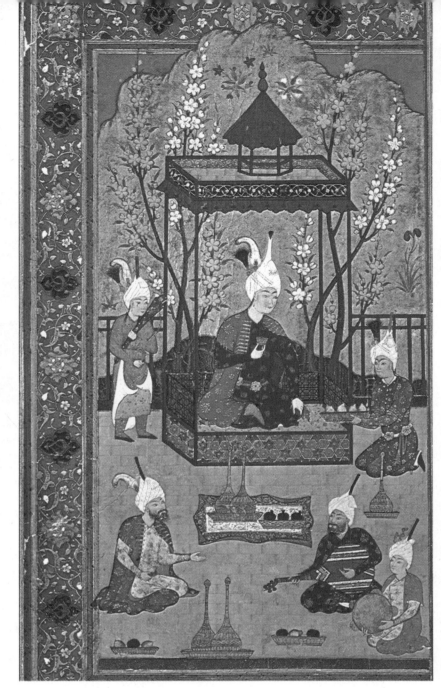

5. School of Sultan Mohammed: *Garden scene*. Period of Shah Tahmasp, 16th century.

6. Islamic art: *Ceramic medallion*, 1263.

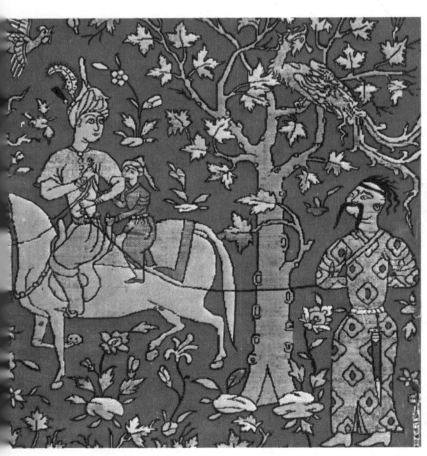

4. Islamic art: *Horseman leading a Mongolian captive*, silk brocade. Safāvid period, second half of the 16th century.

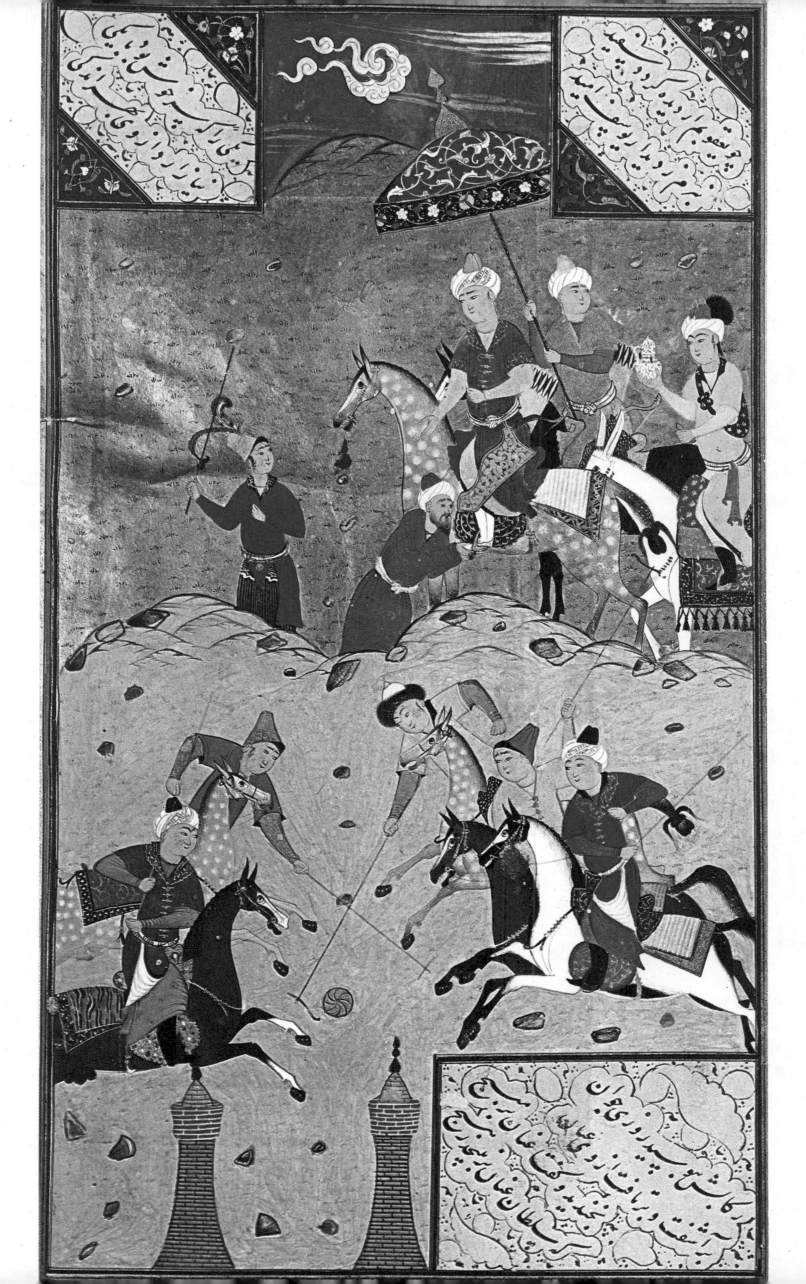

2. *Gushtasp slays a wolf*, 1605–1608.

1. *A game of polo*. From a manuscript copy of the "Būstān" by Sa'adi, 1522–3 (?).

INDIA AND INDONESIA

As Greece was the source of naturalistic Western art, so India was the birthplace of many Oriental art styles. Like the devout Christian painters of the Middle Ages, Oriental artists were mainly concerned with representing the unseen world of gods and supernatural forces. They were less interested in creating realistic representations of anatomy and proportion than in inspiring feelings of awe, terror, or reverence by means of their works. Two great streams of religious thought run through the whole of Indian art: the first to develop was the Hindu religion, followed later by the religion of Buddha, which arose in the 6th century B.C. from the teachings of Gautama Buddha, a humble prince from a small Himalayan village. Buddhist thought, sculpture, and painting spread eastwards following the caravan trails across the Gobi desert into China, and from there into Japan. Meanwhile, India itself slowly turned back to the more complicated Hindu religion which was based on a vision of the world as a vast dream called "Maya". In this dream all created things seemed to emerge like swift rivers, swirling across the earth before they disappeared into eternal darkness. It was this sense of never-ending motion and transformation in the Maya world, set against the background of the eternal natural forces, that Hindu art sought to portray.

The three main Hindu gods were Brahma the father, Vishnu and Shiva. Each of these gods appeared in many shapes, some animal, others human. Vishnu, for instance, was sometimes carved and painted in the guise of a boar or a lion, and sometimes as a human hero, Krishna. At other times he could be seen as the river Ganges, or else as the glorious sun-god mounted on a jewel-decked horse (1). Hindu art also abounded in representations of air and water spirits which were a survival of a prehistoric nature worship.

In the 2nd century A.D., Buddhist sculptors began to make images of Buddha in a style similar to that of Greek sculptures. It was thought that Buddha had certain physical characteristics: he had a third eye (of wisdom) between his brows, extremely long ear lobes and his head was crowned by a lump representing knowledge (2).

In the 5th century A.D. the Gupta dynasty of kings came to power in India. They were proud of India's native art style but under their rule Indian sculptors began to carve figures of a more Oriental nature, with supple, shining surfaces. At the same time the old Hindu religion was coming back to favour in India. The gentle Gupta Buddha (3) is shown accompanied by air spirits flying above him and winged horses prancing on either side. The majestic sun-god (1) belongs to the same tradition.

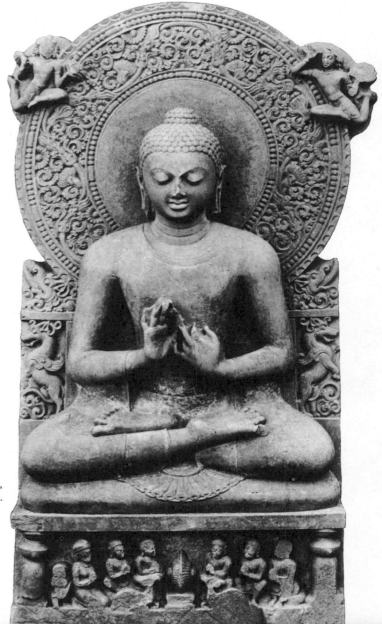

2. *Head of Buddha*. From Gandhara. 4th–5th centuries.

1. *Surya, the Sun God*, 13th century A.D. Konarak.

3. *Buddha teaching*. Gupta period, 5th century A.D.

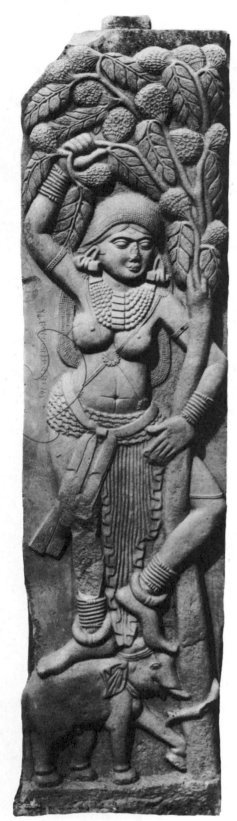

1. *A Yakshi*, 1st century B.C. From Bharhut.

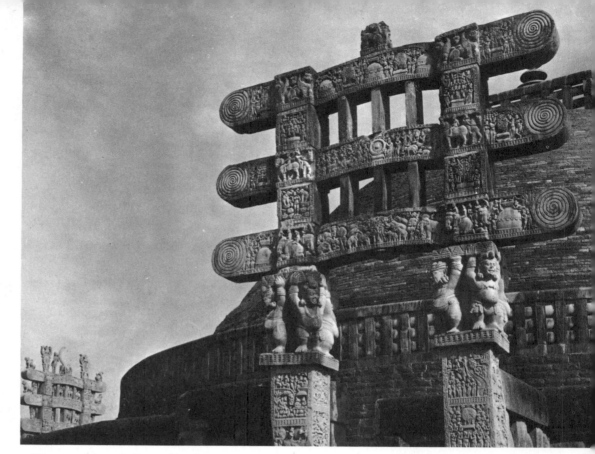

3. *West gate of the main Stupa of Sanchi*, 1st century A.D.

2. *The Great Stupa of Sanchi*, 1st century A.D.

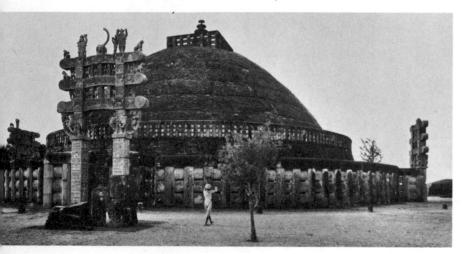

The Hindu tradition was so strong in India that even when Buddhism was established as the official religion, Indian sculptors could not resist adding a number of their nature gods to the Buddhist shrines. Buddha was usually shown standing in a majestic pose, rather like the statues in Roman sculpture. But when the artists made sculptures depicting nature spirits and the old Hindu gods they followed an entirely different style creating undulating, dancing figures full of movement. One of the favourite nature deities was the "yakshi" or tree sprite, who was always shown grasping the branch of a tree while giving the trunk a gentle kick with her foot (1). It was believed that when she kicked it the tree would burst into blossom.

This love of dancing figures was already apparent at the very beginning of Indian art, for one of the earliest works, made two or three thousand years before the birth of Christ, shows a lithe and graceful dancer with one hand on her hip. The *yakshini* at Sanchi are carved clinging to mango trees like acrobats (4) and the swelling curves of their bodies seem to suggest the fertility of tropical nature. Indian places of worship, unlike Christian churches, were not usually designed for congregations, but rather as solitary shrines which the pilgrim visited alone. These Buddhist shrines were called "stupas" and consisted of a great mound of earth surrounded by a stone wall and four carved gateways: inside the mound would be buried a relic of Buddha, such as a piece of bone or a lock of his hair. One of the earliest stupas still standing (2) was built at a time when Buddha was considered too holy to be represented directly in sculpture; as a result, there are no images of Buddha among the many sculptures at Sanchi, but instead, the gateways are covered with

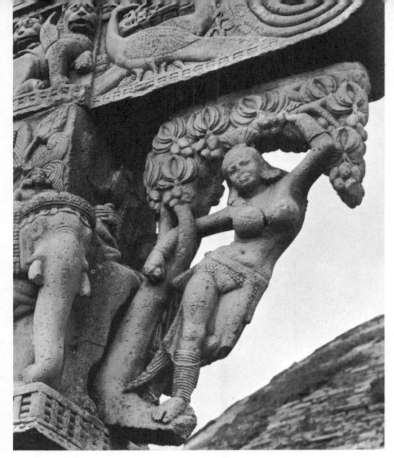

representations of the Hindu nature spirits and carvings of animals to suggest his power and majesty (3).

Following the revival of Hinduism, the shrines became even more splendid. An outstanding example can be seen on a lonely stretch of sea coast near Madras where seven enormous granite boulders are carved into fantastic scenes (5). This shrine is dedicated to Vishnu in his incarnation as the river Ganges. The tangled and confused mass of figures was carved without reference to any pre-arranged plan. Unlike the figures in Greek temple structures, they are not arranged into any pattern or, as in Assyrian or Egyptian works, aligned into rows and sequences.

These rock shrines, each dedicated to a particular Hindu deity, are numerous throughout India. The temple at Konarak (see page 76) is carved into the shape of a colossal chariot with wheels ten feet high. The whole rock is intended to be seen as if moving forward majestically on its journey across the sky, drawn by the horses of Vishnu. Other rock temples have hollow chambers with awesome sculptures of Hindu monsters and gods (pages 80–81).

4. *A Yakshi on the east gate of Sanchi*, 1st century A.D.

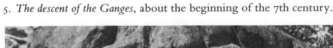

5. *The descent of the Ganges*, about the beginning of the 7th century.

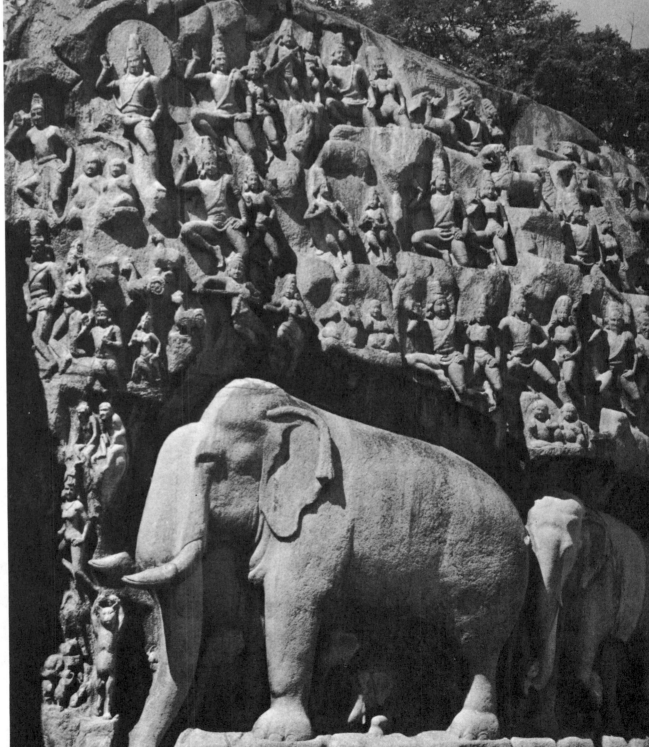

1. *Indra, King of the Gods*. Gupta period, A.D. 750–850.

2. *Vishnu in the guise of a cosmic boar rescuing Bhudevi, goddess of the Earth*, about A.D. 400. Udayagiri.

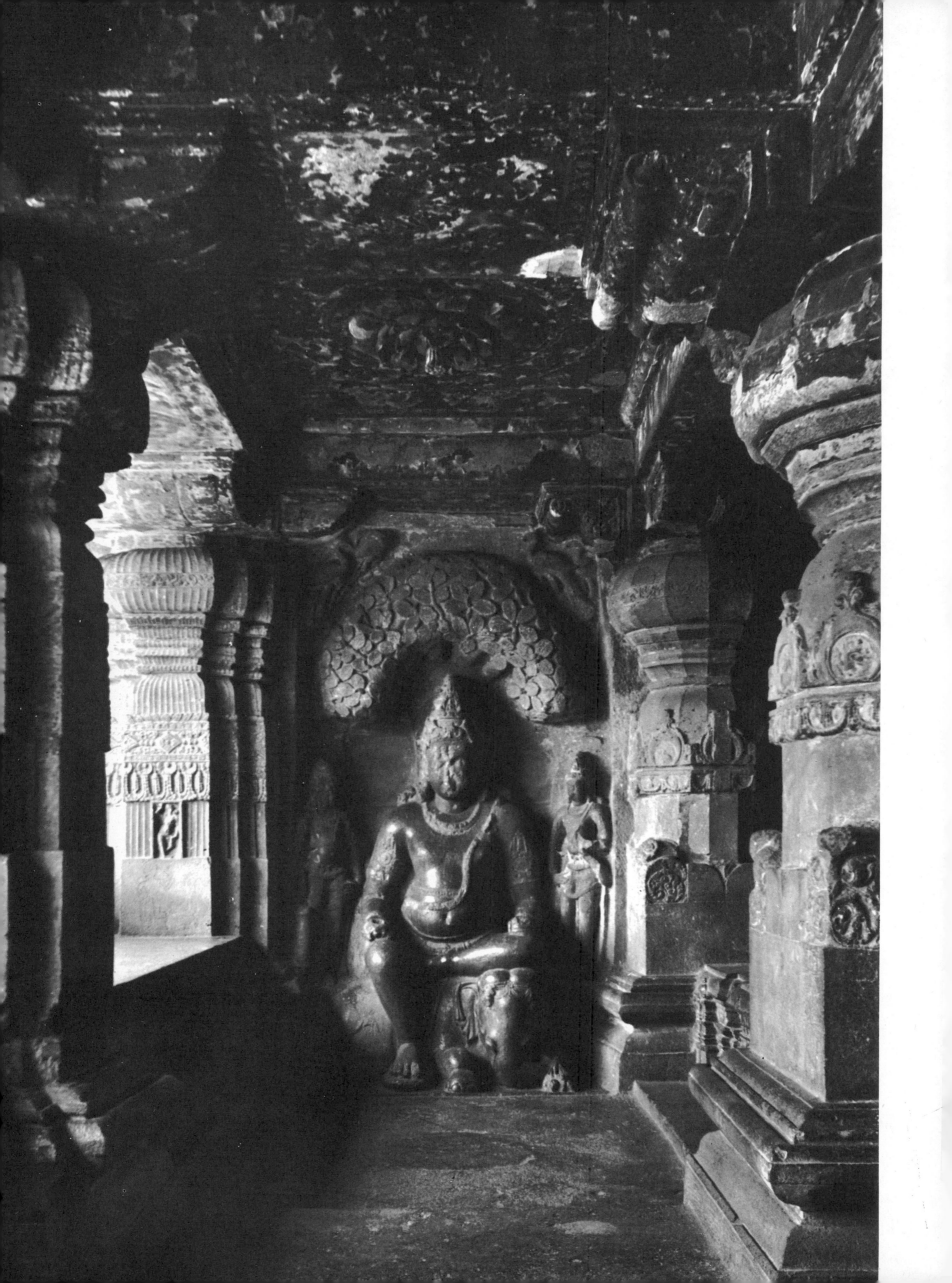

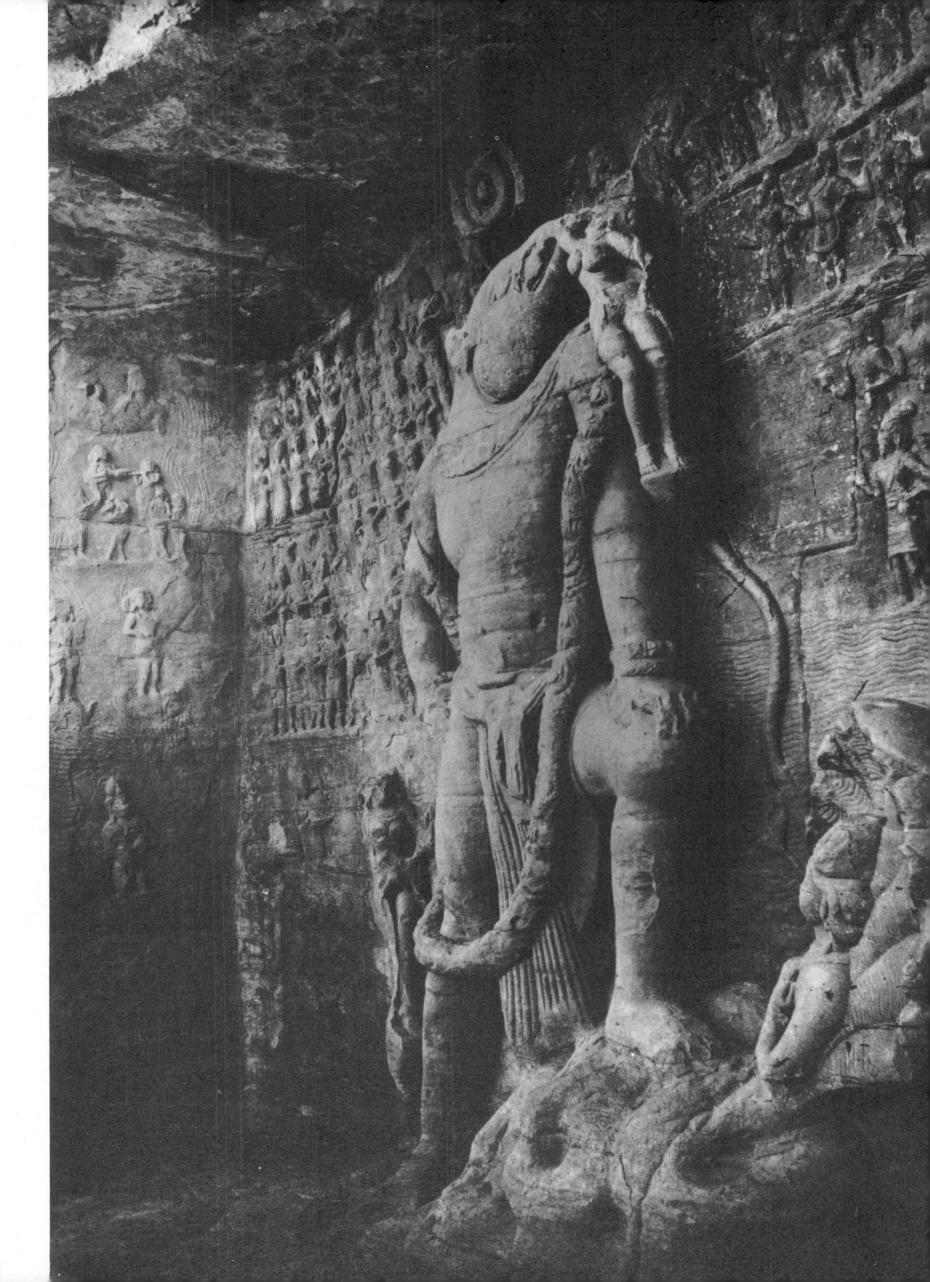

1. *Female donors.* Fragment of a fresco from Sorcuq, Kirin Caves.

2. *Air Sprite or "Apsaras"*, fresco. A.D. 470–480. Ajanta.

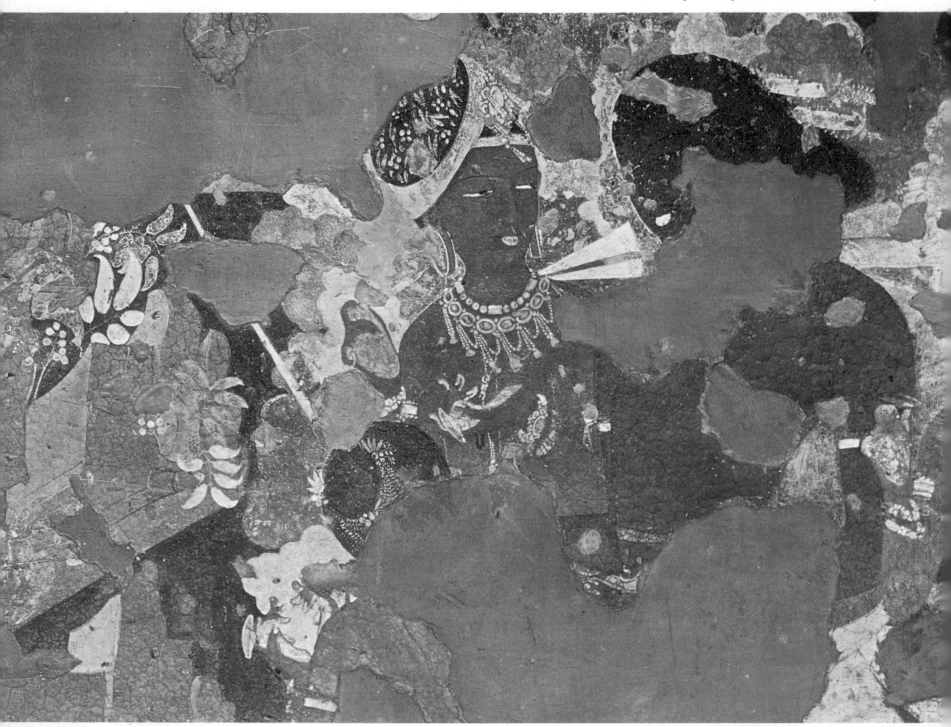

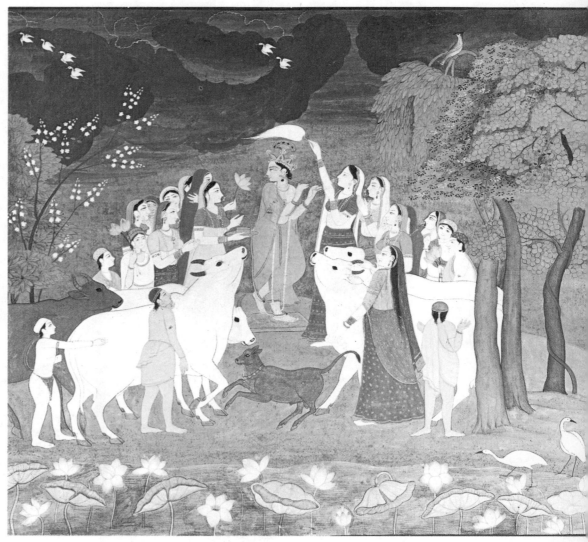

3. Sri Krishna with the flute, 19th century.

4. Palace ladies hunting from a pavilion, A.D. 1760-1770. Rajasthani.

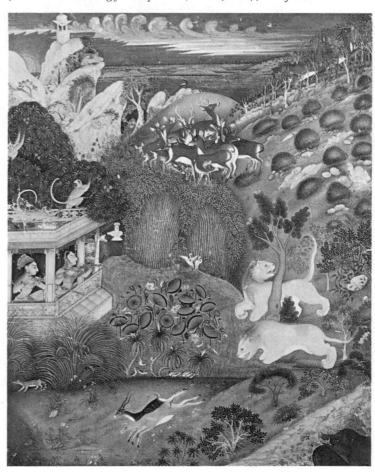

Although almost all the paintings made during the Gupta period have rotted away in the damp climate, a few fragments still remain in the cave temples of central India, particularly in Ajanta. These temples, cut into the sheer rock, were more permanent shrines than the outdoor stupas. A typical rock shrine consisted of a long hall ending in a small rock stupa surrounded by a narrow passageway for pilgrims. At Ajanta the walls were first coated with plaster, and then with white clay. The paintings were laid on in water colours applied with quick brush strokes. The figures were drawn in graceful, flowing serpentine lines and are characterised by their sleepy, half-closed eyes (2).

The Buddhist monks decorated the rock temples with paintings in the style of the Gupta period. These paintings were drawn with simple, clear brush strokes, a method called the "iron wire" line which was to inspire a great school of Chinese painting during the T'ang dynasty.

The Gupta style of painting probably continued unchanged for many centuries, as did the same style of sculpture, but no paintings made before the 16th and 17th centuries have survived. Then, a number of rich Rajput princes who lived in the north-eastern hill regions began to commission works from court painters. The paintings they produced still retained the same grace and flowing lines to be seen in the Ajanta murals. While the Moghul school of painters (page 75) confined themselves to depicting life at the courts, the Rajput painters dealt with the adventures of the Hindu gods, usually in their human incarnations. Rajput painting was sometimes used to illustrate various kinds of Indian music. This was played on shrill, melodious strings and flutes, and was intended to create a different mood or "raga". These moods were described in little scenes depicting the joys or tribulations of lovers.

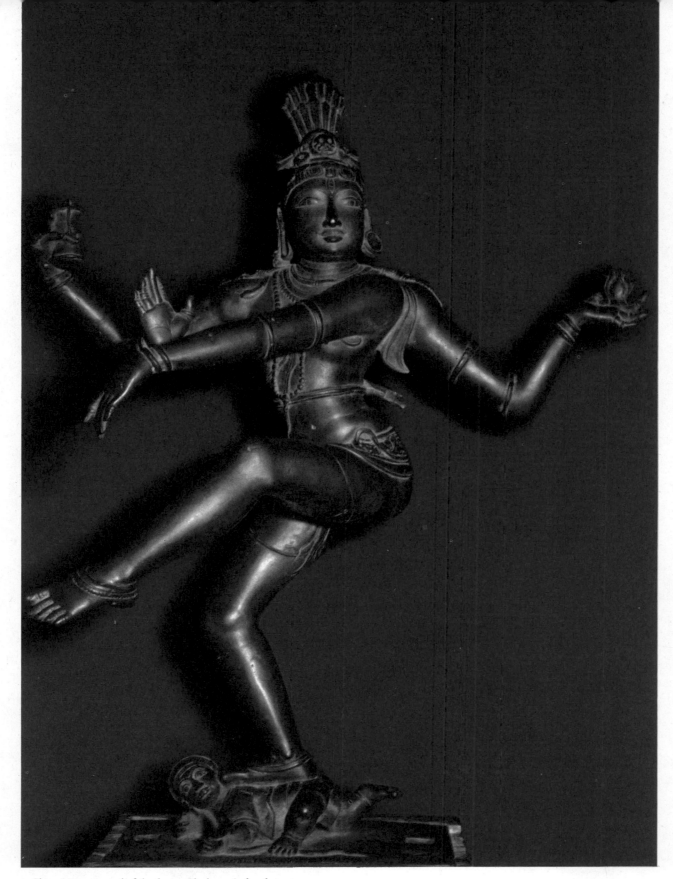

1. *Shiva Nataraja, god of the dance*. Chola period, 9th century A.D.

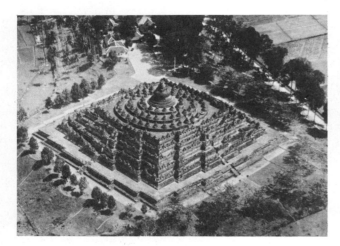

3. *Apsaras dancing*, about A.D. 1200. From Cambodia.

2. *Stupa at Borobudur*, 8th century A.D. Aerial view. Java.

Southern Indian artists who excelled in the art of bronze casting, invented the image of Shiva in his incarnation as Nataraja, "The Dancer". The Hindus believed that when Shiva danced, the universe would fall into chaos and the stars would hurtle in disorder through the skies. During his magical dance the god Shiva would destroy the universe, then re-create it (1). Shiva's arms flail the air around him, his hair and his scarves fly out in the wind, but at the centre of all the tumult his face is calm for he is in "Nirvana": he has escaped from the world and attained a state of eternal peace. A screaming demon lies trampled beneath his foot and represents the conquest of the forces of evil. The balance between furious rhythm and serenity in this figure make it one of the greatest achievements of Indian art.

Today, Buddhist and Hindu beliefs still survive in the kingdoms of Nepal (4), Thailand, and neighbouring countries. In Thailand and Bali, dancers wear grotesque brilliantly coloured masks in their religious festivals, as a last reminder of an ancient pictorial tradition. The great 46-foot long statue of the sleeping Buddha (6) lies in a lonely sanctuary. He is shown in a state of Nirvana, an example to all who pass by, urging them to transcend, as he has, all the evils and sufferings of this world.

Hindu and Buddhist art spread eastwards to Cambodia and the islands of Indonesia. Two of the main outposts of Indian civilisation were at Borobudur in Java, and at Angkor Wat and Angkor Thom in Cambodia. The pilgrim to Borobudur had to tread a long spiral path around a huge stupa. As he ascended, he passed pictures of hell, then scenes showing Buddha among

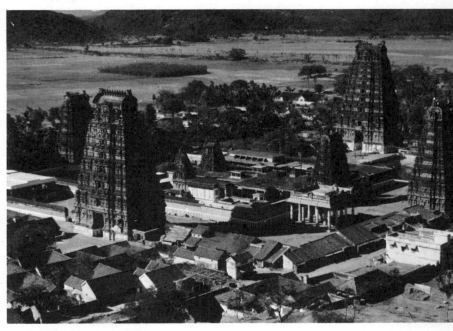

5. *Temple of Tirukalikunram.* South India.

elephants, deer, and birds. Finally, he stepped out onto the summit where seventy-two stone Buddhas sat within their alcoves.

The Khmers, a dynasty of rich kings in Cambodia, built two huge temple-cities adorned with gigantic but delicate sculptures. These ancient temple-cities, and the one at Borobudur, were discovered again only in this century, almost ruined by the undergrowth of the enveloping jungle.

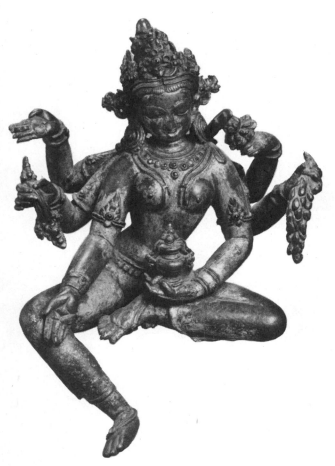

4. *Vasudhara, goddess of Abundance,* 14th–15th centuries A.D.

6. *Colossal recumbent Buddha,* 13th century A.D.

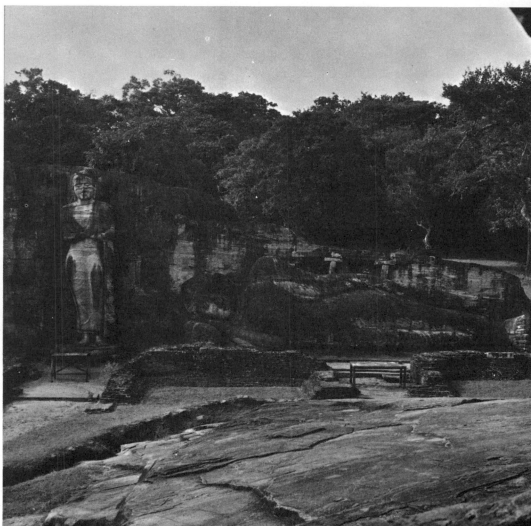

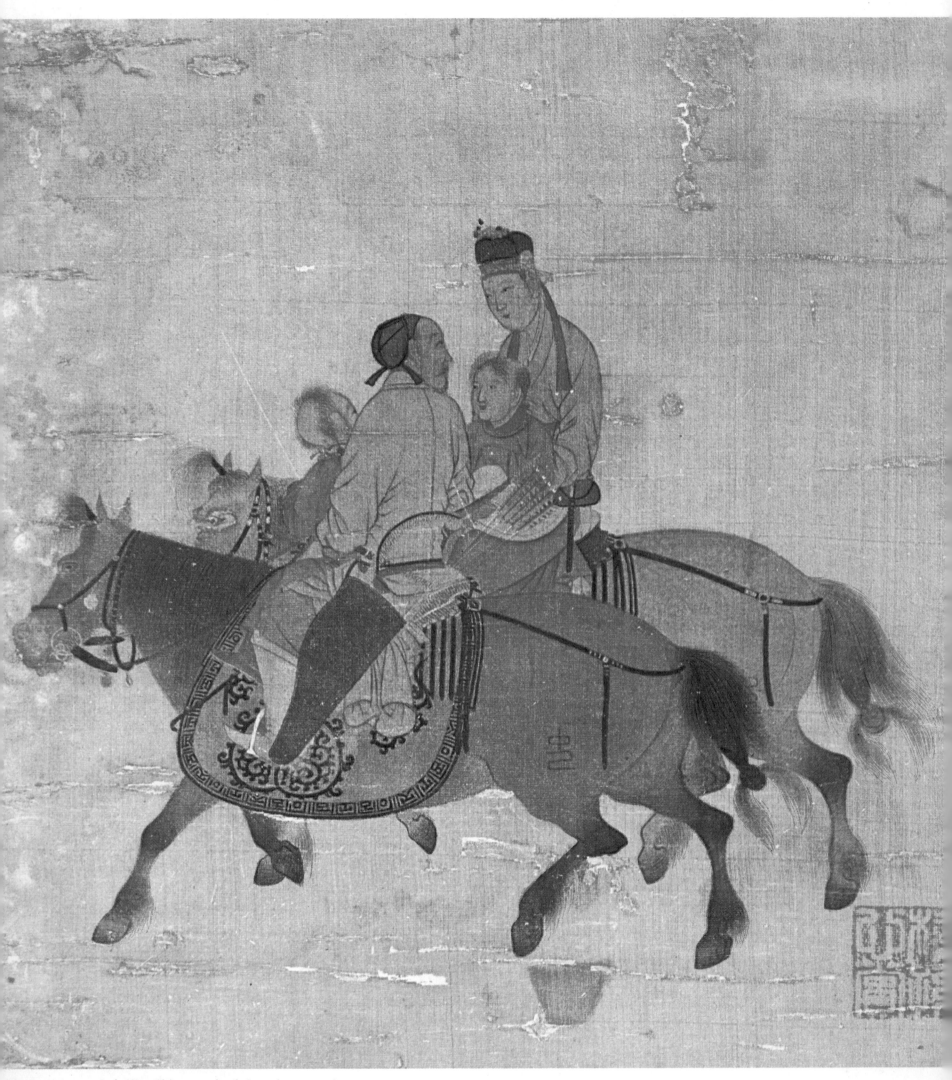

1. *Lady Wen-Chi's return*, detail. Sung dynasty, 12th century.

CHINA

Chinese civilisation has had a more continuous and uninterrupted development than that of any western nation, and this continuity is reflected in its art. Partly because of the immense size of the country and its ability to absorb repeated influxes of foreign invaders, and partly because of the influence of Confucianism and Taoism, Chinese art showed a development of style that remained unbroken throughout the centuries. Once originated, very few motifs were ever lost, and certain ideas and styles were repeated for centuries afterwards. The great paintings of the past were copied and re-copied by successive generations of artists. They did not regard such repetitions as sterile or useless imitations, but made it a point of honour carefully to reproduce the exact works of earlier artists. It was this continual repetition that created the tradition of extreme refinement in Chinese art. With few exceptions, art in China was regarded as something to aid the rich and cultured classes in their poetical and religious meditations. Chinese art found its highest and most meaningful form of expression in the quiet, contemplative sculptures of Buddha and his saints, and in the school of Taoist landscape painting, whose style and technique was unknown in the west and unmatched in the whole world. However, another lively style was borrowed from the nomads of the northern steppes and made its influence felt in the design of both abstract and figurative shapes in the Chinese decorative arts. It can be seen in the gorgeous silks, jades, ceramics, and ivory statuettes for which China became famous throughout the world.

In every part of the ancient East, scholars wrote their sacred texts on scrolls which could be rolled up and easily carried, but it was mostly in China that the painting of scrolls became a great art (see page 90). The scroll shown here (1) tells the story of the beautiful Lady Wen-Chi. She fell in love with the Mongol chief who had captured her and lived happily in her new home until, some years later, her father made her return home. Lady Wen-Chi's heart-broken parting from her husband, and her lonely return on horseback to her father's palace, are depicted in delicate touches of ink and colour upon the fragile silk.

The earliest works of Chinese art were bronze vessels used in religious rites and shaped in the forms of birds and animals. One of these vessels is illustrated (2), moulded in the form of a tiger, and covered with a mass of different symbols to represent the earth's fertility.

The makers of these bronzes were conquered by the Chou, a barbaric people from the north-west, whose lively art used dashing animal shapes and leaping figures, similar to those of the Scythians. The jade disk on the right (3) was a symbol of the revolving universe, and of the king who was believed to be heaven's emissary on earth.

2. *Portable bronze vessel, probably for offerings of wine.* It represents a tiger protecting a man. End of the 2nd millennium B.C.

3. *Jade disk.* Late Chou dynasty, 5th–3rd centuries B.C.

4. *Vessel in the shape of an owl*, bronze. Shang dynasty, 1538–1028 B.C., or early Chou period.

During the 3rd century A.D., missionaries from Buddhist India began to make their appearance in China. The journey was a long and perilous one: they travelled along the caravan trails on foot or by camel, stopping at oases for water and rest, and for shelter from the bandits who preyed on lonely travellers. As they made their way across Central Asia the Buddhists carved great temples and shrines among the desolate hills and rocks. They adorned these temples with painting and sculpture, some in the Roman-influenced style of Gandhara in northern India, and others, like the colossal demon-guardian (1), in a style closer to that of the earlier Chou and Han artists.

Buddhism reached the height of its influence in China during the T'ang dynasty, a period of peace and prosperity in the huge empire, and of great sophistication in the arts. The T'ang artists made use of styles which had originated in north-western India. The sculptors carved figures full of graceful and serene movement, like these musicians (2), the first of whom is shown tapping a small drum, while the second, by the position of her hands, may have been playing a flute. They are clothed in elegantly flowing draperies, and their dignified faces are carved in flat, simple surfaces. Grotesque and even comic little animal and human figures were placed in tombs together with the dead.

2. *Buddhist procession of three musicians and one dancer, detail.*

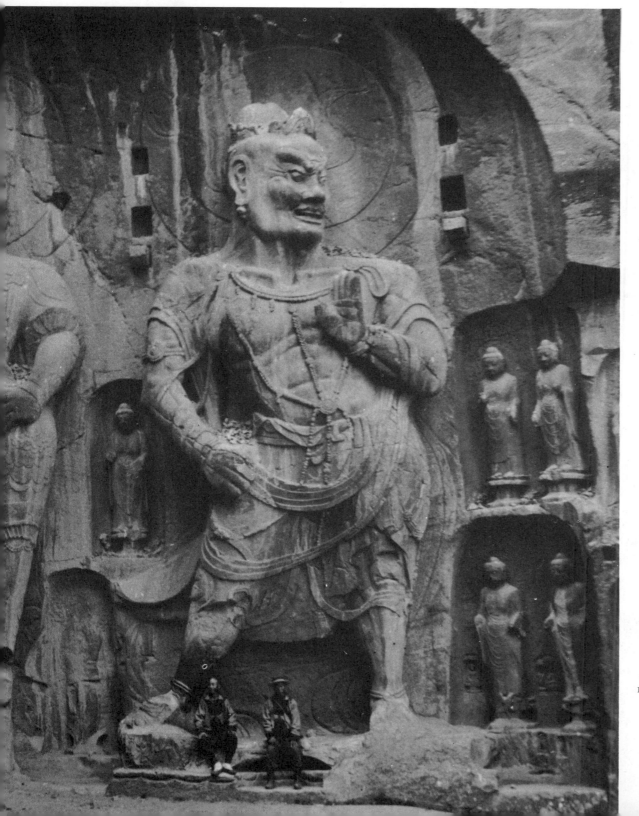

1. *Guardian*, A.D. 672–676

As time went on, Buddhist sculpture gradually became more elaborate. The faces of the figures carved in the early T'ang period were distinguished by their simplicity and sobriety, but later they grew plumper, with rosebud lips, sly, curving eyes and rolls of fat under their chins. As the T'ang dynasty declined in the early 10th century A.D., China was beset by a period of civil wars. Then the figure of a new saint from India made its appearance in Chinese art: Kuan Yin, the goddess of mercy and compassion, who was believed to hear every cry of sorrow and distress, and to bring forgiveness. She was either represented standing, or, more often, seated on a rocky island in the Indian Ocean, dressed in splendid garments and jewellery (3). In this magnificent work we see her carved in wood covered with paint and gold leaf, with her hands and feet gracefully posed like those of a court dancer.

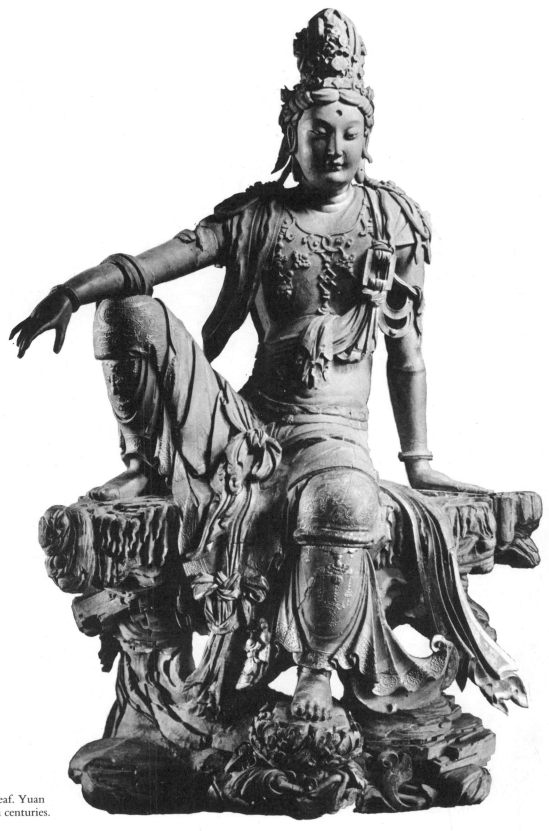

3. *Kuan Yin Bodhisattva*, wood with gold leaf. Yuan dynasty, 12th–13th centuries.

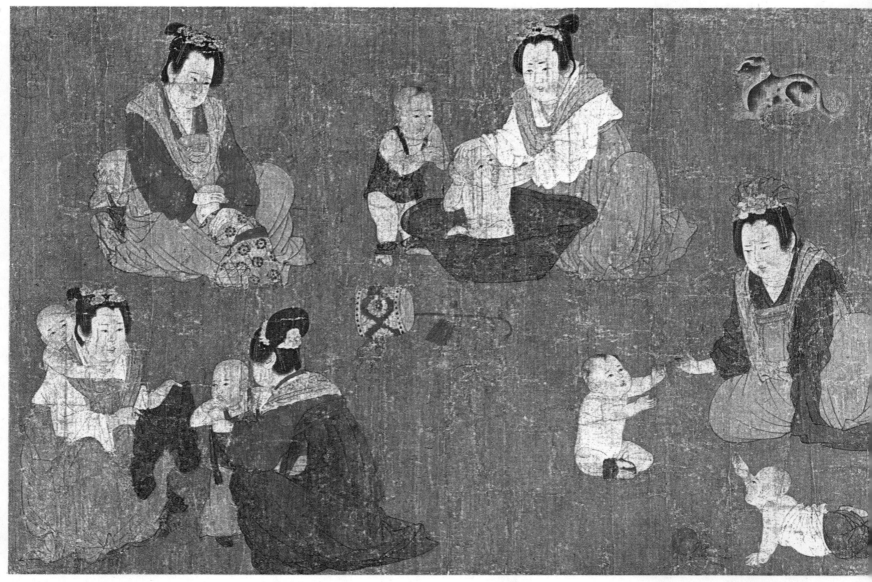

1. *Women playing with infants*, detail. Painted silk. Sung dynasty, A.D. 960-1279.

The T'ang dynasty, which was the period of the second great Chinese empire, favoured the development of one of the most elaborate, sophisticated and refined civilisations the world has ever known. During the T'ang and Sung dynasties artists gave increasing preference to human beings as their subjects, rather than the figures of deities. Women of the T'ang and Sung dynasties were depicted tending their children, making silk, and learning rules of etiquette (1). It is often hard to give a date to these pictures, for the originals have been lost, and we only know them through copies.

When, in the 10th century A.D., the glorious T'ang dynasty was replaced by the Sung, a great new art form appeared—that of landscape painting. It was inspired by the Taoist religion, founded in the 6th century B.C., and practised mainly by the inhabitants of the mountains and forests of southern China. They were a lonely and scattered people who lived in huts almost always blanketed by mists or drenched by cold grey rains. They believed that behind the mists, the forests and the empty spaces, there dwelt a force called "Tao". Taoist painters turned their backs on organised society and city life, to live in meditation

2. Hsai Kuei: *Landscape*. Sung dynasty, A.D. 960-1279.

among the hills and forests. They painted on scrolls which were planned in an original way: the details in their pictures were set in a kind of wide panorama stretching from one end of the scroll to the other. In order to study the paintings one had to unwind the scroll, uncovering only a part at a time, thus gaining a little of the impression of a moving picture. If we look at the scroll below (2), we first see a misty mountain top; then, from the low, tree-covered shore, tiny boats putting out into the river, crossing it and touching the opposite bank. The eye is invited to linger a moment on the dark clumps of trees, and then discovers fishing boats behind them, moored in a peaceful cove. Finally, a rising cliff covered with bushes and lonely trees brings the content of the picture to a natural close.

Pottery of the Sung dynasty (4) has the same gentle, simple lines and its crackled glaze is somehow poetic. The Sung emperors treasured these scrolls and vases, and kept them in silk-lined boxes.

4. *Vase with peony decoration.* Sung dynasty, A.D. 960–1279.

3. Dragon, Chinese fresco from a Korean tomb. Early period.

1. Shih T'ao: *The three summits of the Higher Region*, 1630–1707.
From an album with twelve views of the Lopon Mountains.

3. Shang Yui: Autumnal landscape, 1729.

2. Temple of Heaven, 15th century. Peking.

Chinese landscape painters worked with ink upon silk and paper, and thus could never change a line once it was drawn. They learned to look very carefully at trees, rocks, and clouds, to remember every detail of the way they grew or were formed, and then to paint them swiftly without making any error. Innumerable artists worked in this manner, even after the Sung dynasty fell to the Mongol invaders of the Yuan dynasty, and even when the Yuan in its turn was replaced by the powerful Ming and Ch'ing dynasties of the modern era. As time went on, the painters laid down certain rules for their art, listing the various ways that leaves might be painted, or explaining the several methods that could be employed to reproduce a hill or a tree. The artists sometimes splashed ink on their paper, or smeared it with their hands. Some of their paintings have a kind of supernatural, ghostly quality, consisting of only one or two lines in a corner of the scroll. They were able to achieve a great

4. From *The Tao of Painting*, by Mai-mai Sze:

1. Short brush-strokes representing clumps of leaves.
2. Brush-strokes representing pine needles.
3. Another type of leaf.
4. Flower-like form.
5. Autumn willow, in the Sung style.
6. Autumn willow, in the T'ang style.
7. Rocks, made with brush-strokes like the veins of a lotus leaf.
8. Simple brush-strokes representing human figures.
9. Simple brush-strokes, beginning with the beak, show method of drawing a bird.

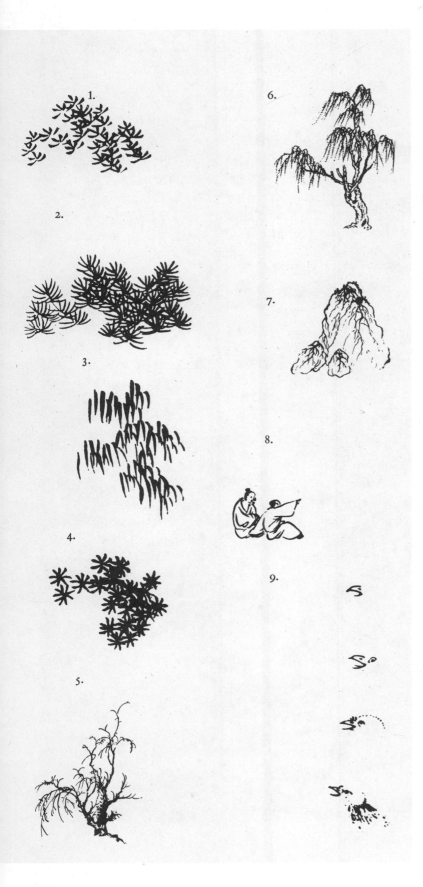

5. *Horse*. Ch'ing dynasty, K'ang-Hsi reign, 1662-1722.

variety of subjects, moods, and styles, by means of the simplest materials and forms ever used by any artists in the world (1) and (3).

Illustrated (4), are some diagrams from a book of instructions for painters, called *The Mustard Seed Garden*. They describe how to apply ink to obtain various effects.

Later Chinese artists excelled in the fashioning of precious small objects. Such works as the little jade horse (5) and the enamelled vase (6) were made with the most delicate and painstaking craftsmanship and became greatly admired in Europe. They became so popular that they inspired the various "Chinoiserie" art styles of the 18th and 19th centuries, when European artists introduced copies of Chinese themes into their works, particularly in pottery and the applied arts.

6. *Bottle vase*, porcelain with green and black enamel, Ch'ing dynasty, K'ang Hsi reign, 1662-1722.

1. *Portrait of Minamoto Yoritomo*, warrior of the 12th century A.D.

JAPAN

Towards the end of the 19th century, interest in the arts of the Far East was greatly stimulated in the West by the coloured wood-block prints from Japan that began to appear in Europe.

Japanese art, like that of China, was indirectly inspired by Indian Buddhism. From the 6th century A.D. onwards an ever-increasing number of painters, architects, and sculptors made their way down the Korean peninsula and across the sea into Japan. It was from these travellers that the Japanese learned the styles of Buddhist painting and sculpture, and the technique of painting in ink on silk which the landscape painters of China, during the Sung dynasty, had developed into a great art. These styles were adapted by the Japanese and continued in a somewhat different manner, but it was not until the 15th century that a series of truly original Japanese styles and techniques appeared. Shinto, the ancient and traditional religion of Japan, taught that the world was ruled by a Sun-god and infested by hosts of evil spirits, eager to snap at the carpenter's hand if he handled his wood carelessly, or to break the potter's bowl if he treated his clay roughly. This belief in mischievous spirits had a great influence on Japanese craftsmen, who attached great importance to cleanliness, and to care and simplicity in the handling of tools and materials.

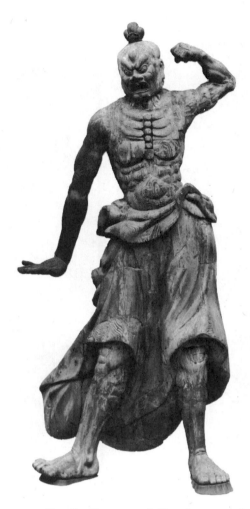

3. *Guardian figure*, wood. Kamakura period, A.D. 1185-1392.

2. *Temple of Horyu-ji*. Asuka period, 7th century A.D. Nara.

Among the earliest works of art found in Japan are clay figures with strong, simple lines and straight, stubby limbs. These figures were buried upright around graves, and probably were meant to represent the spirits who were supposed to guard the body of the dead.

Buddhist missionaries began to enter Japan in the 6th century A.D. and a great Buddhist sanctuary was soon built in the capital city, Nara. Although they were designed somewhat after southern Indian models, the city's temples, walls, shrines, and monastery buildings were more delicate in their structure, with their slender wooden pillars and roofs of curled cedar shavings (2). Colour was dominant everywhere and the walls were painted red, green, blue and gold. Brightly coloured tiles were set beside carved and painted panels, and were decorated with flowers, vines and trailing clouds, like the scenes of "Apsaras" in India. The influence of Chinese T'ang dynasty sculpture was particularly strong in figures like the pensive lute-player (4) and the snarling guardian figure (3).

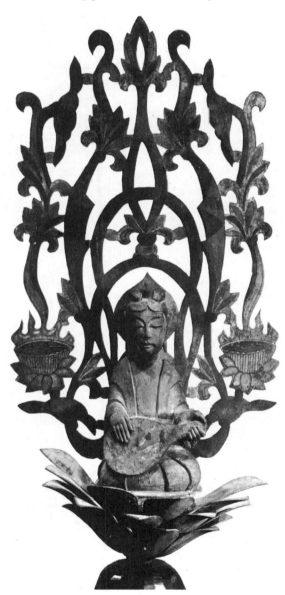

4. *Heavenly musician*, camphor wood. Hakuho period, A.D. 646-709.

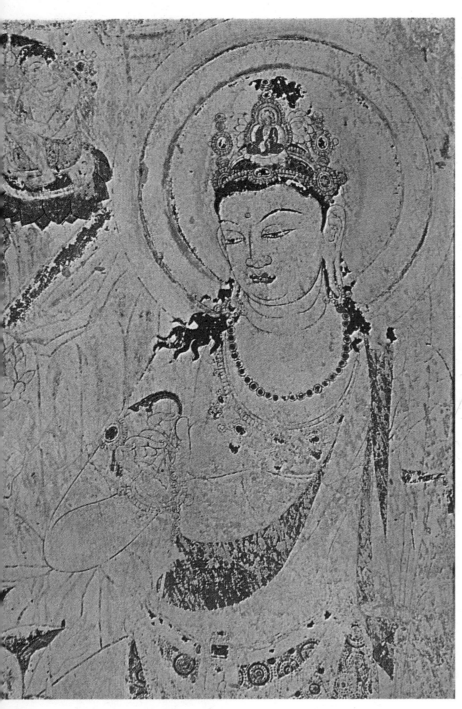

The Chinese style of painting during the T'ang dynasty was carried over into Japan by Buddhist missionaries. Artists at Nara drew plump Buddhist saints in their pictures with the same strong "iron wire" line which had originated long before in north-west China. In the detail from a wall painting at Nara (1), the flat sun-like halo behind the saint's head is typically Japanese, but the flowing garments and graceful gesture might have been drawn by an Indian or Chinese artist.

As the Chinese T'ang dynasty began to crumble at the end of the 9th century A.D., Japan cast off foreign influences. At first, the ruling power came into the hands of a single family, the Fujiwara, who gave their name to the art-style of this period. Paintings of the Fujiwara school reflect the precious, pleasure-loving spirit of courtiers and ladies whose favourite occupations included playing on bamboo flutes, writing poems, and sending love-letters written on silk and coloured paper. One of the few scrolls of this period still in existence tells the story of Prince Genji who was beloved of all the ladies of the court, and the hero of one of Japan's greatest novels written by the noble Lady Murasaki. The illustration (2) shows a scene from the story, with noble ladies of leisure sitting like butterflies upon silken cushions; in this picture we can see early signs of the Japanese taste for highly original, off-balance composition.

Towards the end of the Fujiwara period, Japanese artists began to explore a new kind of art—that of caricature. They used this medium to express in their wittiest manner all the details of human personality that they found so fascinating, and (3), the comic antics of animals who were sometimes compared to the

1. *Amida Triad*, detail from a wall painting by an unknown artist. Early Nara period, about mid-7th century A.D.

2. *Lady Murasaki's Diary*, detail. Heian period, 12th–13th centuries.

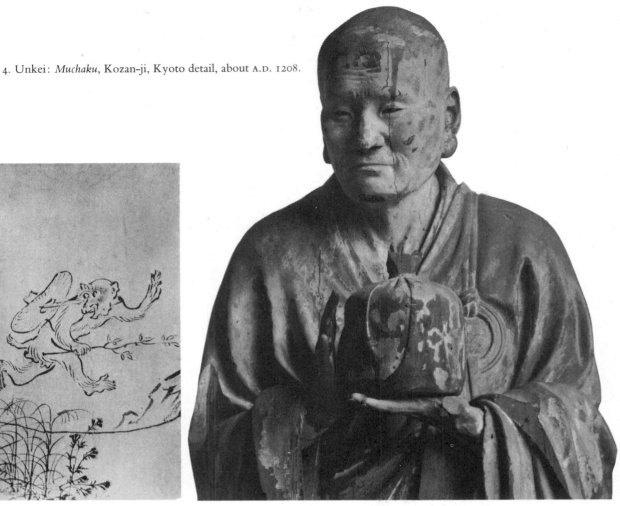

4. Unkei: *Muchaku*, Kozan-ji, Kyoto detail, about A.D. 1208.

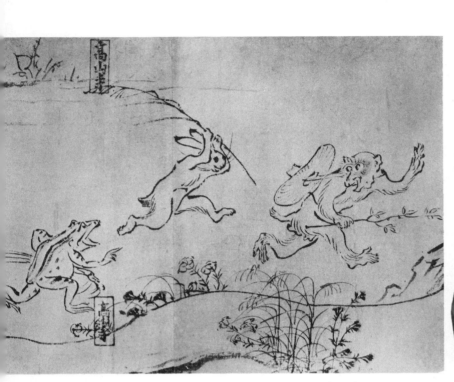

3. *Choju Giga*, by an unknown artist. Late Heian period, 12th century A.D.

pompous and decadent upper classes of the time. Later, many Japanese artists began to observe and record humorous events in the everyday lives of ordinary men and women—subjects generally avoided by Chinese landscape artists.

In about A.D. 1185, the Fujiwara family lost power to the aggressive warriors of the Kamakura, who preferred the swashbuckling arts of war to the elegant and intellectual refinements of court life. A new art style originated under the severe and vigorous rule of these feudal nobles. Strength and realism in the arts were emphasised, and the complexities of the human personality were probed more acutely than they had been by earlier oriental artists. One of the greatest Kamakura artists was the sculptor Unkei. His carved portraits of human faces and figures were almost the first examples in the Orient of a careful, close study of a man's personality. Unkei's figures were carved out of thin pieces of wood which were then joined and painted. A magnificent example of his work is reproduced (4), notable for the strong, simple lines of the carving, and the sober, dignified realism of the face.

This fascination with men's lives and characters gave rise, in time, to a great theatrical art-form, the "Noh drama". Noh actors always wore masks, which announced to the audience the kind of character they were playing. The masks were made with bold patterns which could easily be seen at a distance from the proscenium of the stage, and had striking expressions depicting a beautiful girl, a cruel lord, the god of hell, or any other typical character (5).

5. Noh mask: "*Horai Onna*", attributed to Taiboko. Edo period, A.D. 1615–1867.

1. Sesshu: *Landscape*, mid-15th century, detail.

2. *Burning of Sanjo Palace*, detail. Kamakura period, 13th century A.D.

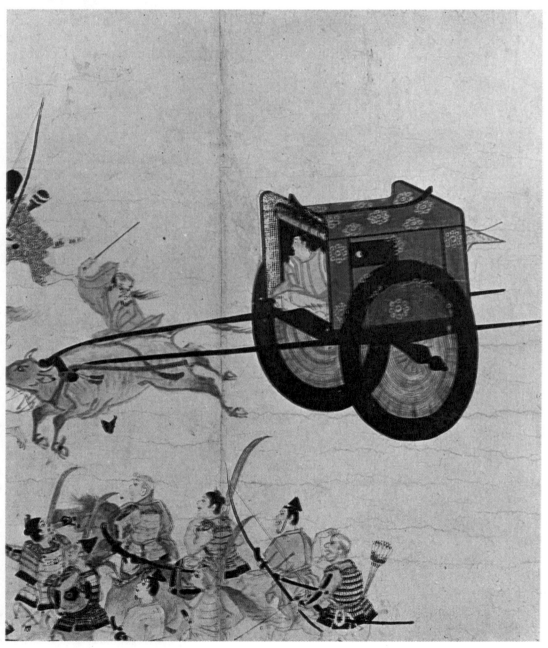

These scrolls of the Kamakura period are designed, like Chinese landscape scrolls, to be read from right to left. But the world they reproduce is a vastly different one (3), for they are full of scenes of battle and rearing horses, men and women either caught up in the tumult of life or else shaking the sleep from their eyes as they rise from their couches. Even more distinctively Japanese was the manner in which these scroll pictures were composed. It was as if the artist had taken up his position in some corner, or at an oblique angle from the scene, before setting it down. Obviously, the artist's intention was not so much to create a perfectly balanced composition, but rather to present a picture full of all the natural accidents and hazards of life.

From the 14th to the 15th centuries Japanese art was influenced by Sung landscape artists who used ink washes to obtain a general misty effect suited to their contemplative temperament. Nearly all the Japanese landscape painters were members of the "Zen" Buddhist sect, partly a philosophy and partly a wonderfully lively art style, which had spread into Japan from China during the 12th century. Zen artists behaved in strange ways, riding backwards on donkeys, drinking beer, making inconsequential jokes and sometimes indulging in a kind of slapstick. It was by such means that they tried to shock both themselves and one another into suddenly reaching the kind of "Enlightenment" which Buddha had found, and which many Buddhist philosophers strove to attain through meditation. Zen artists tried to find a clue to the meaning of the universe in every detail of nature, animal life and mankind. Every act of the day was believed capable of setting off a chain of ideas and feelings which could lead to final "Enlightenment". Zen artists trained themselves by long years of practice at the simplest activities. In the 17th century Japanese artists were affected by the formal, decorative style of Chinese art. This period was notable for its use of rich, well-defined colours, the development of carved lacquer, and the use of enamels on metalwork. The landscape paintings (1) and (4) are a good illustration of the differences between the Japanese style and that of China, from which it originated.

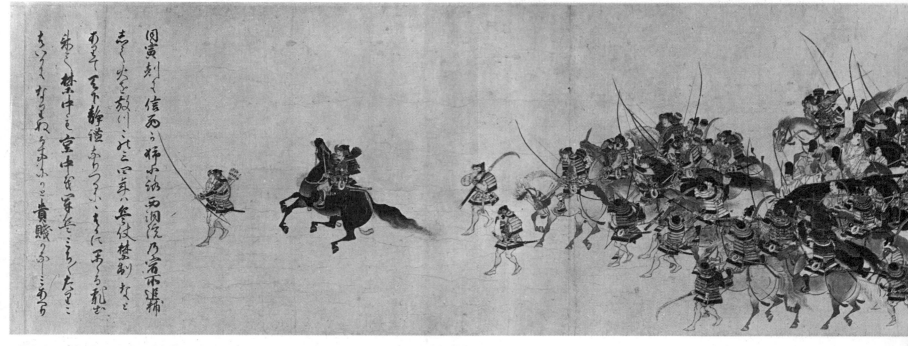

3. *Burning of the Sanjo Palace*, detail.

5. *The Buddhist monks Han-shan and Shihte*, attributed to Shubun. Ashikaga period, 15th century A.D.

4. Sesshu: *Landscape*. Ashikaga period, 1420–1506.

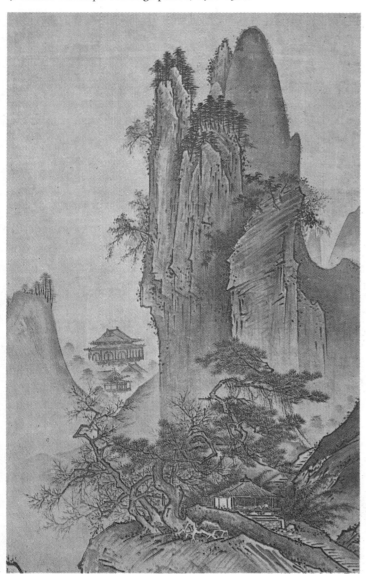

1. *Legends of Muge Hoju no Tama*, detail of an 18th-century screen.

In the 17th century, Japanese artists were faced by a new challenge. Once again, a powerful military class imposed its rule upon the country, and the nobles of the new Momoyama period demonstrated their power and wealth by building huge fortified castles (4). Within these fortresses were great banqueting halls, where the courtiers would gather. There was no longer any place for the small, intimate, black-and-white Zen drawings, or even the witty comedies depicted in the Kamakura scrolls. Gaudy and imposing decorations which could be moved about as the Shogun, or ruler, commanded, were now required. Consequently, teams of painters would set to work, making handsome screens, painted with bright bold designs that would be visible from across a long hall. Each screen of this type had six panels, which were usually painted with scenes of islands rising out of frothy waves, iris flowers, or groups of girls in brightly patterned kimonos (2)—all subjects that did not call for close study. The colours were intense and flat in tone and the compositions were even more bold than those of the Kamakura paintings, literally holding the eye transfixed by their daring form. The greatest of these Momoyama artists was Korin.

2. *Women of the gay quarters*, by an unknown artist. First Edo period, about 1650.

3. *Japanese house, interior*. Now in Garden Park, Philadelphia.

4. *Nagoya Castle*, 1610–1612. Nagoya, Japan.

5. Hiroshige: *One of the "Fifty-three Stages of the Tokaido Shono"*, about 1834.

6. Utamaro: *Three geishas*, about 1793. Woodblock print.

While the nobles called for extravagant palace decorations, the rising middle-classes of 17th- and 18th-century Japan also began to demand art that they could enjoy, but at a reasonable price. As a result some artists began to turn out great numbers of little wood-block prints which could copy a single design many times over, and be sold cheaply. The earliest prints were made in black and white, though some were later hand-coloured, but by the 18th century craftsmen had mastered the art of producing colour prints, using a different block for each separate colour. Like the screens, these prints had a chopped-off appearance, as though the artist was tantalising the beholder, saying: "so much more goes on in the world besides this little scene, which is only a fragment of what I know!" The name given to this type of print was "Ukiyo-ye" or "floating world". Thousands were produced, showing such subjects as elegant ladies of the Geisha quarters, episodes from plays and legends, grimacing warriors and actors, and scenes of everyday life, both serious and comic. Among the most famous of the many great Ukiyo-ye artists were Hokusai, Hiroshige and Utamaro (5, 6). In the 19th century these little prints found their way to the west, particularly to Paris, where they aroused great interest among French painters, of whom Manet, Toulouse-Lautrec and Degas, were so far influenced as to copy their flat, muted colours.

Modern artists in the west have been influenced by many Japanese ideas and styles, for it is not only in painting and sculpture that the Japanese have expressed their taste and high standards of artistic craftsmanship. Moreover, the revolution in modern Western architectural design probably owes more to Japanese architecture than to any other art. Almost everything made and used in Japan can be considered a work of art.

Japanese houses are built of wood and are so constructed that their inside shape may be changed by moving the paper screens which divide the rooms, backwards and forwards. Japanese gardens are laid out with the same love of quiet, empty spaces broken into oblique, striking patterns. Besides containing flowers and plants, they may also have beds of sand, carefully raked into designs and punctuated by small rocks, trees, and ponds, simulating natural mountains and rivers.

1. *Vessel of basaltic granite with human figures.* Maya civilisation. From Yucatan, Mexico.

PRE-COLUMBIAN ART

From about 25,000 B.C., the American continent began to be populated by migrations of Stone Age people who came across from Asia, by the Alaskan peninsula, and who slowly fanned out over the two continents, building a series of complex civilisations in Mexico, and Central and South America. Although they were cut off from all contact with the great civilisations that were developing in other parts of the world, they built cities curiously similar to some in the Old World, notably in the Near East. They built, in most of their cities, great pyramid-shaped structures with temples on the summits, courts for the playing of ball games, and astronomical observatories, all of which were covered with sculpture and painted decorations.

Some extraordinarily expressive images were created in the Maya, Aztec, and Inca cultures, but, for the most part, pre-Columbian art, like the Neolithic arts of Europe and the East was characterised by a rigid and formal language of signs and patterns. In a few puzzling cases, works of art have been found which appear to be related to the earliest art of China during the Shang and Chou periods. It must be admitted that we still know little of pre-Columbian art, while many treasures were lost when the invading Spaniards destroyed these civilisations in the 16th century.

As the various early civilisations grew up in the valleys of Mexico and South America, each one had its own artistic speciality. The Tarascans of western Mexico skilfully modelled clay into a variety of lively figures occupied in their daily tasks, the Olmecs worked in

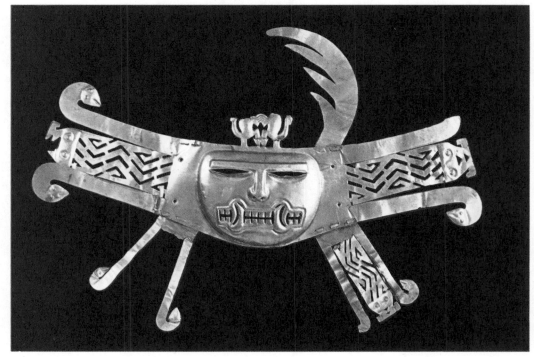

2. *Mask of gold*, A.D. 400–1000. Mochica or Chimu, Peru.

3. and 4. *Child's whistle in the shape of a seated human figure.*

3. and 4. *Child's whistle in the shape of a seated human figure.*

polished jade which they often carved into scowling faces with blunt noses, and the early Chimu people were potters and goldsmiths, the latter craft becoming one of the great arts of South America.

Of the three major cultures that flourished in Mexico, the most noteworthy is that of the Maya. They were great builders of cities and invented both a calendar and a complicated system of writing. They practised an extremely blood-thirsty religion which required the sacrificial killing of thousands of human beings to appease the gods of agriculture, of the elements, and of death. The little seated statuette (3, 4), may well represent a victim awaiting his turn to be sacrificed. He is wearing a very elaborate head-dress which is a frequently recurring characteristic of Maya sculpture.

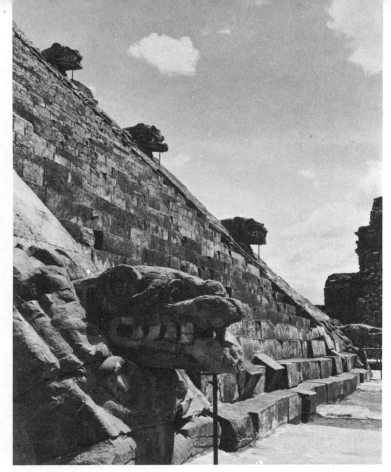

1. *Serpents' heads on the Temple of Quetzalcoatl*. Teotihuacàn, Mexico.
A.D. 770–829.

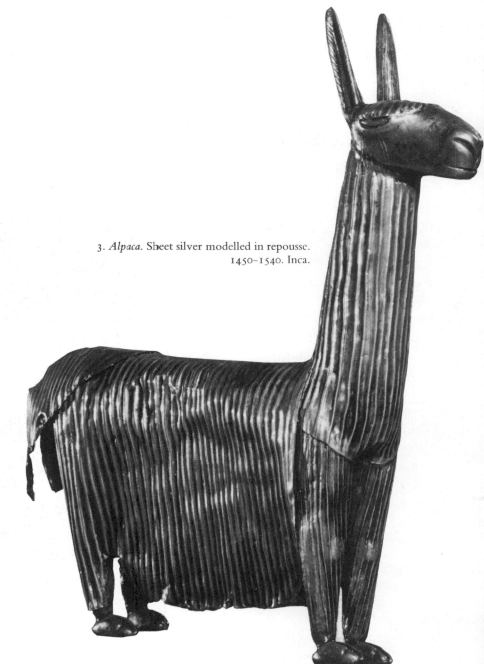

3. *Alpaca*. Sheet silver modelled in repoussé.
1450–1540. Inca.

The other two great Mexican cultures were firstly, that of the Toltecs who built Teotihuacàn, a great city of pyramids, avenues and enormous, grotesque sculptures (1, 5), and secondly, that of the Aztecs who made their first appearance in the Valley of Mexico about A.D. 1300. Among the gods of the Aztecs was the "Plumed Serpent", a grotesque monster with claws, feathers, and a serpent body, and Xipe, the god of fertility. The priest who sacrificed a victim to Xipe had to skin the body and dress himself in the hide, in imitation of the god who put on a new garment of vegetation every spring. The carved stone head (2) represents the priest covered in the victim's flayed skin.

4. *Aztec snake*, 15th century or beginning of the 16th century.

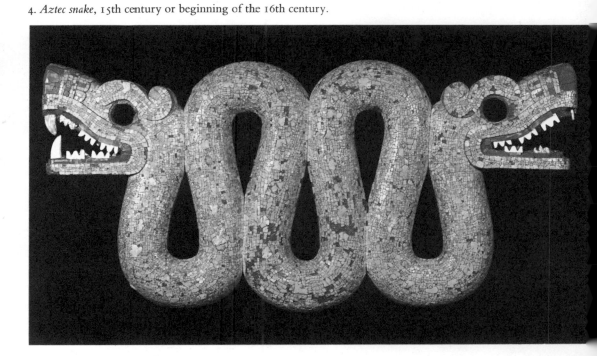

2. *Xipe Totec, god of Fertility*, 15th century, Aztec.
Central Mexico.

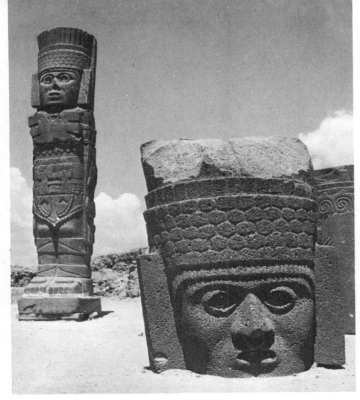

5. *Colossi at Tula*, 12th–13th centuries. Toltec, near Mexico City.

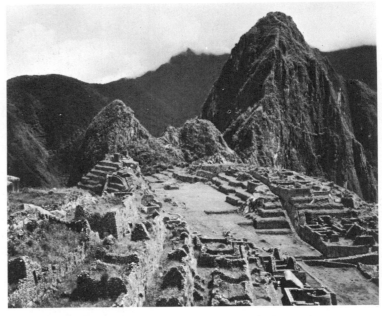

7. *Ruins of the Inca city of Machu Picchu*, 16th century. Peru.

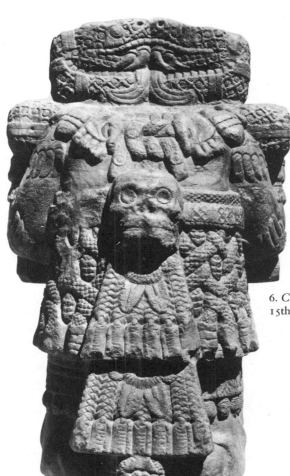

6. *Coatlicue, "goddess of the Earth"*.
15th century, Aztec.

8. *Pendant representing a crocodile with
the head of a frog*. From Columbia,
14th–15th centuries.

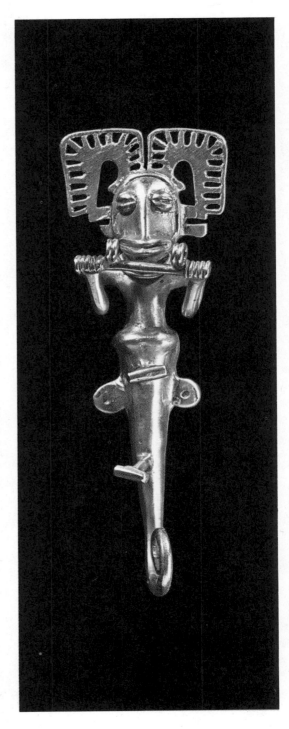

The civilisations of South America, isolated, in what is now Peru, from the rest of the continent by the Andes, produced less extraordinary sculptors than their contemporaries in the north. Their greatest art lay in pottery-making, weaving beautifully patterned textiles, and in both gold and silver work (3, 8). These cultures reached their highest point of development under the Incas. The Inca empire had reached its zenith, with its brilliant rulers and architects, when the Spaniards invaded South America in the 16th century. The Spanish conqueror Pizarro forced the Incas to give up an enormous treasure of works in gold, made in honour of the Sun-god. Thousands of precious objects were melted down into gold bars, destroying forever the monuments and works of art of the Incas.

THE MIDDLE AGES

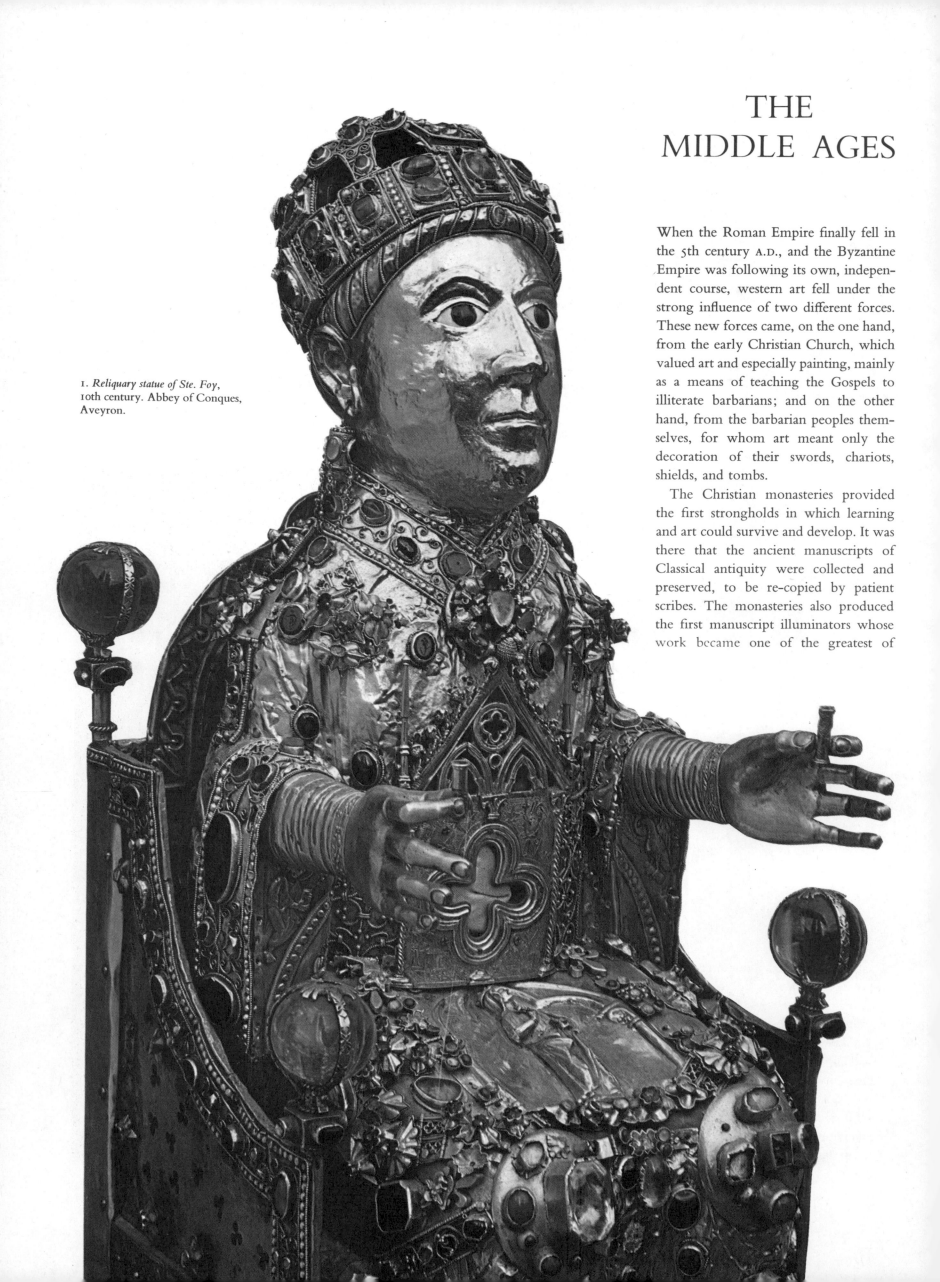

1. *Reliquary statue of Ste. Foy*, 10th century. Abbey of Conques, Aveyron.

When the Roman Empire finally fell in the 5th century A.D., and the Byzantine Empire was following its own, independent course, western art fell under the strong influence of two different forces. These new forces came, on the one hand, from the early Christian Church, which valued art and especially painting, mainly as a means of teaching the Gospels to illiterate barbarians; and on the other hand, from the barbarian peoples themselves, for whom art meant only the decoration of their swords, chariots, shields, and tombs.

The Christian monasteries provided the first strongholds in which learning and art could survive and develop. It was there that the ancient manuscripts of Classical antiquity were collected and preserved, to be re-copied by patient scribes. The monasteries also produced the first manuscript illuminators whose work became one of the greatest of

medieval artistic achievements. As time went on and kings began to carve out small empires for themselves they called for art to glorify their achievements. Although it had long been prophesied that the year 1000 would bring the end of the world, the century passed without catastrophe and a new wave of artistic fervour spread over Europe. Church construction flourished, travel and trade revived and thus brought about a fruitful interchange of art styles and techniques between countries far distant from one another. Gradually the stonecutters and builders, painters of miniatures on manuscripts, the enamellists and bronze workers, rediscovered the ancient secrets of their arts, or learned new techniques from imported Byzantine or Islamic works. As their skill developed, sculptors, masons, weavers and craftsmen organised themselves into their respective corporations or guilds in order to protect their trades. At the same time the new Romance languages were being formed, based on a common Latin heritage, and a new literature was to result. Scholars in many countries developed an enthusiasm for the great written works of the past. Although many were enclosed in monasteries, they faithfully copied the old manuscripts and embellished them with miniatures, that were themselves works of art. Finally, artists rediscovered the individual personality and turned their attention again to the world of mankind. This resurgent interest extended into sculpture, painting, and all the decorative arts such as goldwork, tapestry, weaving, and stained glass, while architecture reached new heights in the soaring Romanesque and Gothic cathedrals.

3. *Gold fibula*, set with red and blue paste, eyes studded with garnets, 7th century.

2. Celtic art: *Fragment of the bronze mounting of a wooden yoke*, 2nd century A.D.

4. *Crown of the Holy Roman Empire*, about A.D. 962.

The Franks, who appeared in central Europe in the 4th century A.D., seem to have learned their arts from nomadic eastern tribes. They continued to make jewelled bronze swords, helmets, and brooches, in the same manner as their ancestors (3).

Barbaric splendour was perfectly in harmony with the ideas of the medieval Church. This gem-encrusted figure, with staring enamel eyes (1), is a "reliquary", made to enclose a fragment of the body of a young saint. The crown (4) was used for the coronation of the Holy Roman emperor until the time of Napoleon. The Celts and the Franks were two "barbarian" peoples whose art styles infiltrated medieval Europe, resulting in the creation of new forms and techniques, and in works of outstanding beauty. The Celts, whose encampments were scattered between Spain and Scandinavia as early as 1000 B.C., made bronze and iron tools, weapons and ornaments, often in the shape of animals (2). Like many wandering peoples, particularly the Scythians (see page 69), Celtic artists used these animal shapes as the basis of complex, intertwined patterns which were used to ornament many different objects. Their rich, decorative styles later influenced the brilliant school of painting centred in the monasteries of Ireland, Scotland and Northumbria.

1. Celtic art: *The Book of Kells*, 8th century A.D.

By the 8th century A.D. the Celts had been driven from the European mainland and forced to seek shelter in England and Ireland. There they were converted by Christian monks, and set up monasteries where they used their native techniques for ornament in the service of Christianity. They decorated the great parchment pages of books of Gospels, and carved stone crosses in the tradition of the tall pagan stones that had been set up by their ancestors. Celtic manuscript illustrations were filled with the animal shapes and elegantly interlacing lines typical of their art (1), as well as with patterns incorporating such motifs as desert birds among vine scrolls, brought from Coptic Egypt. They are among the most intricate designs ever made, full of a whirling, vibrating energy.

Later in the 8th century, Celtic culture was wiped out by the invading Viking hordes from Scandinavia. The Vikings be-

2. *Utrecht Psalter: Psalm 50,* about A.D. 830.

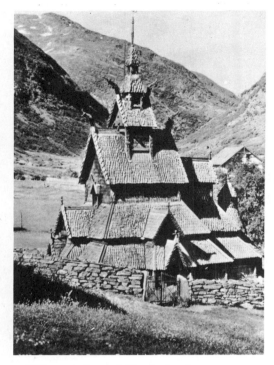

3. Viking art: *Borgund Church*, about A.D. 1150.

5. *Bayeux Tapestry*, detail of the battle of Hastings.

lieved that demons inhabited the forests and seas, and to ward them off they carved dragons rearing from the prows of their ships and from the beams of their houses. Even after they had become Christians, the Norwegians still used these dragon heads to decorate their timber churches (3).

In Europe, the lively ornamental style of the barbarians slowly became mixed with Classical styles. The first impetus to this combination of the two forms came from Charlemagne who succeeded as King of the Franks in 771. Charlemagne wished to establish an imperial state which would link the once barbaric

4. *Adam and Eve expelled from Paradise*, A.D. 1015. Detail from the bronze doors of Hildesheim Cathedral.

Gaul with Italy. Part of his plan was to stimulate a revival of art and classical learning, and he invited scholars, poets and artists to his court to take part in the creation of a new culture. He built great monasteries where, for centuries to come, monks copied and preserved the manuscripts of Greece, Rome, and Byzantium (see page 64). Occasionally the monks invented their own new styles of drawing and painting, partly inspired by the illustrations of these ancient books. The most interesting "Carolingian" manuscript which has survived is the Utrecht Psalter (2). This work like many other manuscripts, may well have passed from one monastery to another, and was imitated in a variety of ways.

After Charlemagne's death in 814, Europe fell back into disorder until the 10th century, when the Saxon King, Otto, built up a new empire. During his reign churches were built, statues were carved and the art of the goldsmith flourished, while the Byzantine influence again became powerful. King Otto III was another great patron of the arts. Early in the 11th century one of his bishops in the town of Hildesheim directed the making of a pair of great bronze doors for the cathedral. The scene reproduced (4), modelled in high relief, might well be a pen drawing from the Utrecht Psalter translated into bronze. Another great work of this time was the famous Bayeux Tapestry (5), made to commemorate the conquest of England in 1066 by the Normans under Duke William. The long, narrow tapestry tells the story of the conquest, showing the Normans crossing the sea in boats with prows carved like those of Viking ships, and contains, ranged along the borders, curious little animals and winged monsters in a partly Celtic, partly Viking style.

1. *The Woman of Samaria*, 11th-century fresco. S. Angelo in Formis, Capua.

2. *Basilica of Saint Ambrogio*. Milan.

In the 18th century in Europe, it was a popular idea that the Middle Ages were mainly a time of barbarism and unreasoning brutality. We now know that the year 1000 was the beginning of a rich and intense new period of civilisation which was to produce the great urban cultures of Italy and culminate in the glorious artistic and intellectual achievements of the Renaissance.

A new architectural style, the "Romanesque", came into being, and was developed and interpreted in various ways throughout Spain, Germany, France and Italy. In Italy the architects were still able to study the great ruins of the Roman Empire, for even though they were decaying or had fallen into ruin, their main outlines and characteristics remained visible. In the 11th and 12th centuries Romanesque architects built the first great cathedrals which became the centres of secular and artistic,

as well as of religious life, serving for important civil occasions as well as religious rituals.

The churches were planned in the form of a Latin cross. Later, the main aisle or nave was divided into separate side sections or "bays", which could be used as additional chapels. The most important innovation was in the construction of the roof. Instead of being a low-pitched wooden roof with a flat ceiling, it consisted of a stone vault held up by walls and pillars. The earliest Romanesque vaults are called "barrel vaults" because of their rounded shape, but later they became more pointed and were supported by ribs. These ribs were really the continuation of stone shafts rising up the walls and columns separating the bays, and ran across the ceiling of the vault to the opposite side of the nave. The earliest ribs were arches resting on top of the piers along the length of the nave, but as architects became more skilful they were made more slender and elegant.

The first great church to be built along these lines was the basilica of San Ambrogio in Milan. It incorporated an earlier structure and preserved the early Christian arcaded courtyard, which is no longer found in later churches, although we can see the remains of one in the graceful portico of the cathedral at Modena. Painting also made its appearance in Romanesque churches: early in the 12th century a great series of pictures was painted in the bays and apse of the basilica of San Angelo in Formis near Capua. The artists were directed by their Byzantine abbot Desiderio, and their frescoes (1) are among the masterpieces of Italian Romanesque art. Towards the end of the 13th century the great Florentine artist Cimabue painted pictures of great power; his *Crucifix* (3), and his frescoes in the basilica of St. Francis of Assisi in Umbria are among the most dramatic works to have been created during the Middle Ages. Among them is his Crucifixion scene, which can still be seen there, although the colours have oxidised so that the whole composition now looks like a photographic negative.

3. Cimabue: *Crucifix*.

4. *Architrave of the right-hand doorway of the Church of the Saviour*, 12th century. Lucca.

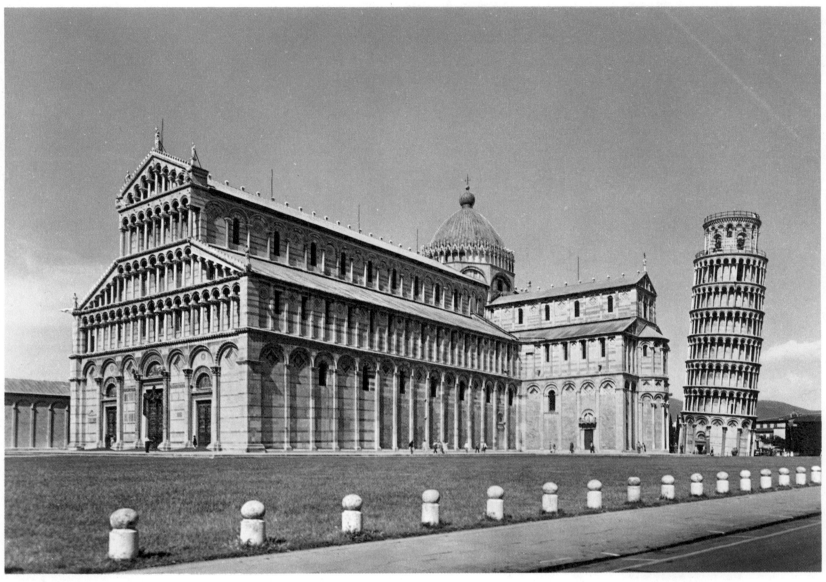

1. *Cathedral and leaning tower*. Pisa.

2. *S. Miniato al Monte*. Florence.

The art of Tuscany, which was to become the vital centre of the Italian Renaissance, was typified by a clarity and restraint of style which can already be seen in its Romanesque architecture. Chief among its cities was Pisa, a prosperous merchant city with a strong fleet, which traded with Sicily and the Near East. Its famous Cathedral and leaning tower were built by the architect Buschetto, whose refined style exerted a strong influence as far as Sardinia and southern Italy. In the splendid Court of Miracles at Pisa, the magnificent marble buildings towering over the surrounding lawns form one of the finest, clearest and most highly planned groups of structures ever created during the Middle Ages. The heart of this complex of buildings is the Cathedral itself, begun in 1063. It contains a series of five aisles with fully curved arches resting on slender columns, and the nave is completed by a centre apse decorated inside with a mosaic partly created by Cimabue, and two smaller side apses. Outside, the upper façade consists of a series of pillared arcades designed to correspond with the main entrance of the baptistery facing it. It was later completed and enriched by the addition of late Gothic decorations along the top. The long succession of pillared arcades along the exterior of the Cathedral are the most striking

3. *Cathedral*. Modena.

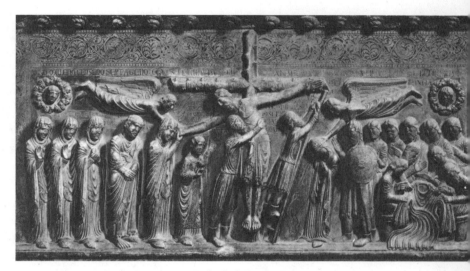

4. Benedetto Antelami: *Deposition*, Cathedral, Parma.

characteristic of the architectural decoration and they are echoed by the successive tiers of columns on the leaning tower which was begun in 1173. All three monuments are set together in the open Piazza, although one side is covered by the long wall of the Campo Santo running along the side of the cathedral.

The architecture of Florence was more clearly geometric and Classical in its design as we can see from the photograph of the church of San Miniato (2). Coloured marble was used both inside and outside for its construction, and the different sections clearly outline the various architectural elements in the building.

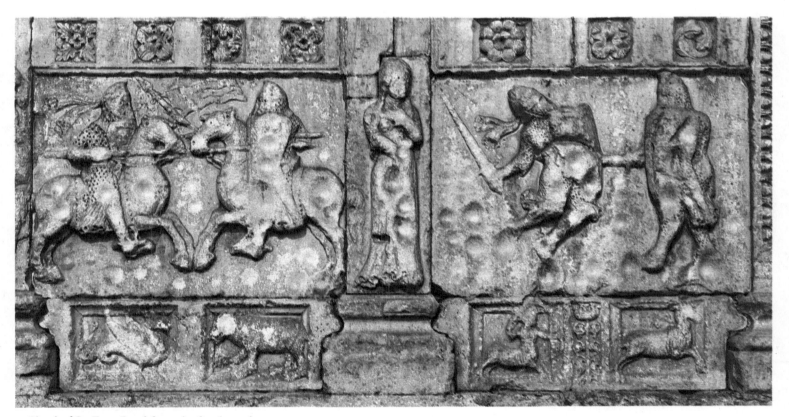

5. *Church of St. Zeno*. Panel from the façade. 12th century.

1. *Christ in Majesty*, 12th century. Detail of the tympanum, Autun Cathedral.

In France too, the Romanesque style in architecture differed from one region to another. In southern France which was in closer contact with Italy, buildings were generally lower and more massive, echoing the spirit of the Roman triumphal arch. In central France, churches like that of Vezelay (3) were higher and more luminous. In the Norman territories of the north, Romanesque churches and monasteries were towering buildings not unlike feudal forts (5).

Stained glass was probably first invented in the Near East and spread northwards through Italy in the early centuries of Christianity. The first examples, like the medallion below (2) were severe and rigid, with bold, black lines painted upon the glass. It must be remembered that since the heavy arches of Romanesque buildings rested entirely on thick supporting walls, the building could not be weakened by the piercing of wide, light windows. Instead, the walls were often decorated with frescoes, painted with water colours upon freshly applied plaster.

Throughout the Middle Ages architecture was considered to be the highest and most perfect form of art. Painting and sculpture were thus subordinated to it and the great artists who practised them had to make their work fit into the overall design of the building on which they worked. As a result, the arches and façades of churches would be

3. *Nave of the Church of the Madeleine*, between 1096 and the end of the 12th century.

2. *Head of Christ*, 11th century. Stained glass.

covered with sculptures illustrating scenes from the Old and New Testaments while the painted walls told stories from the lives of the saints (page 111 (4), page 113 (5), pages 114-115 (1) (4)). But the main form of decoration was sculpture, not of life sized statues in the Classical manner, regarded as "graven images", to which the early Church was opposed, but rather ornamental sculpture which was designed to teach the gospels. The sources for these designs were mainly the precious manuscripts of the past belonging to local monasteries or rulers, and also books brought back from distant lands by pilgrims. Wandering sculptures would also follow the roads of the pilgrims and stop to work wherever they could find a patron. In this way many unknown artists from different regions would take part in the decoration of the same church and the result would be a mixture of different styles. In the ornamentation of some churches we can find winged lions from China and Syria side by side with sharp-beaked birds from Ireland and Egypt. But the most impressive sculpture of each church was usually carved on the "tympanum" or half-moon set over the main doorway in the façade. This front porch was designed to attract the attention of the passer-by, inviting him to enter. The sculptors accordingly chose fantastic and striking themes for their work, as, for example, the day of judgement. This awesome scene showed the sinners on one side, and the blessed on the other, arising from their tombs to meet their fate, while above them towered a figure of Christ "in majesty". The illustration (4) on page 117, shows the Romanesque manner of arranging these figures (1, 4). The new style of Romanesque figure sculpture was carried far and wide by artists following the main pilgrim ways, and spread throughout Italy, France and the rest of Western Europe. But in Spain, and particularly in the region

5. *Mont Saint Michel*, 1203-1264.

nearest the Pyrenees, Romanesque encountered Mozarabic art, a combination of native Spanish and Moorish styles, which contained both Hellenistic and Byzantine influences. The result was a profusion of splendid wall paintings, particularly in the churches of San Clemente and Santa Maria at Tahull, San Quirico at Pedret, and those in the region of Vich. These Catalan frescoes are among the most important of their period in Europe, and are distinguished by their originality, freedom of style and expression, and by their harmony with their architectural surroundings.

4. *The Creation*, 12th century. Detail of the tympanum ("The damned"), Autun Cathedral.

In 12th and 13th century Europe, kingdoms and peoples were united by the crusading spirit which aimed to extend the boundaries of Christendom. On their return from the Near East, the Crusaders told fabulous tales about the wealth, art and learning of Byzantium and Islam. There was an upsurge of curiosity about distant lands, and monks began to write books in the vernacular, rather than in Latin. Universities were founded and new ideas flourished everywhere, particularly in France, which had become the cultural centre of the west. Architects looked for new ways of building, and their innovations led to a new style—later called "Gothic". Its design included two new devices: the pointed arch, which enabled the builders to construct much higher ceiling vaults, and stone vaulting borne on a network of stone ribs supported by piers and clustered pillars. Buttresses and counterforts, two further constructional methods unknown to Romanesque builders, were arranged round the outside of the building to support the lateral stresses of this vaulting. It was then possible to open up the walls with tall, wide windows filled with stained glass through which light could pour into the interior. The basic shape of a "Latin cross" was preserved by intersecting the long nave with a transept. The design of great West Fronts, façades inset by doors and windows and flanked by towers, repeated the structure within.

The greatest Gothic buildings include Notre Dame in Paris and the cathedrals of Chartres, Reims and Amiens. The construction of the first two lasted for nearly a century, the others being slowly built during the 13th century. All the illustrations

1. *Cathedral*, Chartres. 1145–1260. Aerial view and ground plan.

2. *Flying buttresses*. Cathedral, Chartres.

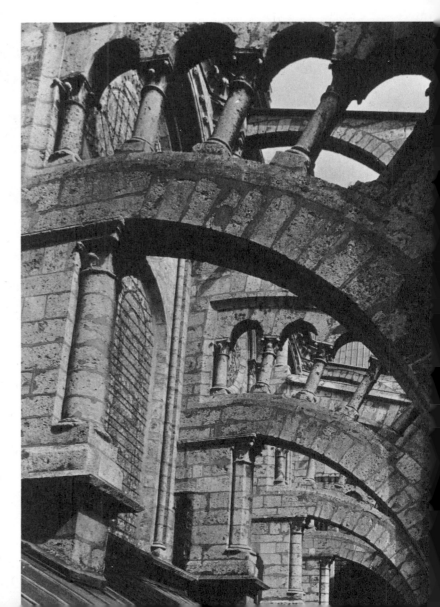

116

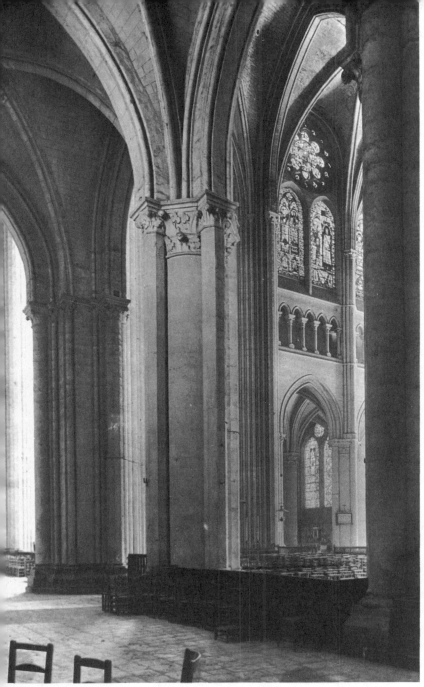

3. *Interior of the Cathedral*, Chartres. Diagonal view of nave and south transept.

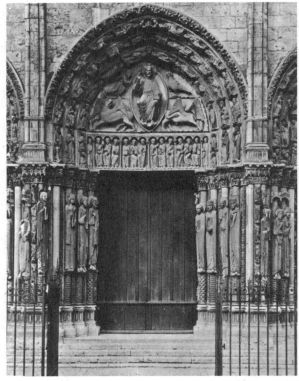

4. *West door or Royal Portal*, about 1150.

5. *Kings and Queens of the Old Testament*, detail of the west door. Cathedral, Chartres.

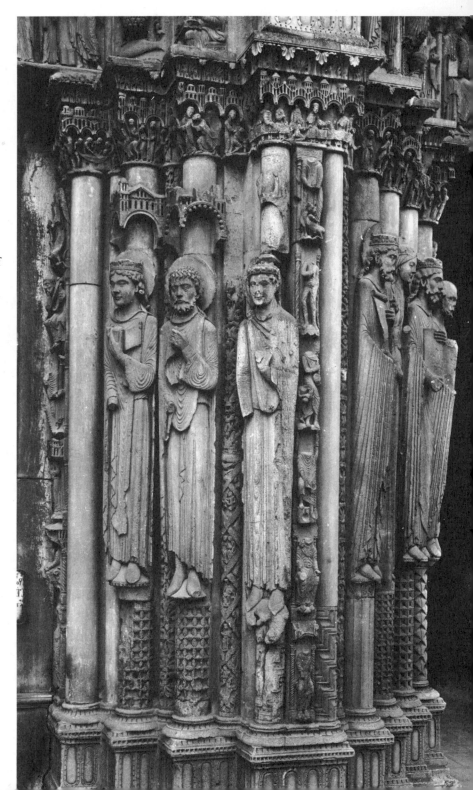

on these pages are of Chartres. With its richness of architecture and design, its splendid stained glass windows and thousands of sculptured figures it is a kind of encyclopedia in stone of the learning and culture of the 12th and 13th centuries.

The West Front of Chartres is still late Romanesque in style, with its long, rigid figures, which are among the great masterpieces of European sculpture. By the massive front entrance, beneath the figure of Christ (4), are the kings and queens of the Old Testament set on either side (5), so that worshippers entering the church had to pass between them. The idea of enlivening the whole portal with carvings of human figures, belonged to Abbot Suger, head of the Abbey of St. Denis in Paris. His plan was for a vast dramatic representation in stone of the Gospels and the stories of the Old Testament. The scholastic philosophers of the new universities contributed their ideas for subjects to be included among the sculptures. Chosen were figures of the ancient philosophers and prophets who foretold the birth of Christ, as well as symbols representing the months of the year, and the human vices and virtues.

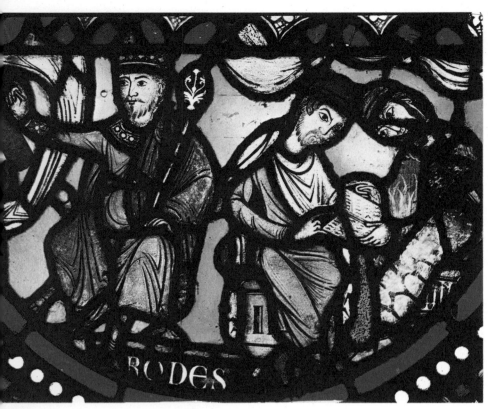

1. *Herod*, stained glass window, about 1145. Basilica of St. Denis. Paris.

2. *Rose window* from the north transept, about 1230.

On these pages are reproduced some magnificent examples of the art of stained-glass, which reached its zenith in the 14th century. The earliest surviving examples are to be found in Germany, and date from about the middle of the 11th century. The finest stained-glass of the Middle Ages survives in the great cathedrals of France and England, such as Chartres and Canterbury.

The purpose of stained glass was to transform the vast stone interiors with warm and glowing colour and at the same time to instruct Christians in their faith. In the Middle Ages it was only used in churches, although, later, stained glass is found in palaces and even private dwellings. Each window consisted of many small, separate panes of glass held together by a framework of lead. These were combined into patterns, figures and scenes from the Bible or lives of the saints. Although the technique of making coloured glass was known to the ancient Romans, medieval stained glass was painted, specially prepared pigments being laid on with a brush. The artists began by making a coloured sketch or design for the entire window to be filled, and then divided the plan into the separate panels. The main outlines of the pattern were drawn and then thickly painted over with black or red so that they could be seen clearly when the uncut glass panes were laid over them. Each piece of glass was then painted with some detail of the overall pattern, and the outlines were drawn in with black enamel. When the painting was

finished, the pieces of glass were laid out on the original plan in the required position and a lead framework laid around them. They were thus bound together before being set into the window.

At first, only small windows could be decorated in this way but, when Gothic superseded Romanesque, the new building techniques made it possible to reduce wall space and to construct great windows to flood the interiors with light. In the transept of Chartres Cathedral the whole of the north wall seems to have been transformed into a sumptuous, glowing screen of many colours, giving an impression of lightness and jewel-like delicacy.

3. *St. Andrew*, stained glass window, about 1300. Church of St. Pierre, Chartres.

4. *St. Bartholomew*, stained glass window, about 1300. Church of St. Pierre, Chartres.

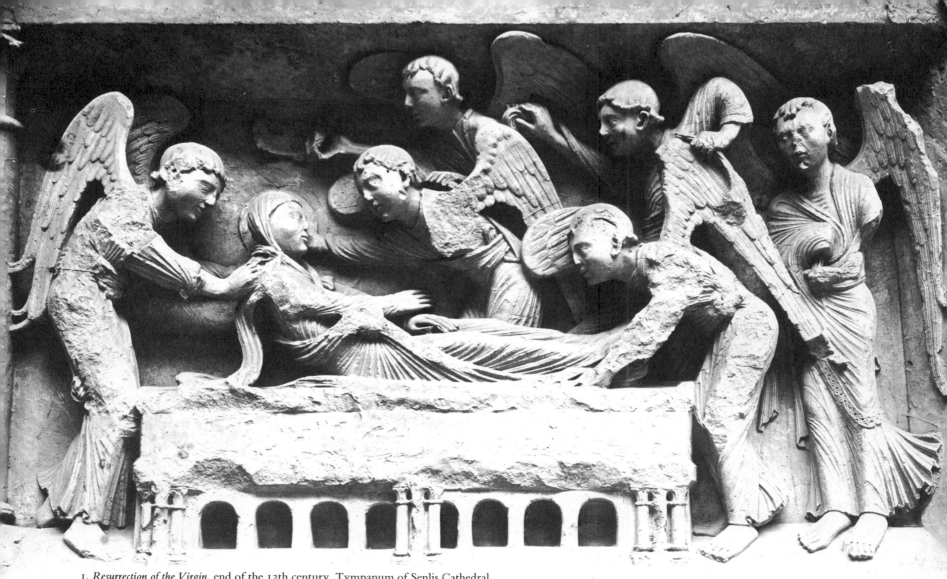

1. *Resurrection of the Virgin*, end of the 12th century. Tympanum of Senlis Cathedral.

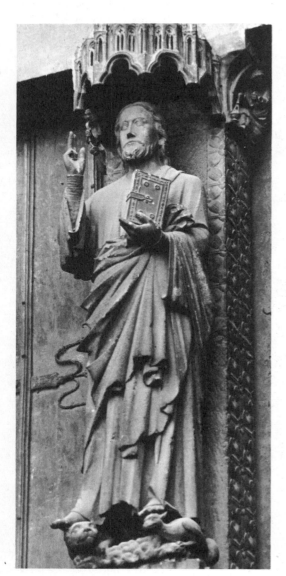

2. *Le Beau Dieu*, 1225–1236. Cathedral, Amiens.

If the sculpture at Chartres still possessed stiffness revealing the influence of Byzantium, the main trend of Gothic sculpture was towards a greater freedom of style. Elsewhere, as in the cathedral of Senlis, sculpture no longer lay closely against the walls, but began to project outwards, as if the figures were detaching themselves from the edifice. Each figure was given its own particular attitude instead of being set into a rigid pattern (1). Other Gothic artists also progressed towards a freer and a more lively and realistic style. The manuscript illustration of a biblical shepherd (3) is still somewhat archaic in its general style, but the scene has some realistic details and a kind of naïve naturalism which is rather touching.

While the other minor Gothic arts were flowering, the cathedral, which had originally been the result of a well-planned solution to set architectural problems, began to evolve in a less happy manner. Ornamentation was carried to such lengths that it began, by its very richness, to overpower the basic structure. The "Beautiful God" of Amiens Cathedral (2) is almost free-standing sculpture, isolated from the building against which it is set. On the south portal of the church is a figure of the Virgin and

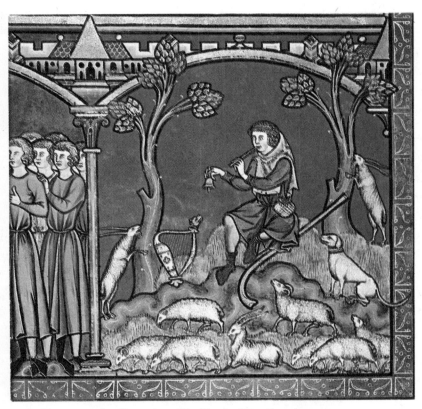

3. Gothic manuscript illustration: *The Shepherd David*, 13th century.

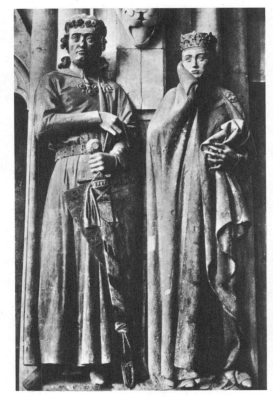

4. *Ekkehart and Uta*, 1250–1260. From the western choir. Cathedral, Naumburg.

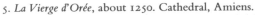

5. *La Vierge d'Orée*, about 1250. Cathedral, Amiens.

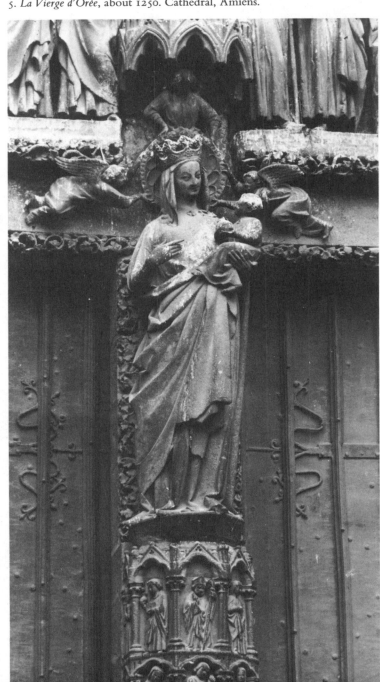

Child, known as the "Golden Virgin" (5). After being shown as a stern and supernatural figure, like the severe St. Foy (page 106), the Virgin was gradually portrayed with gentle features, and, as if to symbolise earthly majesty, crowned like a princess.

The pattern of development found in Greek sculpture from the 6th to the 3rd centuries B.C., was repeated by Gothic artists of the 12th and 13th centuries. At first forms were still and flat, then grew more natural and were presented in a variety of attitudes through which the individual personalities of the artists themselves could be expressed. As a result the great cathedrals of the north are brought to life by a whole host of stone figures such as bishops, kings, queens, prophets and saints. Scenes from the Old and the New Testaments were represented in such profusion that the cathedrals can almost be regarded as "sermons in stone".

This didactic kind of sculpture which we find in the great cathedrals of Chartres, Reims, Bruges and Naumburg (4), led to a vital, new style which affected Romanesque and Gothic sculpture nearer the Mediterranean. In Italy, where the Renaissance was already dawning, it mingled with the remains of the Classical style and can be seen in the work of Nicolas Pisano.

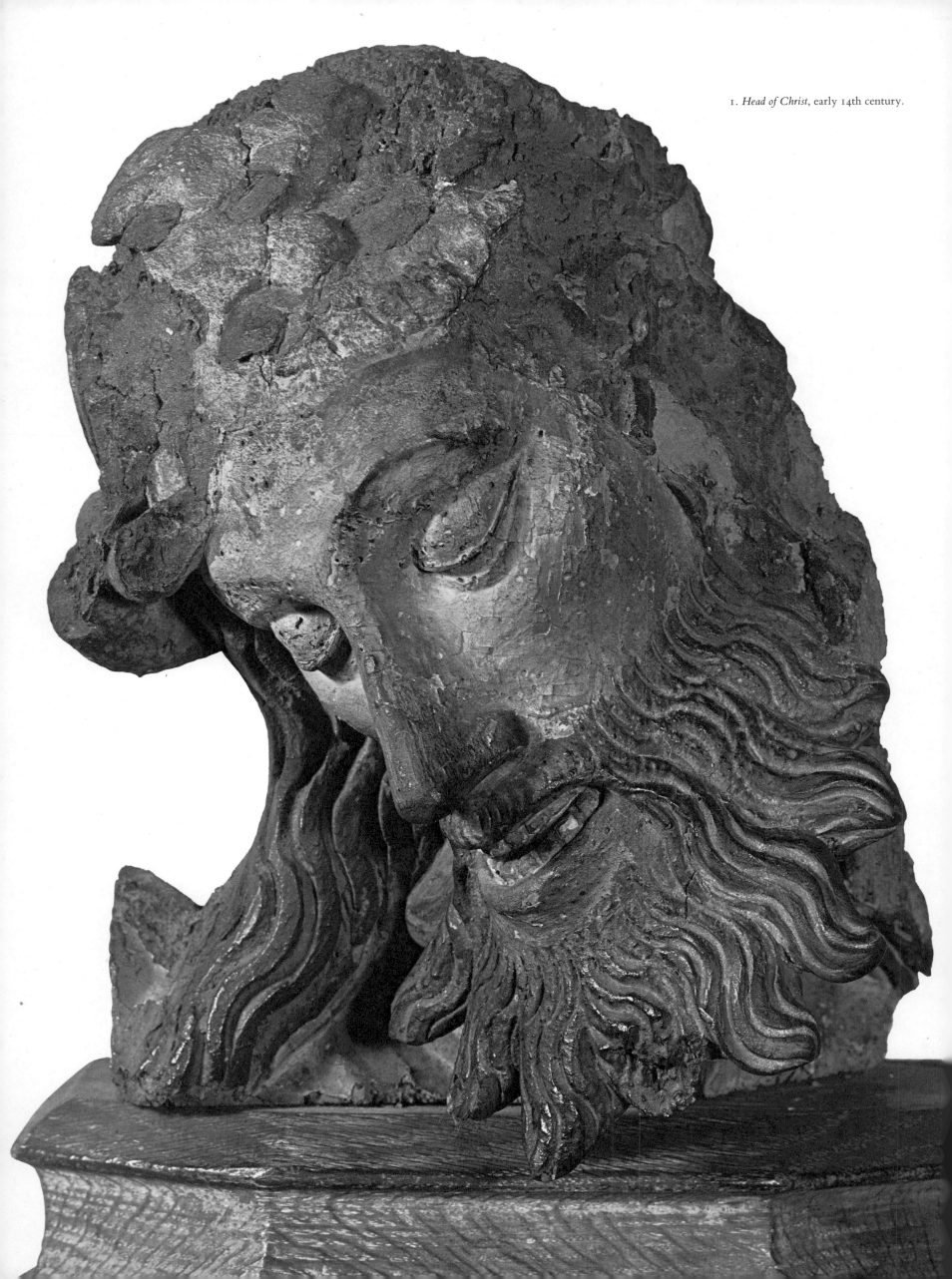

1. *Head of Christ*, early 14th century.

2. *Pietà*, by the Rohan Master.

INTERNATIONAL GOTHIC

Medieval art attained its most splendid climax by the middle of the 14th century. Although Giotto's great mural paintings had opened up a new artistic age at the end of the 13th century, the art of northern Europe remained Gothic both in style and spirit for another hundred years.

The great plague of 1348 brought terror to the whole of the western world and resulted in a strange style which we might now call "expressionist" or even "surrealist". A morbid preoccupation with death, the fear of eternal damnation, and an emphasis on the sufferings and agony of Christ all became new subjects for art and were treated in great detail by both painters and sculptors. Up to the end of the 16th century, particularly in the Netherlands and Germany (see pages 171–175), men's spiritual anguish and fears were reflected in this form of art.

At the same time, there was an upsurge of nationalistic spirit as nations were becoming united. The high courage and sense of pride aroused by the Hundred Years' War were now placed at the service of kings as well as of the Church, and the greatest artists executed their best work to please their rulers. A new relationship grew up between princes and artists and extended beyond the frontiers of each kingdom. The result was a cosmopolitan style in painting, sculpture, and the minor arts, which we now know as "International Gothic". Elegant, mannered and sophisticated, the artists of the Burgundian Court prepared the way for the great court arts that later followed in Flanders, Versailles, and Vienna. But the most daring of the International Gothic stylists were to be found in the Netherlands, for it was they who, in the 15th century, invented oil painting, and who founded the first school of portrait painting (see pages 167–169) in the modern world.

1. Limbourg brothers: *Les très riches heures du Duc de Berry*. Page of the month of March showing the Château de Lusignan, 1416. Miniature.

In the 14th century, one third of the population of Europe died of bubonic plague. The artists reflected the terror inspired by this catastrophe by concentrating on themes like the Crucifixion, very different in spirit from 12th century images of Christ in Majesty. Another theme that made a frequent appearance in art was the Dance of Death in which the figure of death was shown triumphing over commoners and kings alike. This macabre and gloomy spirit lingered on into the 16th century in certain regions, notably Flanders and Germany.

Medieval painting in northern Europe had been confined to the illumination of manuscript pages and the painting of

2. Pontifical of Metz: *Bishop dedicating a church*, 1302.

quam metuendus est locus iste

ue re non est hic aliud nisi domus

et i et por ta celi ps. Bñdictus dñs sum ps et cñ Gloria pñ. Repetendo.

4. *The Wilton Diptych*, by an unknown English artist. Left panel. King Richard presented to the Virgin and Child, about 1395.

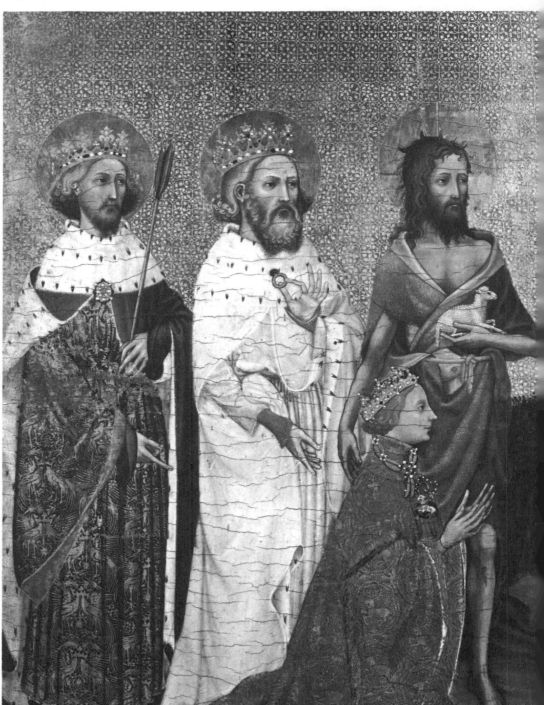

3. French carving: *A tournament*, 14th century.

5. *Unicorn tapestry*, 1509–1513.

frescoes on the walls of churches. Even so, some manuscripts of the time contain illustrations unrelated to the actual text (2). The miniature painters used tiny, pointed brushes and bright pigments made of powdered stones, berries, minerals and shells. They were able to draw graceful limbs and features, and sumptuous brightly-coloured costumes, but they also tried to give an impression of perspective and depth to the flat parchment pages. The miniatures in the *Book of Hours of the duc de Berry* are the size of an entire page, and depict the ladies and gentlemen of the court, as well as scenes of the peasants working outside in the fields (1). All over Europe artists laboured on such elegant, detailed pictures, which had to be refined enough to please their patrons, and ambitious enough to satisfy the miniature painters themselves. When larger pictures began to be made on wood, artists still used the technique of miniature painters. The creator of the Wilton Diptych laid gold leaf upon the wooden panels making them as sumptuous as a Byzantine icon (4), but his real interest evidently lay in the careful detail of the faces and the costumes, displaying in the latter his talent for refined decoration.

The richness and elegance of International Gothic made it the court style of the period, but it was evident also in the minor and decorative arts. Ivory carvers no longer made only stiff little holy figures for the devout, but carved scenes of courtly love and chivalry on boxes, combs and plaques (3). Weavers made great tapestries to cover the walls of the northern castles (5), depicting popular legends and love stories. Some of these patterns, like the "*mille fleurs*" or "thousand flowers" which were woven into the background of the famous French tapestry of the Lady and the Unicorn, show an oriental influence which may have been due to the Crusades. International Gothic and the "expressionistic" style of primitive Flemish painting lasted until the 16th century in Germany and Flanders, but the artists still fitted tiny details of animals, birds and plants into their paintings, even in the horrifying and surrealist nightmares created by Hieronymus Bosch (pages 170–171).

6. *Group of horsemen*, by Master H of the Hours.

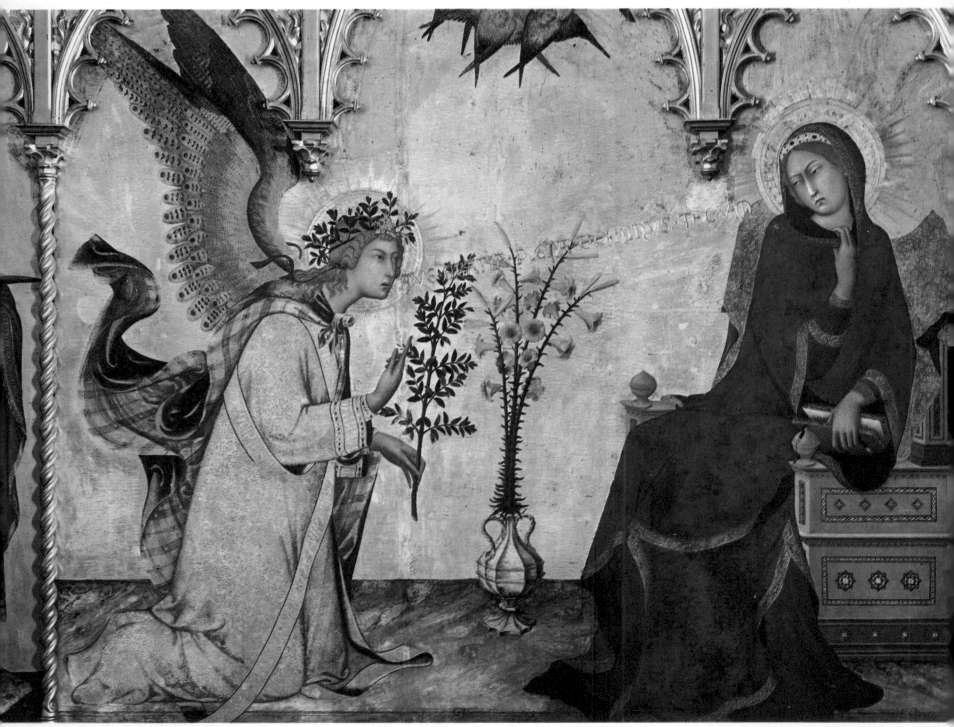

1. Simone Martini: *The Annunciation*.

THE ITALIAN RENAISSANCE
FLORENCE AND ROME

While art in northern Europe gradually developed through the Romanesque and Gothic styles, Italian art took another more independent direction. Italian Gothic painting, sculpture, and architecture had developed characteristic features of their own which took root during the 12th and 13th centuries, and which owed something to Italy's past Classical tradition. Also, the great monastic orders founded in the 13th century and the teachings of St. Francis and St. Dominic gave religious thought a new complexion, substituting the principle of God's love for fear of his divine wrath. While this Italian brand of Gothic art and thought may have foreshadowed much of the humanist

spirit of the Renaissance, it was possible to trace older and more tangible sources. The ruins of Greek and Roman antiquity lay scattered all over the countryside. Although the Germanic invaders had devastated much of it, they had not been able to efface completely the memory and vestiges of Classical civilisation. Moreover, Italy had never been completely cut off from the Mediterranean civilisations of Byzantium and Islam, and her trade had always brought in works of art and even artists from the workshops of the east. All these contacts played an important part in preparing the way for the complex culture of the Renaissance. The true Renaissance was centred on the city of

126

Florence, and the rich and enterprising merchant cities of Bruges and Ghent, in Flanders. Artists began to assert their own personalities in their works, to study anatomy and perspective and to formulate new visual principles based on precise mathematical and geometrical laws.

The three paintings on these pages were made in Siena, a city which was slow to absorb the ideas of the Renaissance. The Greek heritage in Byzantine painting influenced the Sienese artists in the graceful way they delineated the human figure, and oriental traditions lay behind their love of brightly coloured garments and gold-leaf backgrounds. Then, as they learned from their experience and absorbed Florentine and Flemish influences, the Sienese artists gradually came to set their figures into realistic landscapes and to give them a sense of natural movement. The first great master of the Sienese style was Duccio di Buoninsegna (3), who used graceful arabesques and great refinement of line in shaping his figures. The other great Sienese artist was Simone Martini, who had spent a long time at the papal court of Avignon where he had come under the influence of French Gothic art, and in turn, had influenced much of northern Gothic painting during the 14th century. His painting of the *Annunciation* (1), with its gold background, shows the extreme refinement and almost musical harmony of his style.

Another Sienese painter of the same period, but younger than Simone, was Ambrogio Lorenzetti who probably died, like his brother Pietro, in the terrible Black Death that ravaged Europe in 1348. Ambrogio's paintings have a great freedom of narrative expression, as can be seen in his *Allegory of Good and Bad Government* (2) painted as a fresco in the Communal Palace at Siena. His figures express the new emphasis on man as an individual, and on his relationship to the new kind of society that was being created in the city-states.

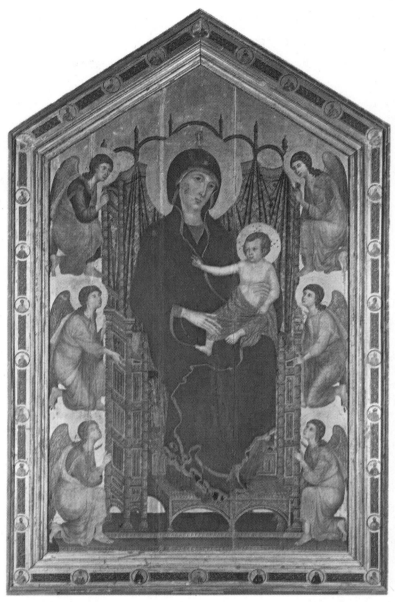

3. Duccio di Buoninsegna: *The Rucellai Madonna.*

2. Ambrogio Lorenzetti: *Allegory of Good Government*, detail. Town Hall, Siena.

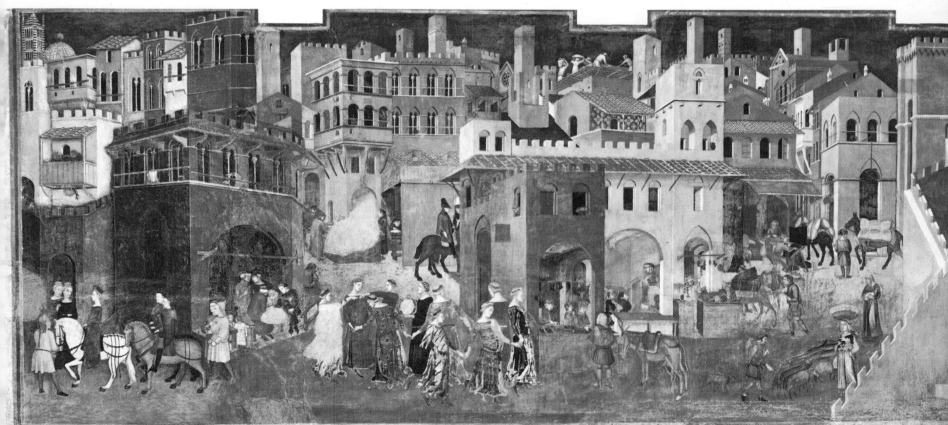

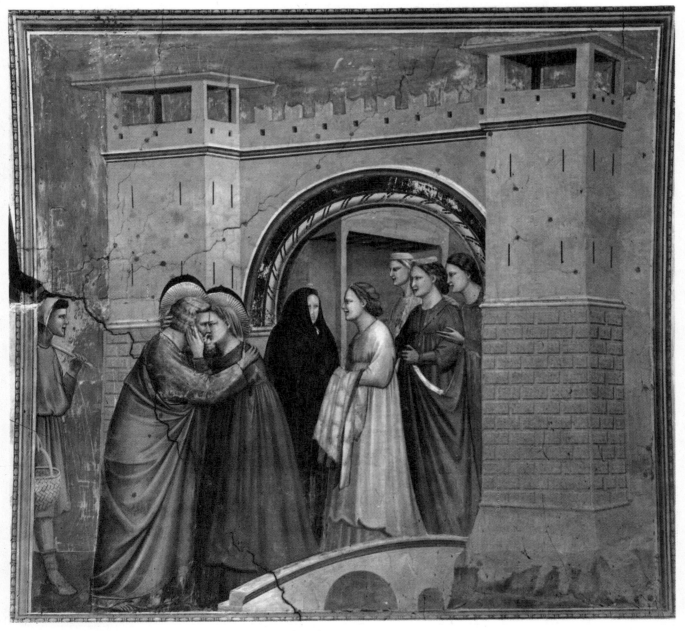

1. Giotto: *Meeting between Joachim and Anna*. Arena Chapel, Padua.

2. Beato Angelico: *The Annunciation*. Cloister of San Marco, Florence.

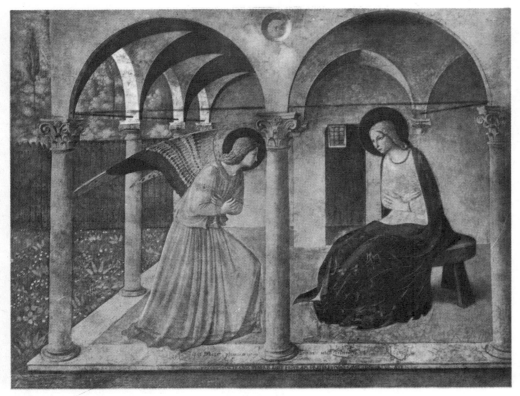

The groundwork for the Italian Renaissance had already been laid by certain great artists of the 12th and 13th centuries, so that one might well say that the artists of the 15th century simply carried to fulfilment what their predecessors had started two centuries earlier. A clear example of this can be seen by comparing Giotto's *Meeting between Joachim and Anna* (1) with the *Tribute Money* by Masaccio on page 130.

We know very little about Giotto except that he was born in Tuscany at Mugelle, that he had learned to look at nature first before he drew, and to study the movements of figures and animals, the way trees grow and hills recede into the distance, and, above all, the relationships between man and his world. He then set out to do what no northern Gothic artist had ever thought of: he tried to eliminate every detail that might confuse his scene, and to create compositions with strong, simple forms, in which man was the dominant element and was given an almost architectonic majesty. He worked at Assisi, in the chapel of St. Francis, where the father superior of the Friars Minor had commissioned him to paint a great series of frescoes to illustrate the life of the saint, and then at Padua in the Arena Chapel where he painted frescoes depicting scenes from the life of our Lady and of Christ, a part of which is reproduced here (1).

These frescoes are vital evidence of the artistic revolution begun by Giotto. They are a complete break from traditional pictorial patterns, for they concentrate all the spectator's interest on the figures themselves, each of which expresses itself powerfully, and is composed with strong, simple masses of colour that give it a kind of monumental quality.

A contemporary of Giotto's was the sculptor Giovanni Pisano, whose figures and compositions (3) have a dramatic violence which seems to anticipate, by two centuries, Michelangelo's style.

The great cathedral, set in the very centre of Florence, seems to lie at the heart of the whole Renaissance movement. Begun in the Italian Gothic style, it took two centuries to complete. In 1334 Giotto was named town architect, with responsibility for supervising part of the construction and also for designing the tall bell-tower inlaid with geometric designs in coloured marble, rising at the right of the cathedral.

The cathedral was completed in 1437 by Filippo Brunelleschi, who planned and directed the construction of the great, eight-sided dome (4). None of his predecessors had been able to devise a way of building a dome vast enough to span the spacious interior. Brunelleschi solved the problem by using Gothic ribs fixed at the base, filling them in with a webbing of brick. Two domed shells of dovetailed bricks were suspended one above the other with iron chains and prop poles and, for extra height, the entire structure was mounted upon an eight-sided "drum" pierced by eight round windows to let in the light.

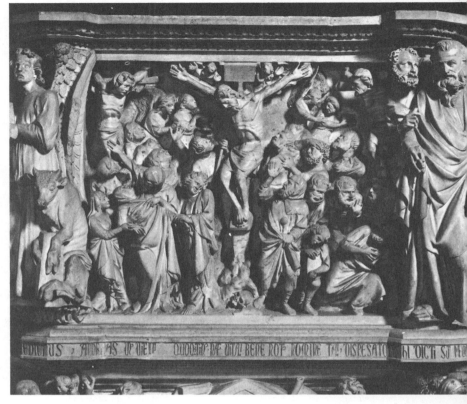

3. Giovanni Pisano: *The Crucifixion*. Painted panel of the pulpit of the church of Sant'Andrea. Pistoia.

4. Filippo Brunelleschi: *Cupola of Santa Maria del Fiore (the Cathedral)*. Florence.

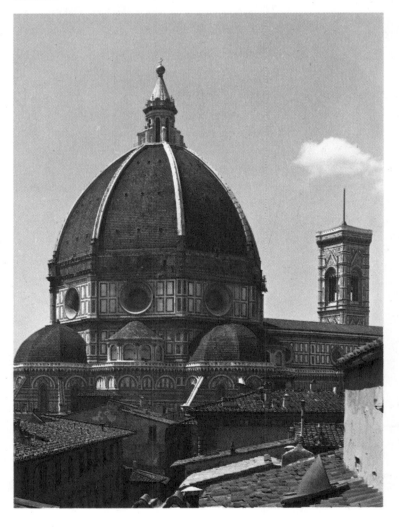

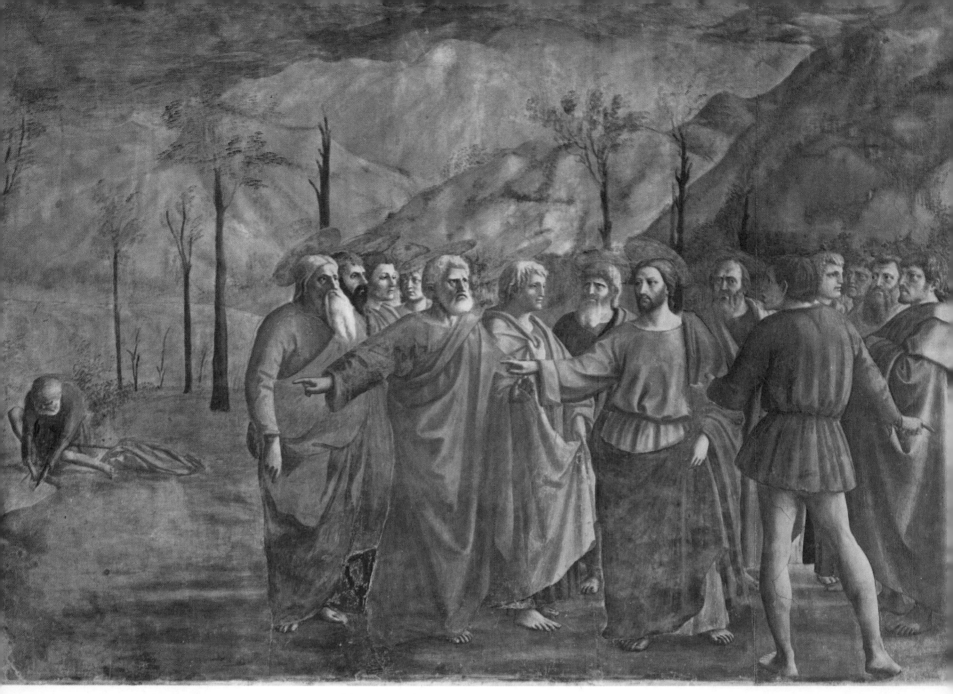

1. Masaccio: *The Tribute money*, 1427. Santa Maria del Carmine, Florence.

A painter who had learned from Giotto's revolutionary style was Masaccio, who followed him almost a century later and painted the frescoes for the Brancacci Chapel in the church of Santa Maria del Carmine at Florence. Even if the actual style of the two artists was quite different, they were alike in the way they both exalted man and his qualities as an individual, and set him squarely at the centre of his environment.

In his painting, *The Tribute Money* of which we reproduce a part here (1), Masaccio has opened up a great space in the centre, revealing the sky and pushing back the horizon into the distance, and has placed his figures firmly in the foreground. Together with the architecture on the right and the great bare expanse of scenery with hills diminishing gradually into the distance, they are linked in exact proportions of perspective and space. Masaccio had learned how to give the illusion of depth by relating figures and scenery in such a way as to guide the spectator's eye into the picture. Each figure is separated from the background and given a three dimensional effect as if it was actually standing in space. The way they form patterns, with their outstretched arms and the sweeping folds of their garments, underlines their relationship to surrounding space and to the scenery behind them.

In 1402 the city council of Florence decided to commission two new doors for the cathedral baptistery. The existing ones had been fashioned by Andrea Pisano who had also taken part in the decoration of the tower. The city councillors now decided that a competition should be held and the commission given to the winner. The competing sculptors were asked to design a trial panel to be cast in bronze. The subject for the panel was the "Sacrifice of Isaac", for this theme not only had dramatic and religious interest, but was a good test of the artist's ability, as it would have to include many objects as well as figures shown in action. Taking part in the contest were Brunelleschi, Jacopo della Quercia, whose trial panel has now been lost, and Ghiberti. The winner was Ghiberti, who then spent the next 21 years working on the doors, and the rest of his life on another pair. They were cast in bronze and then covered with a thin layer of gilt, only recently discovered after the doors had been cleaned. All his work was carried out in Ghiberti's workshop, where he was aided by many apprentices and pupils. When he had finished his life's work there was hardly one Renaissance sculptor who had not worked with him in his studio.

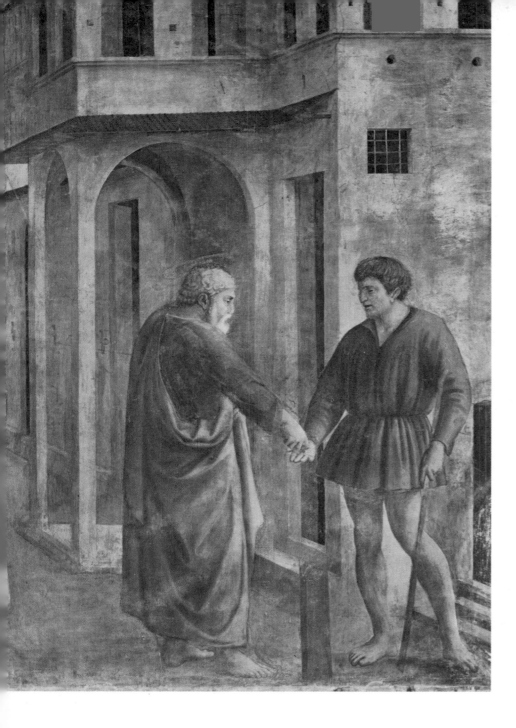

2. Filippo Brunelleschi: *Sacrifice of Isaac*, 1402.

3. Lorenzo Ghiberti: *Sacrifice of Isaac*, 1402.

Compare Ghiberti's winning panel for the baptistery doors (3) with the panel by Brunelleschi (2), who was later to become one of the outstanding architects of the Renaissance. Both panels reflect elements of Gothic style, for each scene is set within a quatrefoil and arranged rather like a manuscript illustration. Within this frame each artist approached his problem differently. Brunelleschi seems to have considered each figure in isolation from the others, whereas Ghiberti tried to co-ordinate all into one harmonious design. Moreover, he achieved something that none of the others had attempted, namely, to cast each scene in a single piece of metal. In attempting this difficult feat Ghiberti had to study carefully the composition of each scene, making every subject flow into an adjacent one so that parts would not break off in the casting. When, years later, he designed the so-called *Gates of Paradise* (4), Ghiberti dispensed with the constricting medallion framework, considering each panel as a pictorial composition in bronze.

"I tried to imitate nature", Ghiberti explained, "to understand how objects strike upon the eye. These, I modelled upon different planes, so that those nearest the eye might appear larger, and those more remote, smaller in proportion."

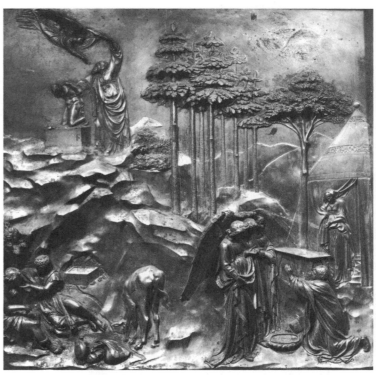

4. Lorenzo Ghiberti: *The story of Abraham*. Detail from the Gates of Paradise. Baptistery, Florence.

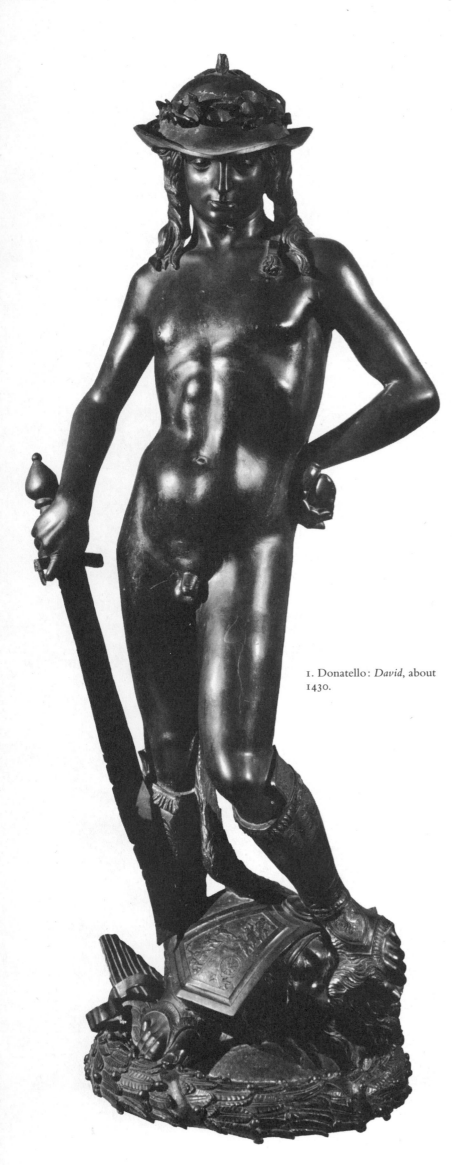

1. Donatello: *David*, about 1430.

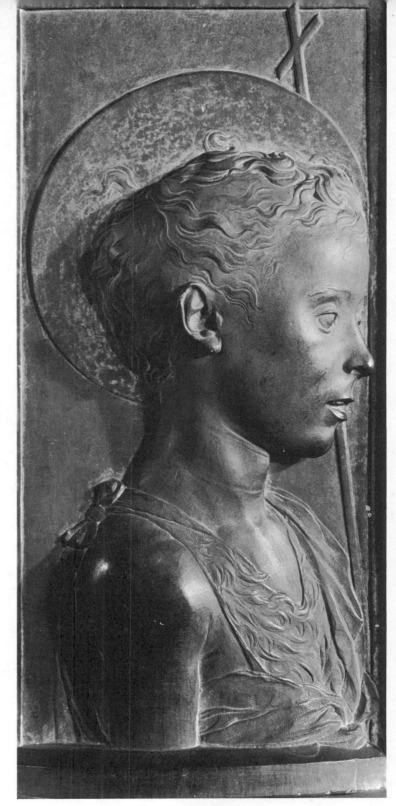

2. Desiderio da Settignano: *The young St. John*.

The works on these pages show how Renaissance sculpture evolved from the work of Donatello, with all its youthful vigour, to the self-assured and mature works of such great artists as Pollaiuolo, Verrochio, Desiderio da Settignano and Luca della Robbia. In his figures Donatello showed that he had advanced the study of the structure of the human body and the laws of physical movement. With his friend Brunelleschi he went to Rome, where he studied the statues and the ruins of the Classical city. People called the two young artists the "treasure seekers", thinking that they were looking for ancient Roman coins. In their way Donatello and Brunelleschi were the first Renaissance archaeologists, and their discoveries gave impetus to the stylistic innovations that followed.

Donatello's figures are rather delicate and their youthful bodies seem to radiate intense but restrained energy. Many of his subjects were young legendary heroes. His statue of *David* (1) was the first free-standing nude sculpture to be made in the west

since antiquity. The figure originally stood on its own in the courtyard of the Medici Palace. With his *Gattamelata*, which is still standing in the centre of Padua, Donatello created the first equestrian statue to be made in Italy since the figure of Marcus Aurelius in ancient Rome (see page 54).

After Donatello, Florentine sculptors experimented with various ways of representing the human body. Some, like Desiderio (2), carved such delicate features that the surface of the marble seems to have been only barely chiselled with a feather-like touch. One of the most famous of his followers was Luca della Robbia. He invented a way of coating clay figures with glazes made of a secret blend of molten glass and tin oxide. His greens, blues and whites not only gave the fragile clay greater strength but also, an air of lively reality. Many members of the della Robbia family worked together in the same studio, and commissions came in from all over Tuscany.

By the end of the 15th century, artists had mastered the technique of casting in bronze. Now they were able to tackle difficult problems of pose and dramatic personality. Pollaiuolo spent his life studying the human body, both in action and in highly contorted positions, when it was out of balance or strained at the moment of greatest tension. The small bronze group (3) depicts Hercules defeating his enemy Antaeus, by lifting him off the earth from which his great strength was derived. A similar vigour of composition can be seen in Verrochio's *Colleoni* (4) with its vibrant, powerful character.

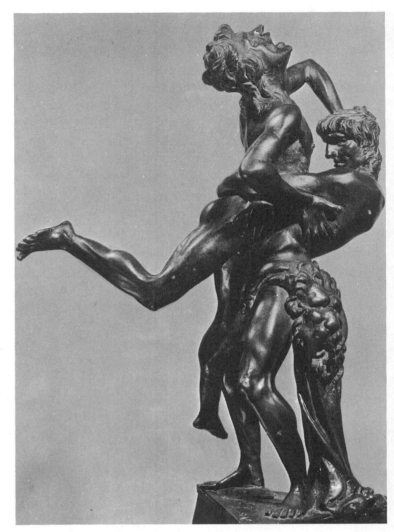

3. Antonio Pollaiuolo: *Hercules and Antaeus*.

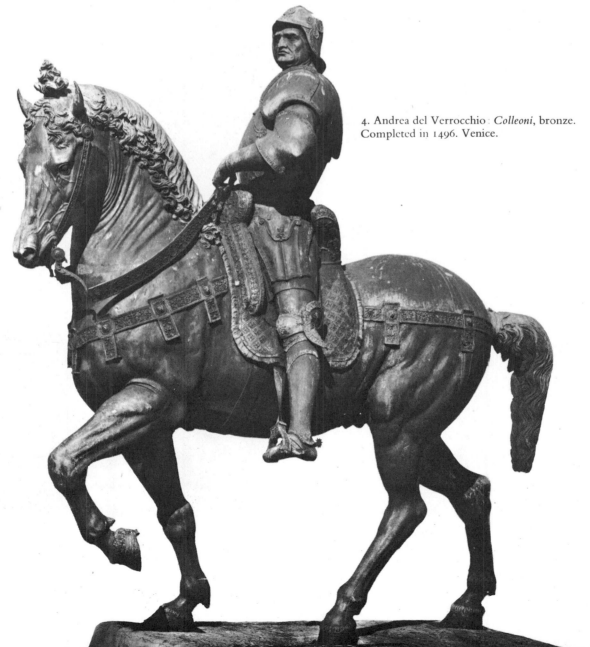

4. Andrea del Verrocchio: *Colleoni*, bronze. Completed in 1496. Venice.

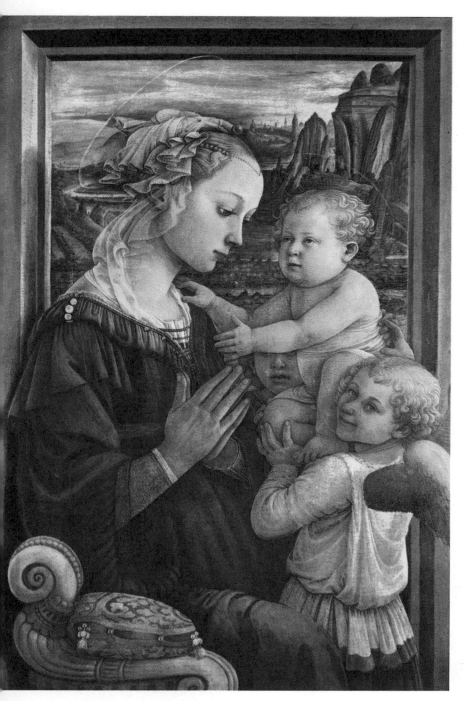

1. Filippo Lippi: *Madonna and Child with the young St. John.*

For a long period both Florence and Central Italy produced some of the greatest and most elaborate works of art ever seen in the history of mankind. Florence generated a movement that exalted every faculty of the spirit, especially in the sphere of art, and which was to permeate and influence profoundly the development of the whole of western European culture.

The works on these and the following pages illustrate different aspects of Renaissance painting during the 15th century. Like his contemporary, Donatello, Masaccio had opened a new road for succeeding artists to follow, creating images that seem to symbolise the spirit of the early Renaissance. The postures and expressions, the solidity of the bodies and the filmy atmosphere of the backgrounds gave Masaccio's pictures a dramatic force and intensity. His figures have something of the quality which was later developed by Michelangelo—a consciousness that art and man were both on the threshold of a new age.

Filippo Lippi's paintings have a different spirit, for the style is more linear and calligraphic. His compositions are not as three-dimensional and his elegant, formal figures have a religious feeling and a serenity which belong more to the past (1). Italian painters following Masaccio made a closer study of technique. They sought to bring out the individual personality in their portraits, and in great, complicated compositions in which they evolved a new language of painting and a new approach to the representation of space. With the rise of a powerful merchant class who could vie with the nobles and the courts, there was a growing demand for portraits. In the early Renaissance, these were usually painted in profile, like faces on coins, as in the portrait by Uccello reproduced here (2). Later, however, full face portraits became generally popular. Uccello also painted great hunting and battle scenes (pages 136-137) in which he gave his lively imagination free rein, and came to grips with complicated problems of composition and space. In his *Battle of San Romano* the lower half of the painting is filled by a crowd of struggling men and horses whose lively colours and striking attitudes show something of the artist's fertile, poetic imagination. The towering lances serve to divide the composition into an upper part where all is serene and peaceful, and a

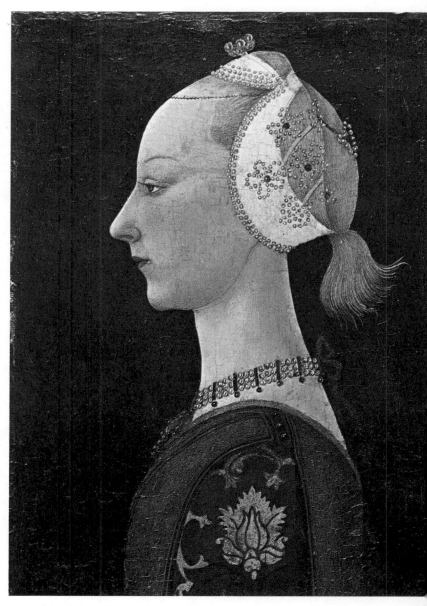

2. Attributed to Paolo Uccello: *Young Lady*, 1450.

lower part where all is noise and confusion, stressed by the mighty, prancing horse in the foreground.

Paolo Uccello was fascinated by the problem of perspective and the geometry of objects. Some of his drawings, and in particular, his magnificent frescoes in the cloister of Santa Maria Novella at Florence are striking examples of the way he experimented to obtain three-dimensional effects. Uccello was one of a great company of Florentine artists of the 15th century who struck out boldly in new directions and who regarded man as the true centre of the world. In their works the human figure is given a prominence unknown since the time of Classical Greece. Energy and audacity are exalted, and, instead of humble religious feeling, it is physical beauty that is stressed. Architecture also followed the great examples of Classical Greece and Rome, and was designed to express man's relationship to well-ordered space.

Like his sculptures, the paintings of Antonio Pollaiuolo, display his ability to represent fast movement and physical exertion. The painting below (3) shows the Greek nymph Daphne, at the very moment of her transformation into a tree in order to escape from the god Apollo. By catching the figures in violent

4. Luca Signorelli: *Stories of the Anti-Christ*, detail. Cathedral, Orvieto.

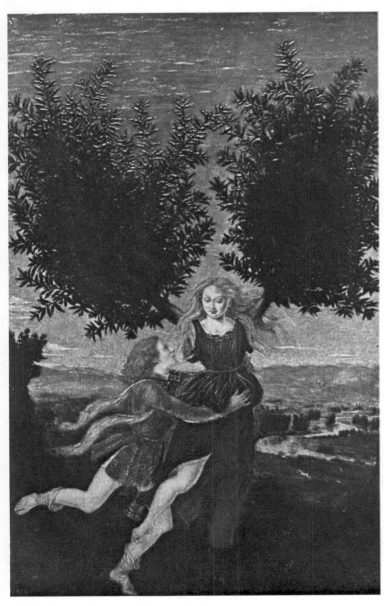

3. Antonio Pollaiuolo: *Apollo and Daphne*, 1475.

action Pollaiuolo was able to heighten and intensify tension and movement. Yet even this scene is more romantic and lyrical than most of his other works, for behind the fleeing figures a gentle river-bound landscape stretches dreamily into the distance. Only a few years separate his painting from Uccello's, yet it is evident that a great change in the style of landscape painting has already taken place.

Luca Signorelli was influenced by Pollaiuolo's work, and his great series of frescoes depicting the Day of Judgment are full of human bodies caught in every conceivable expression of agony and fear. In this detail from the frescoes (4), Signorelli has surrounded the man in the centre with a crowd of figures all with different expressions and attitudes, creating a dramatic, interlacing pattern across the composition. His figures have something of the expressive, violent quality of those of Pollaiuolo, combined with the sense of sturdy power found in Donatello's sculptures.

Paolo Uccello: *The battle of San Romano*.

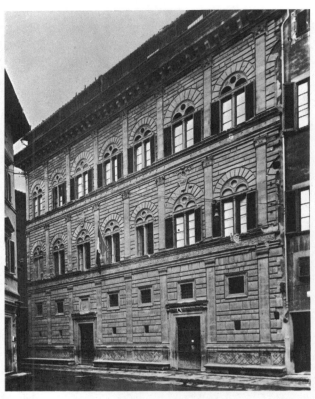

1. Botticelli: *Dante and Beatrice leaving Purgatory*. Illustration to Dante's *Divine Comedy*. 1492-1497.

2. Leon Battista Alberti: *Palazzo Rucellai*, 1444-1459. Florence.

The artists of the Italian Renaissance were encouraged and subsidised in Florence and other cities by powerful noble families or wealthy merchants. The ruling family in Florence was surnamed Medici, of which the two greatest members were Cosimo, known as the "father of his country", and Lorenzo, "The Magnificent". Their portraits are reproduced on the facing page, carved in relief upon large bronze medallions resembling Roman coins (3, 4).

L. B. Alberti's Rucellai palace at Florence (2) could almost be taken as the symbol of Renaissance architecture. It is composed of three stories, divided horizontally by cornices and vertically by pilasters, with the capitals of all three Greek orders: Doric for the ground storey, Ionic for the centre, and Corinthian for the top storey.

The Medici palace was the cultural and artistic centre of Florence. It was a meeting place for artists and scholars. Under the patronage of Cosimo art and science began to flourish. When Constantinople was captured by the Turks in 1453, many Greek scholars and philosophers fled to Florence, where a special Academy was established to encourage the study of Greek and Roman art and philosophy. Out of this revived study of the Classics sprang the intellectual movement known as humanism. It gave rise to a sense of common fellowship among scholars and writers which spread everywhere, giving a new spirit to political institutions, education, and the general tenor of life. Although the humanists were always devout Christians, their attitude towards life and art was fresher and more natural than that of medieval man.

At Florence, splendid festivals and pageants based on Classical myths were held with the help of the artists of the Medici circle, who designed scenery and costumes, and the floats for processions. An impression of these pageants has come down to us in some of the paintings of Botticelli. His *Birth of Venus* (pages 140-141) and *Pallas and the Centaur* (6), may well be based on scenes in the pageants illustrating these myths. Botticelli's style at Florence was outstanding for its refinement and almost feminine delicacy. In his drawings to illustrate Dante's *Divine Comedy* his line is as lyrical and sensitive as the brushstroke of a Chinese artist (1).

Humanist art and culture reached their zenith in Florence under the rule of Lorenzo de' Medici, himself a poet and scholar. But there were many who disapproved of the festivals and the splendid paintings, sculptures and costumes. Such a painting as Botticelli's *Primavera*, which showed the coming of spring in the guise of a Greek nymph passing through a grove, seemed too pagan for their tastes. With the year 1500, superstitious people again feared the coming of the Last Day, and preachers inveighed against the new paganism of the Renaissance, with its representations of the nude, its nymphs and gods of Classical mythology. The most fanatical of these preachers was Savonarola (5). In 1497, the Florentines were so aroused by his sermons that they heaped their art treasures and costumes—branded as "vanities" by Savonarola—into a great heap, which was burned before the assembled people. Thus perished many great paintings and sculptures by Renaissance masters, together with wigs, rouge, false beards, jewels, mirrors, furniture and rich brocades. Although Savonarola himself soon followed his "vanities" to the stake, his violent words seemed to endure. The Florentine Renaissance was over; limits were again set to the free expansion of the human spirit, and a new age in art and ideas began.

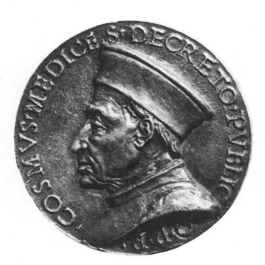

3. Florentine medal with portrait of *Cosimo il Vecchio de' Medici*, about 1464.

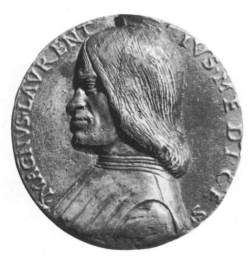

4. Florentine medal with portrait of *Lorenzo the Magnificent*, 1490. Attributed to Niccolo Fiorentino.

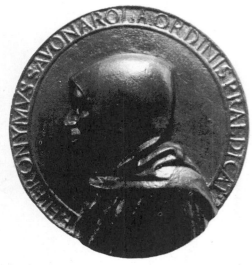

5. Florentine medal with portrait of *Savonarola*, about 1496.

6. Botticelli: *Pallas and the Centaur*.

Botticelli: *Birth of Venus*.

The history of art throughout antiquity and the Middle Ages depends mainly on works which are either anonymous or are the result of collaboration between groups of artists. But after the 15th century, the history of art becomes the story of great individual masters and their achievements.

Their inventions and discoveries continued to contribute to the evolution of styles in western art and to open up vast new horizons to succeeding artists, but it is their separate and personal styles which stand out. This great flowering of individual genius began as the 14th century came to its

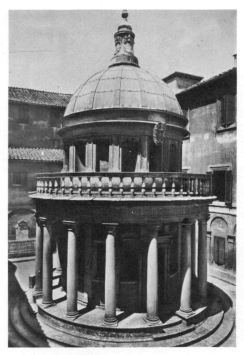

2. Bramante: *Tempietto*. San Pietro in Montorio, 1502.

end. With the Renaissance the time had come for the great artist to assert his personality through his own unmistakable style. The chief characteristics of the early Renaissance at Florence were a spirit of experiment and adventure, and the exaltation of man as a hero both in his own time and in their vision of the past. Yet there was also another side to the Renaissance, especially evident in the works of Piero della Francesca, Bramante and Raphael. All three artists showed themselves capable of assimilating the many cross-currents of thought and new ideas that underlay their age. They were born in Umbria in the very heart of central Italy, and the golden sunlight and misty atmosphere of the region seems to have penetrated into their art. Piero worked in several Umbrian cities and in Tuscany, while Bramante followed by Raphael came to Rome after working in several other cities.

Piero della Francesca was a painter, theoretician and mathematician. He wrote a scientific treatise on perspective and studied the physical laws governing light, for he was fascinated by the way light fell on objects. He isolated his figures in space with all the clarity and precision of a sculptor cutting stone, giving them smooth, firmly defined surfaces which had something of the solemn and impressive quality of architecture bathed in

1. Raphael: *The Marriage of the Virgin*, 1504.

the light of the Mediterranean sun.

The duke of Urbino, Federico da Montefeltro, was a patron of the arts in his own city, as were the Medici in Florence. He commissioned Piero della Francesca to paint the four panels of a diptych, in celebration of his marriage. One side of the diptych had portraits of the duke himself (3), and his wife Battista Sforza, while the other showed the couple seated on thrones in bridal chariots, in an allegorical representation of their triumphal progress.

Piero della Francesca's *Solomom and the Queen of Sheba* (pages 144-145) is one of the most striking episodes in his great cycle of paintings for the "Story of the Cross" in the church of San Francisco at Arezzo.

Bramante was both painter and architect and built the simple little *tempietto*, or temple, at Rome on the very spot where, according to tradition, St. Peter was crucified (2). Bramante made use of the simplest elements of Classical architecture—the column and lintel—but in a new way. The temple has a colonnade of simple "Tuscan" Doric columns without any adornment, supporting an upper floor with a balcony on a Classical architrave, and is crowned with a small dome. In its simplicity and dignity the *tempietto* seems to symbolise all the balance and restraint of humanist thought. Four years later Bramante was summoned by pope Julius II to design a new plan for St. Peter's which was to replace the early, primitive basilica built in the time of Constantine (see page 60). Bramante's design, altered later by Michelangelo (see page 150), was shaped like an enormous Greek cross with, at the centre, a great dome supported on massive piers.

Italy and the rest of Europe underwent great political changes during Bramante's lifetime. By the end of the 15th century Florence fell victim to serious internal disorders and power became concentrated in the papacy at Rome. Bramante, Raphael, and the Italian artists who followed them, all worked for the popes and the great Roman families, and became the artistic interpreters of the new con-

cept of papal magnificence and power.

Raphael was chiefly a painter, but was also the architect of several great Roman buildings. In his youth he had studied at Perugia under Perugino, and in some of his own paintings Raphael recaptured his master's sense of a serene and well-balanced world of the past. In the painting reproduced (1), the gentle figures balance one another in a harmonious, symmetrical compo-

sition. This panel was one of the artist's earliest works, painted when he was only twenty-one. In his later period his style became richer, when he painted his famous Madonnas—the *Sistine Madonna*, the *Madonna of the Meadow*, the *"Belle Jardiniere"* and many others. Still later, he painted the imposing series of frescoes in the "chambers" of the Vatican palace (pages 146-147).

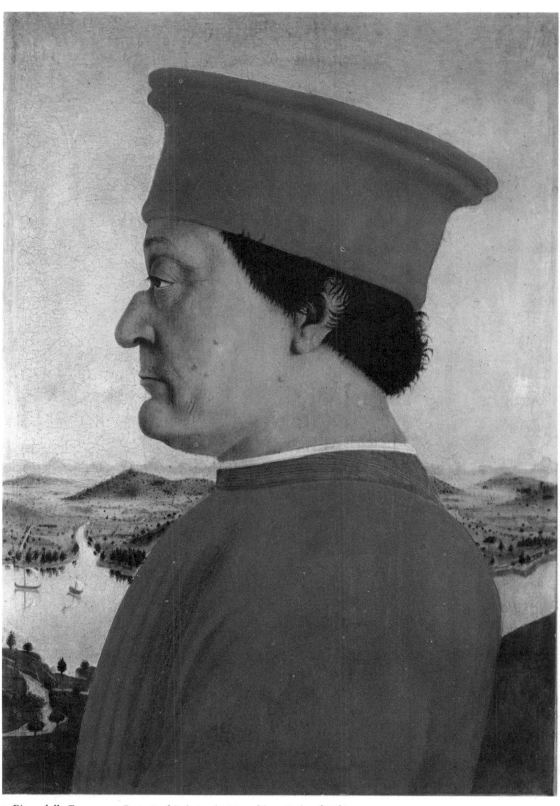

3. Piero della Francesca: *Portrait of Federico da Montefeltro, Duke of Urbino.*

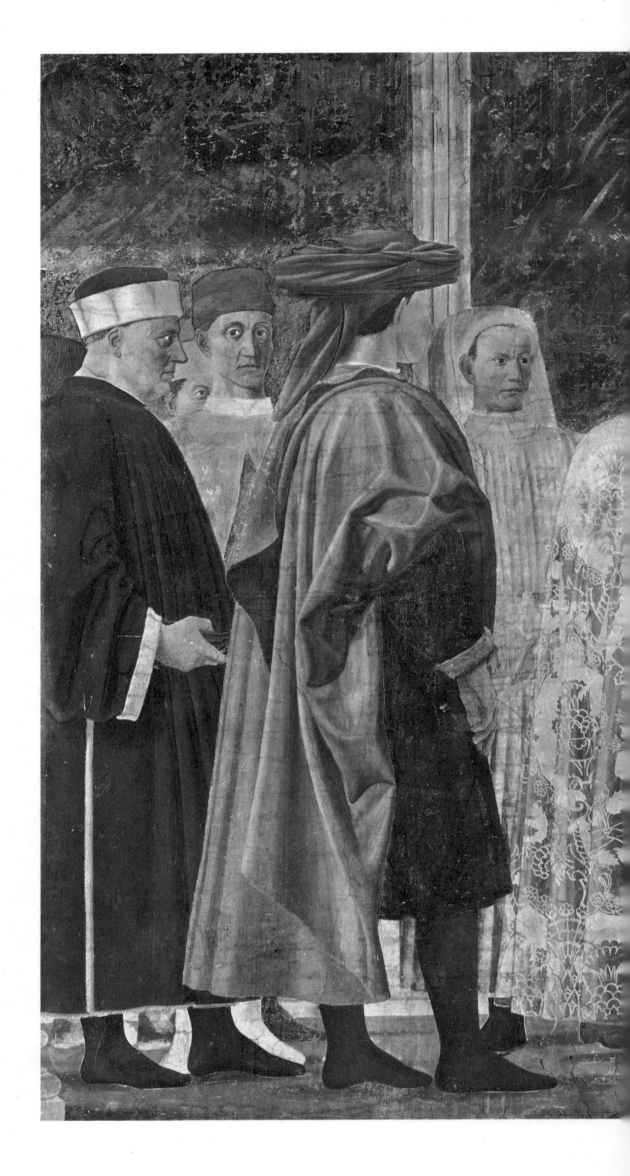

Piero della Francesca: *Meeting between Solomon and the Queen of Sheba*. Church of San Francesco, Arezzo.

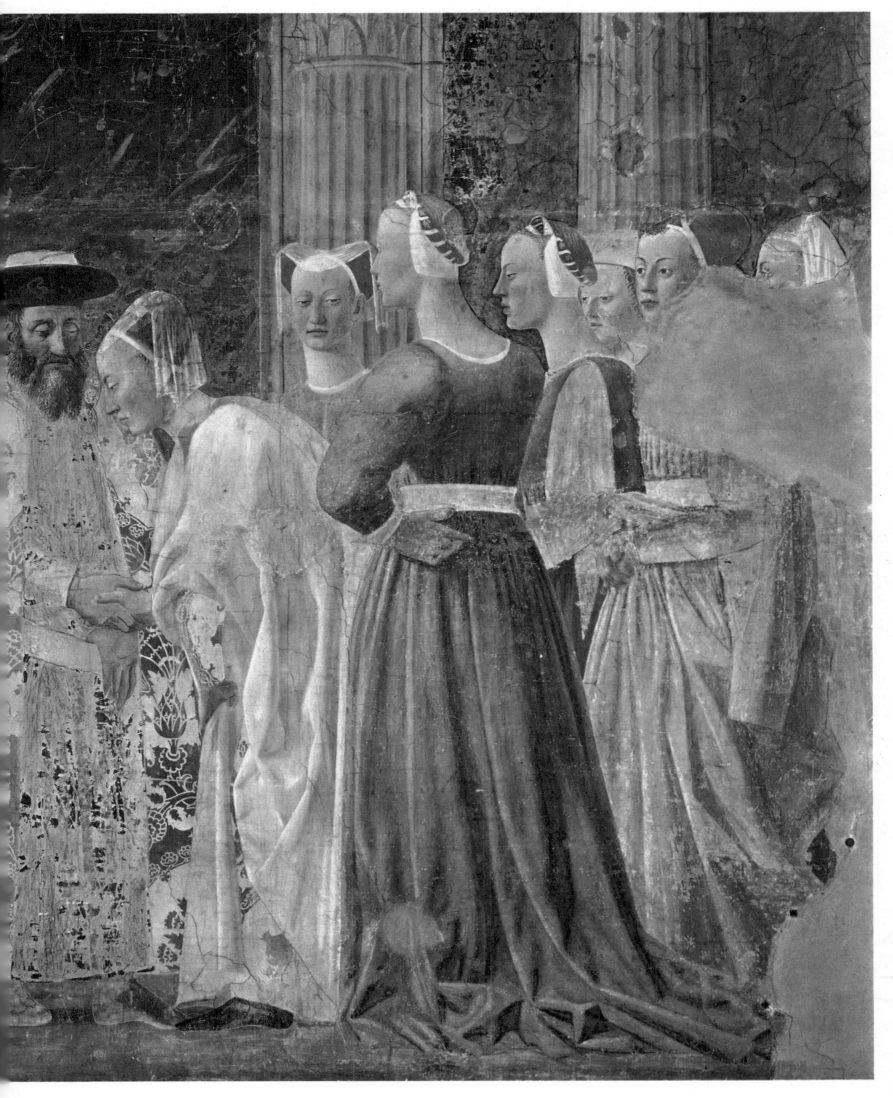

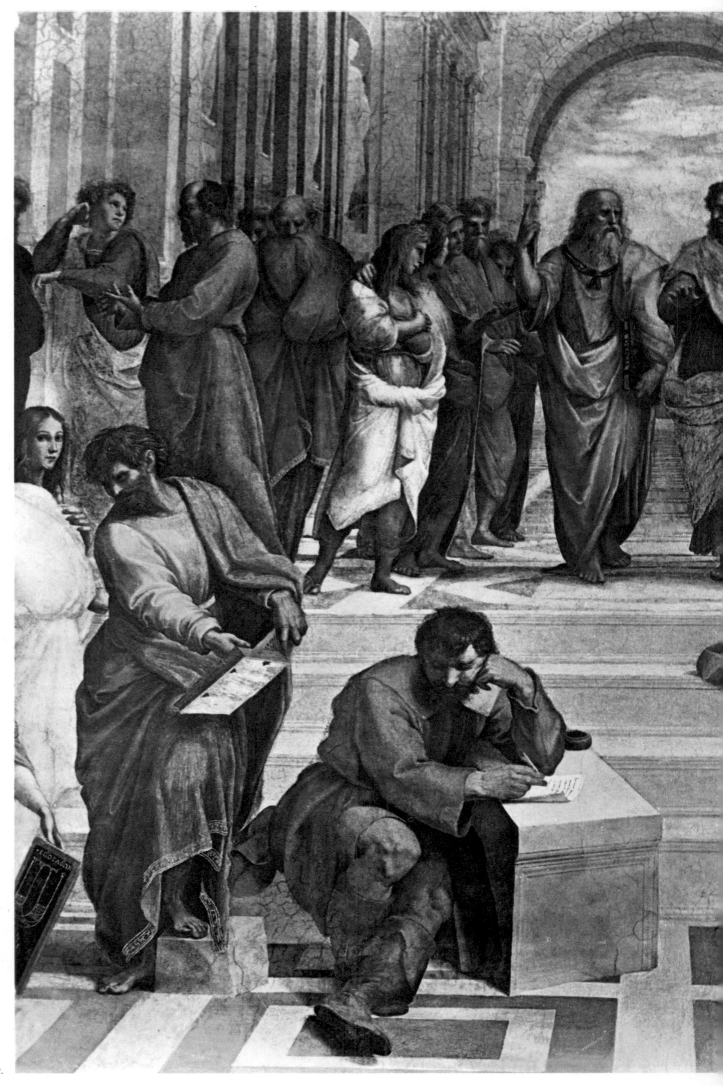

Raphael: *The School of Athens.*

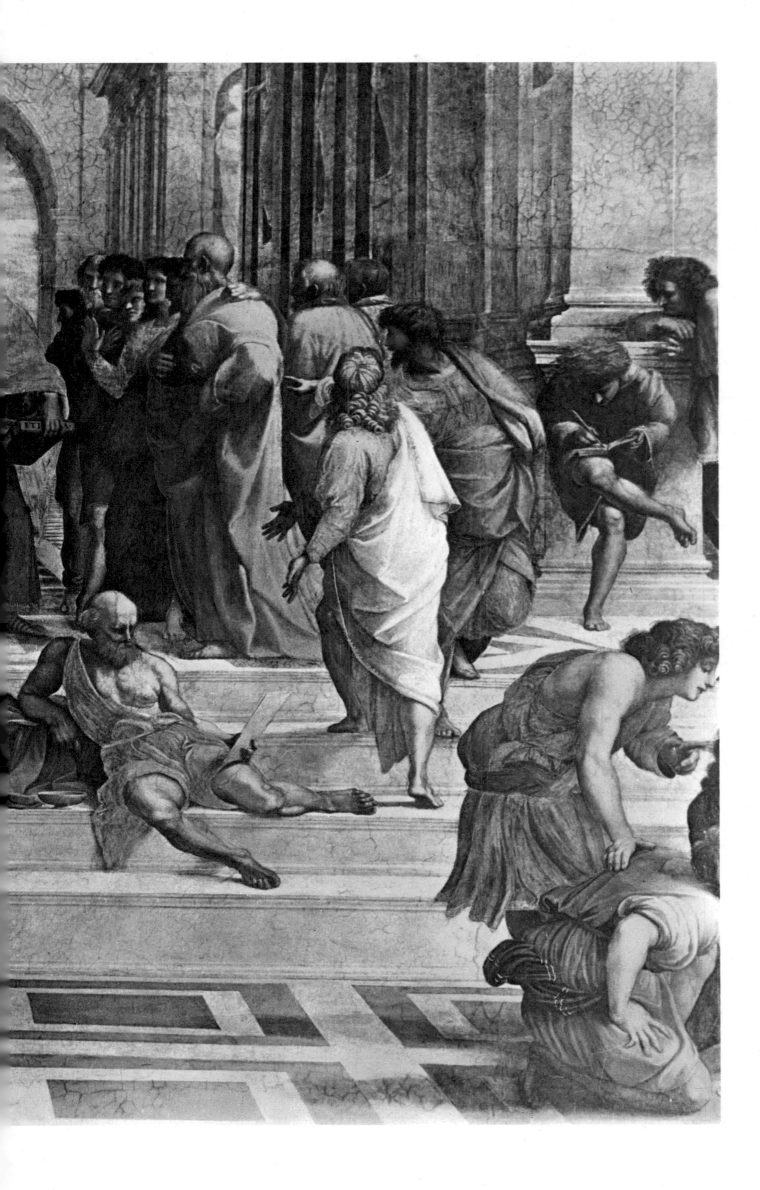

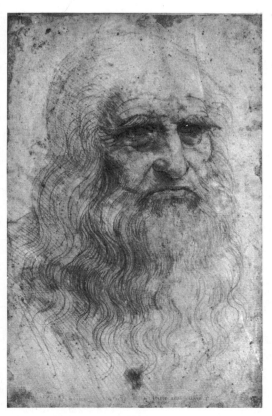

1. Leonardo da Vinci: *Self-portrait*, about 1512.

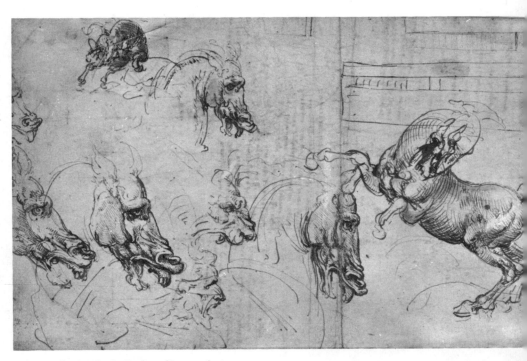

3. Leonardo da Vinci: *Studies of horses*, about 1504.

With the works of Leonardo da Vinci and Michelangelo, the Renaissance entered into a new phase. Both these artists were unsatisfied with any one commission or patron, and moved restlessly from place to place, showing their profound anxieties in their art. The whole structure of the universe seemed to be changing. Far away in Poland, the astronomer Copernicus made the disturbing discovery that the earth was not the centre of the universe. From Italy, Spain and Portugal, great ships sailed westwards into uncharted waters. In his search for the Indies Columbus crossed the Atlantic to discover America in the very year that Lorenzo the Magnificent died. He was soon

2. Leonardo da Vinci: *The Virgin of the Rocks*.

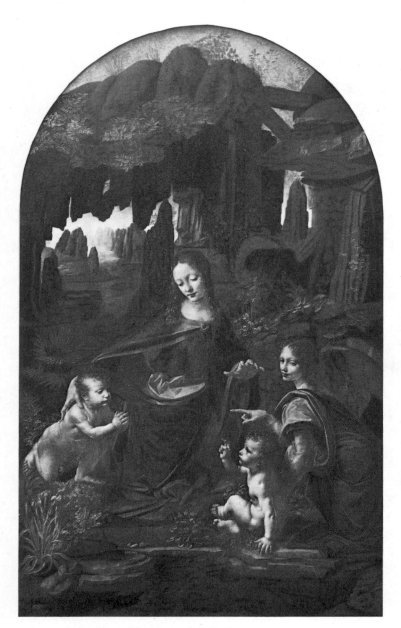

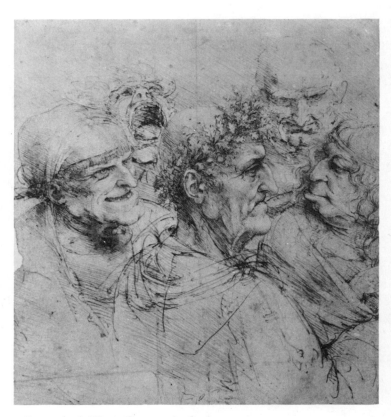

4. Leonardo da Vinci: *Grotesque heads*, about 1490.

148

followed by Cortez, Balboa, Pizarro and Magellan, whose ships came back carrying strange statues of unknown gods and amazing treasures. In every direction, the limits of the known and the safe seemed to be breaking down. "Tell me," Leonardo wrote at the time, "can anything ever really have an end?"

Leonardo was trained as an artist in the Florentine workshop of Verrochio, later moving to Milan and Rome, before finally settling in France at the court of Francis I where he died. He spent all his life drawing, painting, sculpting, designing machines and planning cities. He was interested in everything: he peered through magnifying glasses to observe the growth of plants and the structure of leaves, he watched storms and floods, and the growth of the human foetus in the womb (7). He studied natural phenomena everywhere and filled notebooks with his observations, but everything he saw only increased his sense of uncertainty. Man, above all, fascinated him, as a thinking being made of corruptible matter, and therefore destined to perish, leaving only his thoughts and his works behind him. Leonardo observed that things grow, transform themselves, change and then wither away. Most of his great paintings mirror his disquiet: the clear, sun-bathed atmosphere of early Renaissance painting gave way to a veiled, dusk-like, shadowy atmosphere, called "*sfumato*" because of its smoky effect to the eye. After Leonardo's death other painters made use of this technique in order to create a mysterious, disturbing effect.

Leonardo rarely brought his works to completion, but their unfinished quality was generally limited to their surface technique only, for their visual impact was always successful and powerful in expression. Many Italian painters after Leonardo tried to copy his gentle, graceful lines, the shadowy texture of his flesh and the tones of his draperies, but without his genius they only achieved a cold and empty "Leonardesque" manner.

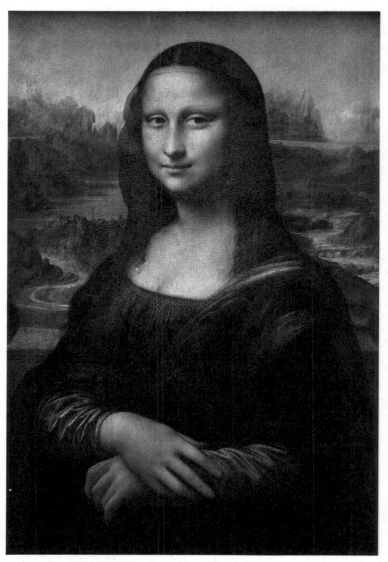

6. Leonardo da Vinci: *La Gioconda, or "Mona Lisa"*.

7. Leonardo da Vinci: *Study of an embryo*, about 1512.

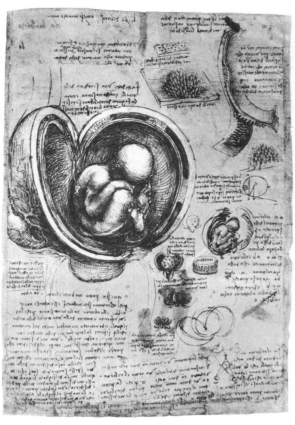

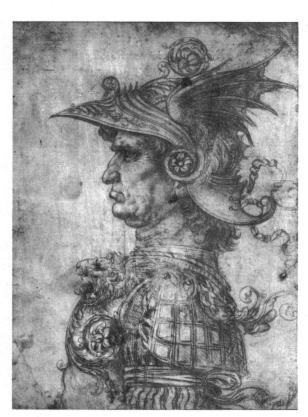

5. Leonardo da Vinci: *The Condottiere*, about 1480.

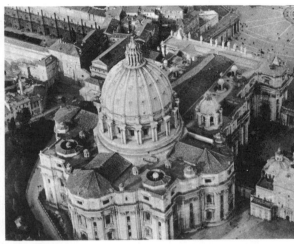

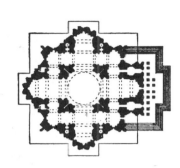

1. Michelangelo: *Cupola of St. Peter's*, Rome, and his ground plan, 1546-1564.

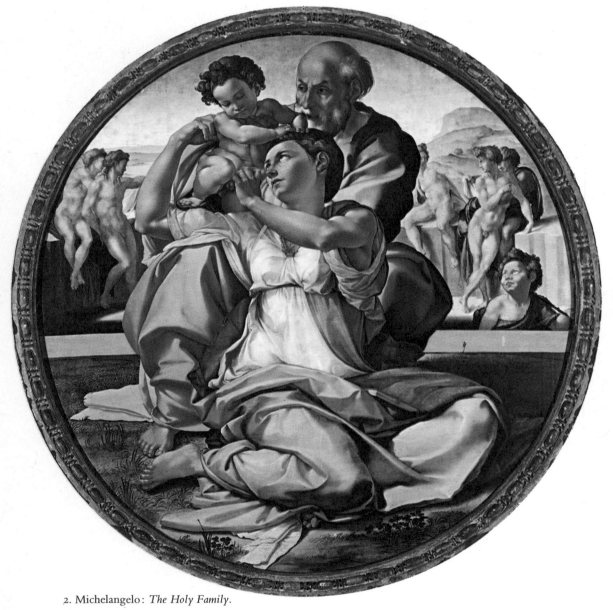

2. Michelangelo: *The Holy Family*.

Michelangelo was primarily a sculptor, and even when painting, he gave to his figures a monumental and three-dimensional plastic quality. His style can be seen at its most characteristic in his vast series of pictures commissioned by pope Julius II for the decoration of the ceiling of the Sistine Chapel in the Vatican (pages 152-153). The Chapel had been built by pope Sixtus IV in 1480, and the famous frescoes on its walls had been painted between 1481 and 1483 by various masters, including Botticelli, Signorelli and Perugino—Raphael's own teacher. Michelangelo began his task in 1508. In order to reach the barrel-vaulted ceiling he had a network of scaffolding constructed with a platform on which he lay to paint. He painted the entire ceiling of the Chapel—lying in this uncomfortable position.

Michelangelo divided the surface area of the ceiling into triangles and rectangles before tracing the outlines of his human figures. The ceiling of the chapel is divided into nine principal panels illustrating the stories of the Creation, the Fall, and other biblical episodes down to the Flood.

The Sistine frescoes are a work of Michelangelo's first mature period and the superb mastery of technique they display is found in even earlier works, as in the sculptured *Pietà* in St. Peter's, Rome (3). Later, Michelangelo deliberately left parts of his sculptures unfinished as if to express the spirit of the still unshaped body struggling against the confining world of stone.

Thirty years after he had completed the ceiling, Michelangelo returned to the Sistine Chapel to paint the *Last Judgment*—a tragic vision of humanity hurled into eternal damnation by a wrathful God and his host of angels.

Michelangelo had also been commissioned

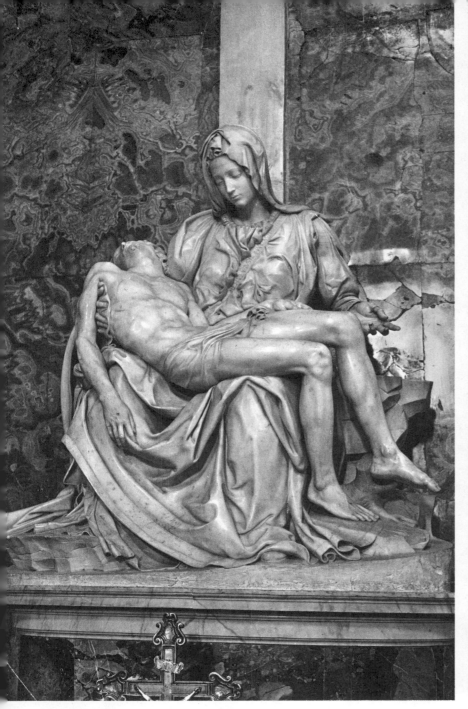

3. Michelangelo: *Pietà*, 1498–1500. St Peter's, Rome.

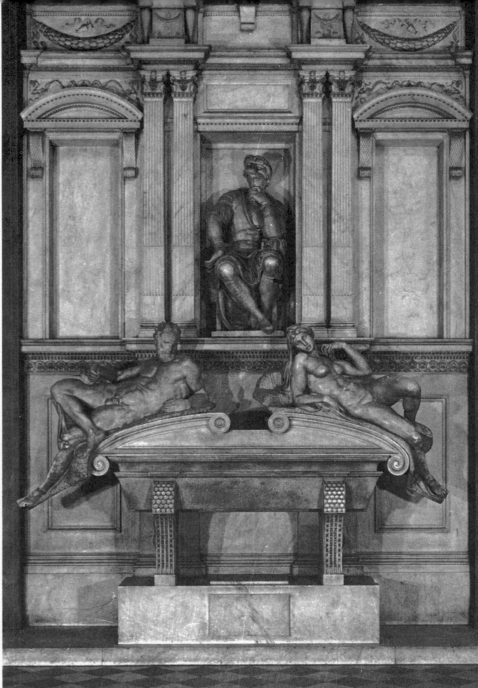

4. Michelangelo: *Tomb of Lorenzo de' Medici*. Church of S. Lorenzo, Florence. Medici Chapel.

by Julius II to build that pope's tomb, and he planned it as an architectural work with massive sculptured figures. Due to a series of disagreements with the pope and his family, lasting about forty years, the project was never realised. This was, in fact, one of the bitterest disappointments of Michelangelo's life. All that remains of the project are a few sculptures including the famous *Moses*, the two finished *Slaves* now in the Louvre, and the unfinished, tenser, more dramatic group of *Slaves* in the Galleria dell' Accademia at Florence.

Michelangelo's last work was his plan for the dome of St.

Peter's which was to crown the new building originally designed by Bramante. After Bramante's death, Michelangelo modified the design (1), cutting out some of Bramante's architectural elements, and concentrating the whole composition around the central dome, itself raised to a vast height. The dome is different in style from that built by Brunelleschi at Florence (see page 130), but is similarly raised upon an imposing drum to gain extra height. This drum serves as a springboard for the great thrusting pilasters and cornices which rise to the top of the dome, giving it a dynamic, upward thrusting effect.

Overleaf: Michelangelo: *Ceiling of the Sistine Chapel*, Vatican, Rome.

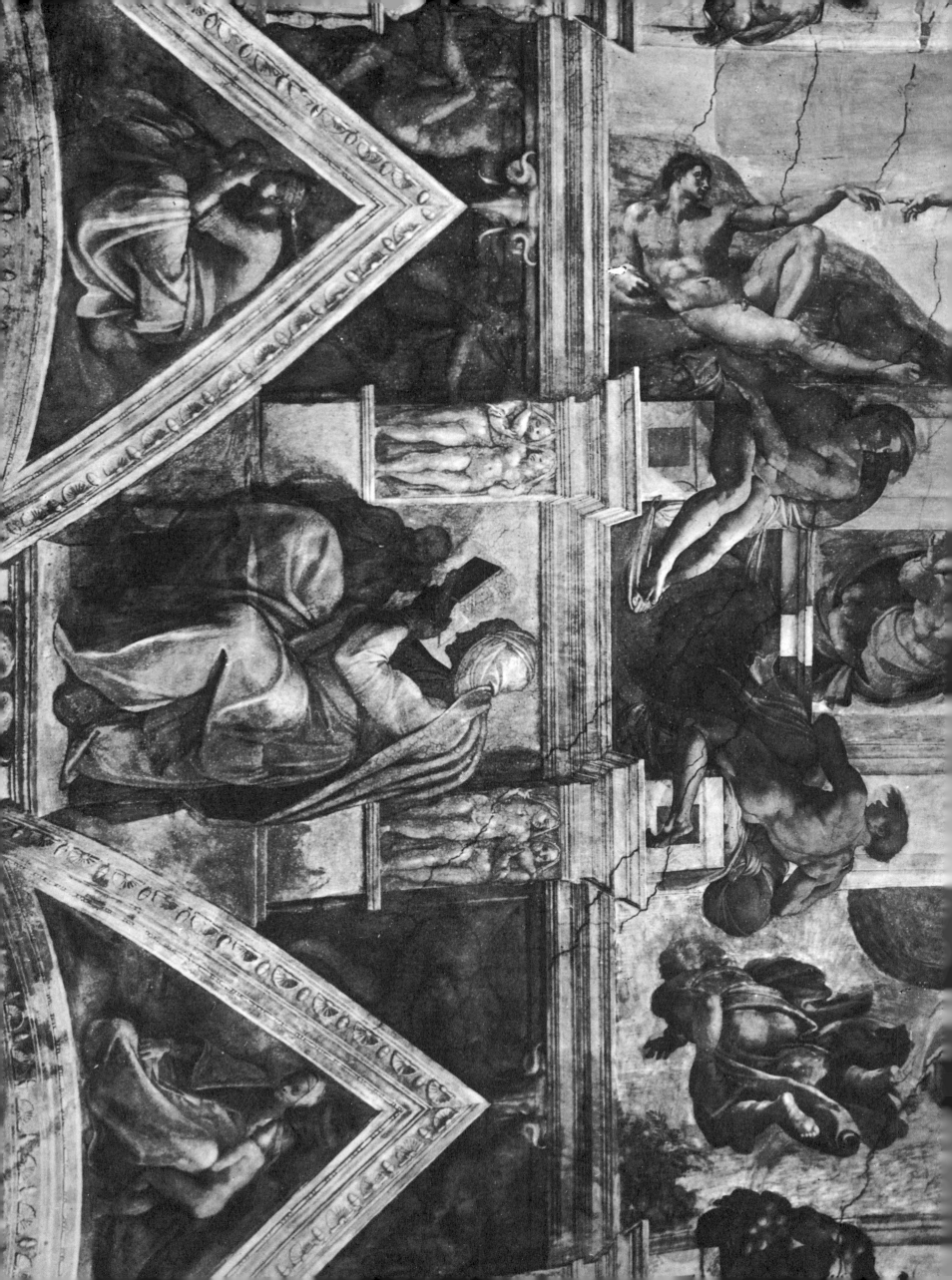

2. Filippo dei Negroli: *Helmet*, probably made for Francis I of France, 1543.

1. Pontormo: *Descent from the Cross*, Church of Santa Felicità, Florence.

After Michelangelo's death, the arts at Rome and Florence underwent further changes. The artists of the generation that was active in the middle of the 16th century came to be called "Mannerists", for they copied the "manner" of past artists without adding the vital element of fresh creation to their works. In fact it was thought, as Vasari had explained in his "Lives of the most excellent painters, sculptors, and architects", that there was nothing great left to be done after the glory of Michelangelo's achievements. The Mannerist artists were well versed in all matters of technique. They could carve stone into fantastic shapes and cast gold and bronze into complicated and exquisitely fashioned pieces (2, 4). But it would be a mistake to consider Mannerist art as something of limited value, or as a mere exercise in elaborate styles and techniques borrowed from Michelangelo, for there were some great masters particularly in Tuscany and Emilia such as Pontormo, Parmigiano and Correggio.

These artists and their works were much sought after in

3. Vesalius: *Secunda musculorum tabula*, 1543.

France, which was then beginning to free itself from the last vestiges of the International Gothic style. The Florentine goldsmith and sculptor Benvenuto Cellini, who fashioned the beautiful cup below (4), spent a considerable time at Paris and Fontainebleau in the court of Francis I. In Italy, painters like Bronzino executed portraits for their rich clients, displaying elegantly elongated hands and feet, and introspective, weary expressions. Pontormo painted the *Descent from the Cross* (1), which has a moving, dramatic quality and a highly original composition. But, until the 17th century revealed new artistic geniuses in other parts of Italy, the greatest works of art in this period came from Venice.

4. Benvenuto Cellini: *The Rospigliosi cup*, gold, enamel, and pearls.

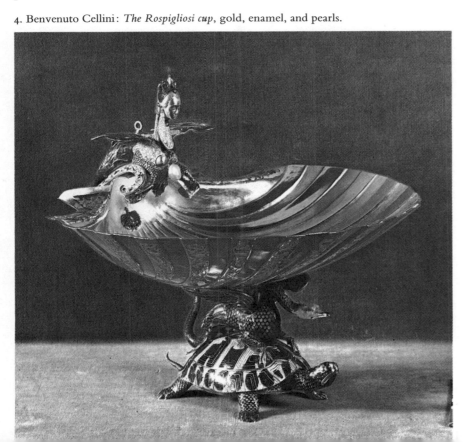

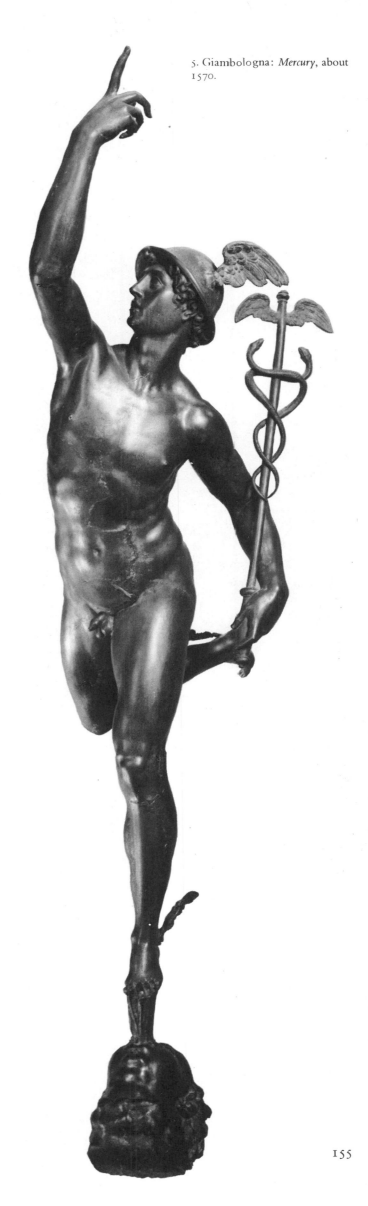

155

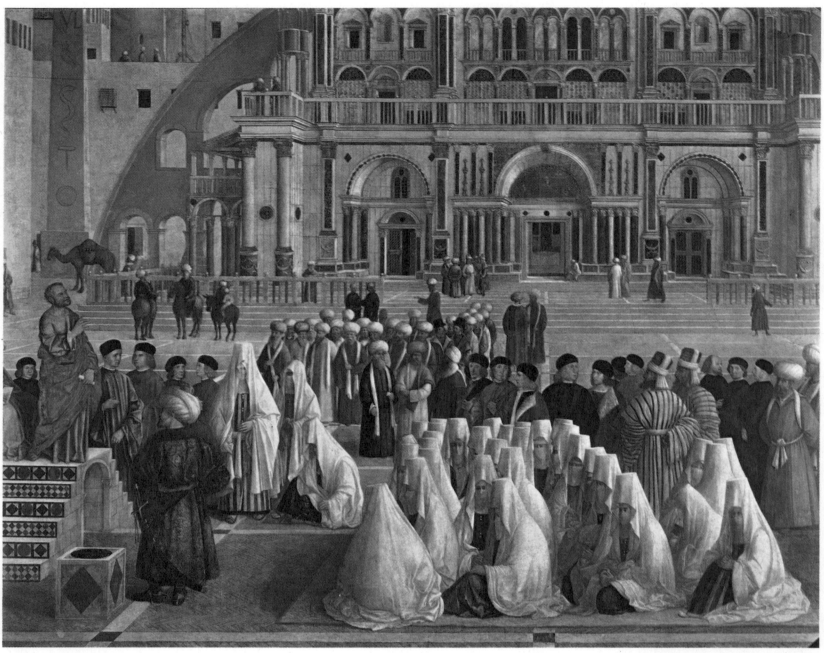

1. Gentile Bellini: *The Sermon of St. Mark*, detail.

VENICE

The Renaissance in Venice took a different form from that in Florence. It began only in the middle of the 15th century and reached its zenith in the first half of the 16th century. It developed primarily in painting, although some of the most important and representative architects and sculptors of the age also lived at Venice.

Little monumental sculpture was produced there; instead, the workshops of the city turned out a profusion of beautiful works in glass, enamel, textiles, jewellery and leather, and in all the other precious materials used by the craftsmen of Byzantium and Islam. Venice had very close trading links with the Near East and even with China. The city had been founded in the 6th century A.D. by the inhabitants of Aquilea who were fleeing before the invading barbarians, and it slowly became wealthy through trade and the spoils of war. When the Mongols and then the Turks overran Persia, Syria and Egypt, in their thrust towards the west, Islamic artists sought refuge in Venice, bringing the

secrets and techniques of their art with them. Venetian blown glass and lace are still renowned in the world today. From these contacts with the east, Venetian artists derived their love of colour, full ample forms, sumptuous splendour and mythological subjects. Once Venetian art had freed itself from the long domination of Gothic-Byzantine styles, the way was open for artists to adopt new techniques. Colour strikes the dominant note in Venetian painting, bringing both figures and objects to life besides the scenery itself—no longer mere background but an integral part of the painter's poetic vision. For the Venetian artists space was not something to be expressed in accordance with clear-cut, scientific notions of perspective, but was to be created out of colour itself. The mood of a picture and the relationship of figures to their surroundings were all to be expressed by luminous tones and shimmering light suffusing the entire composition.

The new painting techniques came to Venice from the nearby

city of Padua—a vigorous centre of the humanist Renaissance, built on the ruins of an ancient Roman city. For centuries various artists had contributed, by their works, to the evolution of the city into an important artistic centre. It was there that Giotto had painted his frescoes of the Madonna and Child in the Scrovegni Chapel, and there, in the main square, that Donatello's equestrian statue of Gattamelata had been set up. Mategna, the greatest of the Paduan artists, had been deeply influenced by these works, but was especially attracted by the "heroic" vision of the Classical Roman world evoked by the humanists. His hard, cold, "chiselled" style of painting had a heroic, monumental quality and offered great opportunities for scientific experiments in perspective. His figures themselves have an air of being scientifically calculated and petrified, as if his world was one of stone rather than of human beings. He formed his style in Venice, where he had married the daughter of the most eminent painter in the city at that time, Jacopo Bellini, the father of Gentile, one of whose works is illustrated (1), and Giovanni (see page 158). Mantegna's cold and austere style was still a great artistic achievement, and was continued by some Venetian painters including Carpaccio (3). Nevertheless, these painters added new elements to their works, in particular a decorative quality joined to a somewhat intellectual technique resulting in a kind of subtle poetry.

3. Vittore Carpaccio: *The Nativity of the Virgin*, detail.

4. Andrea Mantegna: *The Crucifixion*.

2. *Venetian goblet*, 16th century.

In the centuries that followed, Venetian painting techniques influenced court styles throughout Europe. When the princes of Flanders, Spain and France came, in all their finery, to pose for their portraits, the artists who painted them made use of the glowing colours of the Venetian school. The painters of the Venetian Renaissance had a partiality for mythological subjects which afforded greater scope for their imagination.

Paolo Uccello and Andrea del Castagno were among the Florentine painters who visited Venice, and it was there that the Sicilian painter Antonello da Messina brought the secret of painting in oils from Flanders. But Antonello did more than simply introduce a new technique into Italy, for he was a great painter in his own right and occupies an important place in the history of art. It was through Antonello that Giovanni Bellini, and the Venetian school generally, learned how to use colour to give a sense of space, and to evolve a new style of portrait painting. The *Portrait of a Man* (2) is one of Antonello da Messina's greatest works.

Antonello was a solitary and rather mysterious artist, but we do know of his influence on Giovanni Bellini, who was the first great artist of what may be called the Venetian school.

It was through Bellini's works that the new ideas of the Renaissance made their way into the still Gothic-dominated art of Venice. Various influences accounted for the change in Venetian painting at the end of the 15th century. The cold, factual way in which Mantegna observed objects in his paintings must have taught Giovanni Bellini, and others, to observe their subject carefully before expressing their own poetic vision through it. Bellini's compositions are full of diffused pale light (1), and his figures have something of the mysterious quality to be found in Giorgione's works. Coming from a family of painters, it was Giovanni who was the great innovator in Venetian painting, and who pointed to the way in which light and colour could be used together. Although he retained some elements of the Gothic style in his work, such as the hard, clear line and a meticulous eye for detail, he brought a new richness of colour into his paintings which made them glow with life.

After Bellini's death a school of great painters was formed at Venice. One of the greatest of these artists was Giorgione, who had studied in Giovanni Bellini's workshop. We know very

1. Giovanni Bellini: *Allegory of Purgatory*.

2. Antonello da Messina: *Portrait of a man*.

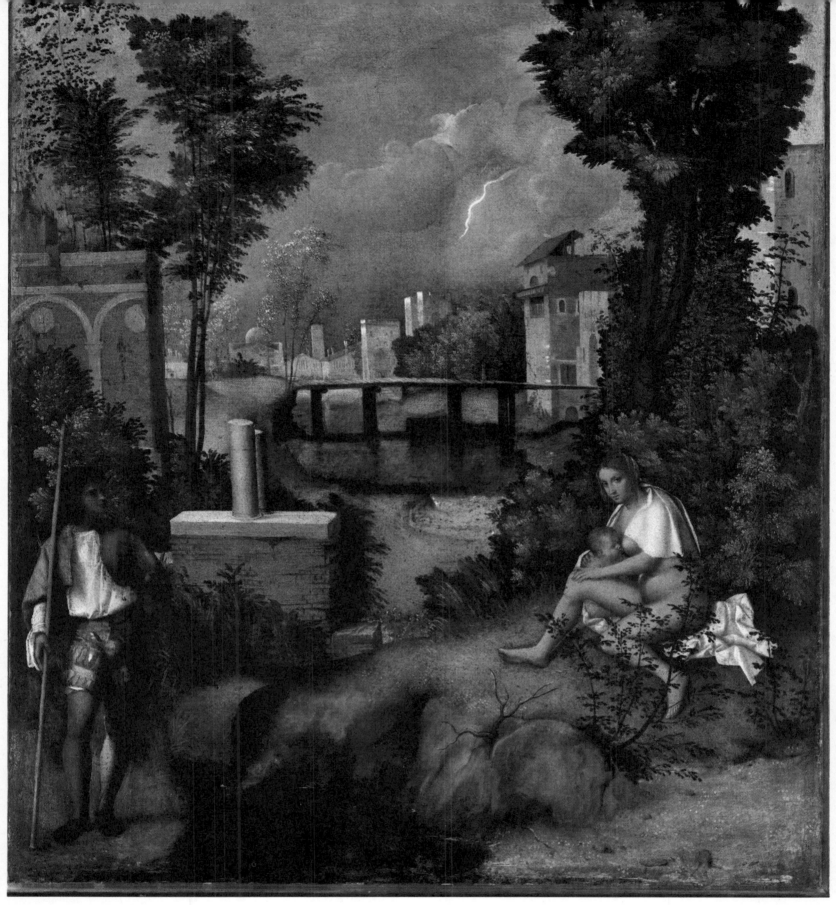

3. Giorgione: *The Tempest.*

little about Giorgione's life, but we do know that his work certainly played a vital part in the development of Venetian painting during the 16th century, and showed painters how to create a new harmony between colour and light. He greatly influenced Titian, who studied under him. The main characteristics of Giorgione's style are his warm, glowing colours and the lyrical, poetic quality he gives to his figures and in particular to his landscapes. He brought large masses of different colours together, and largely dispensed with hard lines for his figures. Even the edges of his shapes are blurred, as though they were seen through a mist. In *The Tempest* (3), Giorgione has created a sense of profound harmony between the figures and their surroundings, both of which seem to be bathed in soft light, thus giving a certain air of mystery to the whole composition.

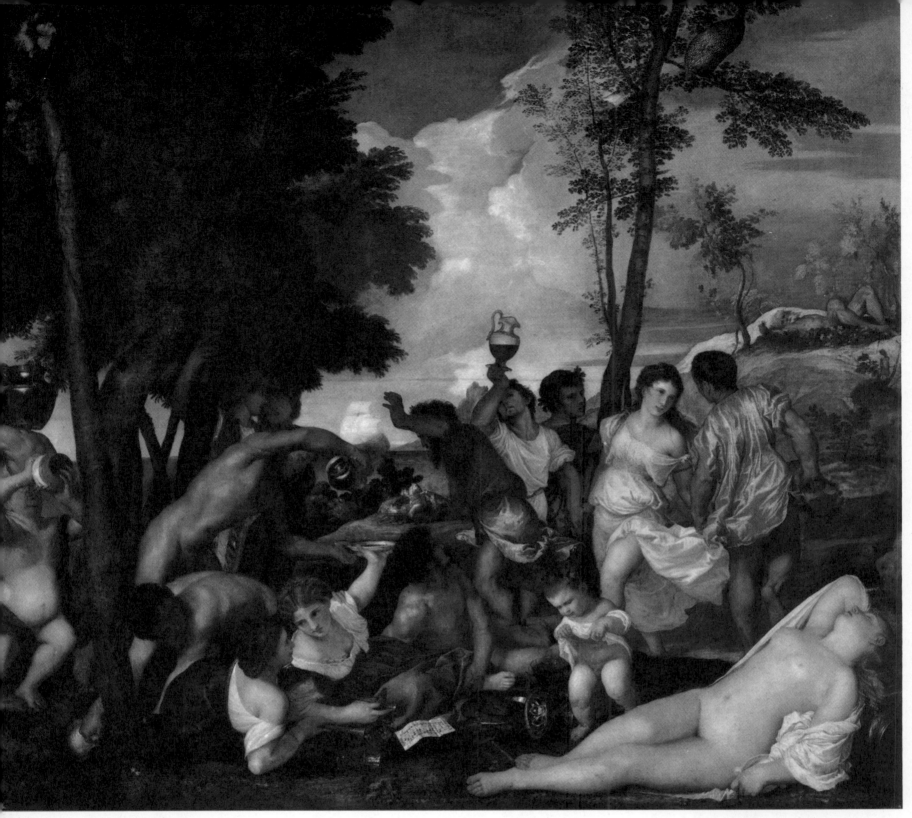

1. Titian: *The Triumph of Bacchus and Ariadne.*

Titian's great painting, *The Triumph of Bacchus and Ariadne* (1), encompasses every basic element of style of Venetian painting in the 16th century. With its rich colouring, its variety of tones ranging from the thick dark masses of foliage to the golden radiance of the flesh parts, the harmonious composition of the figures, and the dramatic radiance of the background silhouetting the clean sharp lines of the vase, it is one of Titian's greatest and most vibrant paintings.

Titian lived to be ninety-nine and his long life encompassed both the beginnings of the Venetian Renaissance and the tragedy that befell Italy with the invasion of the emperor Charles V—who had himself painted by Titian. Every successive phase in Venetian painting is reflected in Titian's work. In his youthful period he painted such radiant panoramas as *Bacchus and Ariadne*

and *The Three Ages of Man.* In his mature, middle period, when he was laden with honours by the courts of Spain and England, he painted portraits of popes and kings, philosophers, and great Renaissance ladies dressed in sumptuous robes and covered with jewels. He also painted nudes of outstanding beauty. He depicted all his sitters at their most impressive, when they were in the full flower of life and at the height of their careers. Towards the end of his life, Titian turned to tragic religious subjects, such as the *Descent from the Cross* (2). The serenity of his earlier works vanished forever, and his figures seem to writhe in space like great tormented shadows. Titian was anticipating the future, for turbulence and storm, restless, twisting figures, and an emphasis on vivid, theatrical lighting effects, were to become the main features of the new Baroque style that was evolving in Rome.

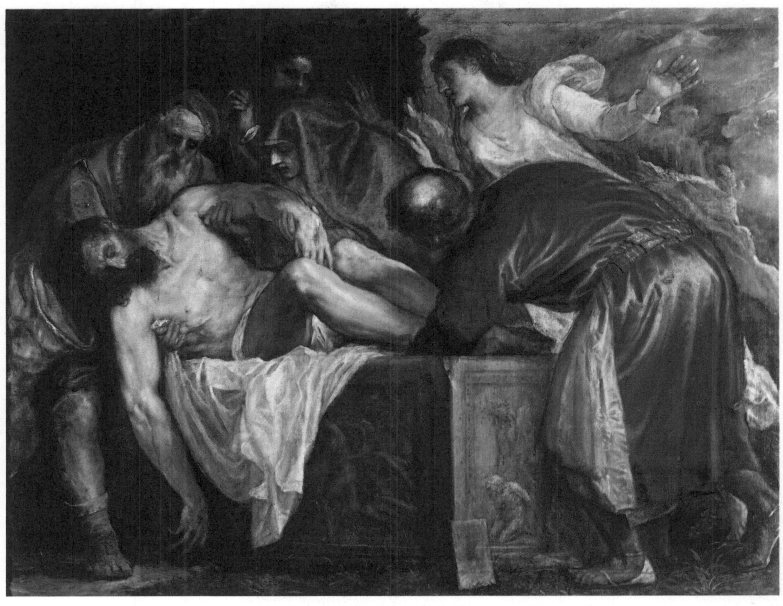

2. Titian: *Descent from the Cross.*

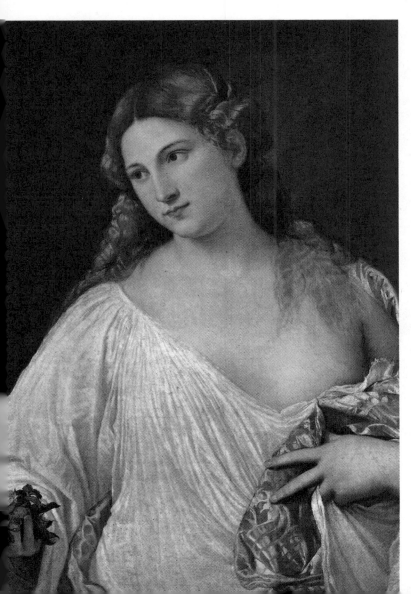

3. Titian: *Flora.*

4. Titian: *Philip II of Spain.*

1. Tintoretto: *The Last Supper*, 1594. San Giorgio Maggiore, Venice.

2. Tintoretto: *Bacchus and Ariadne*, about 1578.

Tintoretto went even further than Titian in heralding the new art style that was to be called the "Baroque". He sometimes succeeded in creating a monumental composition, like *Bacchus and Ariadne* (2), with figures moving calmly through a golden haze of light, but as a general rule his great canvasses were explosive studies in extraordinary perspective, as in *The Last Supper* (1). He filled his compositions with harsh green lights and strange, flying figures, so that the flat surface of the painting became a kind of stage on which to enact his violent dramas. With his agitated figures, his vibrant tones, his apparently chaotic but basically extremely calculated compositions, he fascinated succeeding painters, including El Greco.

Still another great Venetian painter was Paolo Caliari, called "Veronese" after his native town. He was the painter of courtly splendour and magnificence *par excellence*. His grandiose imagination led him to create vast

3. Palladio: *Villa Rotonda*, 1567. Near Vicenza.

compositions full of space and depth; his great canvases and frescoes often represent stage-like banquets and festivities which are far removed from Titian's mythological scenes, and Tintoretto's religious dramas. His great painting *The Feast in the House of Levi*, reproduced (pages 164–165), occupies an entire wall. The staircases and the arches were painted with a realistic technique known as *trompe-l'oeil*, to deceive the eye and create an illusion of great depth and perspective as though the spectator himself was invited to step into the composition. But when Veronese painted this work, times had changed and artistic freedom had become curtailed by the power of the Church. He was accused by the Inquisition of having profaned a sacred subject and of blaspheming against Christ's majesty by introducing such figures as dwarfs, dogs and monkeys—but was acquitted with a caution after a brief trial. His paintings are particularly distinguished for their

richness of colouring, and the almost classical balance of his figures set in well-ordered compositions.

While Venetian painting of the late 15th and 16th centuries was reaching such astonishing heights, another artist was creating a new language of architecture. This was the architect Palladio who based his structures on the essential elements of Greek and Roman architecture, but used them to create a painterly effect. He planned in terms of light, shade, and space to underline the precise relationship between the various elements of his buildings. They were conceived as part of the landscape around them, so that even a completely symmetrical building like the Rotonda (3) fits harmoniously into its natural surroundings, as though it were part of a well composed painting. Palladio explained his ideas on architecture in a written treatise inspired by Vitruvius's "Ten Books of Architecture". Of all architectural styles, he thought that only those of Classical Greece and

Rome were capable of the highest forms of artistic expression. But although he derived his sense of space and proportion from the Classical past, his buildings were not stale repetitions of bygone styles nor exercises in academic formulas. Renaissance art taught Palladio to value colour and light as fundamental elements in planning his constructions. His town houses at Vicenze and his country villas near Venice initiated a new style in architecture that was continued long after he died, although later architects lacked his creative vision.

Although Venice had given the world magnificent painters, and a new architectural style of country house during its glorious Renaissance period, there was a decline in its artistic vigour throughout the 17th century. This lasted until the appearance in the 18th century of two more great painters who were to create memorable pictures of the city — Canaletto and Guardi.

Paolo Veronese: *Feast in the House of Levi*, 1573.

1. Jan van Eyck: *Madonna, with the Chancellor Nicholas Rolin*, 1435.

THE RENAISSANCE IN THE NORTH

The 15th century was a time of great prosperity and artistic splendour in Flanders. Both in the Low Countries and in northern Europe as a whole, there was an extraordinary outburst of creativity in painting. A new style was born which was essentially based on a number of characteristics, namely, precise relationship between form and colour, the transparent quality of light in the paintings, and the kind of composition which obeyed certain strict rules and was the outcome of previous experiments. The northern painters managed to create a universe in which reality and fantasy were indistinguishable, and in which poetic imagination and painstaking attention to detail went hand in hand.

Many of the Flemish painters experimented with new ways of depicting their subjects. They did not work for kings or princely courts, but for the new monied classes and rich merchants. Like others they, too, painted portraits and landscapes, but without using the strong tempera colours of the miniature painters. For

some time many Flemish painters had been using an oil mixture to dilute their colours, instead of water or white of egg. The painter Jan van Eyck perfected the new process and produced the first real oil paintings. This medium allowed artists to paint successive transparent layers of colour, the deeper tones shining through the surface glazing. This new type of painting gave warmer, shinier tones to the picture and an added liveliness which was lacking in tempera paintings. When Jan van Eyck painted the scene reproduced (1), he may have been giving expression to a sense of widened intellectual and artistic horizons and of having outgrown the confines of medieval thought.

Behind the seated Virgin and the kneeling chancellor in this picture, he has painted a marvellously light and airy sun-filled landscape. The misty horizon is executed with the lightest of touches and shows a great sense of space, but his figures still have a monumental quality and are set in a well-balanced and symmetrical composition.

2. Jan van Eyck: *Portrait of Margaret van Eyck.*

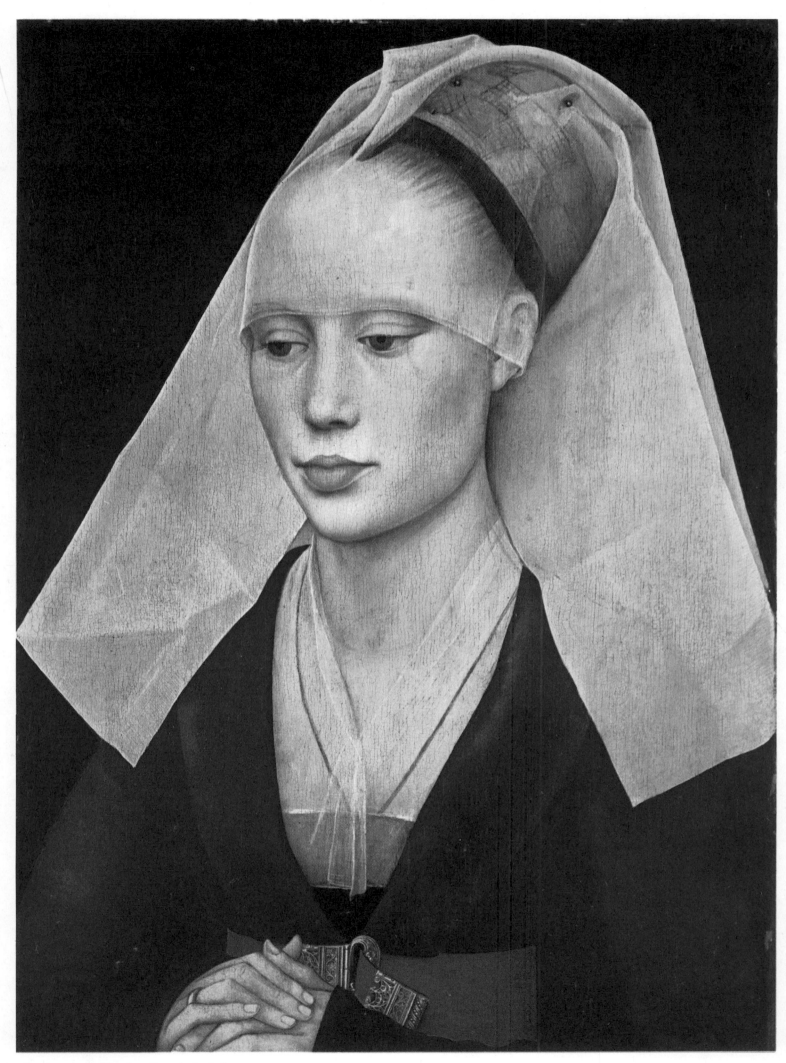

1. Rogier van der Weyden: *Portrait of a Lady*.

The commercially prosperous Flemings were more interested in the prosaic facts of everyday life than in the fanciful stories favoured by the French courtiers. Their artists depicted everyday subjects and surroundings—household utensils, instruments, pet dogs, timid wives and grave burghers—but dignified even the most ordinary everyday themes with the splendour of their colouring. Far from spoiling the unity of their compositions, the numerous little details they included became an essential part of the painting. The picture reproduced (3) shows a young couple in a jeweller's shop; every object in the shop has been painted with the greatest care, even the reflected faces in the mirror.

The great retable or painted altar-piece, from which a detail is reproduced (2), was brought from Flanders to Italy where it made a great impression on the Italian painters, due to the crystalline clarity of its colours. It was painted by Hugo van der Goes, one of the most original of the Flemish painters.

The human face has interested artists in every age, but it has also presented them with problems. In some periods, painters cared little for the individual characteristics, preferring to represent an idealised, perfect beauty. The artists of Classical Greece were the original creators of this kind of idealised portraiture. The later Roman portrait painters abandoned the pursuit of beauty for its own sake, to render the precise characteristics of each individual. In the Middle Ages when art mirrored the general emphasis on religion, painters preferred to concentrate on divine rather than human characteristics, and the art of portrait painting was lost for a time. When, in the Renaissance, man again became the focus of attention, he regained his position as the prime inspiration for artists. An added impetus was given to portrait painting by the artists' patrons, who demanded portraits as evidence of their importance and to perpetuate their memory. The Flemish portrait painters accurately reproduced the personal characteristics of their sitters, while imbuing their pictures with a subtle sense of poetry (pages 167–169).

2. Hugo van der Goes: *The Portinari triptych*, detail, 1473-1475.

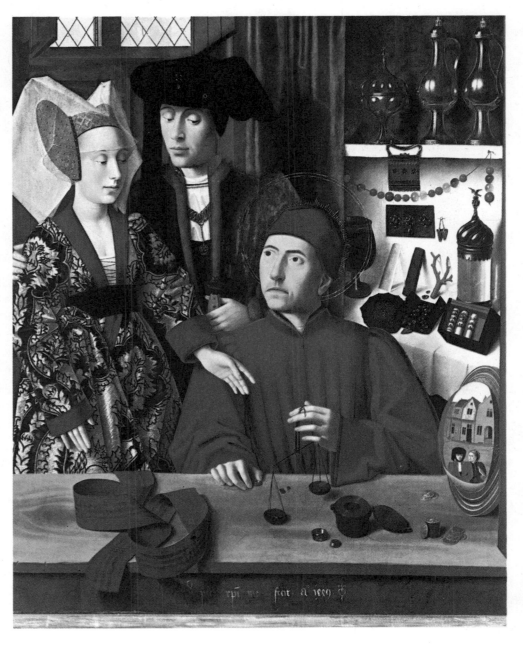

3. Petrus Christus: *Legend of Saints Eligius and Godeberta*, 1449.

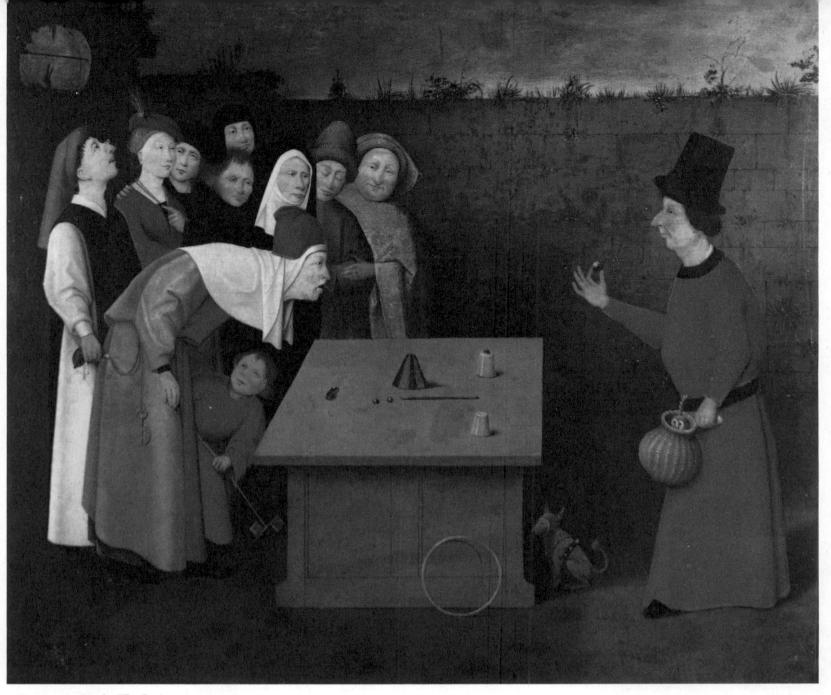

1. Hieronymus Bosch: *The Conjuror*, 1450–1516.

2. Hieronymus Bosch: *The tree-man*. Drawing.

The painter Hieronymus Bosch is one of the most extraordinary and complex personalities in the whole of Flemish art, and indeed of European art as a whole, by virtue of the overpowering richness of his fantasies and the crystal-clear shapes he gave to them. Problems of good and evil, the terror of death and the hope of eternal life, and the evil demons present in mankind, are all to be found in his pictures. His great compositions are teeming with figures and a fantastic variety of weird monsters that could only have come out of the rich and inventive mind of a visionary. They are tinged with a certain subtle and refined humour, which belongs to the age of Humanism rather than the Middle Ages. His ability to invent monstrous forms, combined with a capacity for creating beautiful images and clear cut shapes, make him one of the most fascinating and mysterious of artists.

The part of Bosch's triptych painting, *The Garden of Worldly Delights*, in the Prado Museum (3), shows how, for all the apparent superabundance of themes and figures in the composition, every detail forms a perfectly self-contained entity, painted with a clear and rigorously controlled technique.

3. Hieronymus Bosch: *The Garden of Worldly Delights*. (Triptych, central panel).

Pieter Breughel the Elder was one of the last great artists of the northern Renaissance. In his paintings he set down the minutest details of the outside world: peasants harvesting, hunters in the winter snow and children playing, were among his subjects. He then visited Italy to learn the new artistic techniques of the Renaissance, which particularly helped him to execute vast panoramas with different planes in receding perspective, and huge, complex compositions teeming with figures and minute detail.

As in Bellini's works (page 158), Breughel's figures fit in perfectly with their background. In the drawing reproduced (2), the two tiny figures in the bottom left corner belong to the

1. Pieter Breughel the Elder: *The triumph of death*, 1562.

landscape just as the minute figures in a Chinese scroll painting are essentially part of their countryside. No other northern painter before Breughel had ever given so much space and attention to landscape.

While Breughel was travelling between his homeland and Italy he not only saw majestic scenery but also fearful scenes of

2. Pieter Breughel the Elder: *Waltersburg*. Drawing, 1554.

horror and carnage. In 1556 the new king of Spain and the Netherlands was Philip II—a religious fanatic who devoted all his energies to crushing the attempts of the Flemish Protestants to break away from Spanish rule. With the assistance of the Inquisition and the duke of Alba, who was sent to crush the opposition with an iron hand, thousands of Flemings were massacred, broken on the wheel or hung from gibbets on the hill-tops. These horrors were reflected in some of Breughel's paintings where, for instance, he depicted tall gallows with their pathetic burdens of rags and bones swinging in the wind. The old medieval theme of the *Triumph of Death* made its re-appearance in northern European art, haunting the artist's consciousness in his terrifying painting in which some of the figures are fleshless skeletons, and even the colouring is dark and sinister (1). But even in this painting some of the horror and drama of the subject has been lost in the vastness of the composition. The skeletons themselves, like the figures of the soldiers and peasants, seem to have become a natural part of the landscape.

173

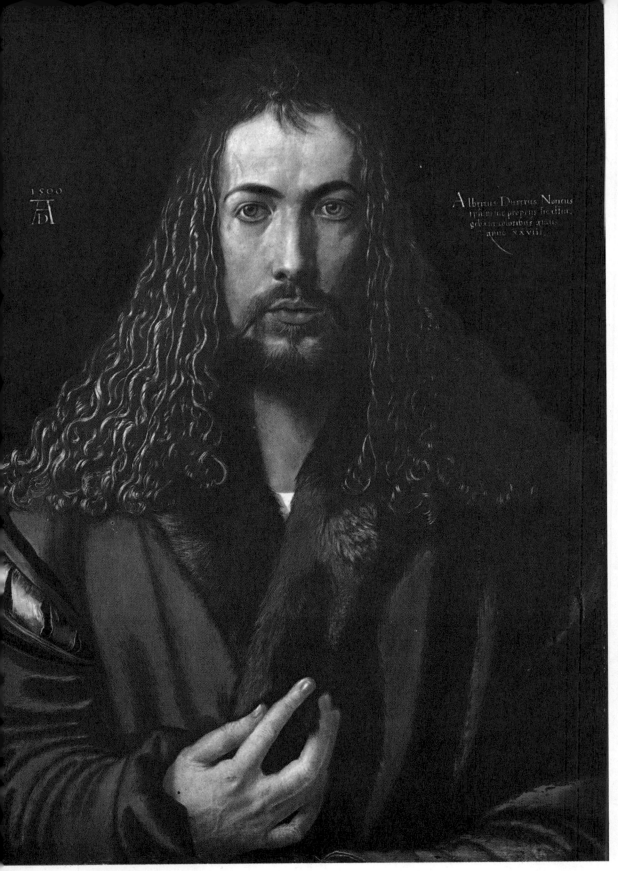

1. Albrecht Dürer: *Self-Portrait*, 1500.

European history of the early 16th century was dominated by the commanding figures of Henry VIII of England, Francis I of France, and Charles V of Spain. It was during the reigns of all three kings that the art and ideas of the Italian Renaissance made their way into the culture of northern Europe, for the monarchs were great patrons of the arts, and encouraged artists to travel from country to country, which they in fact did to a greater extent than is usually thought

today. Albrecht Dürer journeyed to Italy, Hans Holbein to England, and Leonardo to France, and all three artists developed and spread the ideal concepts of Renaissance humanism. They all reflected in their work the same curiosity and spirit of enquiry about the world as a whole, a refusal to be limited by narrow conventions and preconceived notions, and a common passion for probing into individual character.

The spread of new ideas in northern

Europe was accompanied by political upheavals. The teachings of Martin Luther, who denied the need for any priests to mediate between man and his God, encouraged several countries to break away from the authority of the pope. Towards the end of the 16th century there was a new period of turmoil, and Rome led a Counter-Reformation which had important effects on the arts, philosophical thought, and literature. After giving the world such mighty artists as Leonardo, Michelangelo, Raphael and Titian, Italy could only produce mannered and academic works, devoid of any real creative spirit.

A great change came over the art of northern Europe as the new ideas of the Renaissance were being absorbed. The expressionistic fantasies of late Gothic art gave way to a new, realistic style, which was largely imitated by the German painter and engraver, Albrecht Dürer, who represented Renaissance values and ideals in his own country. He was born thirty years before Grünewald, another great German artist, and we only have to compare Dürer's profound and searching study of the human face (1) with Grünewald's frenzied vision, to see which of the two was closest to the Italian tradition. Dürer was the son of a goldsmith and was trained while art was still largely Gothic in style. Vestiges of this early influence survived in his work, especially in his wood-cuts and engravings of biblical scenes. But he was also fascinated by the ideas of the humanists that were infiltrating into Germany across the Alps from Florence and Padua. He visited Italy to study the work of the great Italian masters and, like Leonardo, was passionately intrigued by the mysteries of human personality. Both men were among the first painters to make self-portraits. Instead of including themselves inconspicuously in a corner of a composition, as earlier artists had done, they painted themselves alone, in full face, studying themselves in a mirror, as if to discover the innermost secrets that lay behind their gaze. Dürer became a Protestant and almost convinced himself that he was a prophet of

the future—not in art alone but also in his religious beliefs. In his *Self-portrait* (1) the frontal aspect of the face and its steady, intense expression resemble some of the medieval images of the Messiah, as if Dürer had meant his work to suggest a precise relationship between man and his saviour, both found in the same image.

Grünewald, the Master of Colmar, has been called "the last great artist of the Middle Ages". But he was also a forerunner of a new style: his *Crucifixion* scene painted for the Isenheim altar (3) may be in part a continuation of the northern Gothic tradition, but it is also an example of a completely new pictorial style, which one might call expressionist, or even surrealist. The work expresses an intense, nightmarish vision of the world, in which outward appearances serve to symbol-

ise an inner spiritual reality. He seems to have created a fantastic world of his own in which man, the objects surrounding him, the Virgin Mary and the angels, all contribute to give his visions the impression of utmost reality. His art represents part of the impact of the new ideas of the Renaissance and the humanist philosophers upon art. Even more than Hieronymus Bosch, Grünewald was able to depict the terrifying world of the unseen, and to use his painting as a means of exploring the inner depths of men's nature.

Grünewald's religious symbolism was a vital part of his art and his own personality. Instead of deriving from traditional mediaeval sources, it found its origin and its justification in the anguished religious debates of the Reformation.

3. Albrecht Dürer: *Melancolia*, engraving.

2. Grünewald: *Crucifixion*. Central part of the Isenheim Altar, 1512-1515.

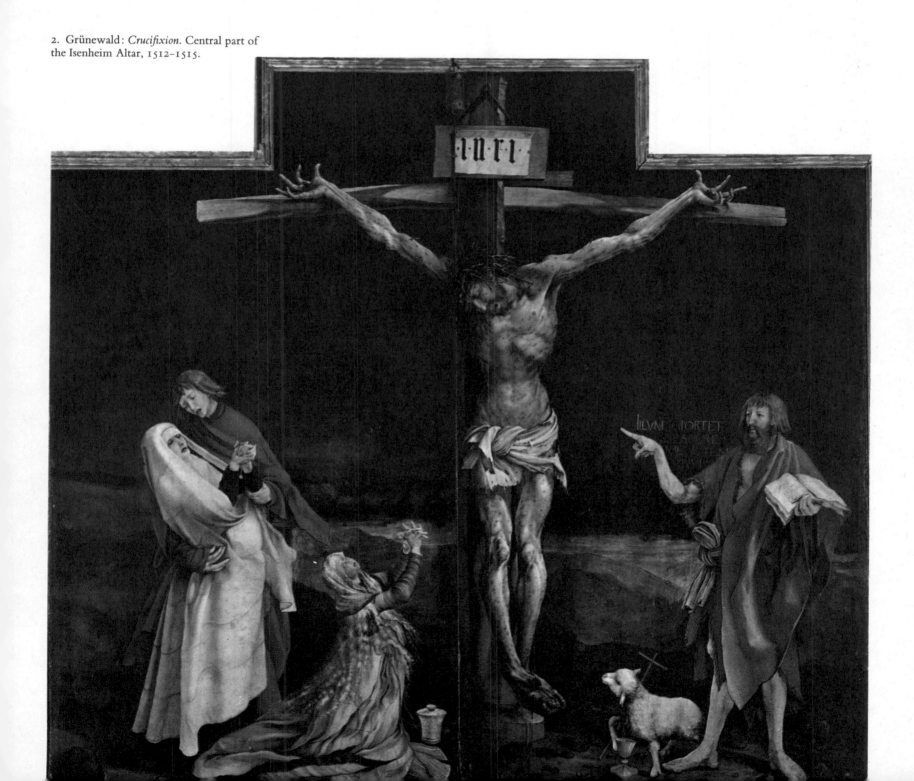

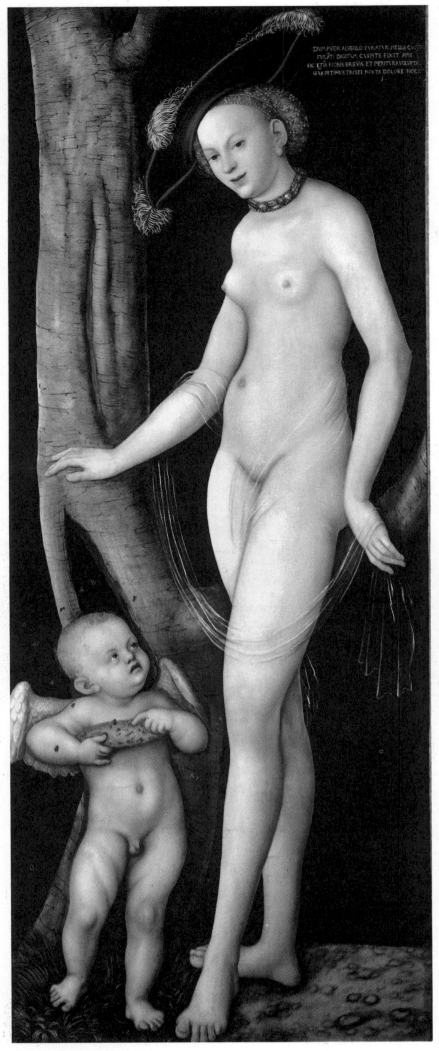

2. Albrecht Altdorfer: *The dismissal of St. Florian.*

1. Lucas Cranach the Elder: *Venus and Cupid.*

3. Lucas Cranach the Elder: *Portrait of the Elector of Saxony.*

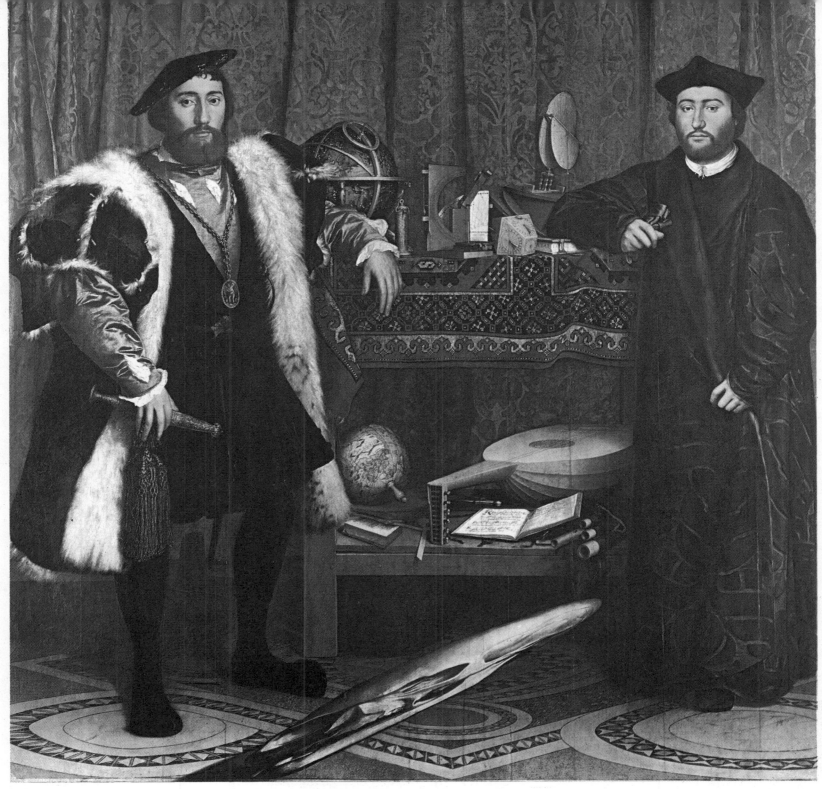

4. Hans Holbein the Younger: *The Ambassadors*, 1533.

Lucas Cranach was painter at the court of the electors of Saxony, and his work combines creative fantasy with a meticulous regard for realistic detail. With his hard, brilliant colours and tense but refined use of line, he portrayed the princes of Saxony, and their wives, with implacable realism (3).

He brought mythological Classical subjects and figures into his paintings, but there was nothing Classical about the way he painted them: his Venus (1) has an almost unreal quality, but her subtle, sensual charm is strengthened by such details as her enormous plumed hat and gauzy, transparent veil which reveals Cranach's inventive style at its most typical. The tall, slender body is drawn with sinuous lines that seem to undulate against the dark background.

Albrecht Altdorfer was another great innovator in 16th century German painting. His paintings show mankind and surrounding nature as different, opposing elements in the world, but closely linked together by a strong poetic imagination in enormous, awe-inspiring compositions full of minute detail (2).

Hans Holbein painted portraits both objectively and accurately. He spent most of his life in England during the reign of Henry VIII, whom he painted several times, as well as portraits of the king's several wives. It was in England that he portrayed the two typical representatives of the great cosmopolitan world of 16th century Europe (4).

The two ambassadors are painted with careful accuracy, but among the objects surrounding them he placed a macabre symbol in the foreground. Using all the technical virtuosity of the mannerist artists, he has painted a skull that appears to be monstrously deformed, due to a trick of perspective. The disturbing object stretches across the foreground between the two men as if it had suddenly appeared out of some medieval image, of the *Triumph of Death*, to mock their solemn gravity.

177

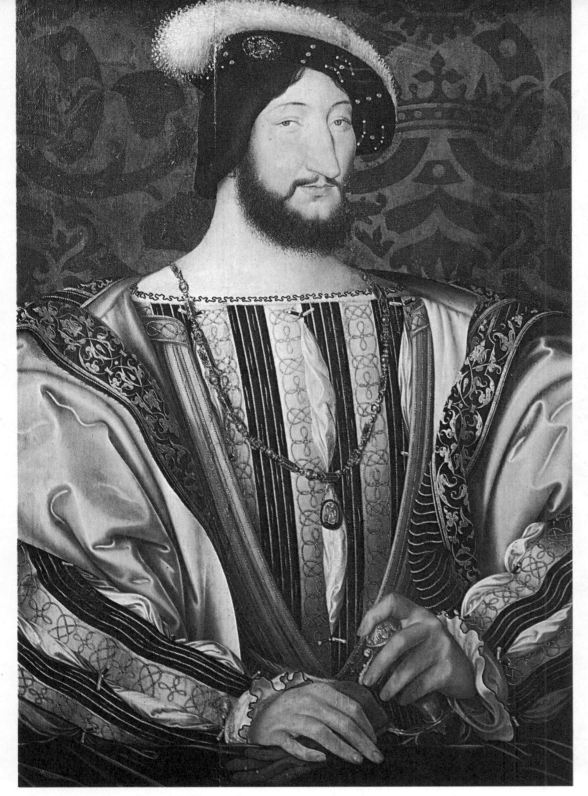

1. Jean Clouet: *Portrait of Francis I of France*, about 1524.

2. *Château of Chambord*, about 1526–1544.

In 1515 Francis I became king of a united France and one of the greatest royal art patrons of the time. Like the emperor Charles V, he was fascinated by Italian Renaissance art. Leonardo da Vinci came to work at his court, and designed buildings, fountains, costumes and monuments, Benvenuto Cellini made dazzling gold pieces for the royal banqueting table, as well as casting bronze statues and decorating fine suits of armour. It was during Francis's reign that the mediaeval fortresses along the river Loire were transformed into great châteaux. The magnificent château of Chambord (2) is a fine example of French Renaissance architecture of the time, with its façade pierced by many windows to let the sunlight flood into the sumptuous interior. These new castles, and the great town buildings were adorned with elegant staircases, galleries and balconies, and gardens modelled on the geometric Italian pattern. Classical columns were added to existing doorways, and the earlier Gothic towers and pinnacles were preserved and incorporated in existing buildings, while architects added new wings designed in the Italian style. In painting however, Francis I had more traditional tastes: his court painter, Jean Clouet, had an accurate eye for detail and produced several realistic, well-composed portraits (1), but drew in a rather Gothic manner and lacked great spirit in his art. Francis I founded a school of painting at Fontainbleau and hired a group of painters from Florence to instruct his own artists. Unfortunately, as often happens when artists adapt a foreign style without contributing any real effort and original ideas of their own, the painters at Fontainbleau were only able to create feeble imitations of the Mannerist school, and produced over-refined, slightly ridiculous scenes like the *Birth of Cupid* (6).

The sculptor Jean Goujon was partly influenced by the Mannerist style, and partly inspired by a genuine enthusiasm for Classical art. The somewhat languid statue of *Diana* (5) is supposed to be a portrait of the beautiful Diane de Poitiers, who was the mistress of Francis I's son, Henry II.

3. *Double-barrelled wheel lock pistol*, made by Peter Pech of Munich for the Emperor Charles V, about 1540.

England was more backward in the visual arts than the Mediterranean countries, but had shown outstanding genius in her literature, having given the plays of Shakespeare to the world by the early 17th century. But despite Henry VIII's ambitions and his admiration for the Italian-inspired art he had seen in France, English art developed very slowly during the century. The king tried to encourage new architecture by giving some of the wealth he had confiscated from the Church for the financing of new public buildings. Nonetheless, the Tudor style of architecture remained throughout the reign of queen Elizabeth and showed itself to be completely different in spirit from that of Italy. Apart from the important works of Holbein (who was only a visitor to the country), English painting during the reigns of the Tudors was chiefly confined to miniature portraits of the sovereigns and their sumptuously dressed courtiers.

4. Anonymous, English: *Queen Elizabeth I* (1533–1603).

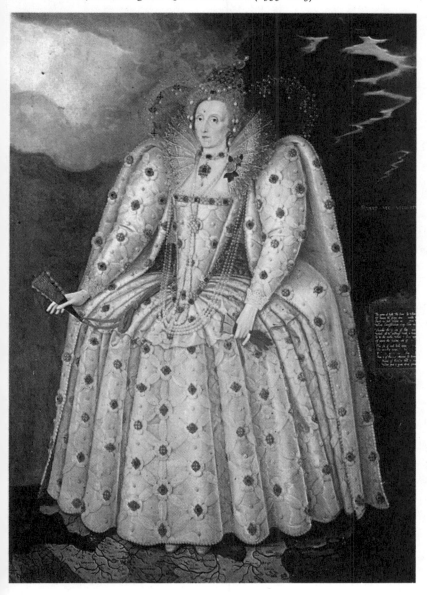

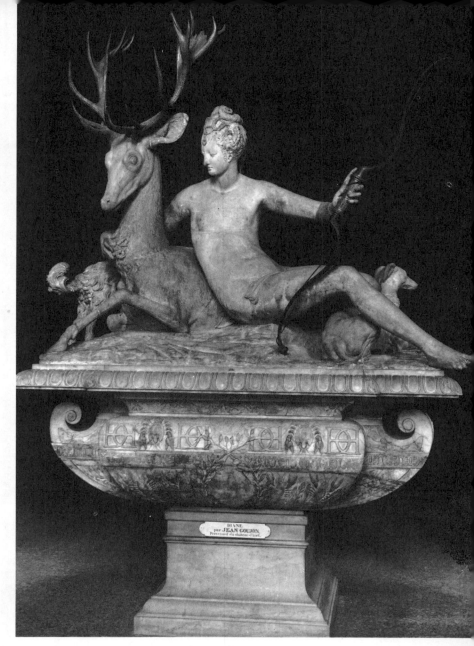

5. Jean Goujon: *Diana*. From the Château d' Anet.

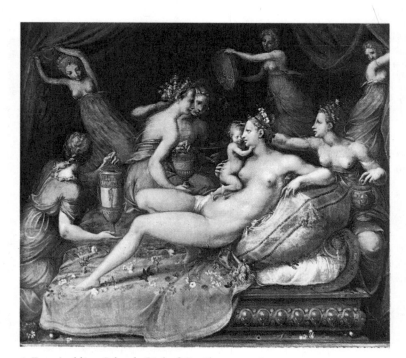

6. Fontainebleau School: *Birth of Cupid*, 1540–1560.

179

1. Giovanni Lorenzo Bernini: *The colonnade of the Piazza of St. Peter's, Rome*, begun in 1656.

THE BIRTH OF BAROQUE

ROME

The word "Baroque" was first used as a pejorative term for the new art style that originated at Rome in the late 16th century, and which was to spread throughout Europe during the next two hundred years. In its early sense "Baroque" suggested artistic extravagance, bizarre design and even bad taste. It was used as a propaganda weapon in the service of the Counter-Reformation after the Council of Trent had laid down precise rules for Catholic art. Art was to have one main function: to combat heresy and bring believers into the all-embracing fold of the Church.

By the close of the 16th century and the beginning of the 17th, Rome had regained her artistic and cultural supremacy in Italy, owing to the patronage of the popes and the great patrician families. Bishops and cardinals gave a new look to the city with the architecture of Bernini and Borromini, whose buildings were designed and sited with an eye for theatrical effects. Bernini's great colonnaded piazza before St. Peter's (1) represented a new architectural conception of space. The two curving rows of columns spread out in front of St. Peter's like part of some mighty stage design to enfold the piazza and bring it into a close relationship with the church, thus forming a tight, unified

pattern. The new style first made its appearance in architecture; it was later taken up with great vigour and freedom in the other arts, and led minor artists into a search for showy effect by an elaborate display of technical virtuosity, designed to overwhelm the spectator. The movement soon influenced music, which abandoned the simple harmonies of the plain chant of the medieval monks or the restrained simplicity of Renaissance music for more elaborate forms of composition. In Baroque "polyphonic" music, various voices joined together in singing different, interweaving melodies, thus creating a new kind of rich pattern of sound, reinforced by the powerful organs reverberating through the churches where the music was usually played. A similar striving for grandiose, dramatic effects influenced architecture, painting and sculpture. Baroque artists made use of violent contrasts of light and shade, and designed forms to give the impression of breaking out of their boundaries to expand into space. Even materials were made to undergo curious transformations in the search for effects: in the sculpture reproduced on page 183 (4), Daphne's fingers are seen turning into leaves, and the entire ceiling reproduced on pages 184–185 seems to be dissolving into a mass of clouds, colours and lights.

2. Giacomo Barozzi da Vignola: *Church of the Gesù*, begun in 1568. Rome.

One of the greatest early Baroque architects was Vignola, who started his career in 1543 after being trained as an artist in his native Emilia, and after some time spent at Fontainbleau. In 1568 he designed, at Rome, the church of the Gesù, which was to be his greatest masterpiece. The original plan was based on a design by the Renaissance builder Alberti, but Vignola emphasised the lines of the volutes, or scrolls, joining the lower horizontal section of the façade to the central upper storey. Inside the church, the single nave was lit up by the light coming from a great dome placed over the intersection of the nave and transept, while the side chapels were left in darkness. The interplay of light and shade in the interior was then combined with rich marble decoration and bold relief work.

Gothic architecture had dwarfed the human figure with its long, soaring, perpendicular lines, drawing the eye upwards, while on the other hand, the low, horizontal lines and circular designs of the Renaissance gave back to man his sense of importance in relation to the structure. The Baroque architects attempted to combine the two different styles by compressing the ground plan into an oval, and then surmounting it by a great dome. They even added twin towers, like those of the Gothic cathedrals, only these were more free and curvilinear in their design. Later, even the walls lost their rigidity and were made to roll in curves so that space itself seemed alive, and to flow between the undulating walls (3). The architect Borromini took a further step in his search for new means of architectural expression. In his *Church of San Carlo alle Quattro Fontane* at Rome, he seems to have set the whole façade into motion, with its rocking, curving lines, as though he had modelled the heavy columns and the balustrades in soft clay.

3. Francesco Borromini: *Church of San Carlo alle Quattro Fontane*, 1638–1646. Rome.

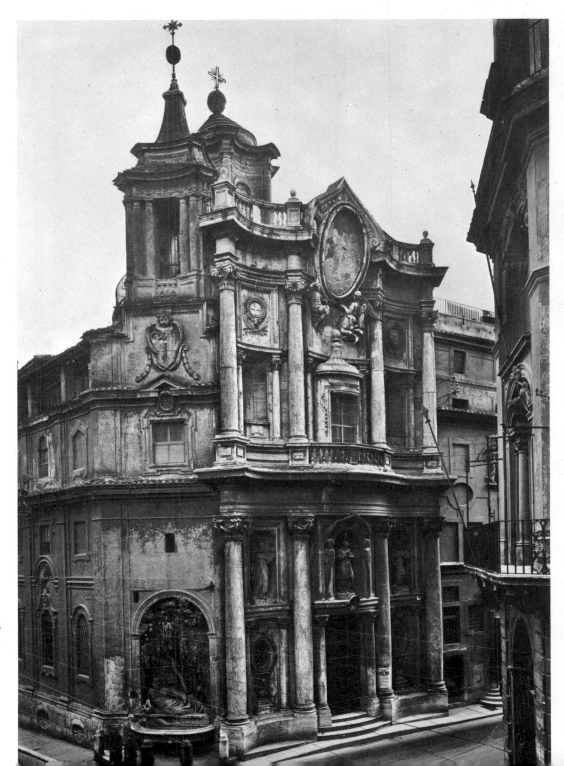

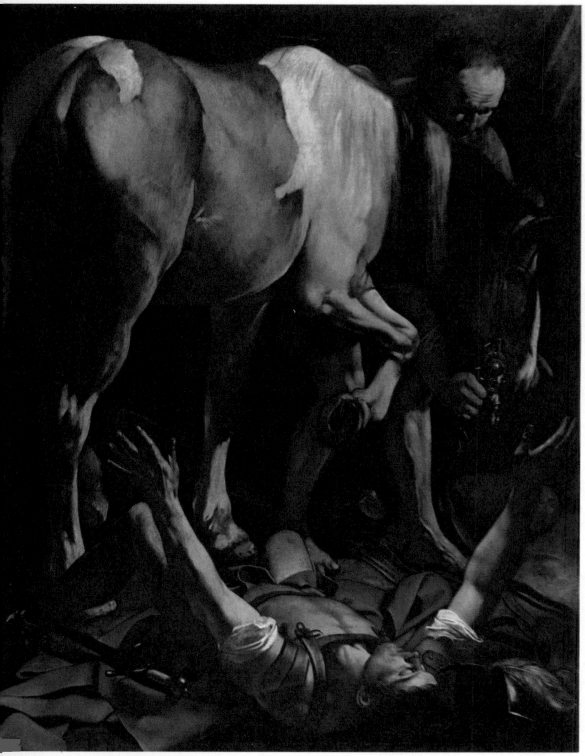

1. Caravaggio: *The conversion of St. Paul*, 1601.

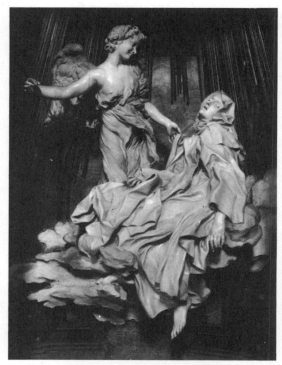

2. Giovanni Lorenzo Bernini: *The ecstasy of St. Teresa*, 1645–1652.

In 17th century Italy the taste for serene, softly-lit compositions in painting, like those of Raphael and Titian, had vanished. Already foreshadowed by Michelangelo and Tintoretto, the new taste was for paintings full of violent movement and sudden rapid contrasts of light and shade. The foremost exponent of the new style was Caravaggio, who revolutionised European painting with his powerful, violent genius. His works were a reaction both against the serenity of the Renaissance, and the worn-out mannerism of his contemporaries. He led a return to the representation of real life, even in its harshest and ugliest aspects. But he was not a realistic painter in the sense that he faithfully reproduced scenes from the world before him. He had a very personal and intense poetic vision which he expressed in highly calculated compositions in which the sense of drama was obtained by violent lighting effects. He composed his scenes so that a beam of white light would cut like a blade through the darkness of the background. He used this forced and theatrical light as a producer would use a spotlight on a darkened stage. Although he first used this novel technique in the painting of religious subjects, he later extended it to secular scenes, in which light invested even inanimate objects with a special significance, so that flesh, glass, and flowers seem to have a life of their own (3).

The Baroque style in sculpture received its greatest impetus from Giovanni Lorenzo Bernini, the creator of the colonnade in front of St. Peter's (page 180, 1). His figures are full of a movement and a violence of expression which almost touches the absurd, but his skill in modelling surfaces was unsurpassed. His career as a sculptor was dominated by his restless desire for the new and the unattainable.

"Is this figure alive, or is it marble!" Such was the question Bernini intended his amazed public to ask themselves when they were faced by his sculptures. Like his great colonnades, his figures of *Apollo and Daphne* (4) hurl themselves into space in a frenzy of violent action, underlined by their swirling draperies and thick, streaming hair. But even such a striking display of technical brilliance was insufficient to satisfy Baroque tastes. Bernini's great sculptural group, the *Ecstasy of St. Theresa* (2) is set like a stage drama, placed as it is between columns, and lit with diffused light from above. One of Bernini's great monuments was his majestic bronze *baldacchino* or sculpted canopy, over the high altar in St. Peter's. The canopy, mounted on high spiral columns which rise up towards Michelangelo's dome, was designed to overwhelm the spectator.

3. Caravaggio: *The Young Bacchus.*

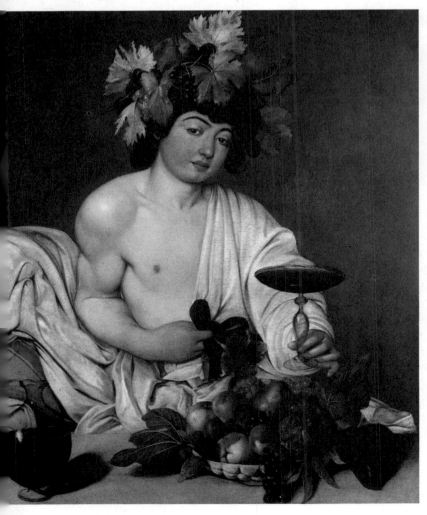

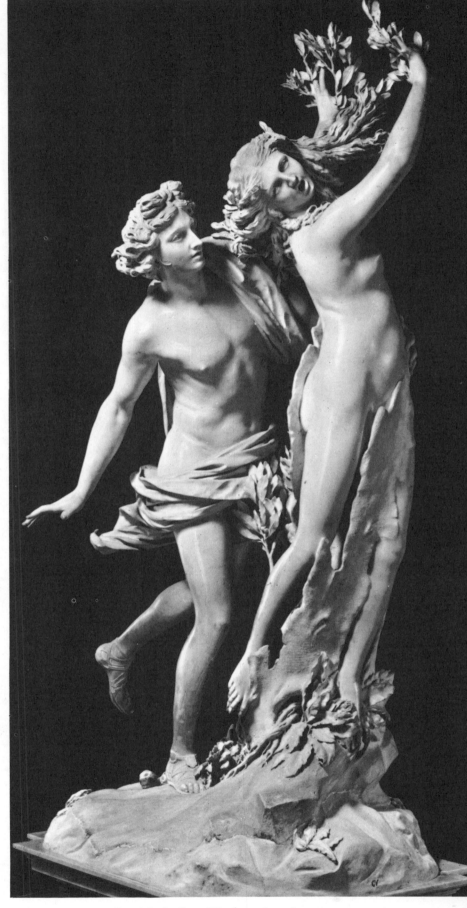

4. Giovanni Lorenzo Bernini: *Apollo and Daphne*, 1622-1624.

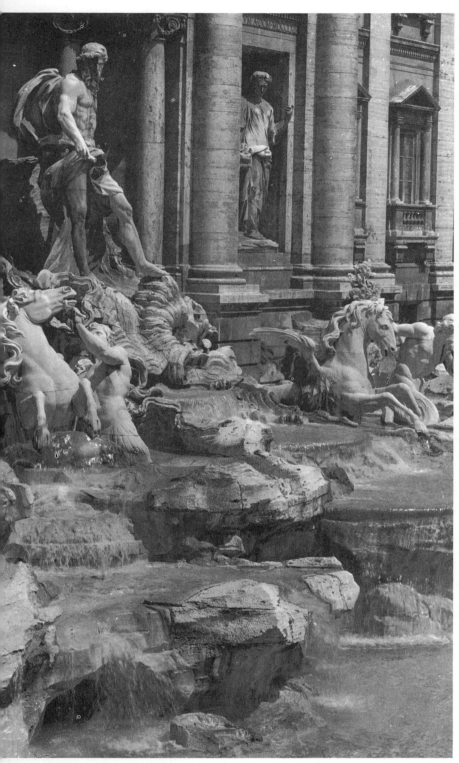

1. Niccolò Salvi: *The Trevi Fountain*, 1732–1762. Rome.

2. Andrea Pozzo: *The glory of St. Ignatius*, about 1702. Ceiling, Church of St. Ignatius, Rome.

While Caravaggio was engaged in expressing his powerful personality in new, dramatic paintings at Rome, the Baroque style was spreading quickly all over Europe. Artists produced works of dazzling virtuosity, triumphing over every technical obstacle. A school of "illusionist" painting grew up in Rome and neighbouring cities, where artists went beyond the *trompe-l'oeil* technique already used by some Venetian painters such as Veronese (pages 164–165), in the decoration of ceilings. Having perfected their technique in the Mannerist schools, they made abundant use of their skill in composing paintings in which

184

3. *Baroque Harpsichord*, Italian,
17th century.

space seemed to explode into an infinite series of receding per-
spectives. After the Jesuit painter Andrea Pozzo had painted his
extraordinary ceiling in the Church of St. Ignatius at Rome (2),
he marked a small spot on the floor below, to show the spectator
where to stand in order fully to appreciate all the complex
perspectives of the painting.

This extravagent painting style, with its emphasis on showy
displays of technical virtuosity, lasted until the end of the 18th
century, but meanwhile the Baroque was reaching its peak in
other countries of Europe.

185

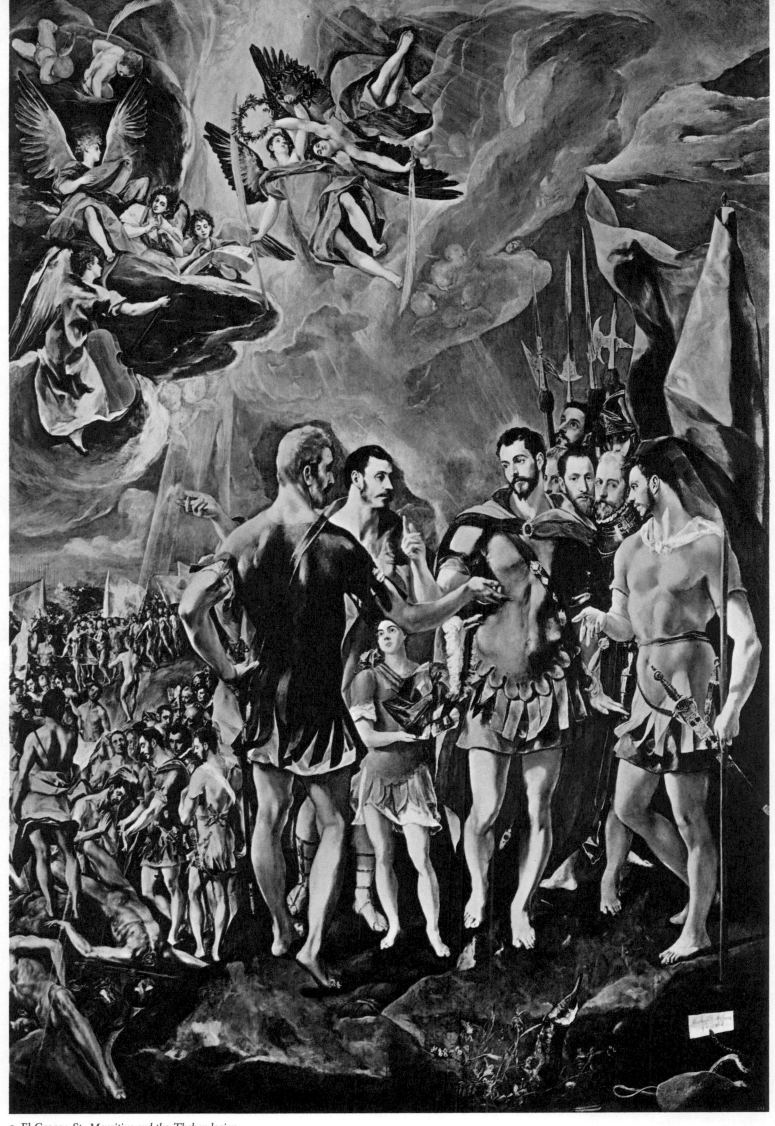

1. El Greco: *St. Mauritius and the Theban legion.*

CATHOLIC BAROQUE

SPAIN, FLANDERS AND VERSAILLES

As the Baroque style spread over Europe, it assumed different forms from country to country. But everywhere, it retained its emphasis on dramatic contrasts of light and shade, and vast compositions filled with teeming, restless figures. In many places the style was still used to express the mystical fervour from which it had originally sprung in Rome, but in some countries, especially in France, it was exploited by artists of a more philosophical and reflective nature. Strangely enough, there was an element in Baroque which corresponded to the evolution of scientific thought of the time. The 17th century was an age of great scientific studies. Newton and Kepler were two of the many scientists and astronomers who were particularly concerned with the laws of light and optics. Among the questions they attempted to solve were: did light consist of waves or of particles? was it composed of rays emanating from divine grace or was it a purely mathematical and physical phenomenon? Such problems were discussed in scientific, religious, mystical and philosophical terms and gave rise to a new form of painting which mirrored this passionate and often poetical preoccupation with light passing through space.

At the same time, artistic imagination found new horizons, with dreams of a Golden Age or ideal state of nature to provide a background for exotic theatrical scenes. Such were the first intimations of the Romantic movement which was to mature two centuries later. In 1643 Louis XIV came to the throne of France and turned the new ideas to his own account. He called himself the "Sun-king", and transformed his regal splendour and even his daily existence into a sumptuous and complicated ritual. All the splendour and excitement of the Baroque, its surprising contrasts of light, its intense, emphatic shapes, and its rich variety of materials, were placed in the king's service to create a stupendous panorama around him of glass and stone, gardens, painting and sculpture. Baroque was originally born in Italy where artists were directly encouraged by the popes, and where the daylight itself became an essential element of painting and could be used to give a feeling of dramatic tension. When it reached the court of Louis XIV it lost its immediate, deeper significance to become transformed into a show of richness and majestic splendour.

El Greco was a sufficiently independent artist not to belong to any one school, but his paintings have the same Baroque emphasis on restless movement and dramatic action as the fantastic *Altar of the Transparente* (2), built more than a century after his death. With its billowing clouds and angels in full flight, sculpted in coloured marbles, the altar, illuminated by a round opening at the end of the shadowy nave, is one of the last masterpieces of Baroque sculpture. Such church decorations reached their climax in the late 18th century in German churches and monas-

teries, but the effect of this particular work is all the more surprising as it is set in a 13th-century Gothic cathedral.

When El Greco came to Spain, the country was convulsed by the activities of the Inquisition, and was undergoing a wave of religious fervour inspired by such mystics as St. Teresa of Avila and St. John of the Cross. It was in this turbulent whirlpool of fanatic piety and mysticism that El Greco spent the rest of his life. His figures, with the exaggerated elongation of their limbs, and their twisting, contorted gestures, seem to be transfixed by supernatural forces. He had learned the Byzantine style of painting angular, accentuated figures bathed in a golden light, from the icons of his native Crete; in Venice he had studied the soft, feathery brushwork of Titian and the explosive compositions of Tintoretto.

In the complex painting reproduced (1), we can see how El Greco gave free rein to his mystical imagination, and combined his flame-like forms into a resplendent, electrifying scene of deep spiritual conviction.

2. *Altar of the Transparente*, completed in 1732. Toledo Cathedral.

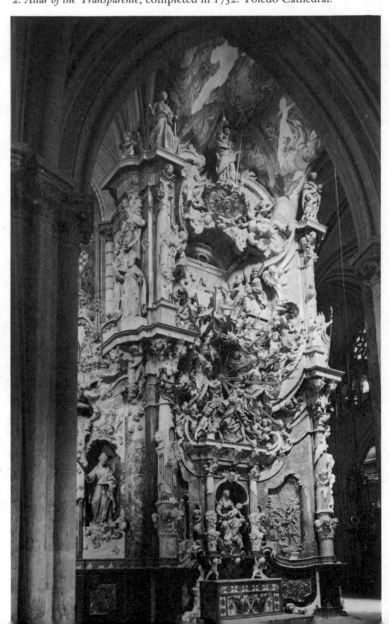

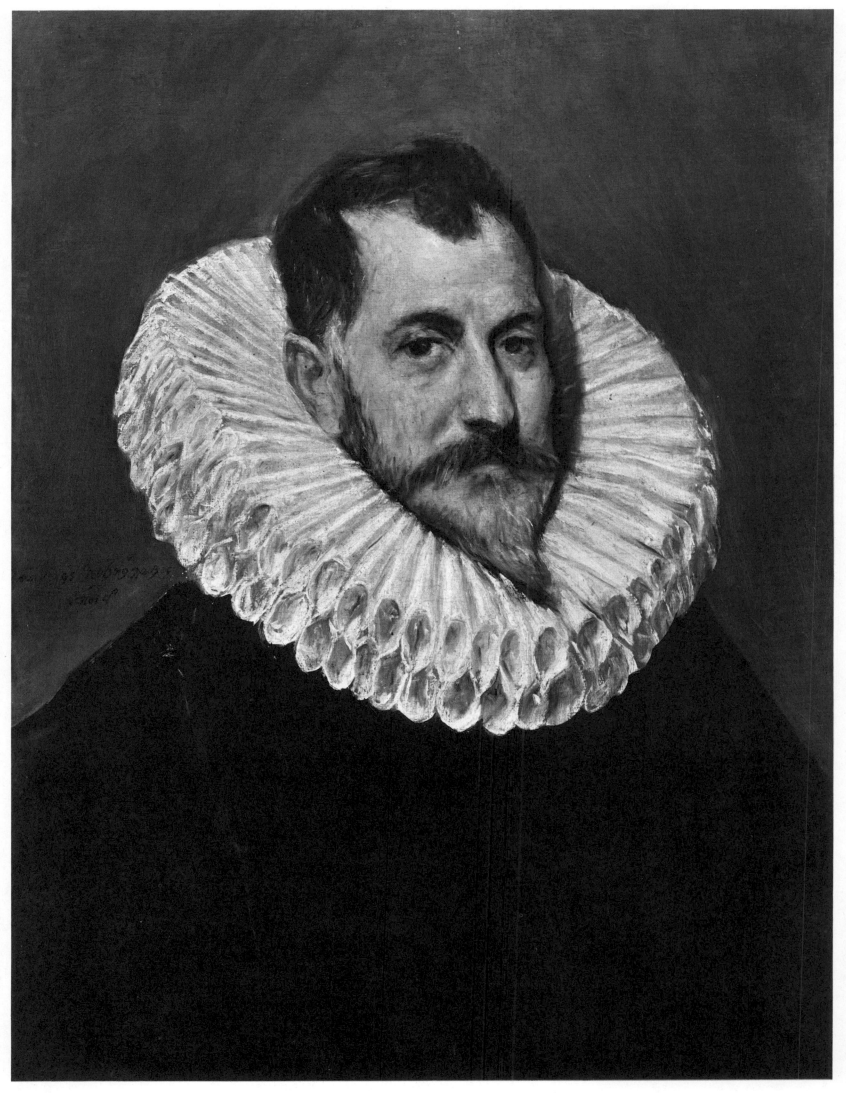

188

While he was at Venice, El Greco had been fascinated by Tintoretto's paintings. Despite his own strong individual imagination, the influence of the Venetian artist showed in his twisting, deformed figures bathed in vivid light, his dramatic compositions based on intersecting lines, and the expressive violence of his shapes. The obsessive mystical climate of Spain under the Inquisition was perfectly suited to such an artist who felt compelled to express his own visions.

Rubens and Velázquez both created their own painting styles with all the individual authority that distinguishes great artists, but they can still be said to belong to the Baroque period. At the age of twenty, Rubens came to Italy and spent the next eight years there before returning to his native Antwerp, where he established the most productive workshop that the western world had ever seen. With the aid of pupils, he painted portraits, religious and mythological scenes, designed tapestries, triumphal arches for military processions, chariots and costumes for festivals. He also executed a series of mural-size paintings to represent the arrival of Maria de' Medici at Marseilles for her marriage to king Henry IV of France. These paintings were hung in the Luxembourg Palace at Paris (although now in the Louvre) and exerted a great influence over painters of succeeding generations.

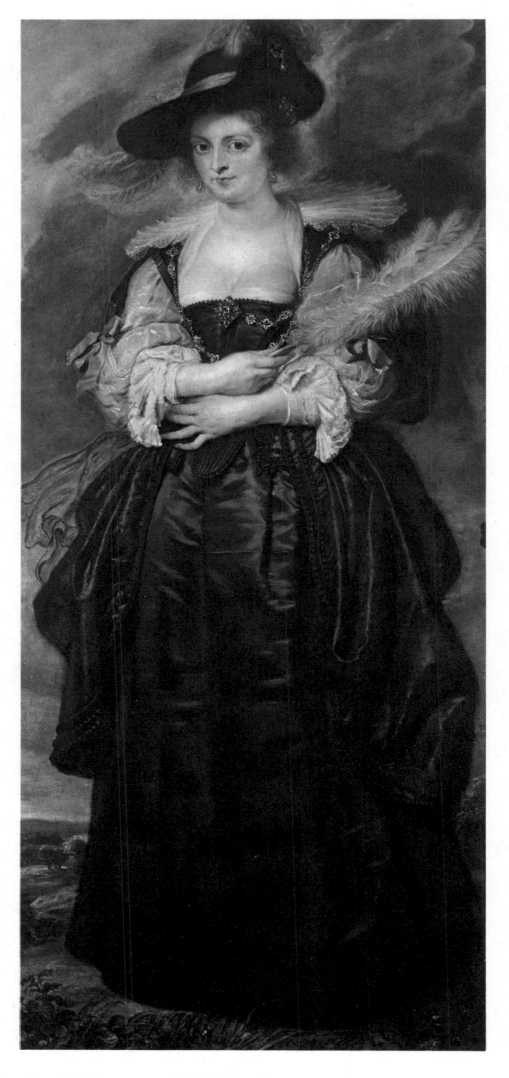

1. El Greco: *Portrait of an unknown man.*

2. Peter Paul Rubens: *Portrait of Hélène Fourment*, about 1630–1635.

1. Peter Paul Rubens: *Landscape*, 1577–1640. Detail.

Between 1627 and 1628 Rubens visited Madrid where he copied some canvases by Titian, whose works he already knew. He rediscovered the importance of Titian's style and technique, with his warm, rich use of colour and light. Like his Flemish predecessor Breughel, Rubens liked to paint long processions of figures, but he surpassed Breughel in his knowledge of Venetian techniques which he took to their furthest limits. No other painter has ever painted such splendid flesh tones.

In his mature period, after his voyage to Italy, Rubens displayed all the fulness of his genius, which was inspired by a great love for life, dynamic high spirits, and a joyous creative spirit. His painting reached one splendid height after another in carefully controlled compositions, full of rich colour vitality in the figures and a golden light shining over landscapes and figures alike. Towards the end of a life which he had lived fearlessly and without self-doubts, and which was dominated by the figures of his two wives, Isabella Brandt and Hélène Fourment (see page 189), the great court painter who had portrayed so many princes and duchesses, turned to the life of the humble people. He exalted the rich vitality and sensuality of country life in landscapes (1), and like Breughel, in scenes of village festivals.

1. Diego Velázquez: *The maids of honour ("las meninas")*, 1656.

If one side of the Spanish Baroque temperament expressed itself in almost expressionistic form, in mystical, ecstatic scenes, there was another side which preferred austere formality. An outstanding example of this latter tendency is the *Escorial* (2), a solemn, fortress-like assembly of buildings, monastery and chapels built in the desolate countryside near Madrid as a residence for King Philip II.

When Velázquez became court-painter to Philip IV, the court had moved to another palace, but the severe, unadorned architecture of the Escorial has something in common with the austerity and grandeur of Velázquez's paintings. It was a time of decline for Spanish power: the "Invincible Armada" had been destroyed during the attempted invasion of England in 1588, and in 1648 the Spanish king had been obliged to grant indepen-

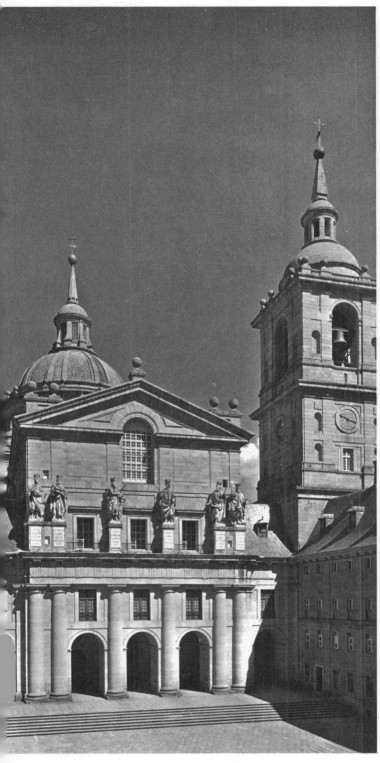

2. *The Escorial*, 1563–1584. Madrid.

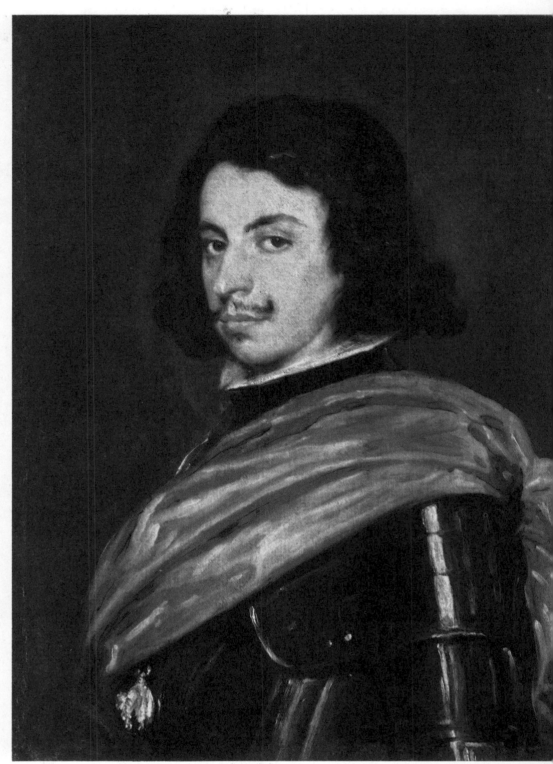

3. Diego Velázquez. *Francis I of Este.*

dence to Holland. The atmosphere at the court of Philip IV was restrained and sombre. Velázquez's method of working was as austere and disciplined as Rubens's was joyous and uninhibited. Velázquez had once visited Italy and produced his impressive portrait of the pope, but for the most part he remained at court, painting grave-faced princesses, melancholy dwarfs, princes and their favourite dogs (1).

Velázquez's visit to Italy—traditional for all artists of his time —gave him a new understanding of light and of the subtle luminous variations in the atmosphere. Whereas Rubens painted with a brush overflowing with rich colour, Velázquez used one that was almost dry. He then touched over several layers of

dark pigment to capture the strange play of light and shade, and the way light fell and dissolved into dust-like particles over a piece of red velvet, or a blonde head of hair, or a mirror. Unlike Rubens, Velázquez never assembled his figures in close groups, united by an overall rhythm of movement, but placed them in almost geometrical compositions balanced by the interplay of light and colour, with, for example, a clearly lit figure standing against a dark background. In his masterpiece, the fascinating *Maids of honour* (1), Velázquez, painted himself at his easel with the royal children, and the reflection of the king and queen in the mirror. The whole composition is a close study of light and pale dissolving forms painted with rapid, light brush-strokes.

193

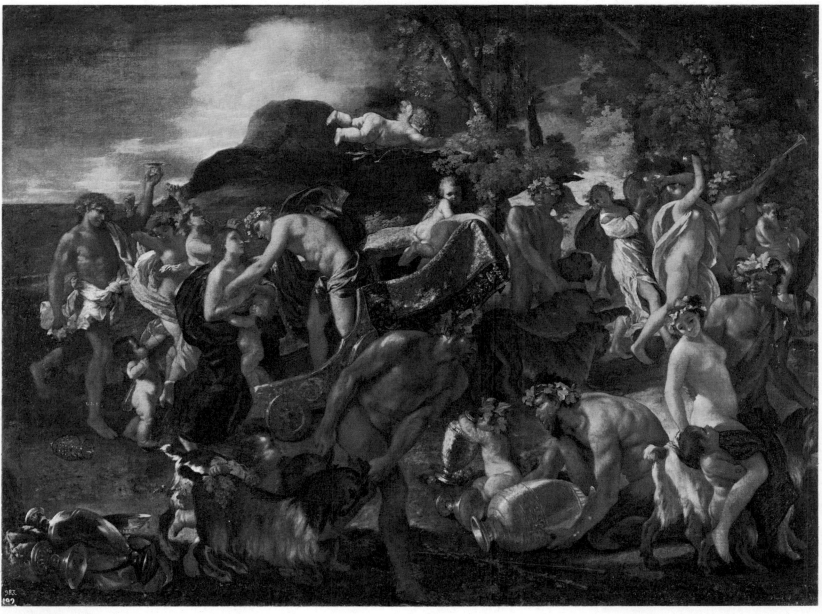

1. Nicolas Poussin: *Bacchanal*.

Poussin and Claude Gellée (better known as Claude Lorrain) were the French counterparts of Velázquez and Rubens: they both belonged to the age of the Baroque, but they represented opposing aspects of it. Poussin's style was cold and rational, like that of Velázquez. His paintings are clear-cut studies of forms set within deep space, and the mood of his compositions is harmonious and serene. On the other hand, Claude's art is full of drama. Both these masters spent years working in Rome, which was not only the source of the Baroque style, but also the home of the late Renaissance. There, Poussin was particularly fascinated by such works as Raphael's frescoes in the Vatican. He composed his great landscapes with mathematical exactitude; his figures generally converge towards a central point; or alternatively, a larger figure may be the focus towards which all the other elements are drawn by diagonal lines, or by the rhythm of undulating, linked bodies (see pages 196-197). The eye is thus slowly drawn in sequence from one form to another in the way that a series of musical chords will finally resolve into the dominant one. This formal process was used by Poussin in his great paintings of religious or mythological scenes as well as in

his majestic landscapes, full of stillness and sunlight in which every shape, every block of stone is clearly outlined. More recent French painters, for instance Corot and Cézanne, studied Poussin's technique to draw inspiration from his bright, clear colours. Poussin lived and worked at a time when the spiritual climate was changing, and a revolution of scientific and philosophical thought was taking place. He was the contemporary of court dramatists like Racine and Corneille who used classical themes for their plays, in which their heroes spoke lines of classical gravity in majestic, measured accents. Meanwhile, scientists and thinkers like Galileo, Descartes and Pascal were opening up vast new fields of human knowledge and understanding.

Claude Lorrain's landscapes are filled with light (3), and the ruins of ancient Roman temples, but the light itself is golden rather than cold white, and it softens and blurs the contours of his forms instead of sharply separating them, as in Poussin's paintings. It falls on strange and indeed barely recognisable objects—a moss-covered tower, a fragment of a pillar, or an abandoned ship in an eastern harbour. There was a profound difference in the way these two French artists observed nature.

2. Claude Lorrain: *The Embarkation of the Queen of Sheba*, detail of figure 3.

For Poussin a drawing was almost a scientific aid to the understanding of solid forms of light. For Claude, it was an expression of the eternal ebb and flow of the elements, hasty brush strokes on paper to be taken back to his studio. There, he composed more organised, imposing works in which all the forms were made to converge towards a single point in the background. But while Poussin usually placed some specific object at the focal point of the composition, Claude would leave the space in the background completely clear.

This kind of composition tended to leave one with a feeling of suspension, as though the last note in a scale were hanging unplayed in the air. Claude was anticipating the Romantic artists and his art was later to influence the Dutch and English landscape painters, who became fascinated by his gentle colours and shapes.

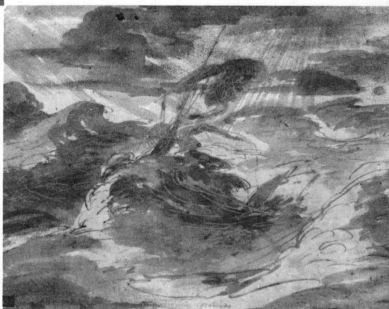

4. Claude Lorrain: *Ship in a tempest*. Drawing.

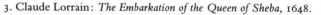

3. Claude Lorrain: *The Embarkation of the Queen of Sheba*, 1648.

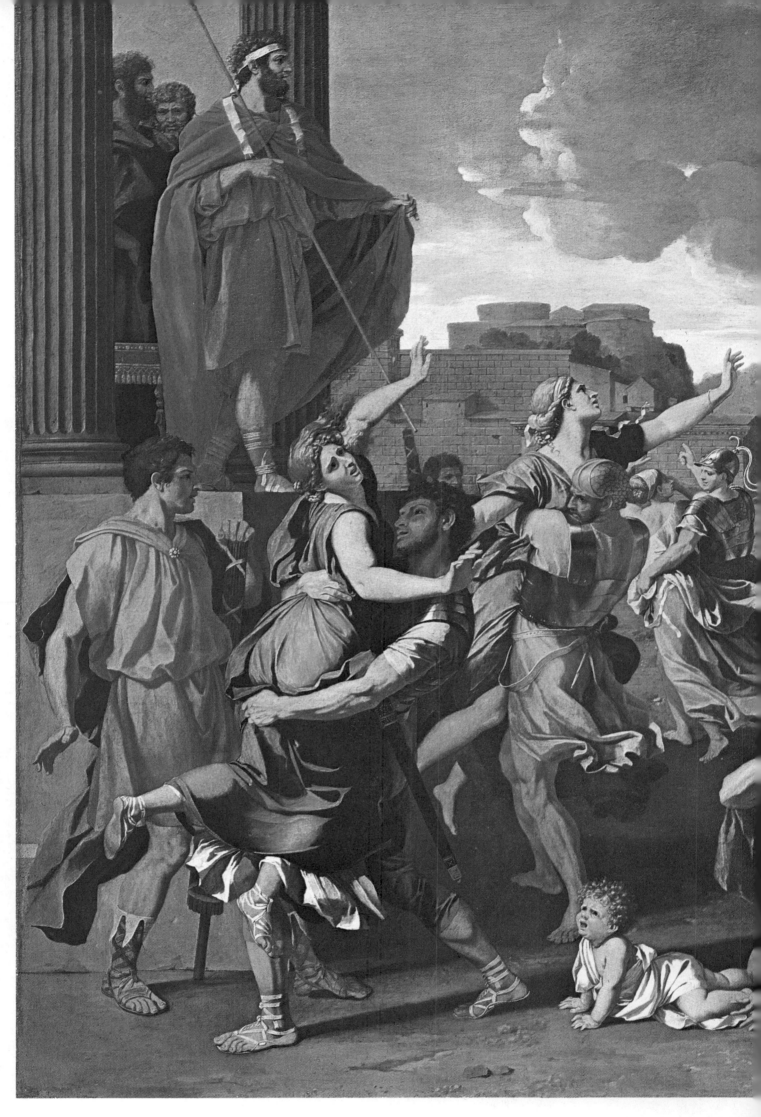

Nicolas Poussin: *The rape of the Sabine women*, before 1637.

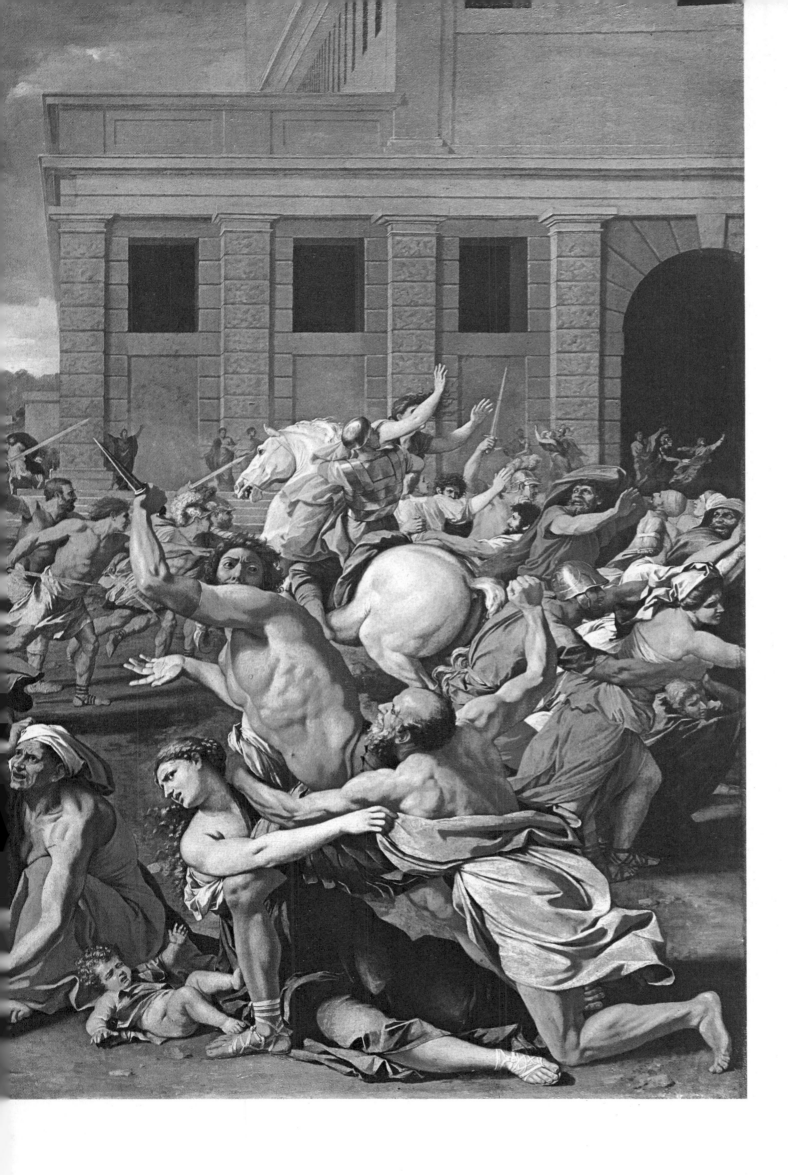

1. Coysevox and Charles Le Brun: *Palace of Versailles, Salon de la Guerre*, 1678.

In the 17th century the artists of Italy, Spain and Flanders made use of light, dramatic shadow effects and deep space in an almost sculptural manner. Louis XIV of France endeavoured to give concrete expression to these elements in his grandiose palace at Versailles. All the finest artists in his kingdom were pressed into his service, and whole factories, including the famous Gobelins establishment, were hired to turn out tapestries, furniture, porcelain and other objects for the palace. The style in which all these works were executed took the name of the king, and was called "Louis Quatorze". Louis Quatorze furnishings retained something of the ponderous heaviness of medieval oak, but used massive bronze and gold leaf, painted stucco and coloured marbles. The wall on the left (1) has been transformed into an ornamental plaque, with gilded angels, wreaths, and stucco figures, paying homage to the Sun-king, himself portrayed in the central relief.

2. André Le Nôtre: Garden of Versailles, 1662–1682.

3. Charles Le Brun: *Four faces: Admiration, Crying, Smiles, Despair.*

During Louis XIV's reign an Academy was established in France which classified all the new art techniques and styles in a truly scientific manner, and imposed models for artists to follow. The first director of the Academy was Charles Le Brun, an architect and painter. In the drawings reproduced (3), Le Brun showed his talent for making a scientific study of all the different expressions of which the human face under the stress of various emotions, is capable.

At Versailles, near Paris, a little hunting château had been built for Louis XIII. In the reign of the Sun-king the château was re-built on a vast scale, magnificently furnished, and was made the brilliant centre of court life. The architect was Jules Hardouin Mansart who created a majestic structure in the style of the Italian Renaissance, divided into three horizontal ranks. The lowest storey was built in the "rusticated" style, the wall being given a rough, rock-like surface similar to that of the Medici palace at Florence, the central storey was faced with elegant Ionic columns and pilasters, and finally, the upper storey was given a row of small windows, a balustrade and a file of ornamental sculpture. For the interior, Le Brun designed great rooms faced with mirrors and inlaid marble, which were to be lit by thousands of candles. André Le Nôtre laid out magnificent gardens in front of the palace (2, 4), designed like one of Poussin's views: fountains, orange groves, and geometrically arranged flower patterns were laid out everywhere, and sculptures in a refined Mannerist style added to the general air of splendour.

For a further century, the palace of Versailles became the centre of court life, an ideal setting for a fabulous world, created by artists who had worked to give form to the dreams and ambitions of their mighty monarch.

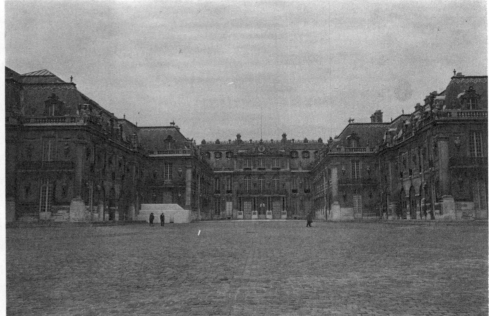

4. *The palace of Versailles*, built by Louis XIV.

1. Rembrandt: *The Syndics of the Drapers' Guild*, 1662.

PROTESTANT BAROQUE

HOLLAND AND ENGLAND

Holland in the 17th century remained free from the more grandiose aspects of Baroque art of Italy, Spain or France. There was neither a court willing to pay for such magnificence, nor a Church to be provided with religious images. The Protestant view of religious art was based on the law of Moses, as interpreted by Calvin, who declared: "Man should not paint or carve anything except what he can see around him, so that God's majesty may not be corrupted by fantasies". Dutch painters were therefore obliged to confine their attention to their immediate surroundings, and to the painting of portraits of individuals or assembled guild members. Landscapes of the placid Dutch countryside and little *genre* scenes which mirrored all the intimacy of domestic life were very popular. Artists painted a profusion of scenes to illustrate every moment of everyday existence, but the school produced several talented masters who were worthy to rank beside the Baroque geniuses of southern Europe like Rubens, Velázquez and Bernini. Among the landscapists and *genre* painters there appeared the solitary, rebel genius of Rembrandt, who brought together all the experiences of his country in works whose grandeur was only appreciated when the Romantic movement began.

In England, the architect was the reigning genius of the century; in other arts the country was still absorbing the lessons of the Italian Renaissance and the Baroque, and transmitting them to her colonies in the New World.

Rembrandt, the greatest 17th-century artist in northern Europe, like Titian, Michelangelo and Leonardo, broke through the confines of space and time in his art, and foreshadowed many later developments in painting. In his early period, he had considerable success with his portraits of prosperous Dutch burghers and their wives. He married the sensual, lively Saskia whom he often depicted in mythological or poetic guise: in one picture (2) he painted her in all the opulent beauty and splendour of Artemis. After her death, Rembrandt withdrew from painting for commissions, although, from time to time, he was called upon for a group portrait, such as the famous *Syndics of the Drapers' Guild* (1), but his subjects no longer mirrored the well-ordered bourgeois world around him, and his style became increasingly expressive. His faces are often veiled by shadows as they loom out of smudged, dark backgrounds, and they are grouped into dramatic patterns which recall those of the Italian Baroque. His figures no longer have the serene relaxed expressions of the complacent burghers, but show all the sadness and wisdom of men who have suffered. At this time, Rembrandt found the source for many deeply inspired compositions among the Jews who lived in the Ghetto of Amsterdam. In his self-portraits, he ex-

2. Rembrandt: *Artemis.*

amined the gradual encroachments of old age and melancholy within the deepening shadows of his own face. He shared a taste for suggestions of exotic foreign countries with his contemporary at Rome, Claude Lorrain, and painted turbaned Arabs and costumed Romans with great golden swords (pages 202–203), and strange buildings towering up into a darkened sky. He also broke the rigid Protestant prohibition against religious subjects and painted several scenes from the Old and the New Testaments.

Rembrandt never lost his interest in the world of man and nature around him. His paintings might be complex and full of mystery, but his drawings often had all the simplicity and precision of a sketch by a Chinese artist of the Sung dynasty (3). For many years after his death, Rembrandt's art was ignored due to a lack of comprehension of his tense, dark compositions. His perturbed spirit, his dense, tormented style, and his use of colour and light were only appreciated in the 19th century, when the Romantic artists rejected Classical restraint to emphasise the eternal struggle between man and nature, and the restless questing of the human spirit.

3. Rembrandt: *A winter landscape*, about 1647. Drawing.

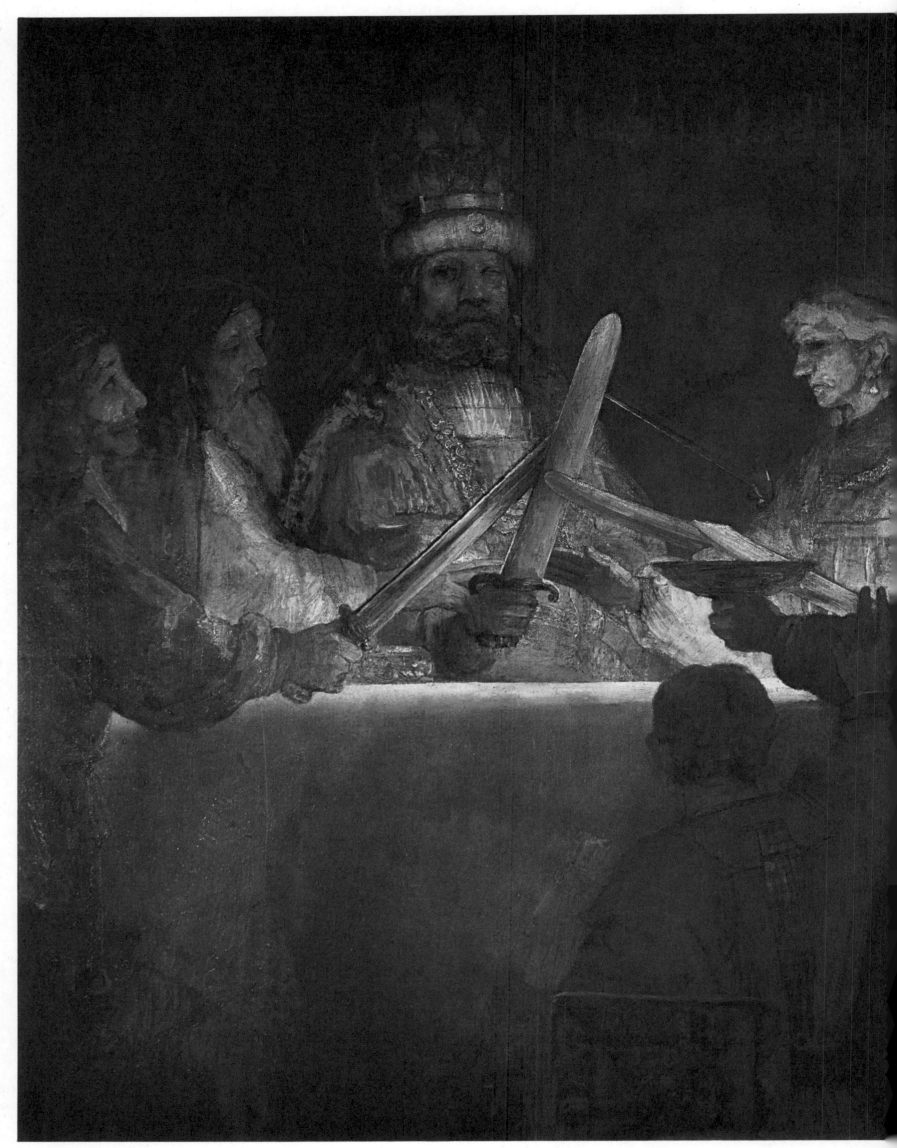

Rembrandt: *The conspiracy of Claudius Civilis*, 1661-1662.

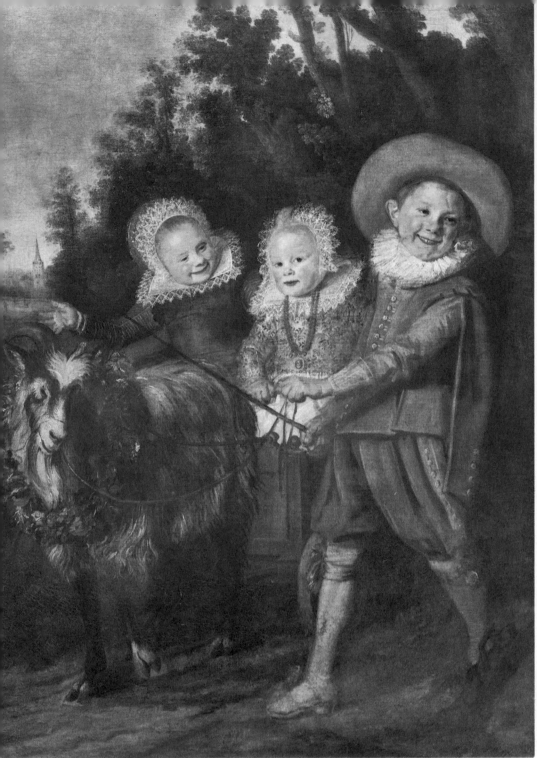

1. Frans Hals: *Group of children.*

but left only a few works, nearly all small and painted on wood. But he was the first great Dutch landscape artist of modern times. His life was restless and complicated, and he seems to have died during a night of orgy. In his works he gave his light and shade effects a strongly dramatic accent. Despite the small dimensions of his pictures he painted vast landscapes in which man is only a tiny figure lost amid the violence of nature. This stormy quality was either expressed by means of tempestuous, rushing clouds or intense shafts of light among the shadows, and his paintings are pervaded by a disturbing suggestion of anxiety.

Painting in the 17th century followed two main opposing directions: on one hand artists were led by the emotional intensity of Rubens and Rembrandt, and on the other by the objective, detailed realism of Velázquez and Vermeer. Vermeer set up his studio in a square-shaped Dutch parlour, amid white-washed walls, heavy furniture and Turk-

It was by way of Rubens' workshop in Flanders that new styles and techniques were introduced into Dutch painting. The Dutch painter Frans Hals had known and admired Rubens when they were both students together and, inspired by the latter's example, conceived a passion for painting and adopted a style of brushwork which made him famous. He used a square, heavily laden brush, and worked with broad, dashing strokes that gave his works the spontaneous freshness of a sketch. He specialised in portraits and, although his popularity soon waned, he has left us many fascinating, intimate glimpses of the life of his time, full of accurate, lively touches (1). But like Rembrandt, his style was too personal for the Dutch taste and he died in poverty.

The wide, flat expanses of the Dutch countryside, where herds of cows browsed among moss-covered trees and the midday skies were either blue and peaceful, or else dark and stormy, inspired many painters to take up landscape art. Two of the greatest Dutch landscapists were Hercules Seghers and Jacob Ruisdael. Seghers was esteemed by Rembrandt himself,

ish carpets. Then, deliberately and without letting the slightest hint of emotion disturb his eye or his brush, he would compose every object he painted into a static pattern. He followed the Baroque artists in allowing light to pour in upon the scene, but his was the clear white light of a Dutch midday, not the tumultuous struggle between light and darkness found in Rembrandt's paintings. Vermeer's shafts of sunlight seem to dissolve into dust over the rough surfaces of carpets and draperies, or to caress the high pale forehead of his model. Every object was carefully sited so as to balance another—the map symbolising the passionate Dutch curiosity about the world, the heavy curtain falling across the scene (3). Should a dark patch, like the painter's costume, appear in the composition, then it had to be compensated by a light and luminous area.

The subjects that Vermeer selected for his studies had none of the exotic, dramatic overtones of Rembrandt's work. The

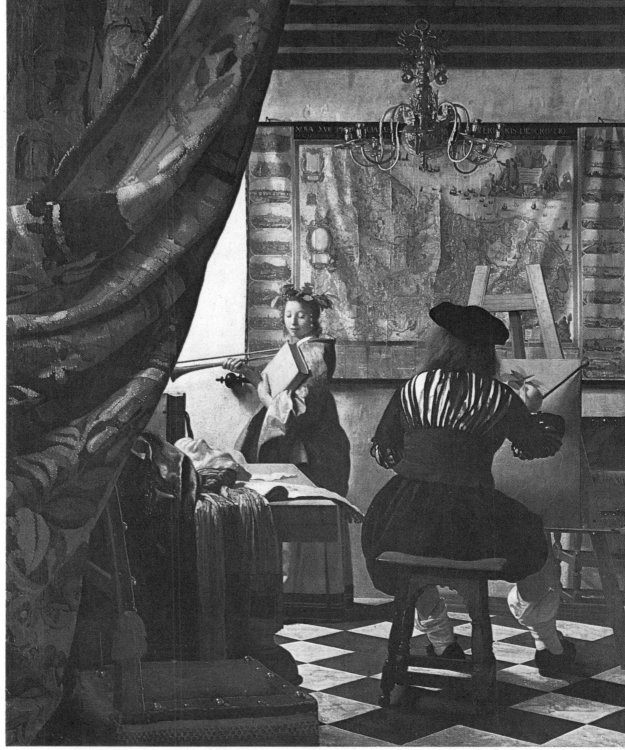

3. Jan Vermeer: *The artist in his studio*, about 1670.

same pale girl with the high forehead, reproduced here dressed as the Muse of Poetry or Art (3), was probably his own daughter. Vermeer painted this same room many times. It was probably his own. In some scenes he includes musical instruments, in others, a work-table. The man seated at the easel may be Vermeer himself, but no self-portrait of his has ever been found. Like Rembrandt's "romanticism", Vermeer's "constructivist" style, as it is called, was too advanced for the taste of his time, for he only had a slight reputation in his lifetime and was soon forgotten after his death. He was rediscovered in the mid-19th century when some artists took an interest in his severely disciplined studies of light, and dark shapes in space.

2. Hercules Seghers: *Landscape*.

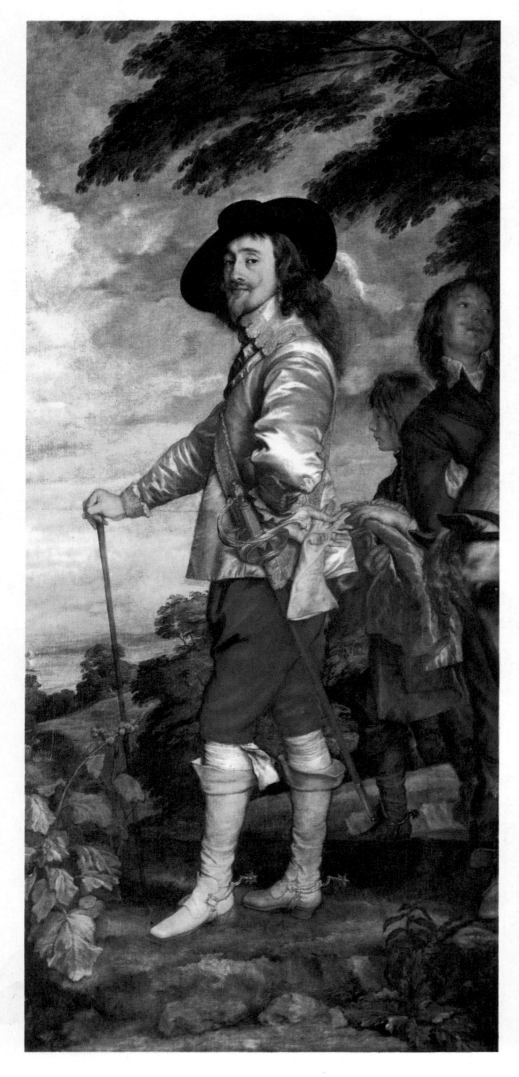

Until the 17th century, England had expressed her creative genius mainly in literature and had lagged behind the other European countries in the visual arts. But as the century advanced English art began to show signs of progress, although, at first, English painting was derived from the Flemish, and Van Dyck (1) took Holbein's place as the great court painter.

The first "modern" English architect was Inigo Jones, who had spent some time in Italy, where he had studied Palladio's villas before returning to the courts of James I and Charles I. He then designed many buildings of which the most elegant was his Banqueting Hall in London (2)—a perfect example of the Italian Renaissance style. Inigo Jones was later followed by Christopher Wren, who brought the Baroque into English architecture. He had been in Paris during the magnificent period when Mansart, Bernini and others were working for Louis XIV, and it was from them that he derived his taste for majestic proportions (4). After the Great Fire of London in 1666 he was called upon to plan many new buildings, particularly churches, for the devastated city.

During the course of the 17th century maritime power was gradually won from the Dutch by the English navy, which became the most powerful in the world. This increase in physical and political power was accompanied by a great upsurge in the arts, poetry and even in science, due to the investigations of

1. Anthony van Dyck: *Charles I*, 1635. Detail.

2. Inigo Jones: *The Banqueting Hall, Whitehall*, 1619-1622.

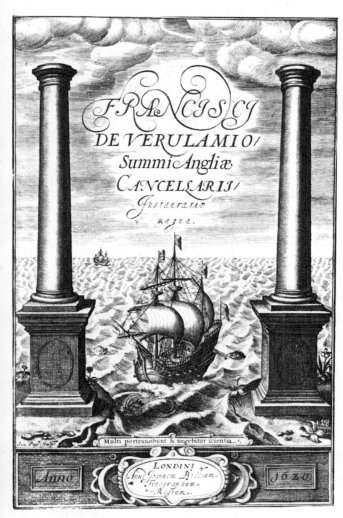

3. Francis Bacon: *Title-page of "Instauratio Magna"*, 1620.

4. Christopher Wren: *St. Paul's Cathedral*, 1675-1720.

Francis Bacon, one of the great philosopher-scientists of the modern age. The engraved title-page (3) taken from one of Bacon's treatises seems to suggest what the explorers of the time must have felt when they saw new horizons appearing beyond the seas.

In the Dutch and English colonies of the New World men were striving to build a society like the one they had left behind. In the British colony of New England the settlers lived in rather dark, large wooden huts whose shapes recalled the styles of the old Tudor homesteads in their native land. In the Dutch settlements along the mid-Atlantic coast states, the planters were more prosperous and lived in a fertile, temperate climate. Their public buildings and houses were built with richer materials, and showed some of the typically Italian proportions brought to England by Inigo Jones and Wren. The simple Virginian manor house (5) may not have any columns or pilasters to adorn its plain brick walls, but in its proportions and rows of windows the design shows a regular, unifying rhythm.

5. *College of William and Mary*, 1695-1702. Williamsburg, Virginia.

1. Antoine Watteau: *Embarkation for Cythera*, detail, 1717.

THE EIGHTEENTH CENTURY

ROCOCO AND NEO-CLASSIC

The first half of the 18th century saw the emergence of a new art style, in which the decorative element was the basic and determining factor. The solemn, grandiose and often exaggerated forms of the Baroque were transformed into a highly refined, showily decorative style, which sprang out of a tendency to regard all life as an elegant and somewhat affected form of art.

The French court of Louis XV developed a taste for rich, graceful, flowery interior decoration which was meant to suggest intimacy and light-heartedness rather than overpowering splendour. The new art style spread to architecture and sculpture in France and then made its way all over Europe where it found its most fervent imitators in the royal courts and castles of the nobility. In Austria the Habsburg descendants of the Holy Roman emperors built cathedrals and monasteries crowned with sumptuous towers and domes, and everywhere castles were built which were no longer gloomy fortresses but elegant, showy residences.

Yet the 18th century was one of the most complex periods in the history of art and ideas. New schools of thought advanced their theories in opposition to older and declining views of the world. Philosophy came to be considered as the synthesis of all human knowledge, embracing the entire universe and presenting it to man for his consideration. The discovery of the ruins of Pompeii and Herculaneum inspired a passion for archaeology, led to a renewed interest in the Classical world and to the birth of a new art theory called "neo-Classicism". Since, it was

2. *Marie Antoinette's harp.*

argued, the Greeks had led art to its most perfect expression and forms, it was to Greek art that one should look for examples to follow.

As an example of the Rococo style, the richly gilded mouldings in the Palace of Versailles were replaced by panels in delicate pastel-shades painted with slender arabesques, like the design for a decoration by Watteau (3). Instead of Bernini's powerful, vibrating shapes, artists made dainty little figures in porcelain. In the theatres the solemn cadences of Racine's dramas gave way to the Italian style of comedies, featuring the gentle, graceful figures of Pierrot and Pierrette and costumed harlequins, which have survived as part of the theatrical language of our own time (pages 210–211).

Just as Rubens was the most splendid exponent of the Baroque style, so Watteau took Rococo to its greatest heights. Watteau had worked in the Luxembourg Palace among Rubens' great series of Medici paintings, and he had learned so successfully from the brilliant, luminous style of Venetian painting that he was nominated official painter of Louis XV's "fêtes galantes". These were wonderful evening entertainments held in the gardens of Versailles, and Watteau painted them in all their colour, their shimmering lights, and the splendour of their cos-

3. Watteau: *Colombine and Harlequin*. Engraving.

4. *The imperial coach of the Viennese court,* 18th century.

tumes, in works which have the richness and fantasy of a breath-taking stage set. Follow the lines of the figures in his *Embarkation for Cythera* (1), as they wind over the hill-side and down into the valley, and notice how they are arranged like a garland, and how the flying cupids are entwined like a wreath around the ship's mast—all these undulating lines seem to echo the curling shapes of waves or sea-shells. But there is also a gentle touch of melancholy in the misty shadows of the garden and in the tones of the silks and powdered wigs of the dancers with their oranges, violets, dark greens all bathed in a soft golden light.

Antoine Watteau: *Players of the Italian Comedy*. 1720.

210

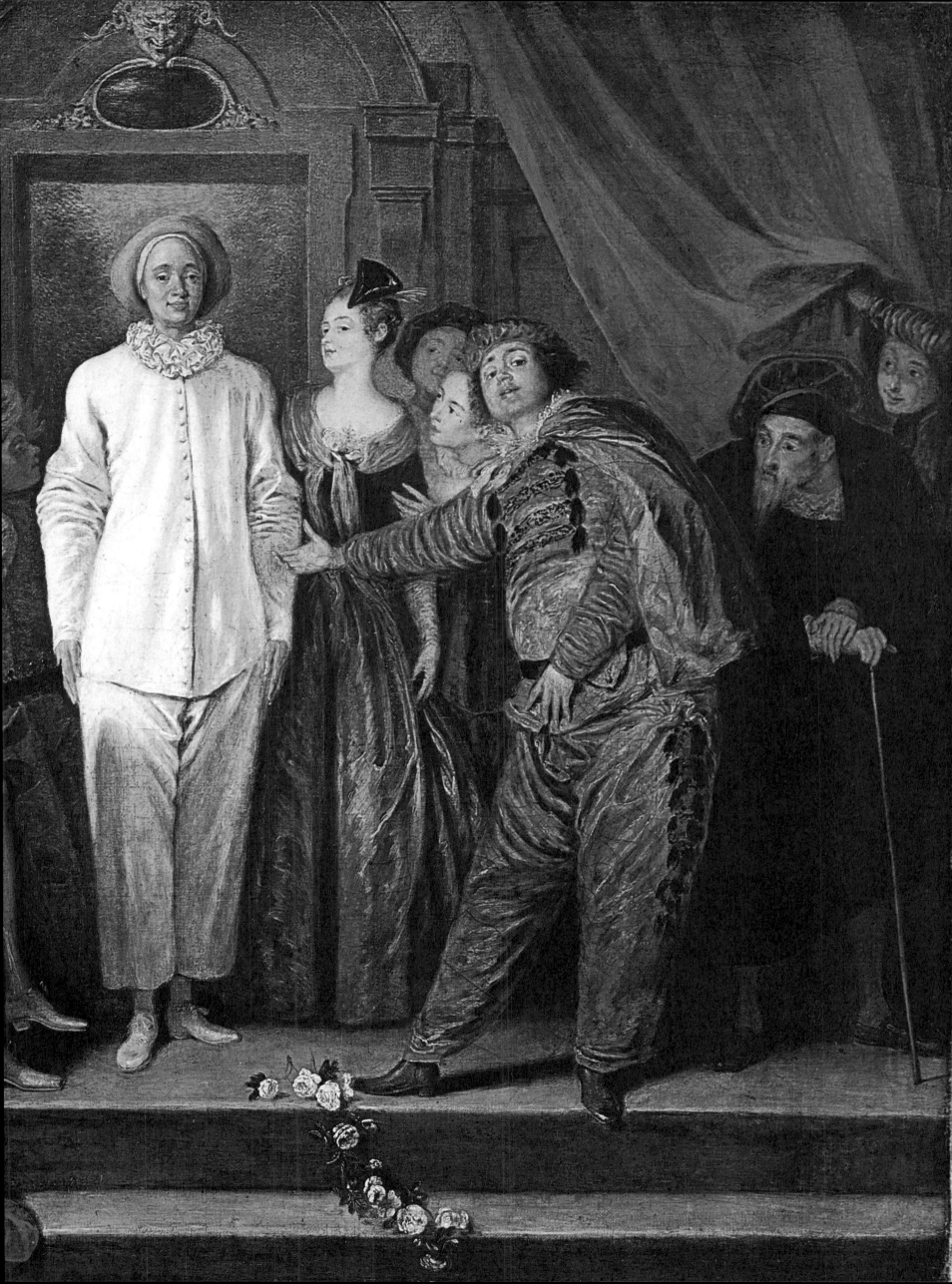

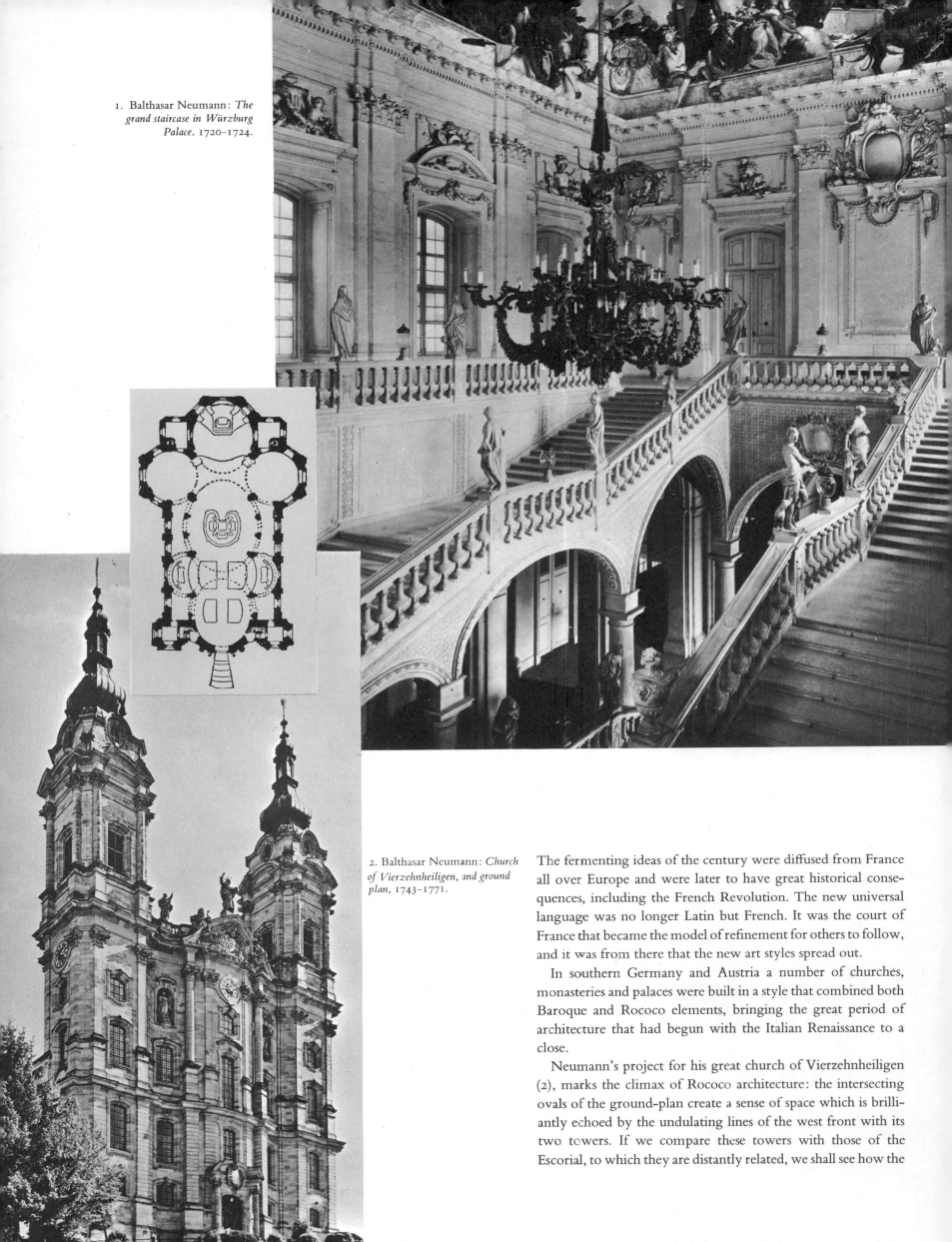

1. Balthasar Neumann: *The grand staircase in Würzburg Palace.* 1720–1724.

2. Balthasar Neumann: *Church of Vierzehnheiligen, and ground plan,* 1743–1771.

The fermenting ideas of the century were diffused from France all over Europe and were later to have great historical consequences, including the French Revolution. The new universal language was no longer Latin but French. It was the court of France that became the model of refinement for others to follow, and it was from there that the new art styles spread out.

In southern Germany and Austria a number of churches, monasteries and palaces were built in a style that combined both Baroque and Rococo elements, bringing the great period of architecture that had begun with the Italian Renaissance to a close.

Neumann's project for his great church of Vierzehnheiligen (2), marks the climax of Rococo architecture: the intersecting ovals of the ground-plan create a sense of space which is brilliantly echoed by the undulating lines of the west front with its two towers. If we compare these towers with those of the Escorial, to which they are distantly related, we shall see how the

Rococo style added a mass of exuberant ornamentation to basic structural forms.

In Renaissance buildings space was divided into simple, well-defined compartments, volumes were determined by a unifying sense of harmony, and staircases were given a precise function to fulfil in relation to the rest of the structure. But in German Rococo buildings the staircase itself became the heart of the design, sometimes twisting upwards like the spirals inside a shell, and sometimes turning back on itself, as in the magnificent example illustrated (1). Space itself seems to be dissolving in fragments. Light streams in from the windows across the white walls, into the arched recesses of the well of the staircase, over stucco garlands, angels and the Classical figures adorning the walls and balustrade. The ceiling is painted in the "illusionist" style perfected by the Romans and Venetians, and was the work of the Venetian Tiepolo, who was especially called to Germany to give the finishing touches to this royal palace at Würzburg.

Venetian painting regained its creative vigour in the 18th century. Some of the greatest artists of the time worked in this city, which was so well suited to reflect the colours and fantasies of movement in Rococo art. Among those who gave Venice back her former primacy in art were Tiepolo and Francesco Guardi. Although Rococo had become an international style, Tiepolo left his own individual mark on it, maintaining the splendid traditions of Venetian painting.

The deliberate, analytical aspect of Baroque style was continued in another guise by Rococo artists. It became lighter, more delicate and graceful, although it never lost its character of accurate, scientific observation. One of the great masters of late 18th century painting in Venice was Guardi, who became so popular that visitors to the city used to take home his pictures to remind them of the buildings and monuments they had seen.

4. Giambattista Tiepolo: *Helios*. Drawing.

He bathed his scenes in light and air, using pale colours, giving touches of dark colour to the blue sheen of the light and water. His nervous, brittle style gives the impression of fragility but is, in reality, part of a carefully calculated and controlled technique. He did not limit himself to the Venetian scene but gave his imagination greater play in compositions like *Tobias and the Angel*, in the Venetian church of the Archangel Raphael. His vibrant technique and delicate lighting effects later made him of great interest to the French Impressionist painters.

3. Francesco Guardi: *Canals of Brenta*.

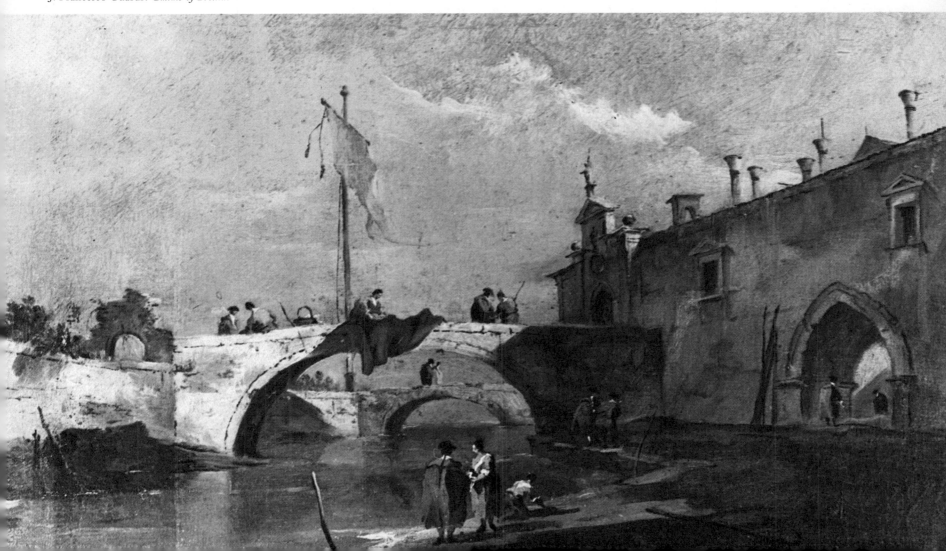

1. William Hogarth: *Laughing audience*, engraving.

In 18th century England and France an ever-growing number of artists rebelled against the artificial court styles. Two of the leading exponents of the more natural style of painting were Hogarth in England, and Chardin in France, although they still used the delicate, light tones that were in fashion. But the subjects they painted tended to be those favoured by the Dutch *genre* painters (2). Hogarth was brilliantly gifted as a satirist and mocked, by caricature, the hypocrisy and artificiality of the pleasure-loving society of his day (1). Chardin, on the other hand, won great popularity with thousands of French families who bought paintings and engravings of his unpretentious works, such as *Blowing Bubbles* and *The Blessing* (4, 5). At present Chardin is admired for his skill in rendering the light and shadows of candle and lamp light playing upon humble household objects. Although his figures are small and slight of build, like elegant courtiers, they are nearly always simple, sober middle-class citizens. In the new age that was beginning it was people such as these who were to become the artist's patrons, instead of royalty as in the great Baroque period. Few great artists were able to keep pace with the popular demand for rather sentimental subjects without lapsing into sugary affectation, and in the following century most of the outstanding artists were forced into a position of rebellion against society.

In the first part of the 18th century the European tastes in decoration came to England. Some architects and designers still followed Italian Renaissance styles while others gave a more original aspect to English art by experimenting in the exotic and fantastic manner that found expression in Rococo. Chippendale, for instance, published a book of patterns for tables, chairs, and mirrors which included Chinese, Classical, Rococo and even Gothic elements, but he gave them all his personal imprint. His

2. William Hogarth: *The Graham children*, 1742.

3. Thomas Chippendale: *Design for a frame*.

4. Jean–Baptiste Chardin: *Blowing Bubbles*.

5. Jean–Baptiste Chardin: *The Blessing*, 1740.

design for a mirror frame (3), includes a fanciful plumed bird perched on the edge, a fat Chinese Buddha seated above, a Chinese girl below, combing her hair, an assorted medley of plum-blossoms, chrysanthemums, icicles, shells and plant motifs, but the essential lines of the frame still remain clear. A famous house and landscape architect, Sir William Chambers, wrote a book on Chinese gardens which so delighted contemporary property-owners that the vogue for wild, rambling gardens spread, although such "landscape gardens" may well have been originally encouraged by a reaction against formal French and Italian designs. The writer Horace Walpole even went as far as choosing the Gothic style: his mansion, "Strawberry Hill", had all the pinnacles, arched vaults, tracery and pointed windows typical of Gothic architecture.

The fashion for the strange and the exotic was to contribute to the Romantic movement at the end of the century, but the leading style in Europe was to be for a time the neo-Classical which was based directly on Greek and Roman models.

1. François Boucher: *Rinaldo and Armida*.

2. Thomas Wedgwood: *Copy of the Portland Vase*, 18th century.

3. Horatio Greenough: *George Washington*, 1832–1841.

The aura of melancholy pervading some of Watteau's works may perhaps have been a reaction to the new movement gathering strength beyond the artificial confines of Versailles. The new movement in art and the sciences lay in the continuous search for knowledge and a tendency towards objective analysis of history, art, human nature and the forces of destiny. The result in art was the birth of the neo-Classical style (2, 3), which was intended to give contemporary themes all the classical dignity of ancient Greek and Roman art. Another of the new style's objectives was the analytical study of all the aspects and details of the physical world. In the past, Mantegna had expressed his own conception of Classical Rome in his paintings, and Poussin and Claude Lorrain had both created imaginary reconstructions of the ruins of antiquity; now, a host of scholars and scientists began a systematic excavation of the ruins of Pompeii and Herculaneum and for the first time gave the world a fairly accurate and complete idea of Classical life and art.

This new enthusiasm for Classical culture was strengthened by the writings of the German archaeologist Johann Joachim Winckelmann, the painter Anton Raphael Mengs, and many others. Scholars and artists visited the sites of Classical civilisations in Italy and Greece and endeavoured to bring them to life again in their art and writings. Meanwhile, undisturbed by this fervour for the remote past, the French court painter Boucher was producing his elegant, highly refined works for an aristocratic public (1).

In England, while some architects and designers explored the curious and exotic styles of the East others joined the neo-Classical movement. In 1768 the painter Sir Joshua Reynolds (5) founded the Royal Academy of Arts in London, to preserve and maintain Classical ideals in art. The movement spread to every branch of art, and Josiah Wedgwood made this exact copy of a newly discovered Roman glass vase (2) and later designed the neo-Classical table-ware which still bears his name. The architecture of the time is called "Georgian" after the four kings of that name who reigned during the century. Georgian houses were built as smaller versions of Palladian villas, which had been based upon careful studies of Roman architecture which Palladio had then adapted in a highly individual manner (see page 163). The main features of Georgian design—imposing columns upon a small central portico between two balanced wings—were often copied in America where brick and wood was used instead of stone and marble. Here, too, these houses are still called "Georgian". One of the most famous furniture designers for Georgian homes was Robert Adam, who had made a close study of Roman remains and decoration. His chairs and tables were inspired by Pompeian wall-paintings although he added elements of his own personal style.

In America the greatest artist of this period was Copley. Although his figures were often set in mannered poses against dark backgrounds and carefully arranged Classical draperies, they have an intimate character which is closer to the style of Chardin than that of Reynolds. Portraiture was also affected by the rising tide of neo-Classicism, and radically changed its character. Subjects lost their individual personality and there was a move away from subjectivity towards the expression of precisely defined aesthetic ideals. The neo-Classical style survived in America until the 19th century and led an artist like Greenough to depict George Washington in a Roman toga, his chest bared and his hand raised in the attitude of a Greek or Roman hero (3).

Even the architects of the New World followed Classical styles as transmitted to them by England. When Thomas Jefferson built a house at Monticello in Virginia, the design he chose included a dome modelled on that of the Roman Pantheon. American craftsmen like Duncan Phyfe made furniture, based on English patterns, for such houses, and silversmiths such as Paul Revere made cups, bowls and dishes in austere, unadorned shapes, thus bringing a note of Classical simplicity into everyday life.

5. Sir Joshua Reynolds: *Col. George K. H. Coussmaker*, 1782.

4. John Singleton Copley: *Daniel Crommelin Verplanck*, 1771.

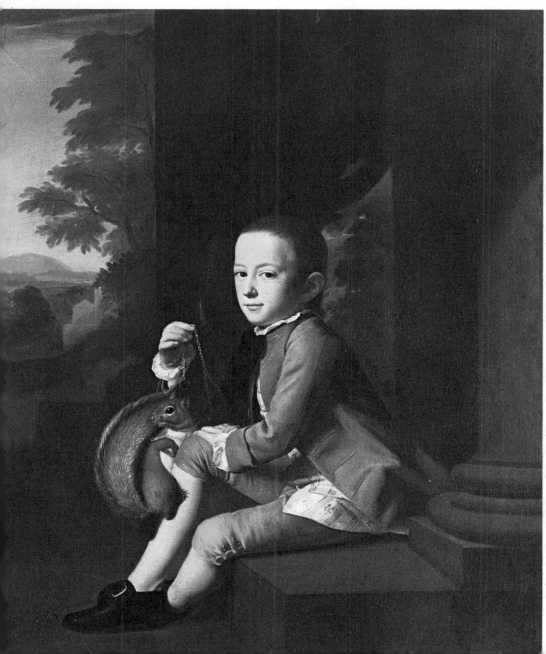

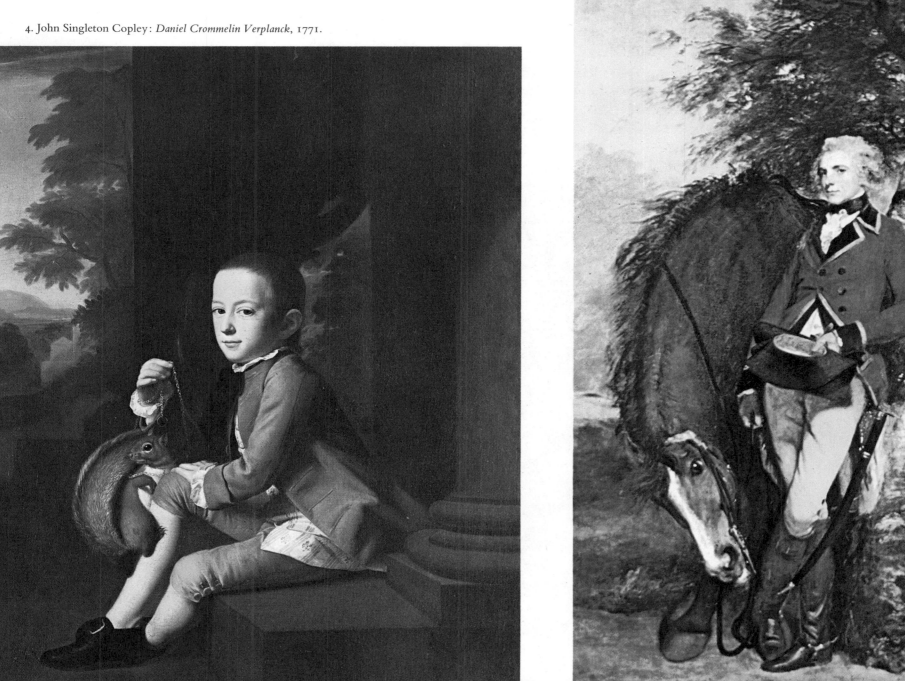

2. *Marie-Antoinette's cottage in the grounds of Versailles.*

1. *Marie-Antoinette's salon,* Versailles.

3. Jean-Antoine Houdon: *Voltaire,* 1781.

The works on these pages illustrate the changes that came over the intellectual and political structure of the western world in the late 18th century. The spirit of the time was reflected in the work of the sculptor Jean Houdon. Besides his work for the French court, he also modelled the men whose combined ideas were to lead to the overthrow of the monarchy: Voltaire (3), Rousseau, Washington and Franklin were among his sitters.

In France, Louis XVI himself gave the seal of royal approval to the neo-Classical style. Compare the austere perpendicular lines of Marie-Antoinette's salon at Versailles (1) with the exuberant decoration of a typical Rococo interior. The legs of the tables and chairs are straight and fluted like Classical columns and the walls are covered with panels of simple designs taken from Pompeian models. But Marie-Antoinette preferred her

"English garden" to the official Louis Seize style. She even had a make-believe shepherd's hut built for her (2). The greatest painter of this dying age was Fragonard, who delighted his contemporaries and the court ladies with playful, joyous scenes of their games and flirtations (4, 6).

In July 1789 the Paris mob rebelled and stormed the Bastille in the very heart of Paris. After the devastations and massacres of the French Revolution, life and attitudes towards art were never to be the same, either in France or in the rest of Europe and America.

The painter Jacques-Louis David was a friend of the revolutionaries and gave artistic expression to their ideals and ambitions. He symbolised their aspirations by painting, in a Classical style, scenes of Roman warriors and heroes, like the impas-

4. Jean-Honoré Fragonard: *La chemise enlevée.*

5. Jacques-Louis David: *The Oath of the Horatii*, 1784.

sioned brothers Horatii who died to keep their country safe from its invading neighbours (5). David drew his figures with a hard, cold line, and painted with opaque, ashen tints. He carefully based the designs of every piece of furniture, armour and costume, and even the hair styles of his female figures, on the archaeological discoveries and knowledge of his time. With the end of the Revolution, and the beginning of the period of Napoleon's conquests, David abandoned his glorification of the Revolution and began to paint flattering portraits of the new emperor, and to depict his victories. As had happened during the reigns of Charlemagne and Louis XIV, the age of Napoleon saw the invention of new art styles. Added impetus was given to the neo-Classical movement, and the new "Empire" style emerged. One of Napoleon's most significant contributions to art was his foundation of a national museum in the old royal palace of the Louvre. In this museum—the first to be opened to the public—were gathered all the works of art the French armies had looted in their campaigns across Europe and Egypt, besides many private collections which had been either confiscated or bequeathed.

6. Jean-Honoré Fragonard: *Drawing*.

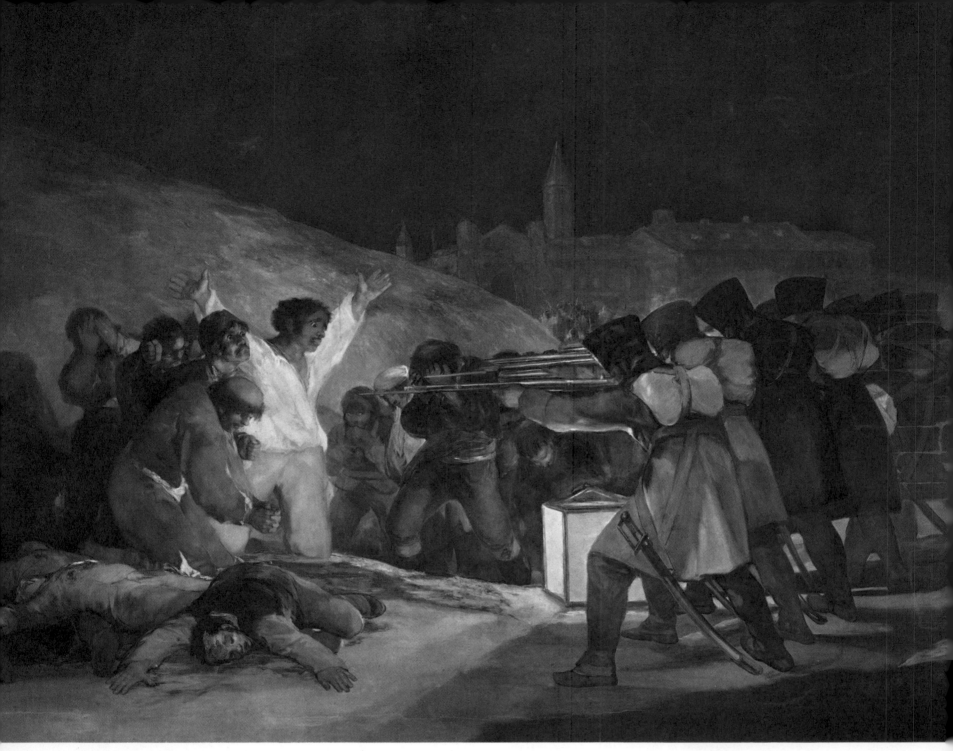

1. Francisco Goya: *The executions of the 3rd of May, 1808*. 1814.

THE NINETEENTH CENTURY

Revolution, which changed the face of Europe in the 19th century, also had great consequences for art, transforming both its aspect and its essential meaning. Rococo styles belonged to a vanished world dominated by the great courts, but in the new century of revolutions there were few royal patrons to commission tapestries, ceramics, articles of luxury and court portraits. A new type of client arose from out of the middle classes which counted an ever-increasing number of landlords, businessmen, lawyers and journalists. They were seldom disposed to be either bold or adventurous, most tended to be conservative in their opinions and politics, and they had little time to devote to art and the acquisition of an artistic culture. On the whole, they preferred works of art which glorified the deeds of their ancestors

in pictures, sculptures and monuments, all in a neo-Classical style. As a result, a prosperous art industry developed in Europe, along lines that we now call *academic*, because this was originally the style recognised officially by the French and English Academies. Much 19th century architecture imitated past styles and lacked both true understanding and any real vitality. As examples of the confusion of taste, the Houses of Parliament in London were rebuilt in a Gothic-revival style, whereas the Paris Opera was built along Baroque lines.

Medieval painting had been mainly sacred in character and had served to instruct the faithful; as the Gothic period drew to a close the art of portraiture flourished again. As the Renaissance artists had turned to mythological and classical subjects for

inspiration, so the 19th century artists made use of the most outstanding heroic episodes of their own time and world. Some took up political attitudes and added their own pleas for justice to the appeals of the revolutionary idealists. Others, concentrated on an analysis of their own inner world, rediscovered the values of the medieval past, and created a new movement in art and ideas which was to be known as Romanticism. The greatest creative minds in Europe, among them Goethe, Byron, Keats, Beethoven and Wagner, took part in this movement together with painters and sculptors. Violence, passionate feelings, and a love of individual liberty were all part of the Romantic ideal. Another aspect of the Romantic spirit was the exploration of the natural world, as seen in the peaceful poetry of Wordsworth and the great English and French landscape paintings of the 19th century. As in past centuries, while the artists probed and analysed the world of nature, their works kept pace with the great scientific discoveries of the age. While the scientists were inventing photography, the telephone, the telegraph, discovering X-rays and the power of radium, artists were passing from Romanticism to Realism and Impressionism until, finally, the poetic vision of the Expressionist painters seemed to open doors into a still undiscovered universe.

Goya and Blake were contemporaries but had no contact with each other, yet both managed to bridge the past and the present in their work. Like Velázquez, Goya was a painter at the Spanish court, his style can be seen at its most sensual and delicate in his two presumed portraits of the Duchess of Alba, *The naked Maja* (2) and *The clothed Maja* (3), with their rich tones, mysterious and refined light effects and subtle expression. Many of his other works are a complete contrast to his courtly style, and are among the most dramatic and intense works ever to have been produced in the history of art. His great painting, *The executions of the 3rd of May*, showing the execution of Spanish civilians by Napoleon's invading army (1), is painted with a savage realism: the whole scene is overhung by a sullen sky, blood seems to have been flung onto the canvas, the figures have been sketched with great gashing strokes of the brush. This was Goya at his most sincere, faithful to his own bitter style in spite of the fact that he was a court painter. His portraits of the Spanish royal family are equally cruel and powerful in their impact, and show the monarchs as decadent and feeble human beings. He was a wonderful draughtsman and engraver and his many etchings and drawings range through every phase of human experience. His great series of etchings, the *Disasters of War*, are one of the most strident, powerful and impassioned protests ever made by an artist against cruelty and the destruction of human dignity.

William Blake had studied the academic neo-Classical style prevalent in England and made use of its clear cold line even when decrying the evils afflicting his own land. He used his art to protest against the social injustices that went hand in hand with the Industrial Revolution, against the excesses of puritanism, and against everything which he considered to be representative of the godlessness of modern man. Blake may have been mad, but it was a madness that conferred a formidable power upon his drawings and his poetry. The awe-inspiring, scaly figure, shown in the picture (4) on this page, is from one of his many illustrations for the Bible.

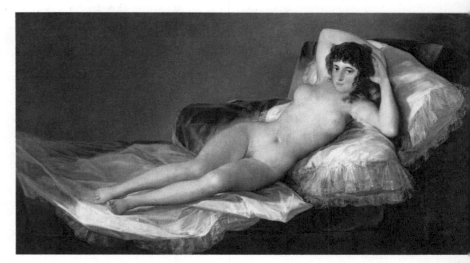

2. Francisco Goya: *The naked Maja.*

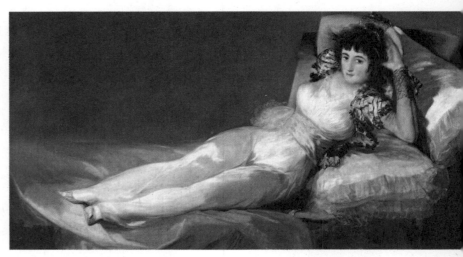

3. Francisco Goya: *The clothed Maja.*

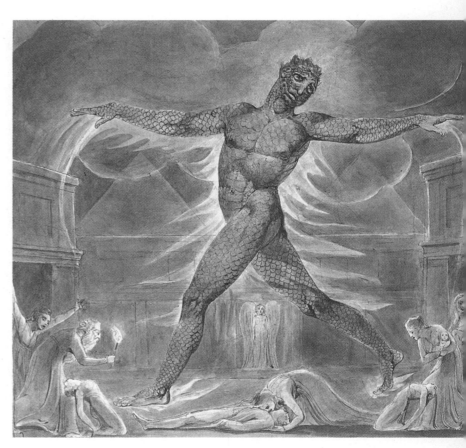

4. William Blake: *Pestilence: death of the first-born*, 1805 Illustration for the Bible. Watercolour.

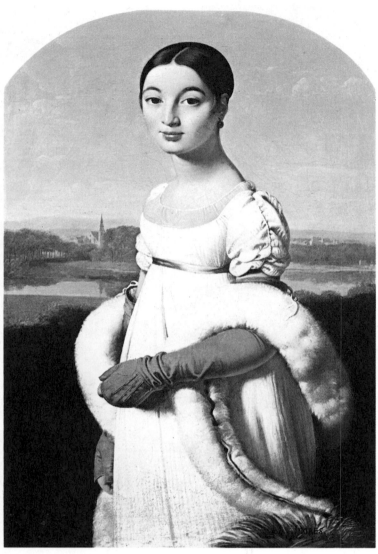

1. Jean-Auguste-Dominique Ingres: *Mademoiselle Rivière*, 1805.

Eugène Delacroix: *Liberty leading the people*, 1830.

Romantic painting was characterised by its emotional pre-occupation with the exotic and the sensual, in contrast to the more formal conventions of neo-Classical art. But the art of Ingres stands apart from both the solemn and grandiose neo-Classicism of David and the impassioned exoticism of his contemporaries, the Roman painters. As a result, he was attacked by both sides: the neo-Classicists decried his work as "Gothic", using the adjective to mean barbaric, and Romantics like Delacroix and his friends took him to task for his cold and inexpressive style. Still undeterred, Ingres went his own way and painted some of the most elegant and enigmatic portraits in the history of art. In his portrait of Mademoiselle Rivière (1), the young girl is almost classically posed, like an Italian or a Flemish model, in front of a landscape which reflects her placid expression; but the sensual curves of the painter's lines make a dramatic contrast to the serenity of the pose. His nude figure (4) is more Classical in composition, for the model is posed like a Venus of antiquity although her gesture is a modern one. But even here, the soft interlacing flow of lines, the contrast between the white body and the dark background, and the impassivity of her expression all show Ingre's decided penchant for a refined and somewhat glacial sensuality.

Eugène Delacroix broke completely with neo-Classicism—even as represented by Ingres, who himself found Delacroix's art so explosive in its power that once, seeing some of his paintings in a gallery, he was moved to exclaim "I smell gunpowder!" In both the paintings reproduced here (2, 3) intricate medleys of forms surge together from out of the darkness, rising up to explode into flashes of bright colour and soaring figures before falling back again into a mass of dark brushstrokes and vague shadowy shapes. Each of these paintings was based on an actual contemporary event: Delacroix was inspired by the fighting at the Paris barricades during the 1830 revolution which overthrew the Bourbon monarchy; Géricault depicted the rescue of the survivors from a terrible shipwreck.

Another aspect of the Romantic movement had already been foreshadowed a century before when some English furniture designers like Chippendale had made use of exotic Oriental motifs (see page 214). This search for the strange and exotic, this desire for new worlds of experience, encouraged Romantic artists and poets to turn to the Orient, which was still an undiscovered and mysterious world for Europeans of the time. Delacroix, for example, went to Morocco, and returned spellbound by its fascination, with memories of harems, tiger-hunts, bright striking colours and strange faces which he was to immortalise in his art (3).

222

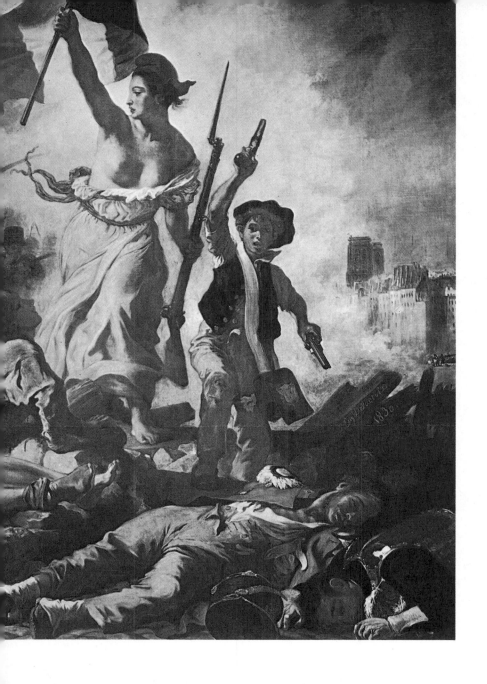

4. Jean–Auguste–Dominique Ingres: *The spring* ("*La source*"), 1856.

3. Eugène Delacroix: *Algerian women*, 1834.

5. Théodore Géricault: *The Raft of the Medusa*, 1818–1819

223

1. Jean-Baptiste Corot: *Florence from the Boboli gardens*, 1835-1840.

French painting underwent a radical transformation in the course of the 19th century. The neo-Classical style had ended in an empty lifeless rendering of outward shapes with meticulous attention to detail. But as the century advanced, and the number of technical and scientific discoveries multiplied, as new paths were explored in philosophy and as the great movements for individual liberty and social justice gained strength, important new artists emerged who worked in isolation, or else in oppos-

ition to dead formulas upheld by the established academic modes of their day, discovering new forms and creating new styles. The new artists used painting and sculpture to express deeper spiritual truths and to widen the understanding of mankind. There was an explosion of talent in 19th century France as all the rich variety of human experience and the dramatic upheavals of the age were mirrored in the works of great thinkers, writers and artists.

When, during his search for a new style and new pictorial forms, the painter Corot turned to figure-painting, he treated his masses of flesh and bone in the same way as his skies, earth, stone and water; building up his shapes in hard, thick brush strokes with alternating light and dark tones (1 and page 226; 2). Manet went still further: like Velázquez (pages 192-193) he also used a stiff brush to apply delicate layers of cold colour over his compositions, and carefully constructed forms which appear to dissolve into particles of light (3). He followed Goya, whom he admired and studied, in the way he was fascinated by strong, violent contrasts between the whiteness of flesh against dark backgrounds, and the striking tints of mauve, pink and yellow draperies. His painting of the *Execution of the Emperor Maximilian* was undoubtedly influenced by Goya's *3rd of May*, and is one of his most powerful and dramatic works. He placed his figures against backgrounds of violently contrasting tones, so that they seem to be projecting forward, almost out of the picture, thus creating a three-dimensional effect. With his hard brush-strokes and strong contours, he used black and white tones, deep shadows and strong contrasts of light to build up a dense, almost monumental but realistic style of painting. Art was

2. Gustave Courbet: *The painter's studio*, 1855.

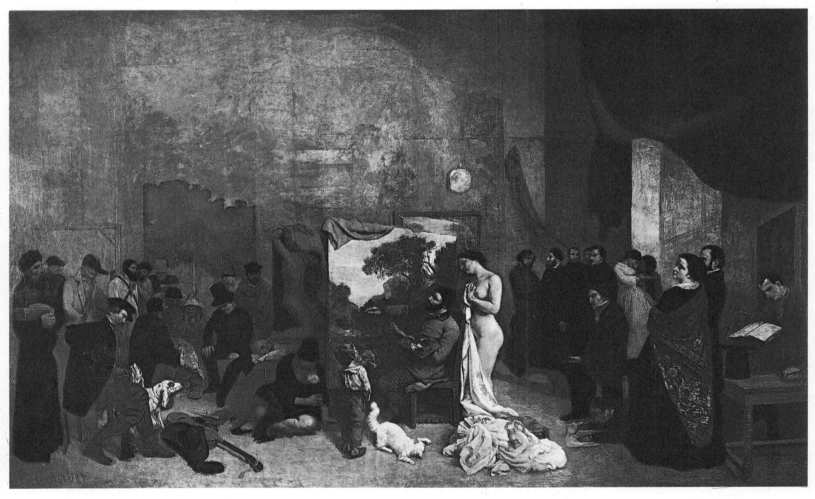

now creating a new kind of reality, and it was a time rich in promise for those who could meet the challenge to break with the conventions of the past.

A number of French artists proclaimed themselves as "Independants" and felt themselves perfectly free to choose new subjects for their paintings, through which they could demonstrate their defiance of the Academy which was thenceforward to become a synonym for all that was most trite and sentimental in art. They also turned their backs on great patriotic or mythological scenes and went to much humbler subjects for inspiration. Artists like Daumier, Pissarro and Courbet (2) preferred to record scenes and moments from the daily life of a poor and workaday world which, nonetheless, was rich in life and vigour. Daumier, especially, painted the working people of Paris in their faded working clothes, and their faces marked by tiredness after their long hours of toil (4). Such subjects were far more earthy than any the Romantic painters had deigned to use. Like Goya, Daumier was a cruel caricaturist, and ferociously castigated the pretensions and manners of the reigning bourgeoisie. His caricatures were published in the French newspapers and are the first and most brilliant cartoons in the history of the Press. As the century went on, such artists felt themselves increasingly isolated and solitary in a society that was dominated by politics and big business; artists in Paris began to band together to live a life they called "Bohemian", from the French word for gypsies, as it had some of the carefree quality of their life. They proclaimed themselves to be the "avant-garde" and, indeed, their boundless self-confidence was to lead them to explore hitherto ignored aspects of existence.

4. Honoré Daumier: *The washerwoman*, 1862.

3. Edouard Manet: *La musique aux Tuileries*.

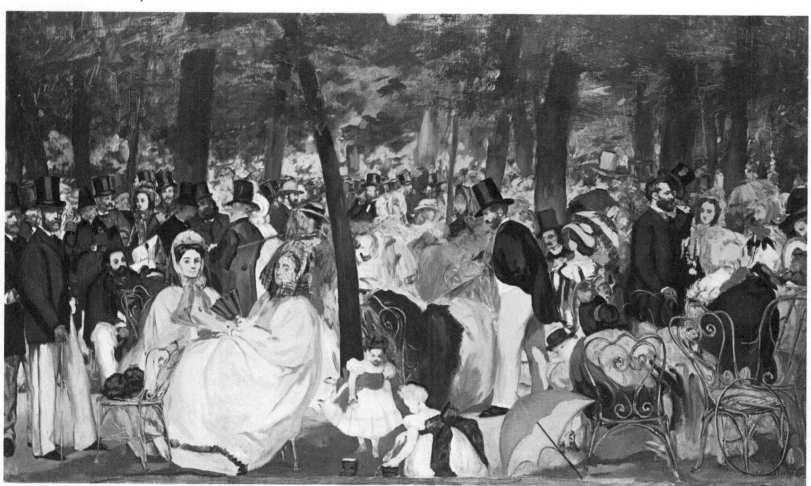

We can trace the progress made by painting in this period by studing the way in which painters applied their paints on the canvas, and the use they made of line, colour, and light.

Two English painters of the period, Constable and Turner (1, 3), exerted just as great an influence on the succeeding generation of French artists as Delacroix's Romanticism had done. What Constable did was to paint nature as he saw it, in all its moods and sudden changes, and to create great open spaces extending far into the distance, filling his low, flat horizons with warm luminous colours and shining light. He painted with

1. John Constable: *Dedham Mill*, 1820.

2. Jean-Baptiste Corot: *View of Rome*, 1826–1827.

3. Joseph M. W. Turner: *The Fighting Téméraire*, 1838.

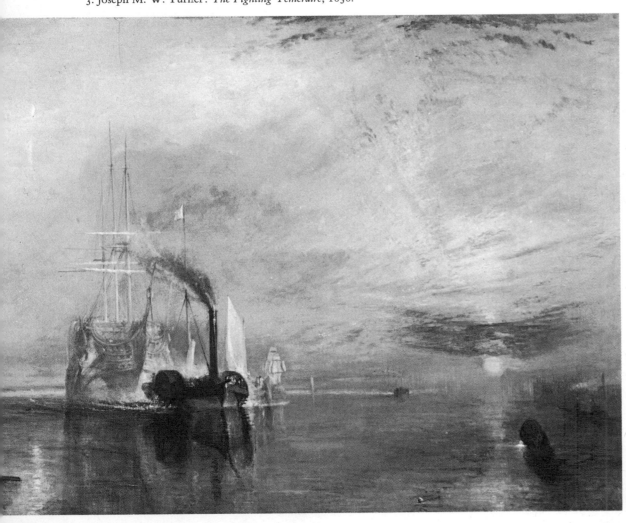

flat strokes of colour, placing them side by side to form relationships between different tones, and laid on white brush-strokes to highlight spots where the sun's rays were reflected in the landscape. Turner used colours in an even more unusual way: he would paint the sea as though it had been set on fire by the sunlight, and fields under flaming skies which seemed to transform every detail into a blazing mist of pure colour, in which objects lost their outlines and solidity.

In the 1830's in France, a group of painters met in the little town of Barbizon, set in a forest near Paris, to paint landscapes. They laid on colours with quick, large brush-strokes and carried Constable's technique a stage further. To mark their break with the traditions of the past, they began by painting in the open air, in direct contact with nature. Since French forests tend to be filled with a whitish, softening mist which blurs shapes

seen through it, the paintings of these artists also took on something of this milky quality, as though the whole composition lay under an invisible veil. But the Barbizon painters took pains not to romanticise their subjects. The strongest personality of the group was Corot, who often travelled to the south, especially to Italy. In the clear light of the countryside near Rome he painted pictures with cool, contrasting swathes of colour in a manner rather resembling Constable's sketches (2). This new technique, which consisted of seeing objects as sharply defined areas of light and shade, and then painting them clearly but without modelling their edges or surfaces, gave an extraordinary quality of hardness and luminosity to Corot's works.

The next daring step was taken by Monet, who, in 1872, exhibited a painting which was to have a most disconcerting effect on the public (5). A critic mocked the group to which Monet belonged by calling it the "Impressionists", after the title of a painting, and the name has remained to this day. In reality, Impressionism is still alive at the present, and is still progressing along the lines first set by Corot. It implied the breaking down of solid objects as seen in nature into that mysterious element that painters had loved ever since the Venetian Renaissance—light itself. As scientists made the discovery that solid matter could be broken down into an almost infinite series of smaller parts, artists broke the entire world down into fragments of pure colour. When they were looked at from short range, the paintings of Monet and his fellow-artists had no meaning for the Paris public who flocked, in disgust, to their exhibitions. But if the spectator stood back a few feet, the pictures would come to life, all their colours flickering and vibrating like water under the sun. Monet, the most determined of the Impressionists (4, 5), would paint the same scene at different times of the day. He would study the way light would change from moment to moment, at dawn, at midday, and finally at dusk when it turned blue and violet, blurring the outlines of objects until they seemed to lose all impression of physical weight and density. His last pictures were painted in a garden filled with ponds, and show trees, streams and water-lilies deprived of their substantiality, seen no longer as elements in a story, or as something to be analysed, but purely as patches of radiating light (3, page 229).

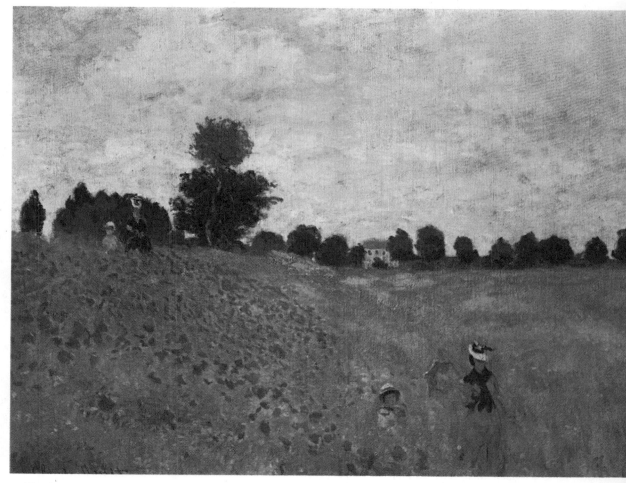

4. Claude Monet: *Poppies*, 1873.

5. Claude Monet: *Impression – Sunrise*, 1872.

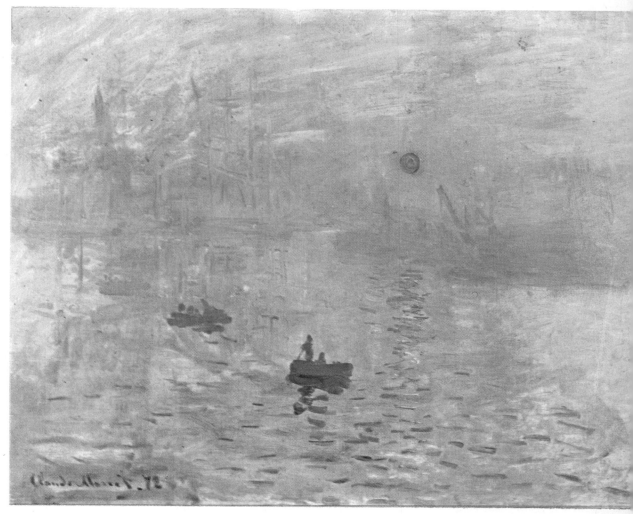

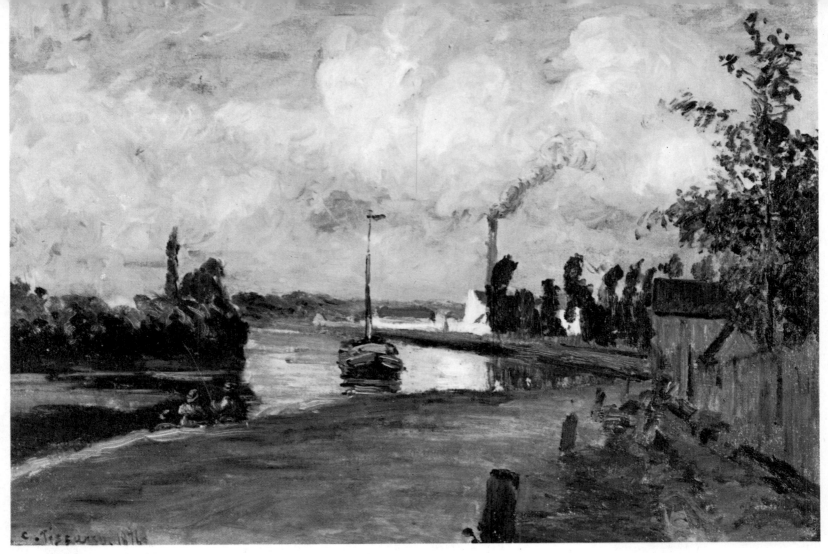

1. Camille Pissarro: *Banks of the Oise*, 1876.

2. Sisley: *The flood at Pont-Marly*, 1876.

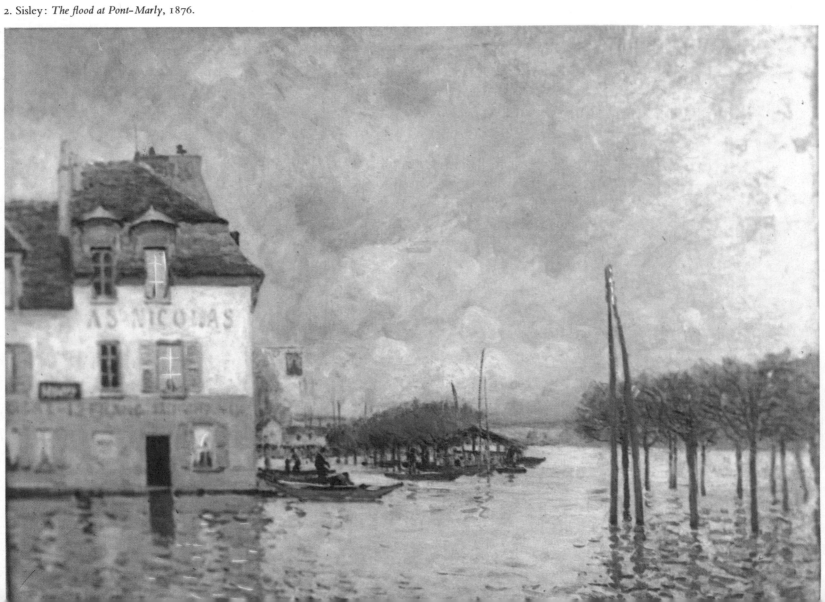

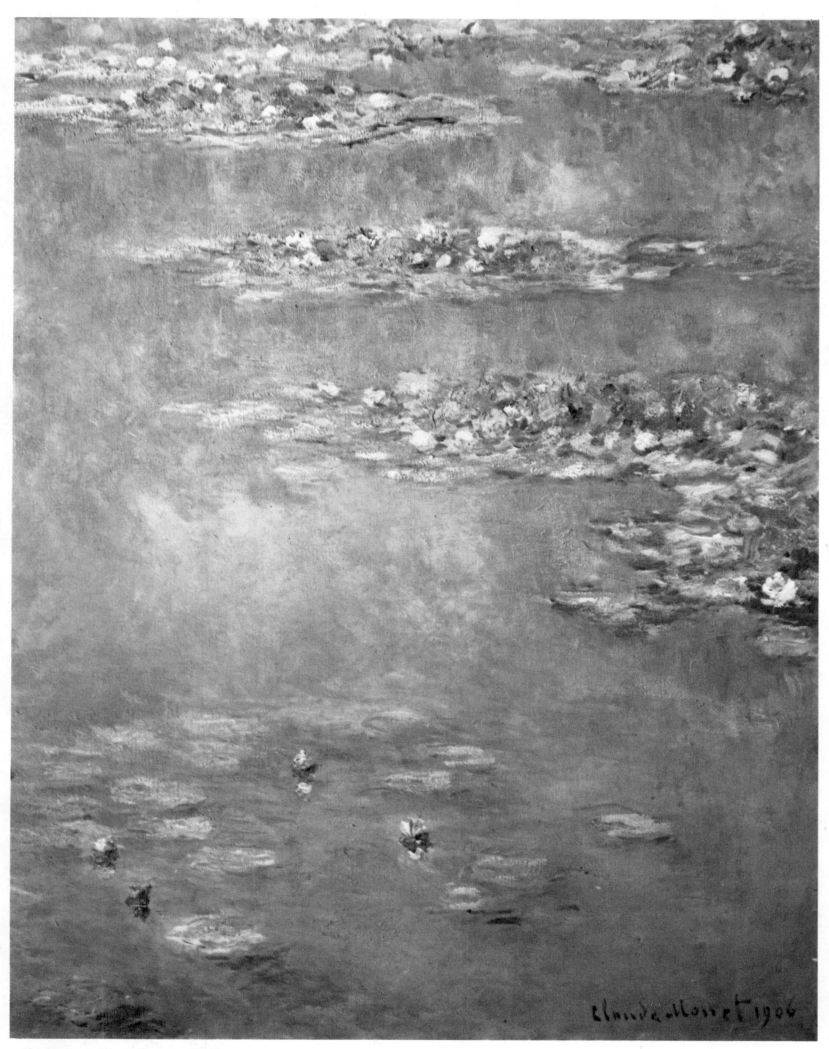

3. Claude Monet: *Water Lilies*, 1906. Detail.

After Impressionism, modern art moved in two different directions: on one hand it remained faithful to the Romantic tradition with its emphasis on personal feeling, and on the other it moved towards great austerity of style, and a tendancy to analyse and dissect. These two different trends are represented by Renoir and Cézanne in painting, and by Rodin and Maillol in sculpture. Together with Monet, Renoir learned to paint scenes bathed in a sunlight which gave lavender, green, pale pink and reddish tints to the faces of his figures. Renoir's paintings are full of an intense vitality and an almost animal splendour. But although he made use of the technique of the Impressionists, he never altered the physical structure of his figures and, in his long search for a personal style, he would occasionally return to the older Classical ideals of a linear, self-contained manner of painting (see page 233).

Like Renoir, Rodin also seemed to have been close in spirit to the passionate ideals

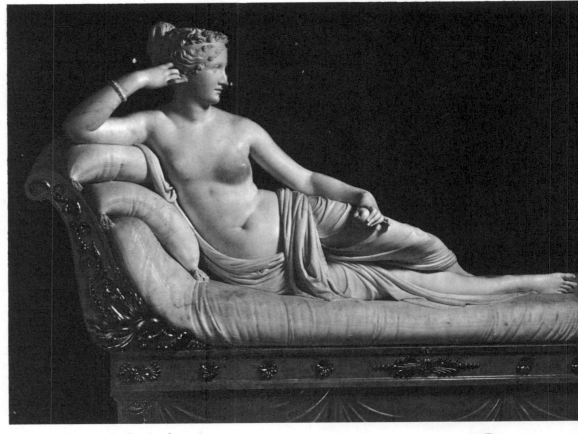

1. Antonio Canova: *Pauline Borghese*, 1811.

3. Aristide Maillol: *Leda*, 1902.

2. Auguste Rodin: *The burghers of Calais*, 1884–1886.

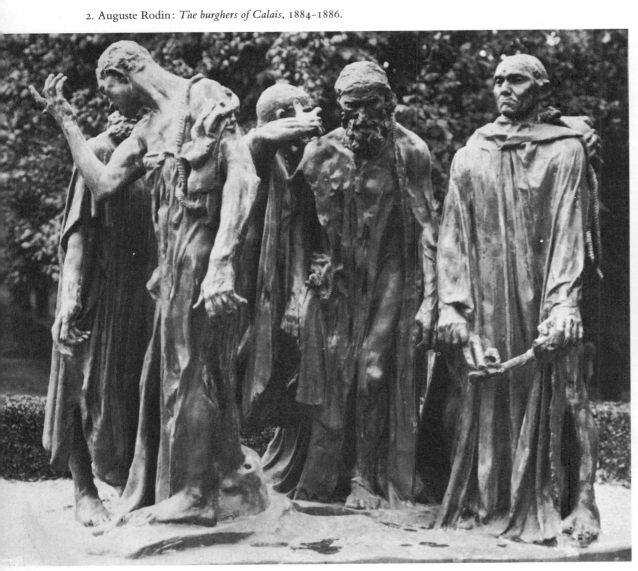

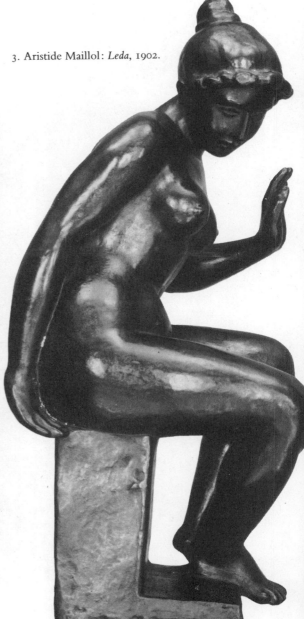

4. Paul Cézanne: *Study for "L'Ecorche"*.

5. Paul Cézanne: *Landscape with viaduct*, 1885-1887.

of the Romantics, giving them all his expressive power and the benefit of his constant researches. Just as Michelangelo had done, Rodin left parts of his sculptures in an unfinished state, with the figures still imprisoned beneath their suffocating layers of shapeless clay or stone. His statues seem to surge out of the lifeless material before falling back again into formless chaos. His famous group, *The burghers of Calais*, is reproduced here (2). The most famous neo-Classical sculptor was Canova (1) and we have only to compare his works with Rodin's to see how great was the distance that separated these two artists in style and spirit.

Cézanne had also learned from the Impressionists how to compose a picture out of a mass of separate particles of colour, but instead of laying them on the canvas in such a way as to create a flickering, hazy impression, he used them to create works that were cold and hard but full of harmony. As Cézanne gazed at the landscapes of Provence, he noticed how the trees cut across his angle of vision, and how the hills gradually receded until they lost themselves in the misty horizon (5). The marks he made on his canvases were only indications of what he had

seen with his eye. When he drew the human figure (page 234) he looked for the same kind of relationship of position in space: he was not interested in laying colours on smoothly or in making the lines of the body flow into one another. If he had to paint a round or a curved surface he applied his brushstrokes to the canvas as one might set bricks into a set-back wall, each one being equally flat and

6. Auguste Rodin: *Balzac*.

straight, but set back one behind the other.

Like Renoir, Cézanne was unconcerned with all the little details and deformations that distinguish one object from another similar one. Compare his painting of Harlequins (page 235) with that by Watteau (pages 210-211): at first sight we may find that Cézanne's composition lacks the balance and compactness of Watteau's where the central figure is set up like a column, surrounded by a wreath of human faces. Cézanne's picture is constructed out of angular fragments of forms which lean and curve towards one another like a mass of broken stones heavily pressing together. With their complex and elaborate composition, Cézanne's paintings show that passion for analysis which was the fundamental characteristic of his style. They have a powerful quality which was to be a great source of inspiration for twentieth century artists. Maillol (3) was also concerned with the same kind of massive, static shapes that obsessed Cézanne, but he went back to Classical traditions for the subjects and treatment of his figures.

Overleaf: Pierre-Auguste Renoir: *Luncheon of the boating party*, 1881.

231

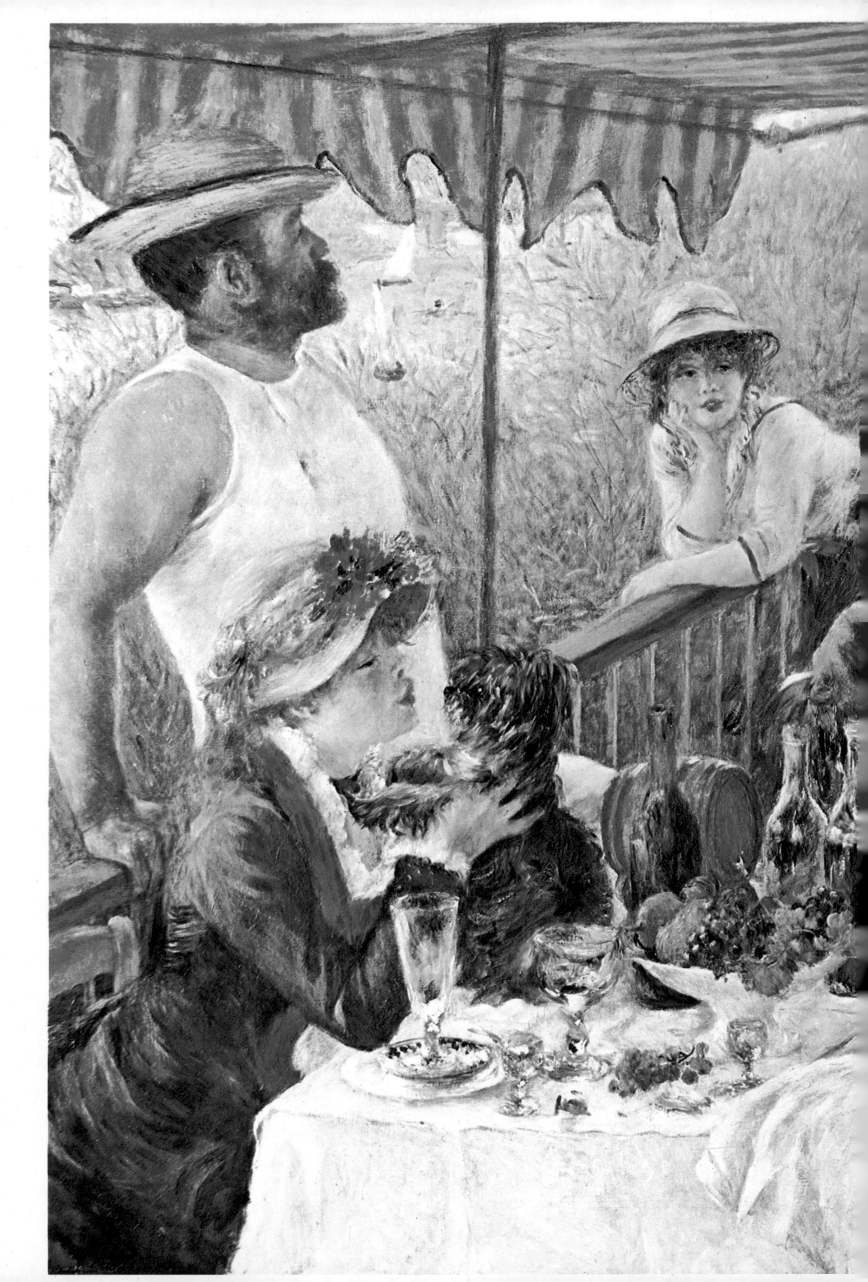

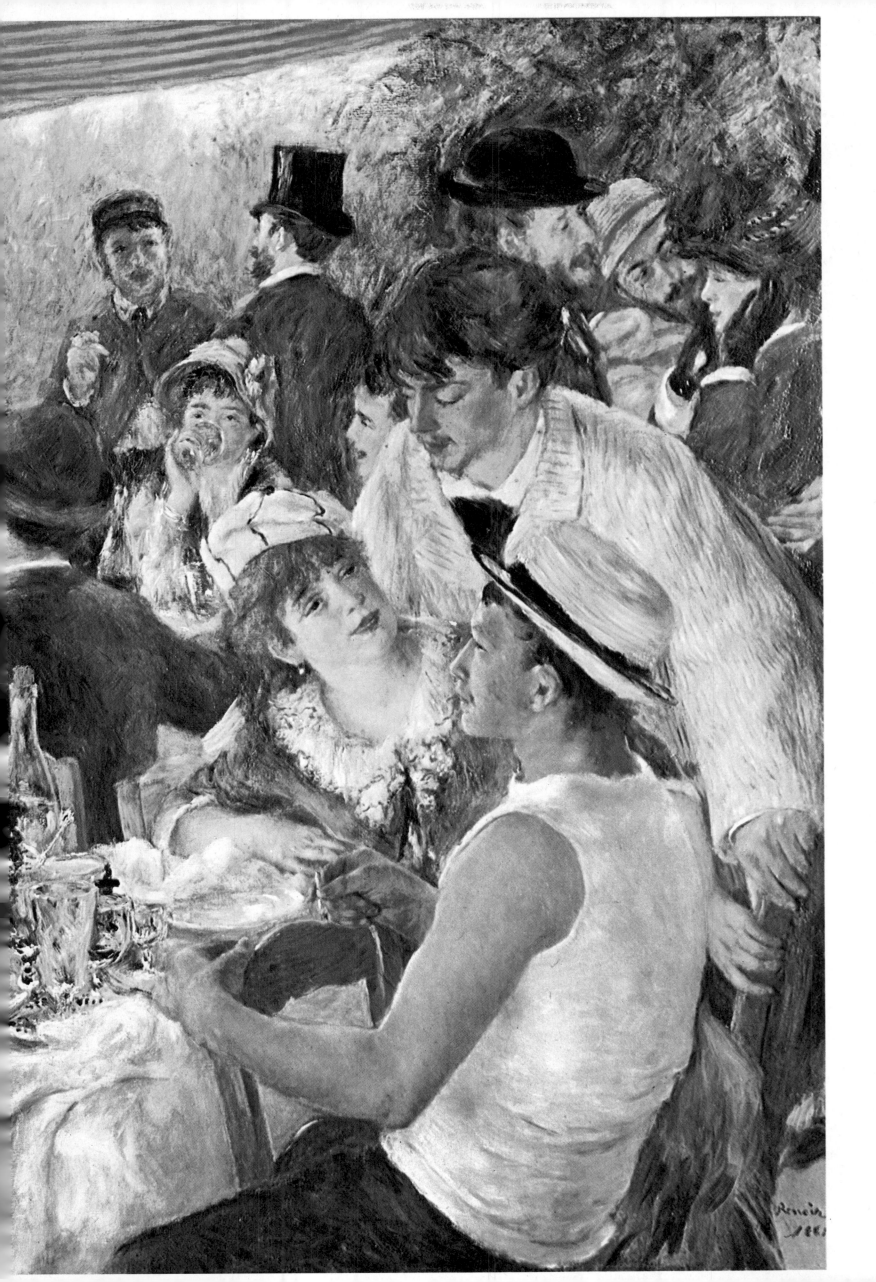

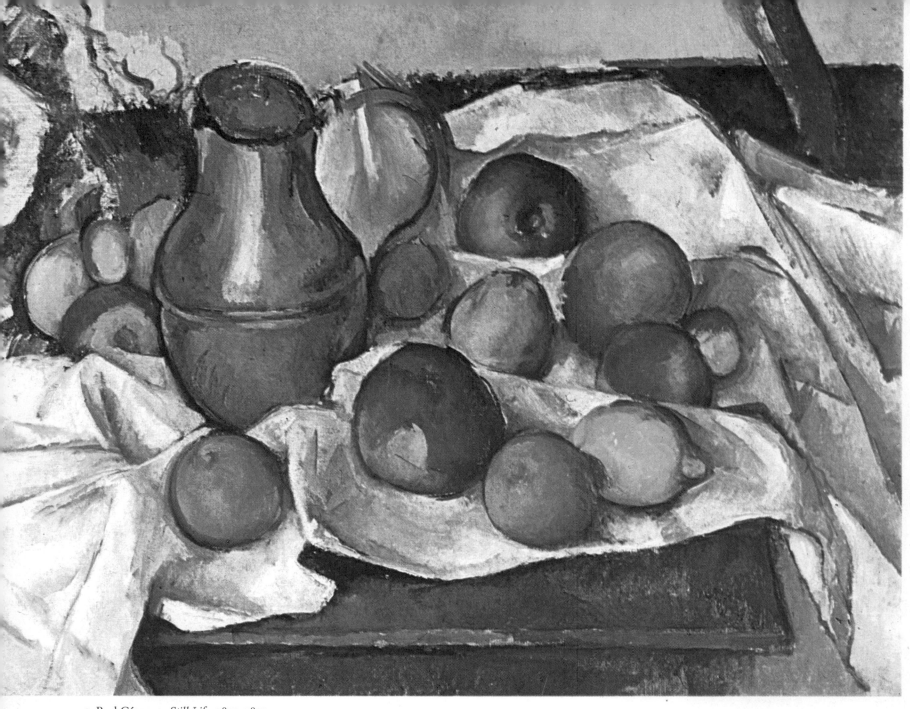

1. Paul Cézanne: *Still Life*, 1890–1891.

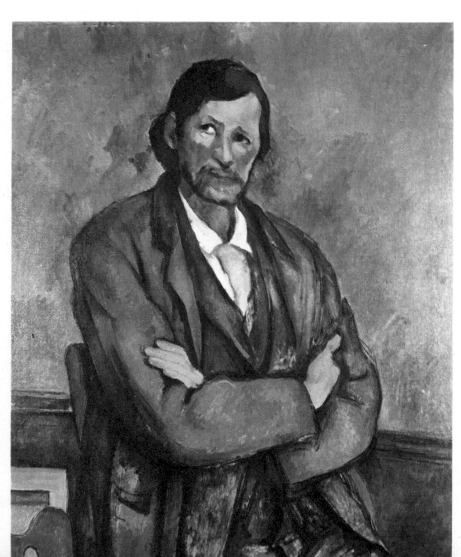

2. Paul Cézanne: *The watch-maker*, 1895–1900.

3. Paul Cézanne: *Mardi Gras*, 1888.

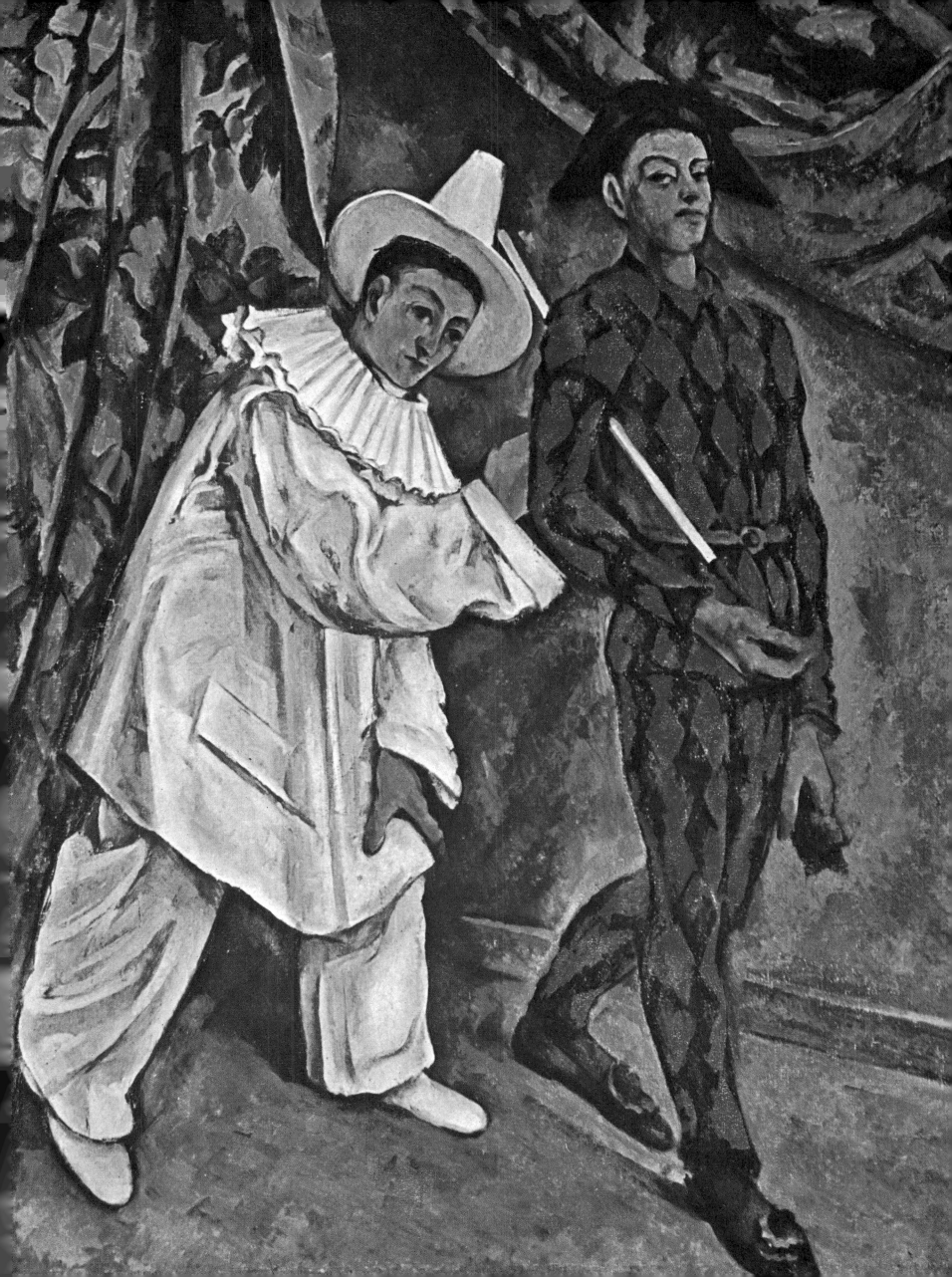

Paul Gauguin: *I Raro Te Oviri* (*Under the pandanus trees*), Tahiti, 1891.

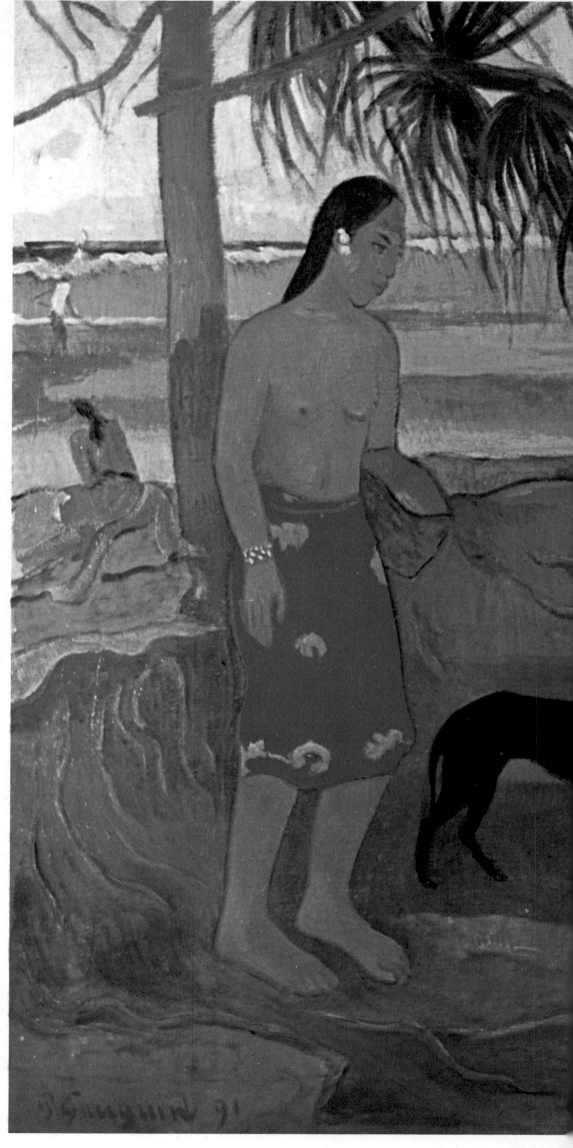

To re-create external reality after it had been transfigured by the poetic vision of the artist had been the basic purpose of all experiments in painting in Europe since the 14th century. Now, as the 19th century drew to its close, several painters abandoned this aim and gave up trying to capture the solidity and perspective of real life in their works. Instead, they made use of a form of artistic expression which had already existed in other countries and which consisted of the use of line and colour alone, on a flat surface, to make dramatic patterns.

Seurat (pages 238–239) and Gauguin were two of the Western artists who chose to work in this way, although they had both begun their careers by studying nature among the Impressionists, and, in fact, it was Seurat who took Impressionist techniques to their furthest limits by evolving "pointillism". His method consisted of covering his canvases, inch by inch, with tiny dots of colour, and constructing his figures like stiff mannikins seen in profile against a grainy, unnaturally flat background. Gauguin had not only studied Impressionism, but also the art of the Middle Ages, tapestries, enamel work and Japanese prints. In his hands, the Impressionist brushstrokes became transformed into great flat masses of colour, which spread out over the canvas like ink-blobs on a window, or like the different patches on a quilted tapestry. He was a restless man and journeyed over much of France, from Britanny in the north to the sun-filled "Midi" (the south) before finally voyaging to the Polynesian isles. It was there, in the South Seas, that Gauguin created his greatest works and finally died, alone and almost forgotten, but among men and women whose natural instincts were still free from the trammels of civilisation.

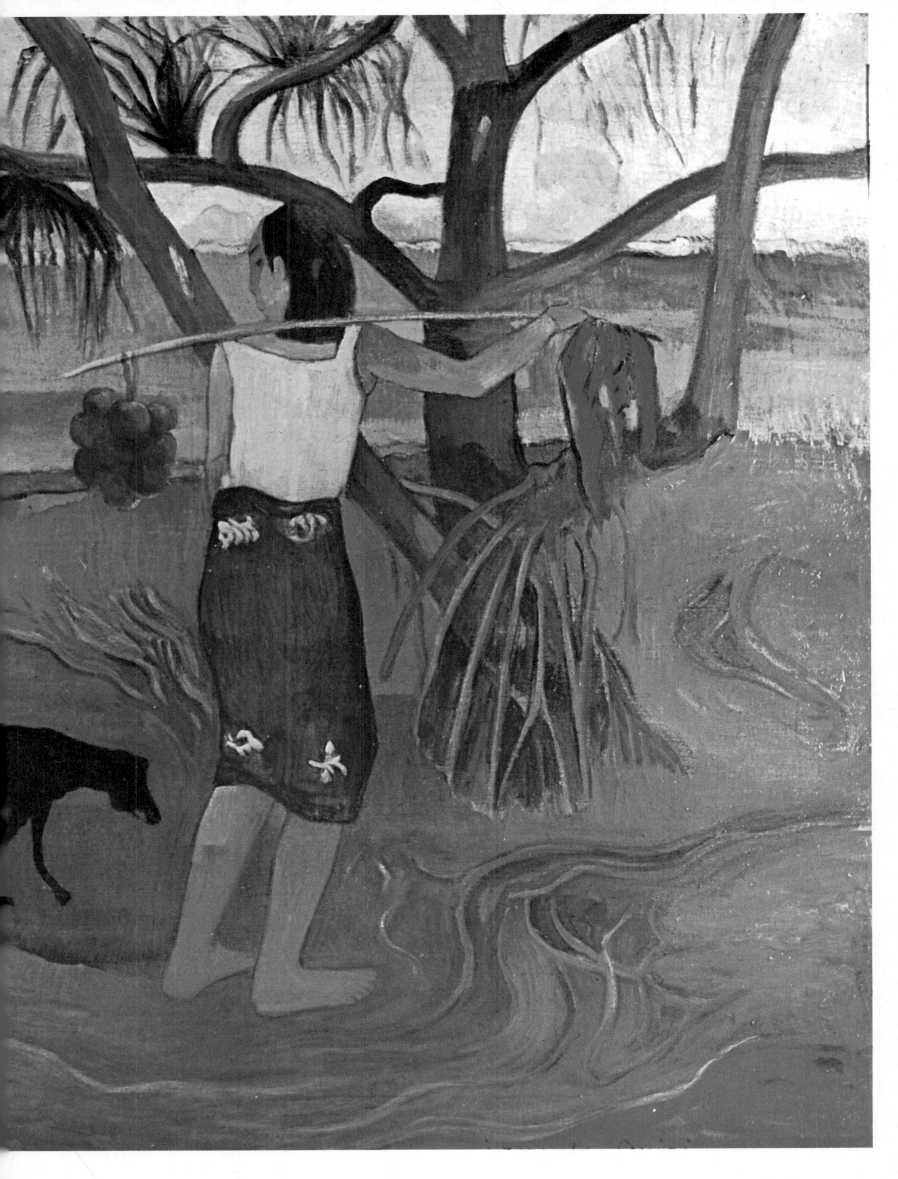

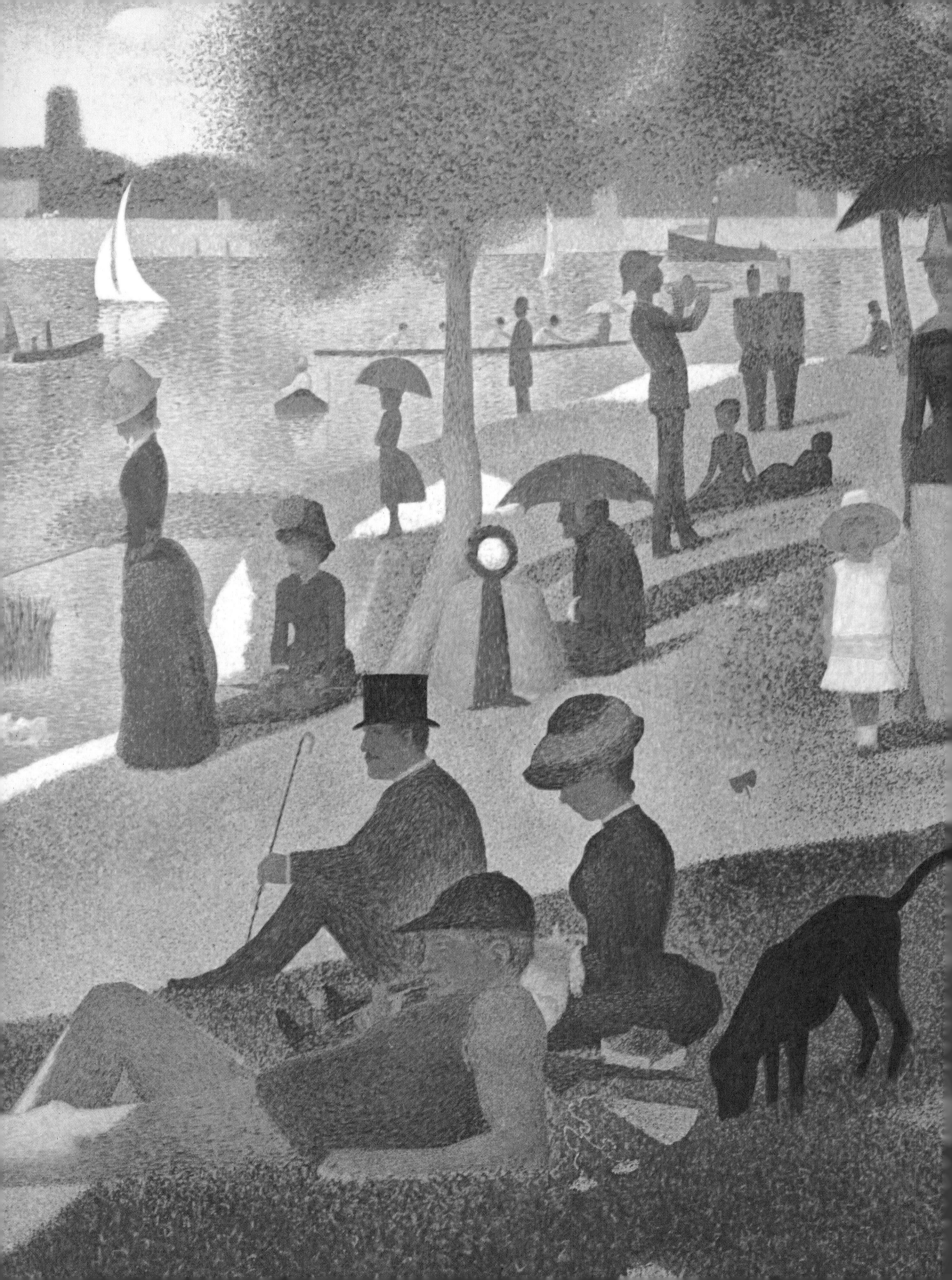

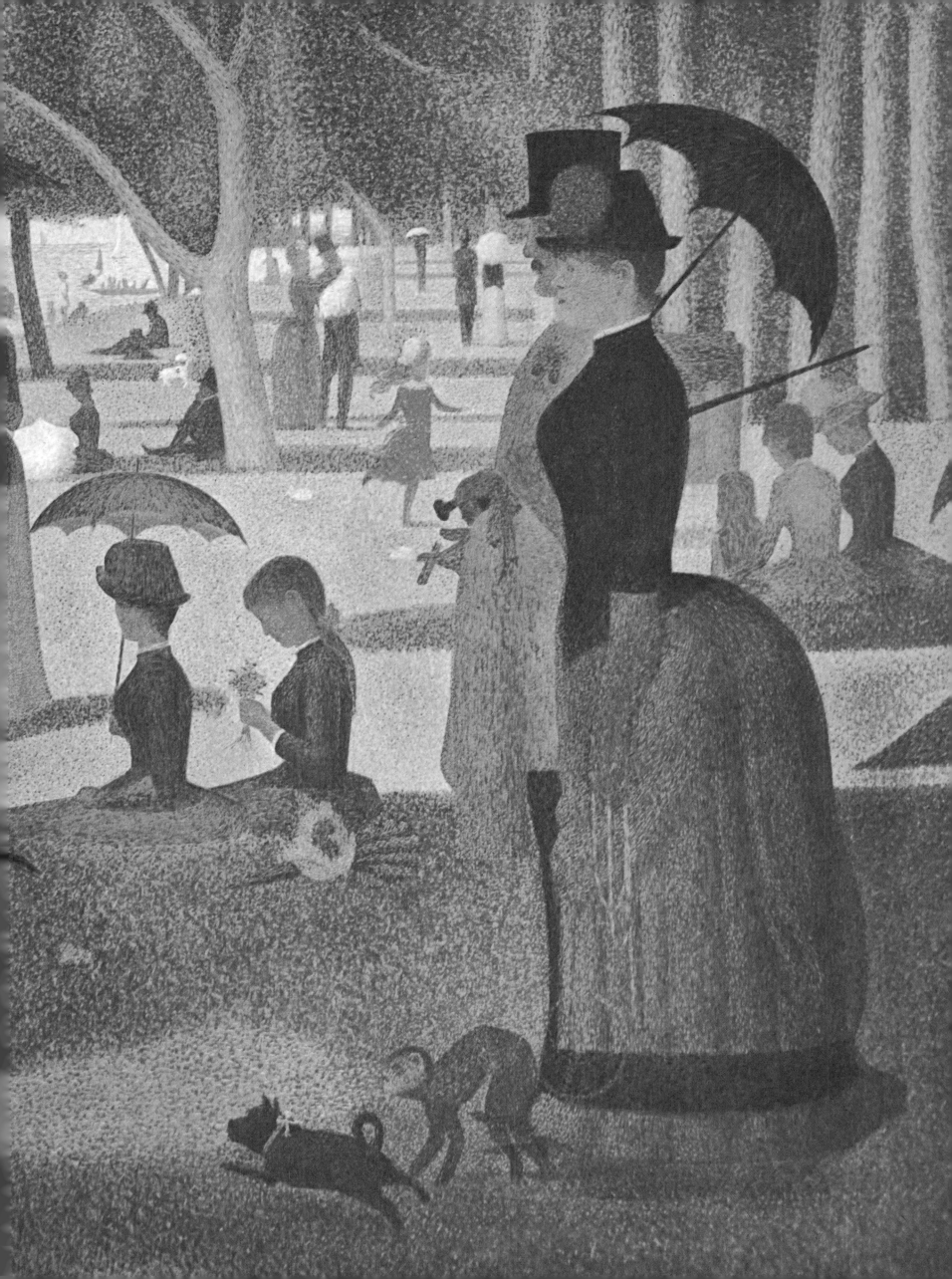

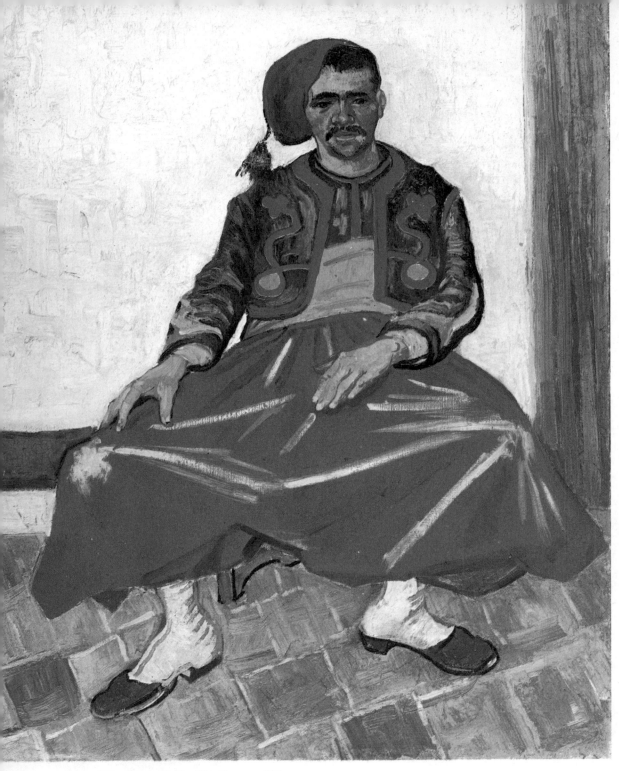

1. Vincent van Gogh: *The Zouave*, 1888.

2. Vincent van Gogh: *Old man in tears*, 1882.

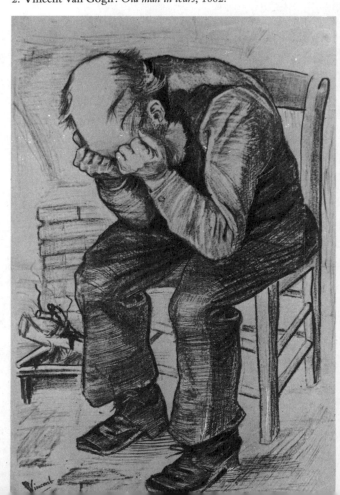

The story of Van Gogh's life has passed into legend. His un-swerving sense of purpose, his extraordinary sensitivity to shapes and colours, and his final battle against madness have all contributed to the myth of this great Dutch painter. Yet the underlying source of both Van Gogh's agony and his art was his sense of the distance between the outside world and the image of it in his mind's eye. For him, every painting was a laborious struggle to bring his sight to focus on the outside world of men and things. Unlike Bosch, he did not paint nightmarish mon-sters and landscapes, nor, like Grünewald, wretched human bodies tormented by leprosy and spiritual anguish. Instead, his whole career was a long search after the true inner reality of the human condition. He painted landscapes, bowls of flowers, the corridors of the hospital where he was confined, and the faces of his doctors, friends and neighbours. In his early period, when he drew a peasant overwhelmed by misery (2), he sketched him as a massive block of hard, thick lines, emphasising the man's bent

240

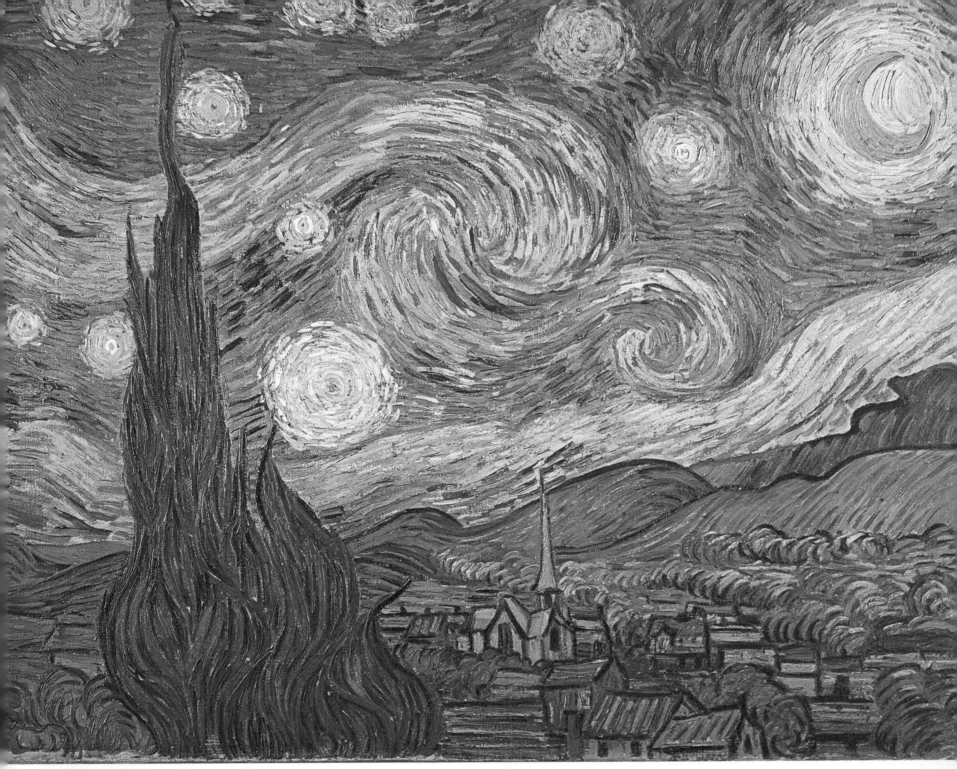

3. Vincent van Gogh: *Starry night*, 1889.

shoulders and thick, knotted hands. During a brief stay in Paris, he met the Impressionists and Post-Impressionists before settling in the south of France where he learned their new way of looking at nature, and indulged his passion for bright lights and colours under the burning sun of Provence. Like Degas, Van Gogh, together with his friend Gauguin, was fascinated, as were later Degas and Toulouse-Lautrec, by the subtle simplicity of Japanese prints which had a direct influence on some of his paintings. In his painting of a Zouave (1), every line and pattern has been carefully calculated to give a dynamic, oblique, distorted yet simple effect to the composition.

His destructive madness kept pace with his ever-increasing passion for painting, and a recurring series of break-downs led him away at an ever-increasing pace from the reality of the visible world, and it was art alone that enabled him to hang on to the sense of physical existence. At times his frenzy and sense of exaltation led him to paint a picture like *Starry night* (3) in which

thick rushes of colour make the trees writhe with life and the stars explode like fireworks, while the hills, the valley and the stars all seem to be hurtling towards the sea. But in his more lucid periods, he could paint a landscape like the one reproduced on pages 242-243, full of delicate trembling brushstrokes and silvery tints. But all his paintings, even when they are at their most lyrical, bear witness to an inner tension in his spirit, and are all direct expressions of his internal conflicts and his passionate desire for the redemption of outside reality. Van Gogh spent the last year of his life, a desperately sick man, at Auvers-sur-Oise where he was to commit suicide. There, in a series of paintings that swung between strict reality and wild distortion, Van Gogh's genius both expressed and destroyed itself.

Later artists made use of this quality of formal distortion to express their own turbulent or ecstatic feelings but they lacked Van Gogh's powerful genius and their works can seldom compare with his in intensity.

Overleaf: 1. Vincent van Gogh: *Landscape at Arles,* 1889.

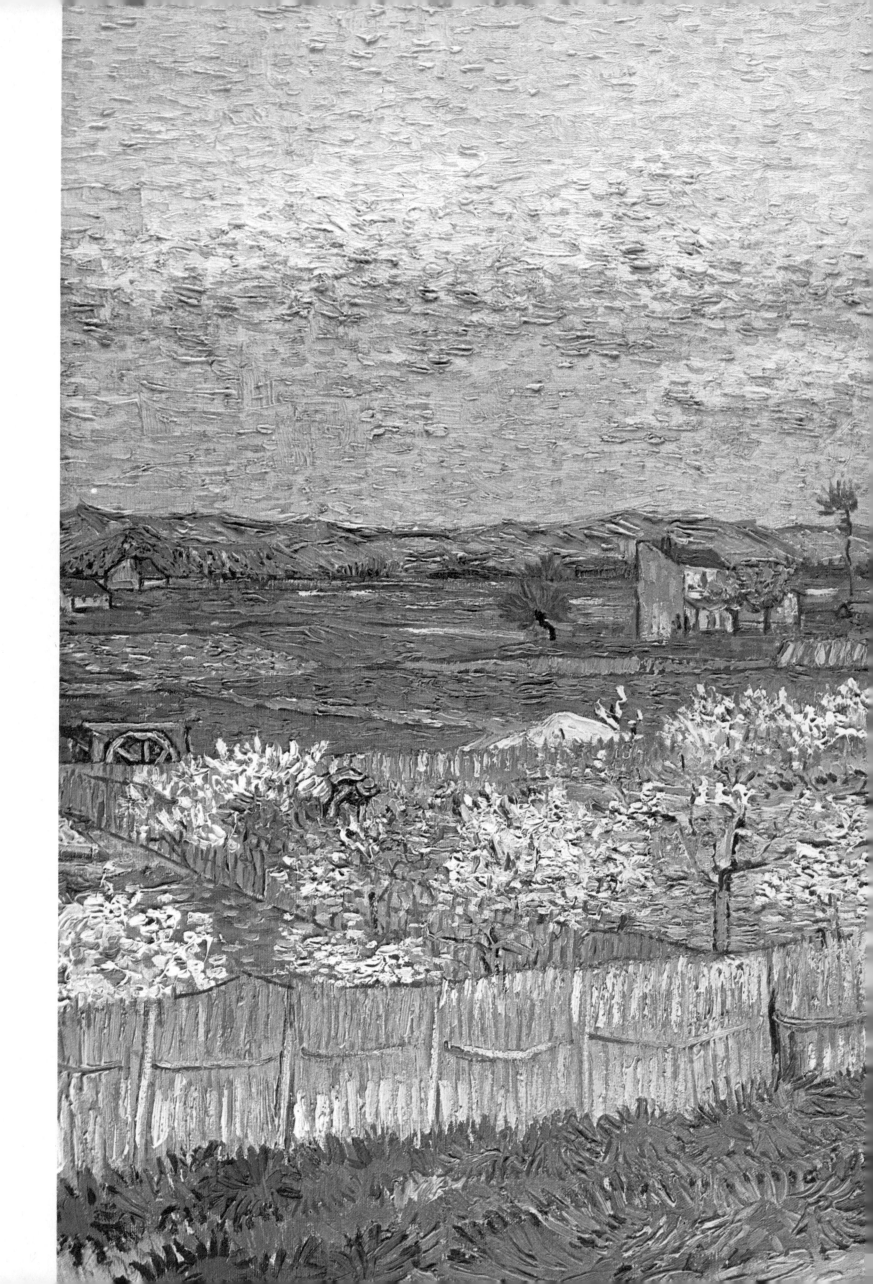

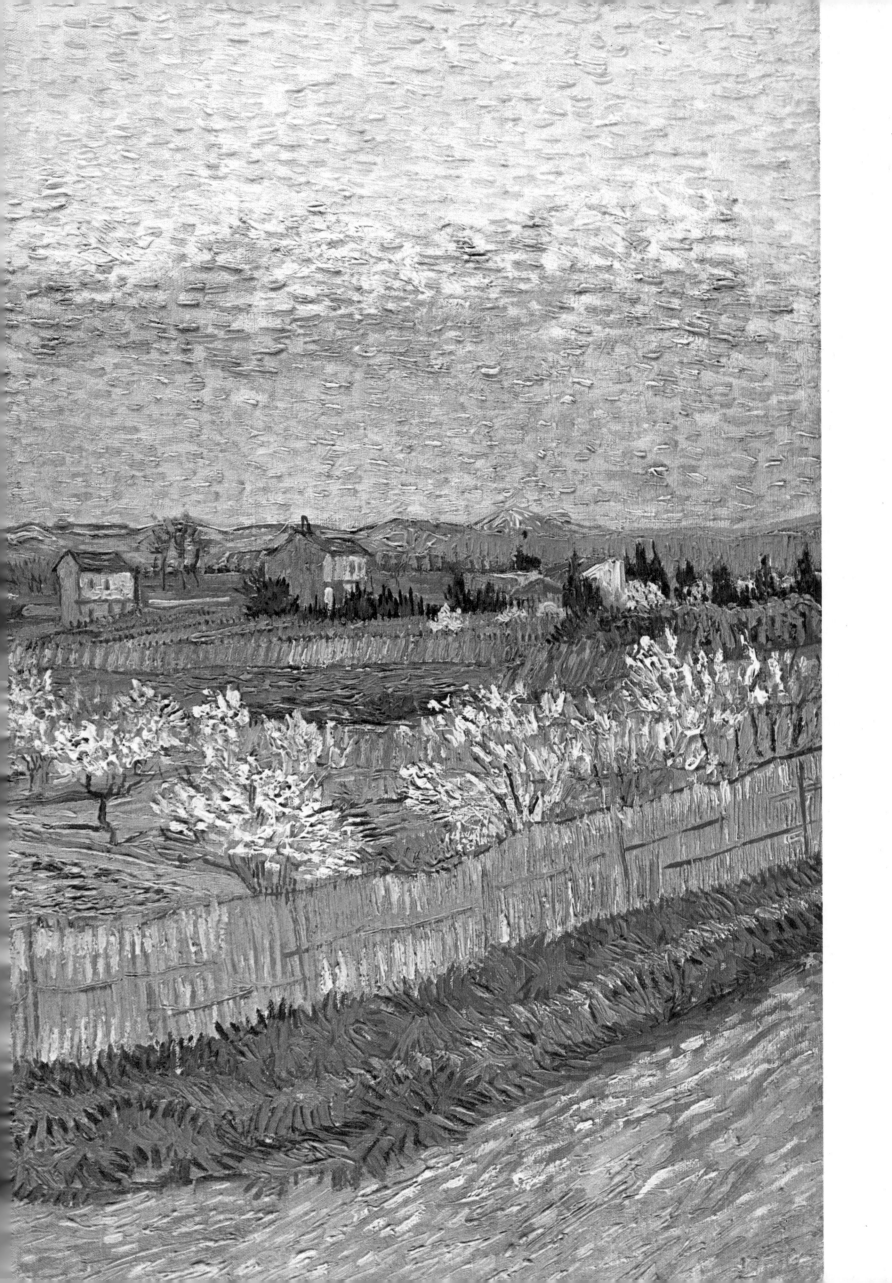

duced by the recently invented camera, for photography could also give the same kind of sudden, off-balance, spontaneous view of what the Japanese artists called the "Ukiyo-ye" or "floating world".

Several painters tried using this technique in the composition of their pictures, among them Degas and Toulouse-Lautrec in Paris, and the American artist Whistler in London. Degas's method of working was to go and draw ballerinas dancing, practising or putting on their costumes. He painted the evanescent flashing of their delicate bodies in the lights of the stage, with their tutus and legs gleaming like phosphorus against the dark background of the scenery. He would paint each picture from a different angle of vision, preferably oblique, and as though he were studying the scene from above or close up. For his ballet pictures he often sat in a box right above the stage and must have sketched extremely quickly. Back in his studio, he only re-composed his forms and shadows to emphasise the shafts of light piercing through the darkness of the theatre. He also rediscovered the importance and value of studio painting which obliged him to think out a picture carefully, to eliminate improvisation and to subject himself to the

1. Edgar Degas: *The dancing class*, 1874.

2. James Whistler: *The Golden Screen*, 1864.

Towards the middle of the 19th century Japanese prints began to turn up in Europe, some being found in the corners of packing cases, others being brought in by booksellers and travellers. At first, people found the prints strange and unbalanced in their composition. Western eyes were accustomed to see figures disposed in a series of horizontal planes and the manner in which these prints were composed came first as a shock and then as a revelation. The figures often seemed too big and gave the impression of being about to come out from the frame. Other designs were tilted off the horizontal as though the artist had tried to capture phases of a swiftly-passing scene. Even more surprising, the designs of the prints gave a similar impression to that pro-

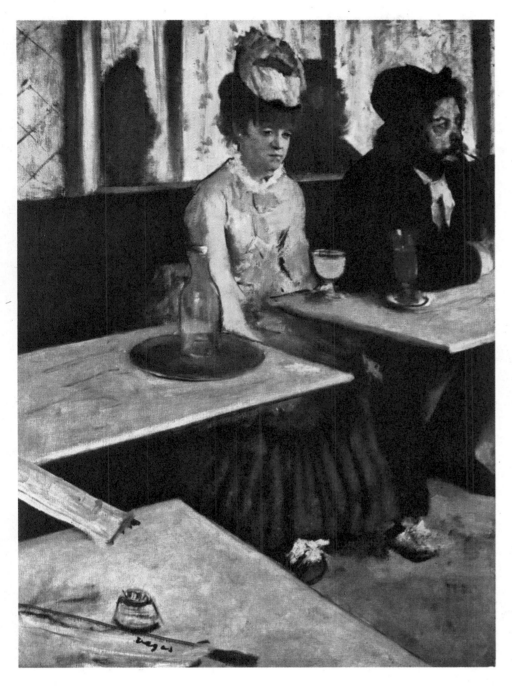

No 19th century artist ever surpassed Toulouse Lautrec for the rigorous accuracy and bitter mockery of his sketches. Both a dwarf and a cripple, he was an outcast from a society that had rejected him, and he remained as isolated from the people he portrayed as had Van Gogh from among the sturdy peasants of Provence. But whereas Van Gogh filled his paintings with his violently exploding emotions, Toulouse-Lautrec exerted an almost icy control over his mordant lines and acid colours, although he did give them a certain subtle hint of poetry. He knew how to use his pencil like a whip, sometimes exaggerating and sometimes underplaying his subjects, catching the personality of the extraordinary Yvette Guilbert with a few swift lines, or else the strange, debonair faces of the habitués of the Moulin Rouge.

His theatre posters are masterpieces of design: no eye could escape the fascination of their intense, contrasting pastel-coloured patterns. His painting of the *Moulin Rouge* (4), with its arrangement of figures behind the sloping orange balustrade, is a marvellous *tour de force* in its composition.

3. Edgar Degas: *Absinthe*, 1876.

4. Henri de Toulouse-Lautrec: *At the Moulin Rouge*, 1892.

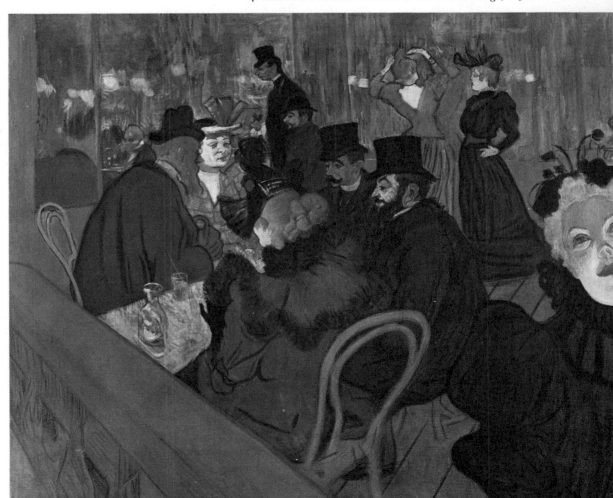

discipline of a studied technique. He did not model his figures so much as build them out of light and shade, and he made astonishing use of wide, empty spaces in his scenes in order to draw the eye across the composition along firmly established and precise diagonal lines, and, as in (3), to create a carefully calculated relationship between surfaces, planes and figures.

Whistler was an American artist who had left his homeland for good to find a richer and more congenial artistic atmosphere in London and Paris, where he painted delicate figure-studies, like the one reproduced here (2) of a young woman in the attitude and costume of a Japanese lady. Sometimes he simply titled his pictures *Nocturne* or *Studies in Colour*, to emphasise the foremost importance to him of colour in his composition.

architectural vision had yet appeared in this new world which was only just learning to make use of new materials—steel, iron and cement. It was only towards the end of the century that a new architecture emerged, thanks to the impulse given in England by William Morris with his theories of a new type of rational building free from needless decoration, and the buildings of the innovators Philip Webb and Norman Shaw who were setting a pattern for the future. The heavy weight of tradition that had so long dominated architecture in both Europe and America was finally thrust aside towards 1890 by the rising new generation of American architects who were lifting their country out of its slough of narrow-minded provincialism. Springing from the need to build upwards, the development of the framed structure forwarded the building of great sky-scrapers. Thus America found herself influencing architecture throughout the world.

Henry Richardson (3) was one of the first pioneer-architects to attempt to free buildings from the ornamental superstructure and useless decoration that cluttered up their basic lines. He felt that only the Romanesque style fittingly expressed the youth and virility of his young country. But perhaps even more than Romanesque lines and solid spaces, Richardson's buildings express his fascination with heavy, rugged materials.

1. Albert Pinkham Ryder: *The forest of Arden*, 1888–1897.

AMERICA

Very few Americans in the 19th century managed to combine a Romantic, poetic vision with a simplicity and broadness of style which saved them from sentimentality. Of these, Ryder was the greatest (1). Almost alone among his contemporaries, he composed in big, powerful shapes, strong patterns which engulfed the meticulous details that other Americans laboured over.

The architecture of early 19th-century America was, like that of Europe, an ill-assorted medley of undigested styles cluttering the skylines of nearly every town and city. Buildings in the Italian Renaissance style were to be found side by side with neo-Gothic edifices, and imitations of Greek and Roman structures. No new

2. Louis Sullivan: *Golden Portal*. World's Columbian Exposition, Chicago, 1893.

246

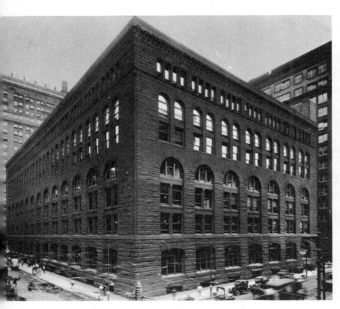

3. Henry Richardson: *Marshall Field Warehouse*, Chicago, 1885–1887.

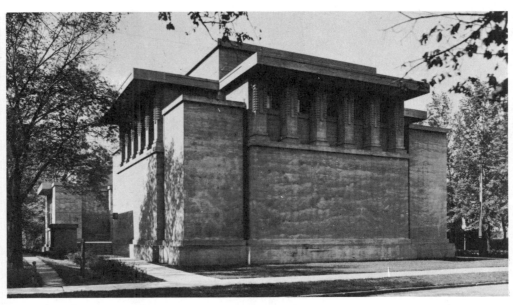

4. Frank Lloyd Wright: *Unity Temple*, Oak Park, Illinois. 1903.

Louis Sullivan was the next experimenter with original architectural shapes. He was partial to decoration but only as an integral part of the structure, and not as something added as an afterthought, to weigh down the original concept.

Great impetus was given to modern architecture by two technical inventions: steel girders which could carry greater weights than iron, and, at the end of the century, poured-concrete construction, which meant that liquid cement could be poured directly into moulds on the building site itself. Architects were now able to gather great blocks of strong concrete together, made on the spot, and to strengthen them from within with a network of iron wires and rods. The great explorer in this new medium was Frank Lloyd Wright. Like so many of his contemporaries, Wright had felt the influence of the Far East. Now that he had a material which could be used as simply as Japanese wood and paper and yet withstand the arduous Western climate, he began to design buildings as starkly laid out as Japanese houses. His approach to the new materials and techniques can already be seen in his earliest projects dating from the end of the 19th century. They are without a hint of Greek, Gothic, or Renaissance style or ornamentation, for all that can be seen are the rectangular lines of the walls and the roofs which echo the horizontal ground plan and the vertical lines of trees and human beings. His church (4) has all the sharp simplicity of a painting by Vermeer or Cézanne.

Wright's further innovations are a part of the modern world, in which art no longer has any physical limits and frontiers in space, and has become an international form of expression.

In Europe, Maurice Utrillo was painting scenes of the suburbs in his native Paris that have some affinities with the Impressionists, but an entirely different and poetical content. The Paris he shows us (5) is a city of pauses and silences, quiet deserted streets and dreaming houses, painted in silvery whites, dark reds and flashes of green.

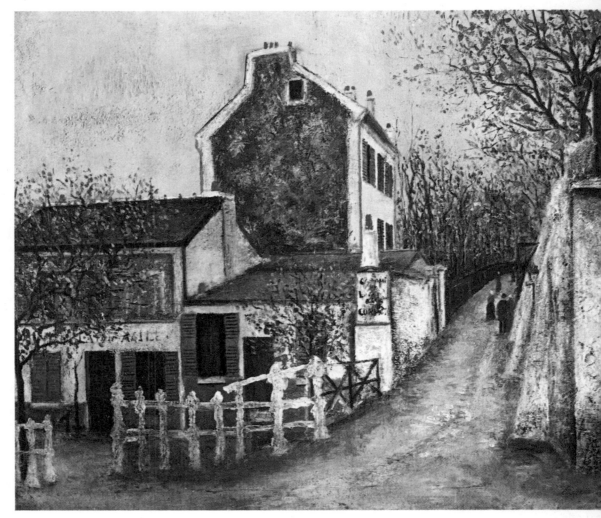

5. Utrillo: "*Le Lapin agile*".

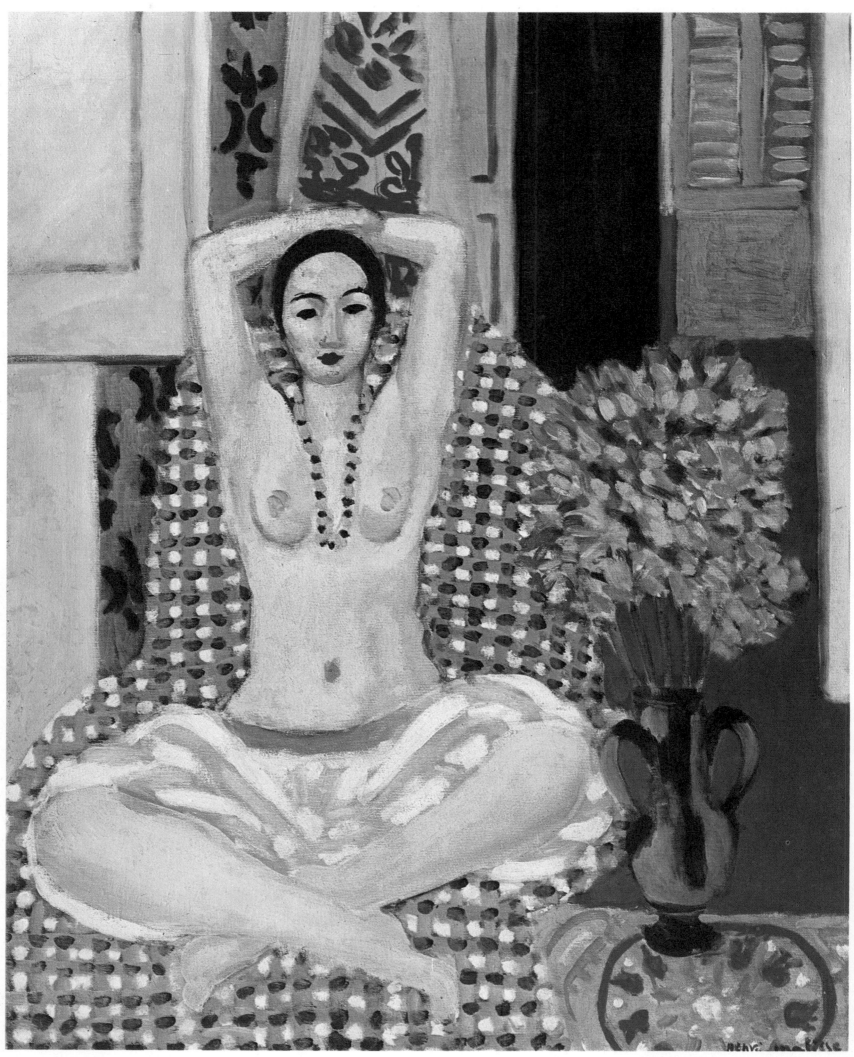

1. Henri Matisse: *The Hindu pose*, 1923.

THE TWENTIETH CENTURY

Since 1900 art has grown ever more varied and profuse. The Romantic artist had claimed the right to create, not out of an objective view of the world and of art, nor out of an objectivity imposed by the demands of a patron's proposal, but out of a subjective need to express personal ideas and feelings, and in modes as closely attuned to this need as he could manage. To claim this right was one thing; to exercise it another. Revolutionary as many 19th-century artists were, their conception of what could be done in the name of art was still limited. The painters departed drastically from naturalism and idealism, questioned the pictorial value of perspective and used colour with a new intensity, giving it constructive and symbolical roles, but they did not question the necessity for recognisable subject matter in painting nor the traditional concept of a picture as a flat object normally surrounded by a frame. Rodin and other sculptors expressed very personal sensations through figures that ignored traditions inherited from classical Greece, late-medieval Europe and the Italian Baroque; they did not question the materials and methods they had inherited, nor the role of sculpture conceived as an art of making three-dimensional solid objects comparable to those we see about us. Twentieth-century artists, much supported by their predecessors' achievements, have ceaselessly questioned inherited assump-

tions, and the result had been an age full of new artistic idioms, quickly developed and rejected in favour of even newer ones, of great stylistic diversity in any one period or place, and, at the same time, of growing international affiliation.

Until about 1945, Paris continued to play the leading role it had long held. French artists, and those who converged on Paris from Spain and eastern Europe, created and supported a series of movements that found echoes all over the western world. Matisse and a circle of other painters exhibited together for the first time in 1905. Their art was characterised by dynamic, often anti-naturalistic, colour and vehement handling that owed something to Seurat and Van Gogh. A critic described them as *fauves* (wild beasts), and their movement became known as Fauvism. Matisse himself soon transformed his style into a highly sophisticated language of subtle colour and elegant, incisive forms at the service of timeless subjects, such as dressed or nude women, still lifes, interiors and landscapes. It was his avowed purpose to give us pleasure and comfort through his work, and to this purpose he brought the finest sensibilities and professional skills. Other Fauve painters, such as Vlaminck, continued to be satisfied with an art redolent of energy and enthusiasm; others, notably Braque and Derain, transferred their allegiance to another movement, Cubism.

2. Henri Matisse: Pages from Mallarmé's *Poésies*, with etched illustration, 1932.

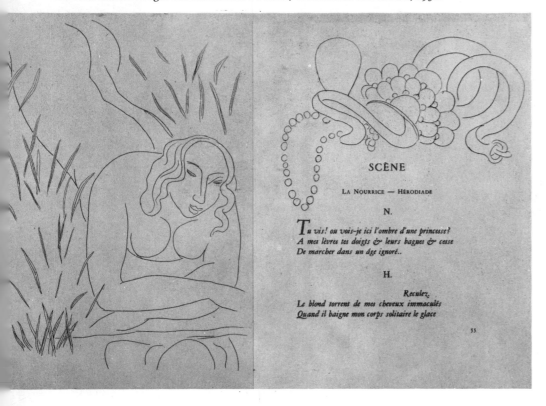

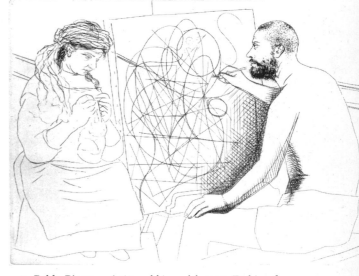

3. Pablo Picasso: *Artist and his model*, 1931. Etching for Balzac's *Le chef d'oeuvre inconnu.*

Overleaf: Pablo Picasso: *Night fishing at Antibes*, 1939.

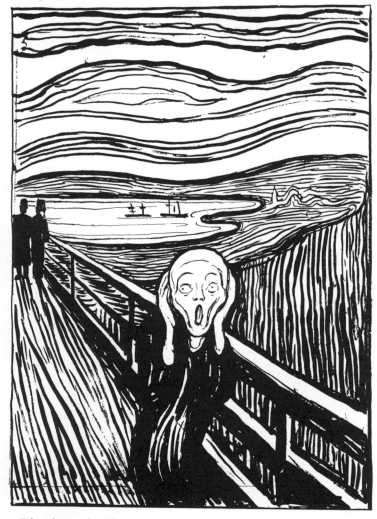

1. Edvard Munch: *The cry*, 1895. Lithograph.

Expressionism, which implies the distortion of natural appearances in art for the sake of communicating intense emotion, is perhaps the northern European mode *par excellence*. It characterises the art of Grünewald and his time (see page 123), which was covered over by a veneer of classicism during the centuries dominated by the Renaissance, and re-emerged during the 19th century as an art of personal anxiety and social protest. Most of the art of twentieth-century central Europe is of this kind. Expressionist artists were influenced by the example of Edvard Munch (his work was then better known in Germany than in his native Norway), who gave unequivocal pictorial form to his deep unhappiness, and that of Van Gogh, who had so greatly extended the communicative power of line and intense colour. Oskar Kokoschka, born in Austria, is one of the finest painters among the Expressionists, combining in his work vehement colour and brushwork and disdaining any kind of elegance (3). In other countries, too, Expressionism flourished in varying degrees. Vlaminck, one of the Fauve group gathered around Matisse, translated an excited and optimistic view of life,

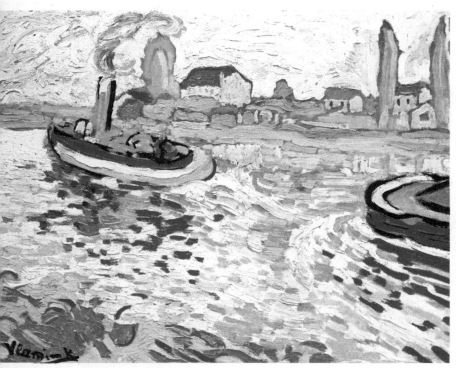

2. Maurice de Vlaminck: *Tugboat on the Seine*, 1906.

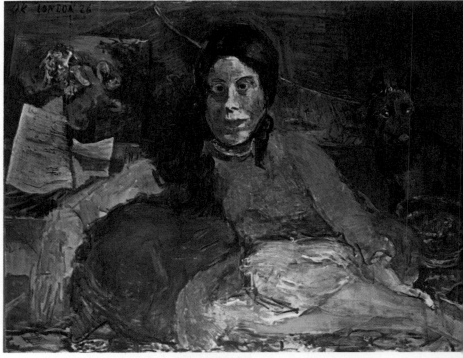

3. Oscar Kokoschka: *Adele Astaire*, 1926.

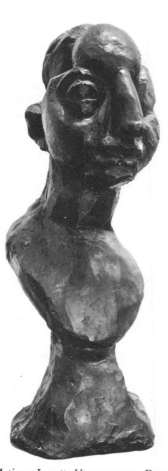

4. Henri Matisse: *Jeanette V*, 1910–1911. Bronze.

5. Henri Matisse: *Chapel of the Rosary*, Vence. 1950–1951.

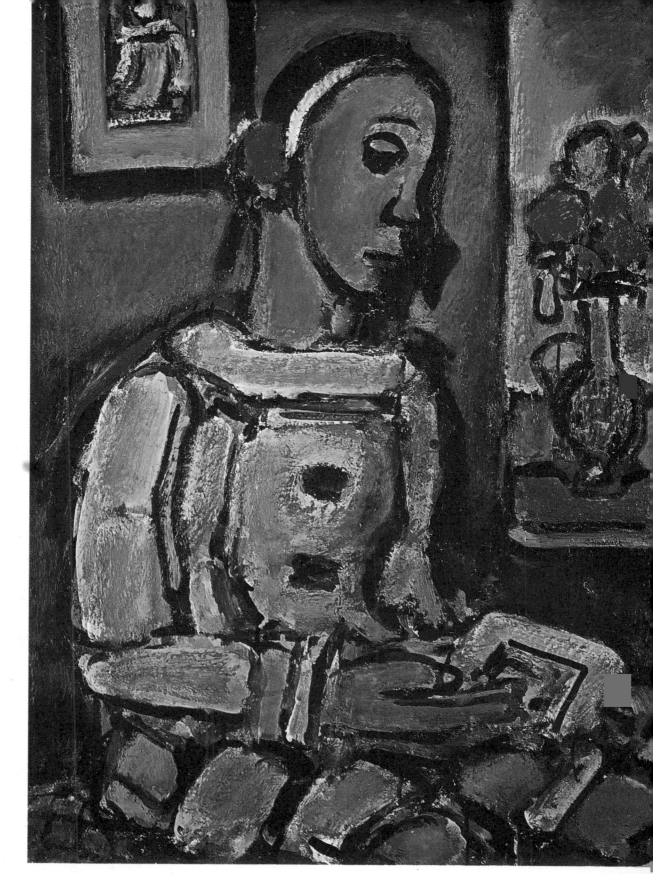

6. Georges Rouault: *The seated clown*, 1945.

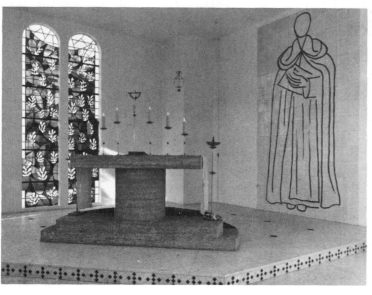

together with his compelling physical energy, into turbulent compilations of bright colour in thick paint. The picture here reproduced is one of his mildest (2). If there is a sense of emptiness about his work it is because his enthusiasm did not have any goal outside himself. The opposite is the case with Rouault, another French painter, whose religiousness is expressed in passionate but controlled pictures in which richly glowing colours and simplified forms suggest stained glass windows (5). However, in the work of Rouault's fellow student, Matisse, the urge to expression is purified by the strictest economy of means: Matisse is very much a Mediterranean artist, who withdraws himself behind the clear harmonies of his art (4, 5).

253

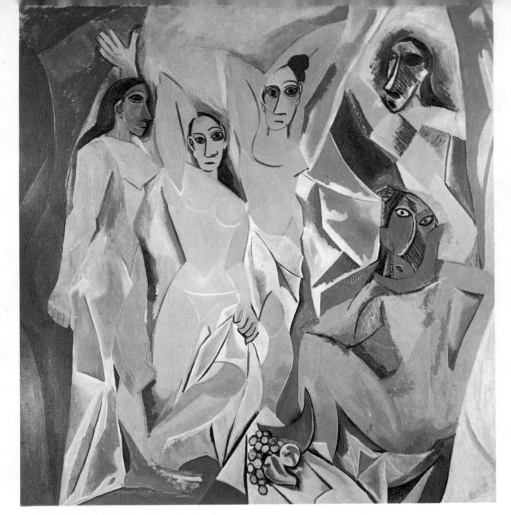

1. Pablo Picasso: *Les demoiselles d'Avignon*, 1907.

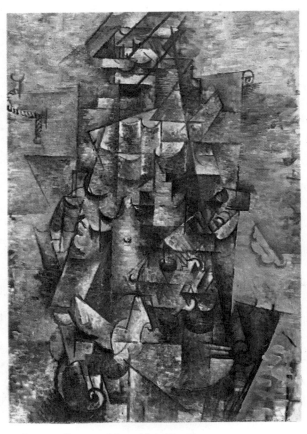

3. Georges Braque: *Man with guitar*, 1911.

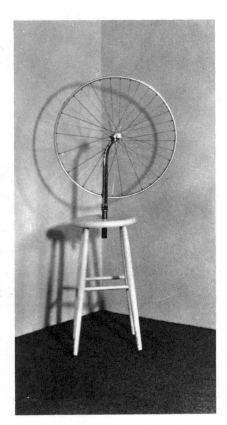

2. Marcel Duchamp: *Bicycle wheel*.
("Ready-made"), 1913.

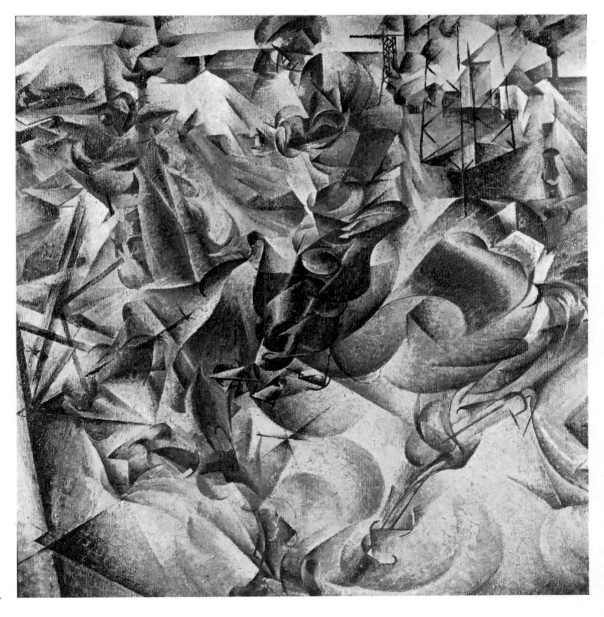

4. Umberto Boccioni: *Elasticity*, 1912.

254

Cubism was an attempt to create a new pictorial language in which the solidity of objects and the fixed viewpoint required by traditional art were exchanged for an open arrangement of facets reminiscent of the object from which they were derived as it might appear seen from many different angles. To the perspective space of Renaissance painting and the flatness of Gauguin and Matisse, the Cubists opposed the effect of a low relief that might even seem to project from the canvas. The style was created during 1908-10 by Picasso and Braque working together. It seems to have originated in Picasso's *Demoiselles d'Avignon* (1) where the painter used formal ideas from Cézanne and from African Negro carving to create a modern version of the time-honoured theme of nudes. Cubist pictures can at times be very difficult to read, but the link with visible subjects is never entirely broken. In the art of the Italian futurists, of whom Boccioni was the most adventurous (4), the Cubist idiom was adopted to celebrate the marvels of the modern world. Not only did they try to convey in pictures the total experience of a scene—its appearance, its noise, the unstable image of moving objects, as well as any emotional reactions— but they especially valued mechanical speed and sounds as the outward manifestations of a new technological world. As an art movement Futurism lasted only a few years, from 1910 to about 1915, but its ideas were widely disseminated. Léger developed Cubism into an almost abstract style with strong mechanical connotations, and with it sought to create an art that would communicate particularly to the modern industrial worker.

The art of Modigliani, born in Italy and working in Paris, owes much to the work of Picasso and Cézanne and to negro carvings, from which sources he evolved a personal style at once strong and simple and firmly expressive.

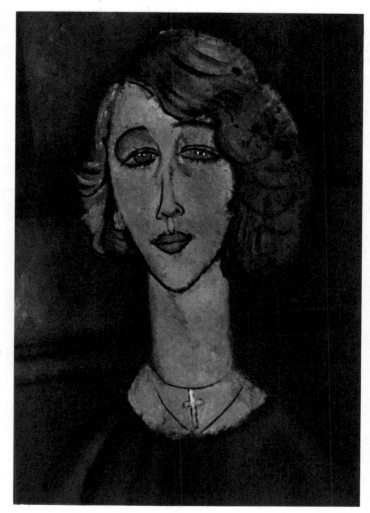

6. Amedeo Modigliani: *Renata*.

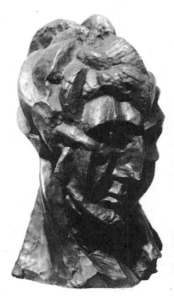

5. Pablo Picasso: *Head of a woman*, 1951.

7. Fernand Léger: *Contrasts in form*, 1913.

1. Paul Klee: *Child consecrated to suffering*, 1935.

The concern of our age with deep layers of motivation in human activity has found expression in art at various levels. De Chirico (3) and most of the Surrealists of the 1920s and '30s (of whom Ernst is probably the finest) assembled in their pictures strange and disquieting objects of dreamlike character. In this they were aligned with contemporary developments in poetry (particularly in France); they also derived support from certain artists whom they saw as precursors, notably Ensor (2) and Bosch (see pages 170-171). They were interested, too, in the work of Klee (1), but he was more concerned with a dreamlike *process* of creation in which lines, forms and colours were allowed to combine into significant images.

3. Giorgio de Chirico: *Hector and Andromache*.

2. James Ensor: *Intrigue*, 1890.

256

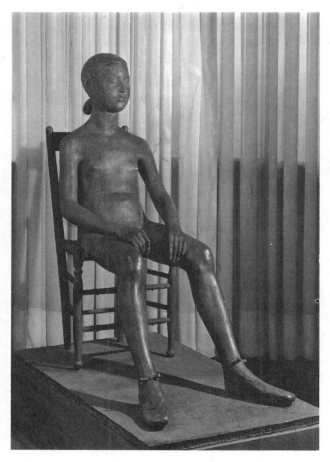

4. Giacomo Manzù: *Little girl on a chair*.

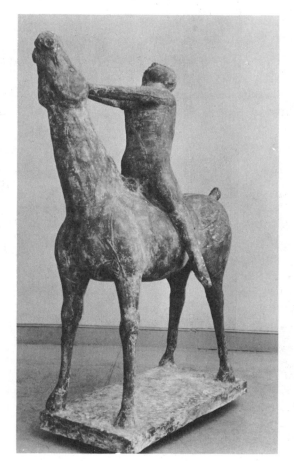

5. Marino Marini: *Horse and rider*, 1950.

6. Max Ernst: *The Elephant of the Célebès*, 1921.

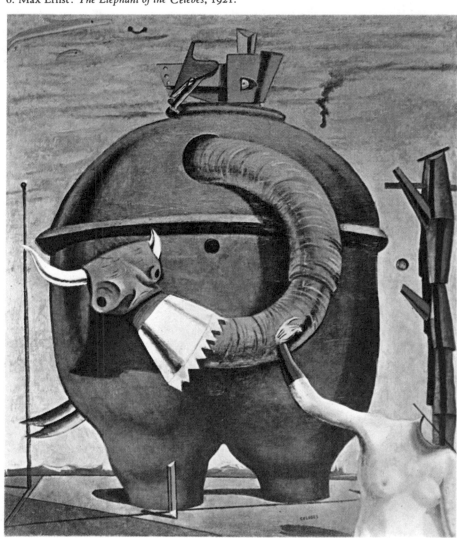

Although the Cubist idea of destroying the solidity of objects by opening them as separated facets was a starting-point for a new sculptural language (see page 262), and although Duchamp's seizing upon a handsome but manufactured object and exhibiting it as art represents an extraordinary challenge to the whole tradition of sculpture as a Fine Art, many modern sculptors have adhered to traditional techniques. Marini's horseman (5) is a late descendant of the carved horseman of archaic Greece; in his boldly simplified forms and tensed organisation he is clearly modern. Germaine Richier's work is dominated by a sense of fear and destruction, expressed both in the shapes she uses and in their apparent decay; at the same time her subject matter is timeless. Max Ernst (6) was one of the most important painters of the Dada and surrealist movements, although he remains a vital force in modern Western art.

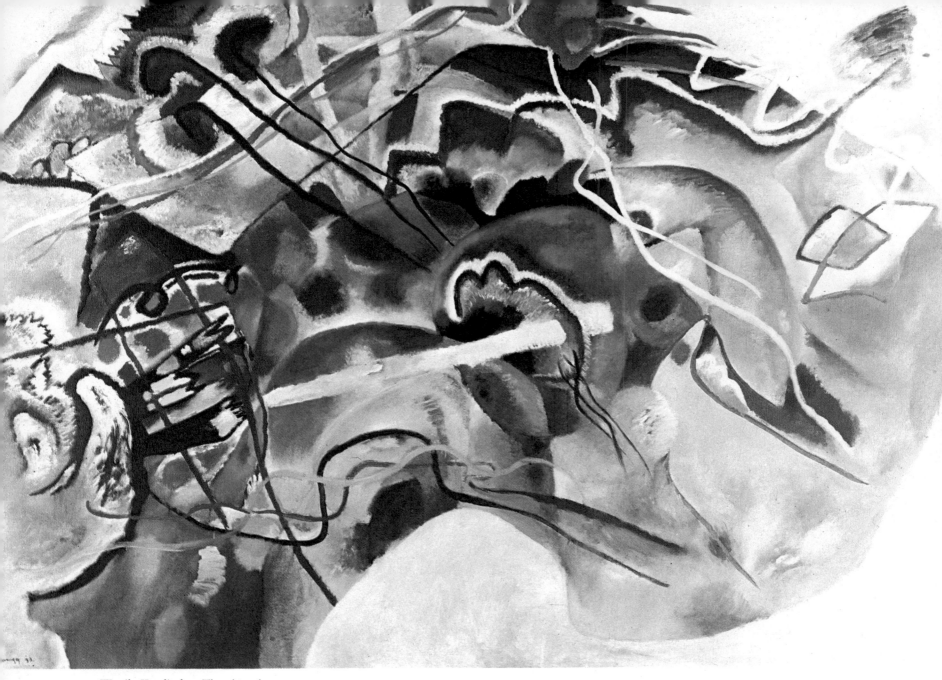

1. Wassily Kandinsky: *The white edge*, 1913.

2. Jean Arp: *Pepin Geant.*

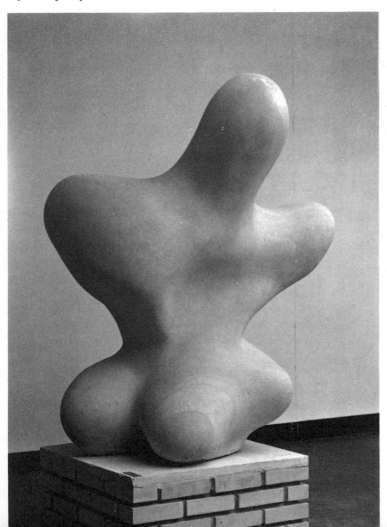

Other sculptors departed more drastically from the normal appearances of things. Arp, who was connected with the Surrealists, exploits the interchangeability of natural forms. His freely invented, rounded sculptures inhabit the wide world of nature by hinting at clouds, fruit, human anatomy, certain roots, and so on; they also, as in the example illustrated here (2), suggest growth and movement and demand some kind of response from us. The British sculptor Moore is of especial historical importance as the senior and greatest member of a British school of sculpture that has flourished since his emergence in the 1930s. Moore has always found a particular depth of meaning in the age-old theme of the reclining female figure and in his best work he has striven to express human warmth inherent in this subject while transforming the female form in order to include in it references to landscape and also, perhaps, in this example (3), carved at the end of a long World War, hints of helmets and a general sense of protectedness. He has also been much concerned with the character of the materials he uses, adapting his vision of the figure he wants to carve to the structure and the quality of the wood or stone he has chosen to carve it in.

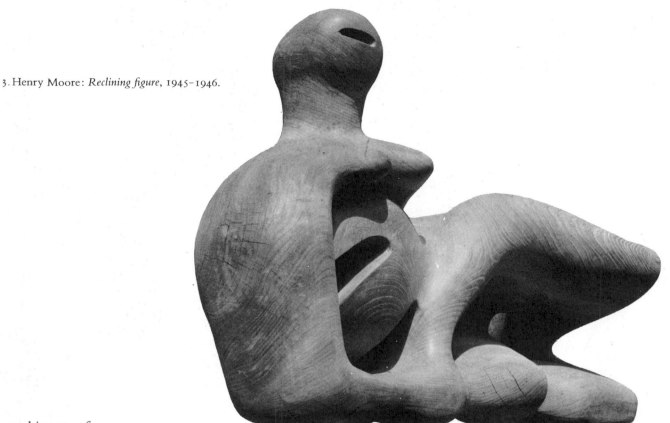

3. Henry Moore: *Reclining figure*, 1945-1946.

Behind abstract art lies a long history of a declining interest in subject matter of the traditional kind. The time came when the assumption that a work of art had to resemble an object in nature was questioned. Gauguin claimed to paint pictures whose subjects were obscure to himself; he demanded for painting the freedom of direct communication that music has always enjoyed. Similarly, when Cézanne painted the same mountain again and again, and demanded of his posing wife that she should "be like an apple", he was in another way stressing the primacy of what the painter makes with paints on his canvas. Although Picasso and Braque as Cubists always retained an objective theme in their paintings, these were so abstract in appearance that they helped others to reject subject matter entirely. One of these was the Dutch painter, Mondrian, who, after doing outstandingly beautiful Cubist paintings, evolved the Neoplasticist style in which rectangular forms of blue, red or yellow (the primary colour) and black, white and grey (the non-colours) were placed in rectangular relationships (4). The Russian, Kandinsky (who worked in Germany until 1933, and then in Paris), saw abstract painting as a direct exteriorisation of his turbulent emotions. Beginning in 1910 he tried to put on canvas as direct a transcription of spirit as possible, sometimes improvising like a musician (1). His Abstract Expressionism (as it has subsequently been named) has been of considerable importance to more recent developments.

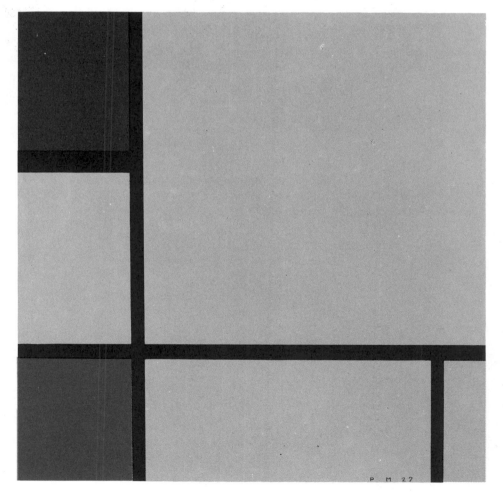

4. Piet Mondrian: *Composition*, 1929.

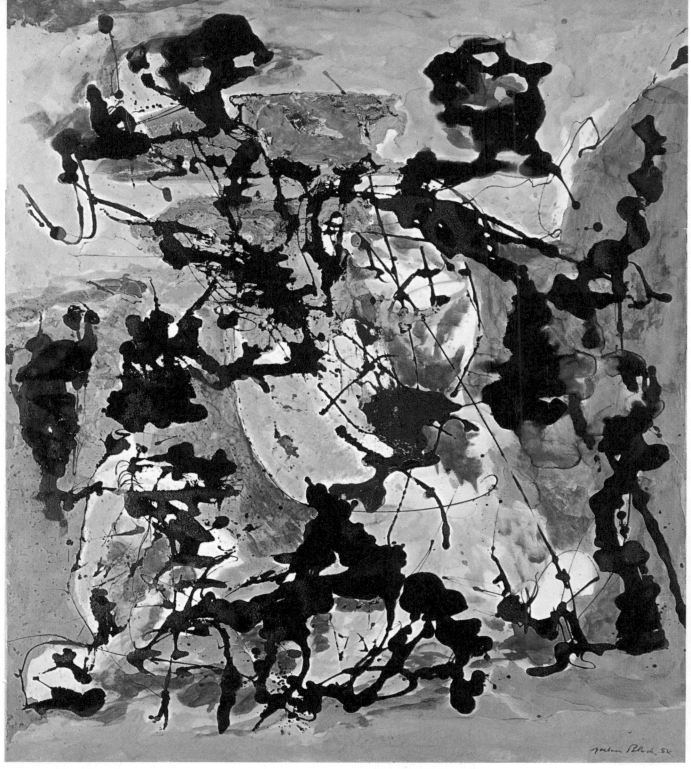

1. Jackson Pollock: *Number 12*, 1952.

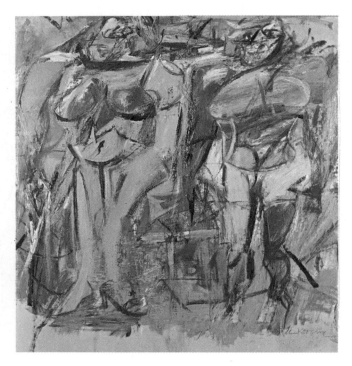

During the first decades of this century the United States did not play any leading rôle in contemporary art. This situation has changed drastically since World War II. The late 1940s and early '50s saw the emergence, principally in New York, of American painters remarkable for their energy and freshness. Largely abstract, their frequently very large pictures are in some ways the logical outcome of the ideas more tentatively explored by Kandinsky during 1910–20, but this influence and others from Europe are overshadowed by an impatient rejecting of the long tradition of *belle peinture* (fine handling of paint) in favour of boldness of attack. The two dominant artists were Pollock and de Kooning, but there are several other outstanding painters and there is no sign of loss of impetus. The influence of the new American painting has been world-wide.

2. Willem de Kooning: *Two women*, 1954.

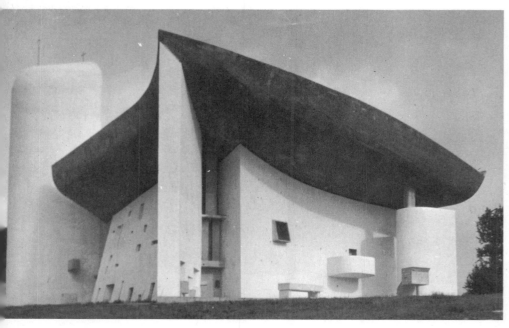

3. Le Corbusier: *Notre Dame du Haut*, 1955, Ronchamp.

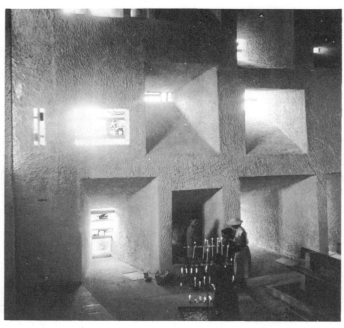

4. Le Corbusier: *Interior of Notre Dame du Haut*, Ronchamp.

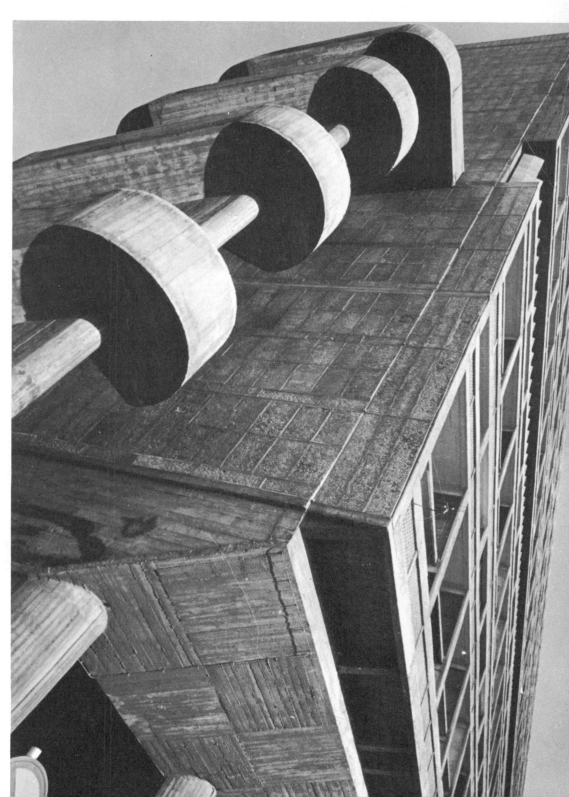

Without doubt, the greatest architect of our century is the Swiss-born Frenchman, Le Corbusier, who early recognised the advantages of building in reinforced concrete. He gave his first masterpieces (notably private houses built in the 1920s) a clarity of form and solemnity of proportion not normally found in radical works but echoed in the contemporary paintings of Mondrian.

The opportunity to put some of his most fundamental ideas into practice has come to Le Corbusier since the last war. First at Marseilles and then at Nantes he built large *Unites d'habitation* (residential units), immense monolithic buildings standing on piers, housing not only large numbers of flats but also all the shops and social facilities that are part of life. In India he and other architects have collaborated to create the new capital city of Chandigarh. These buildings, and the pilgrimage chapel at Ronchamp, show him working in a more dramatic, more sculptural manner of great originality.

5. Le Corbusier: *The Marseilles housing estate.*
View of the north-west, 1947-1951.

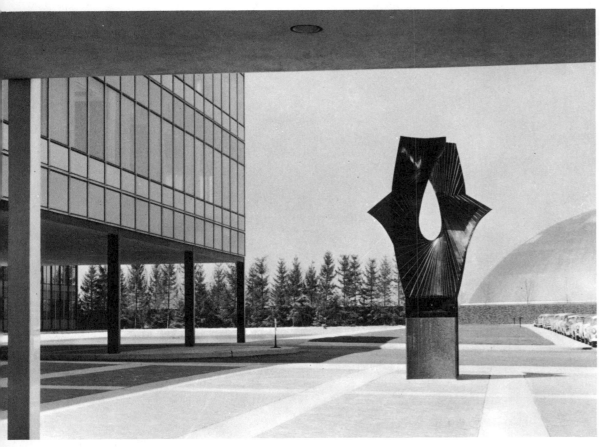

1. Antoine Pevsner: *Bird in flight*. General Motors Technical Centre, Detroit.

The history of sculpture in this century has not been as brilliant as that of architecture or painting. Social change and revolutionary advances in technology have perhaps helped architecture to re-create itself, while its physical properties as well as the material unreality of two-dimensional images make painting an art particularly suited to adventure. Renaissance painting had to some extent diminished sculpture by taking over its capacity for presenting three-dimensional subjects convincingly; in spite of the great sculpture of Donatello, Michelangelo, Bernini and a few others, painting reigned over the arts. The nineteenth century, so rich in painters, produced remarkably little in the way of really outstanding sculpture.

The interest in new concepts of matter as energy rather than inert solids and of space-time relationships hinted at in Cubism, has become paramount in a new form of sculpture, peculiar to our century, known as Constructivism. Just as Cubism analysed objects into spatially separated facets, so Constructivism is concerned with making three-dimensional objects that will exist in space rather than displace it, and often include elements making for sensations of light and change, such as transparent and reflecting materials. Constructivism appears to have been sparked off by some rough wooden reliefs made by Picasso during 1912–14; it became a movement in Russia during 1914–21 and it was the Russian brothers Gabo and Pevsner who brought it back to

2. Constantin Brancusi: *King of Kings*. Wood.

the west when political conditions in Russia made unproductive and propagandaless art unwelcome. Since then Constructivism has found adherents everywhere, though Gabo and Pevsner continue to dominate on account of the quality of their work. Pevsner, who now works in France, bases his work in part on mathematical formulae. Gabo works more freely and poetically, and frequently turns to plastic materials for their lightness, malleability and transparency. He is now in the United States,

3. Naum Gabo: *Linear Construction*, 1950.

girders. The additive process of Constructivism is closer to modelling than carving, but it is the spatial, as opposed to the massive, character of this form of sculpture that has been developed most consistently, even when the intention is that of creating a persuasive image.

Although various forms of Constructivism have tended to dominate the world of *avant-garde* sculpture, there has been one really great sculptor committed to traditional methods. This was the Rumanian Brancusi, who worked in Paris. With the doggedness of the peasant that he was, and the sensibility of a Matisse, Brancusi sought for perfectly expressive sculptural form. All the great figurative sculpture of the past was to him "beafsteak"; what he wanted to achieve was that absolute simplicity where reticence turns eloquent. Out of rude lumps of stone he carved mysteriously living masses that distantly recall heads, birds, fishes, seals and torsos; making slight alterations to them he sometimes cast the same subjects in bronze, and when he had highly polished them they seemed to become transparent and weightless. He also carved rough wooden sculptures that suggest both African utensils and East European folk art, objects of primitive intensity that seem utterly contradictory to the perfection of his stone and metal works. Sometimes he combined the two branches of his production as bases and sculptures. The quiet creativity of the man, his technical ability, his regard for the materials of sculpture, and the idealistic quality of his forms, made Brancusi one of the most admired and influential sculptors of his time. During the earlier decades of the century architecture had tended to strip itself of the arts in favour of a nakedness that was equated with functional rationalism. Since the last war there has been a greater willingness to allow painting and sculpture some place in the architectural environment. It has in fact been found that the freer forms of painting and sculpture offer perfect foils to the impersonality and machine-made quality of much modern architecture. Only in Le Corbusier's work, however, do the arts and architecture achieve full integration, and that is possible only because he is his own artist.

having worked for a time in France and Great Britain.

Two very influential extensions of the Constructivist idiom have been the mobile and Expressionist Constructivism. The American, Calder, is credited with the invention of the mobile, a constructed sculpture that is designed to move with passing currents of air. A particularly clear expression of our age's new awareness of space and motion, mobiles are also an arresting form of art on account of their ever-changing shapes, and many other artists have worked in this idiom. Expressionist Constructivism grew out of the collaboration between Picasso and the sculptor-blacksmith Gonzales in 1931, when Picasso took odd pieces of iron and welded them into expressive images. This free use of junk metal, permitting free formal fantasy enriched by associative content of the shapes and condition of the pieces used, has become one of the most fruitful of modern sculptural techniques, and as time has gone on much larger constructed sculptures have been made out of such ingredients as crushed car bodies and steel

4. Le Corbusier: *Villa Savoye*, Poissy, 1927-31.

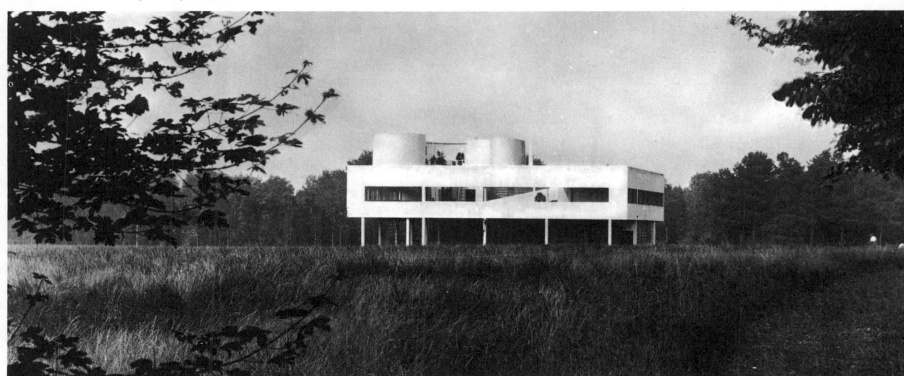

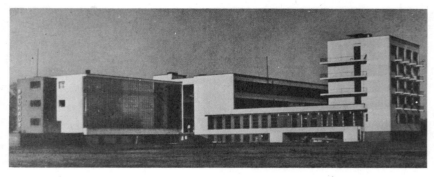

1. Walter Gropius: *The Bauhaus*, Dessau, 1925-1926.

The Bauhaus building in Dessau, designed by the German architect Gropius to house the design school of which he was principal, represents a synthesis of the advanced architectural thought and style of its time. Its character was determined by the example of Le Corbusier, of the Dutch architects who worked in the spirit of Mondrian, and of German architects such as Mies van der Rohe, as much as Gropius himself. Remarkably free in its planning, its exterior dominated by multi-storey walls of glass, the Bauhaus building sought to express functionalist ideas while unconsciously accepting the stylistic conventions that went with them.

work in the United States is dominated by the skyscrapers he has built. They are all tall towers, rectangular in plan, elevation and detail; they are built mostly of steel and glass. The Seagram Building, designed by Mies in collaboration with his admirer Johnson, has the additional refinement of being built in copper instead of steel. Architecture of this kind has a dignity and a Brancusi-like perfection that some people find chilling, while others relish its crisp impersonality and sense in it a welcome challenge to their own sense of dignity.

Other architects offer their clients more spiritual protection. Wright's Kaufmann House compensates for the pioneering note implied in its situation astride a waterfall, by enclosing the resident behind a series of parapets and massive walls. In other houses in other situations, Wright used drastic horizontality of design to emphasise the earth-bound quality of life. In some of his last designs he fashioned country villas as fairy-tale castles of a semi-fortified, multi-garage kind.

The structure-dominated classicism of Mies, to some extent a descendant of the ideology of the Bauhaus building though by no means a stylistic imitation of it, has tended to dominate architecture everywhere. All over Europe and the United States, and in the cities of South America, Africa and the Near

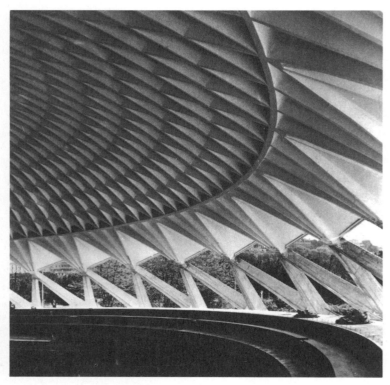

2. Pier Luigi Nervi: *The Palazzetto dello Sport*, Rome, 1956-1957.

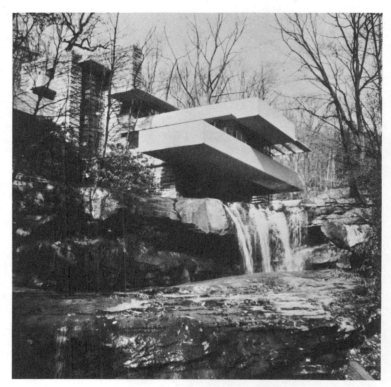

3. Frank Lloyd Wright: *Kaufmann House*, Bear Run, Pennsylvania, 1936.

Similarly the design school itself preached rational attitudes based on social needs and mass-production techniques, but practised design in terms of the simplest geometrical shapes and unadventurous colours.

The influence of the Bauhaus school has been considerable. What is more, Mies van der Rohe, who directed the Bauhaus during its last two years, has become one of the dominant figures in international architecture. To his architecture he brings a sense of quality and refinement not equalled in our time, and a feeling for simplicity of form and perfection of proportion that is ultimately classical in essence and in inspiration. His post-war

and Far-East, buildings of a fundamentally similar kind are to be found. It was indeed against what he feared would become a world-wide uniformity of design that Wright struggled in his designs and his pronouncements. Recently, however, there have been signs that a new formal adventurousness has come into architecture, bringing with it exciting and sometimes extravagant buildings that offer man new experiences of space and scale and contrast utterly with the ruler-designed international style. In fact the full potentialities of concrete, for some decades now the dominant material of modern architecture, are only today being fully investigated. Whereas architects had been content to

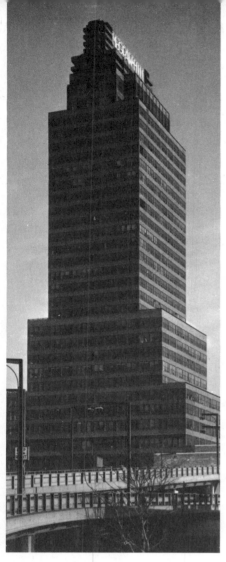

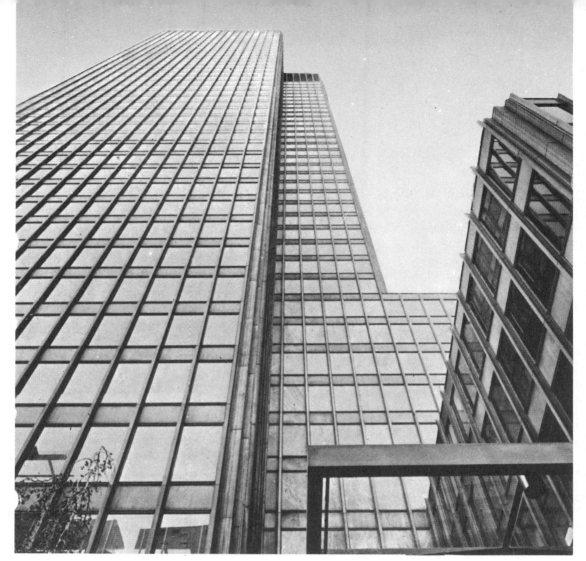

4. Raymond Hood: *McGraw Hill Building*, New York, 1930

6. Mies van der Rohe: *Seagram Building*, New York, 1958.

use reinforced concrete for the lintel-and-post structure that the Egyptians and the Greeks had developed for use with stone, new techniques of pre-stressing, shell-concreting and folded slab concrete have now been invented and refined. Among the men responsible for this technological advance, and a man also capable of exploiting the formal beauty made possible by them, is the Italian engineer Nervi, whose work has included several airplane hangars, exhibition halls and sports stadia. His solutions to structural problems, found empirically by experiment, rather than on the basis of theoretical knowledge, bring with them as though inevitably quasi-ornamental features such as ribbed vaults that before the last war would have been avoided as self-indulgent. Similarly Saarinen in his TWA airport building exploited the constructive potential of shell concrete and at the same time fashioned a symbolically communicative building

that is as much a vast sculpture as a functional building.

It may be, however, that the future will lie neither with the architects of glass and metal nor with the architects of concrete. While the concept of the industrial production of large architectural units (as opposed to their being built up on the site) is all too slowly beginning to affect the production of houses and office blocks, research is being made into the question of making buildings of plastic, and even into such suggestions as covering whole cities with transparent domes. It would be merely dizzying to look too sharply and too far into the future; what is clear is that in the arts and in architecture great possibilities lie ahead, and it seems likely that the talents and the will to explore them will not be lacking if political and economic conditions serve to provide the limited degree of relaxation that is a necessary basis for all advance in this sphere.

5. Eero Saarinen: *The Trans World Flight Center*, Idlewild, 1961.

7. Jorn Utzon: *Opera House*, Sydney, 1956. Model.

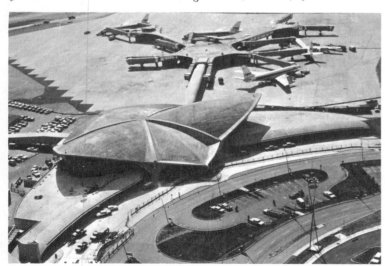

SHORT BIOGRAPHIES

ALBERS, JOSEF (*b.* 1888).—German non-objective painter, ex-Bauhaus teacher, now at Yale University in the United States. Albers limits his forms to strict geometric shapes, squares and triangles, so as to emphasise his powerful colour contrasts. The colours are applied un-mixed, direct from the tube.

ALBERTI, LEON BATTISTA (1404-1472).—Italian architect, scholar and humanist whose ideas greatly influenced the course of the early Renaissance. Beauty, to Alberti, existed in the perfect balance of all components of a structure or composition; in the true work of art, nothing could be added or subtracted without disturbing the essential harmony of the piece. He revived interest in the classical proportions of Greek temples and the monumental dignity of Roman architecture, while at the same time he acclaimed the new perspective vision of Masaccio. The façade of his most renowned building, the Palazzo Rucellai in Florence, incorporates the three major Greek orders, each dominating a separate storey: Doric on the first, Ionic on the second, and Corinthian on the top storey. In the latter part of his life he designed the Church of Sant' Andrea at Mantova, calling it the ideal form of the Christian church. The building has a single nave roofed with a Roman barrel vault, and crossed by a single vaulted transept. The focal point to which the eye is irresistibly directed is the cross, set beneath the cupola covering the intersection of the transept and nave. Alberti, like many Renaissance artists, wrote extensively about his theories; the most important of his books is "De re aedificatoria", on architecture.

ANGELICO, FRA (1387-1455).—Florentine painter, outstanding among the earlier Renaissance artists for his successful mingling of the traditional Gothic forms with the revolutionary ideas of Masaccio and Brunelleschi. His spacious and airy compositions, brightly-coloured landscapes peopled with gracious figures, are both charming in their humanity and profound in their religiosity. A Dominican friar from his youth, Fra Angelico's fundamental simplicity and devotion to God pervades his frescoes and panels. Following his precept that art is the handmaiden of religion, he travelled widely in Italy in the service of his Order, decorating the walls of monasteries and painting altarpieces. Fine examples of his frescoes may be seen in the Vatican and in the San Marco monastery in Florence.

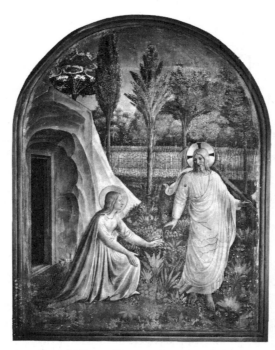

Angelico, *Noli me Tangere*. San Marco, Florence. (Alinari)

ANTONELLO DA MESSINA (1430?-1479).—Italian painter born in Messina, Sicily. He was familiar with northern art through visiting Flemish painters in Sicily, from whom he learned the technique of oil painting, until then virtually unknown in Italy. Antonello's influence was considerable among Italian painters, especially in Venice where he introduced the new technique and thereby cleared a path for the warm, luminous colours of later Venetians such as Titian and Tintoretto. He sought to synthesise the early Renaissance ideals of harmonious geometric forms with an enriched interpretation of life by means of colour. During his lifetime, Antonello was most famous for his portraits, which are structured in clean, uncompromising forms, almost architectural in their essence.

ARP, JEAN HANS (*b.* 1887).—Alsatian artist of exceptional versatility. A painter, sculptor, graphic artist and poet, Arp was active in several of the more important movements in art at the beginning of the century. Along with Kandinsky, Marc and Klee, he belonged to the Expressionist "Blue Rider" group. Later, as one of the founders of European Dadaism, he composed the irrational "fatagaga" collages with Max Ernst. During his first period Arp worked with rectangular and geometric forms, but after 1917 he devoted himself to the simple rounded forms now associated with his name. The limitations imposed by the flat canvas surface induced him to turn to

sculpture and three dimensional compositions in carved wood. After 1924 Arp joined the surrealist movement. Apart from sculpture and collages, his works include illustrations, lithographs, and engravings, as well as designs for rugs, embroideries and tapestries.

Arp, *Die Nabelflasche* (*The Navel Bottle*). From folio of eight reproductions of drawings. About 1918. Museum of Modern Art, New York.

AUDUBON, JOHN JAMES (1780-1850).—American painter of birds and wild life. After studying drawing with David in France around 1802, Audubon returned to the United States where he began the first of his numerous enterprises. His passion for the bird life of his country prompted him to travel far and wide collecting specimens and drawing them with scientific exactitude. Concentrating his energies thus, Audubon produced his masterpiece, a vast collection of drawings of North American birds. Only in 1826, after his work had been praised by British scientists and art critics alike, did he find an editor in London who was willing to publish them. "Birds of North America" was published in London in 1827-1838, and was followed by "Quadrupeds of North America" in 1845-1848.

BASSANO, JACOPO (1510?-1592).—Italian painter of the Venetian school and one of the foremost landscape and *genre* painters of the late Renaissance. In technique and style he was most influenced by Titian,

though his themes were more humble than his master's. Bassano chose to paint village life and landscapes with cattle; he also did portraits, historical scenes and religious themes. His work was exceedingly popular, and his four sons followed closely in his footsteps, unfortunately with mediocre results. Genuine works by Jacopo are relatively rare; there are numerous inferior copies by his sons and other followers.

BECKMAN, MAX (1884-1950).—German painter, one of the most important figures in the Expressionist school of the '30s. In the early part of his career his work was influenced by the expressive distortion of the medieval painter, Lovis Corinth. During the '20s his commentary became more caustic and emphasised man's inhumanity and life's futility. Beckman's themes were mainly social and aimed to express symbolically "the idea behind reality". In this regard he differs from the majority of Expressionists who described a quite personal and pessimistic criticism of reality. In the '30s Beckman's use of colour was enriched through the influence of the French school, yet throughout his career colour remained rather harsh and spare. He left Germany to escape persecution at the start of the war and in 1949 went to the United States where his art exerted a strong fascination on many American painters.

BELLINI, GIOVANNI (1429?-1516).—Italian painter, second son of Jacopo and brother of Gentile, the foremost Venetian painter of his generation. In his first period he turned from the graceful style used by his father, preferring the more austere form of Mantegna, his brother-in-law. Later his style became mellowed with a more subtle use of light and the warm colours of nature. Bellini enjoyed a remarkably serene and successful life. He was the teacher of two of the greatest painters in history, Giorgione and Titian, and during his own lifetime was generally considered to be the best painter in Venice. Among his more important works are the *Pietà* in the Brera Gallery in Milan, and the *Portrait of the Doge Leonardo Loredan* and the *Agony in the garden*, both in the National Gallery in London.

BERNINI, GIOVANNI LORENZO (1598-1680).—Italian sculptor and architect whose works best realise the tendencies of baroque art. Bernini's astounding mastery of technique and control of his materials allowed him to imitate in marble the textures of flesh, feathers, and diaphanous fabrics. His penchant for fervent, dramatic scenes is well represented in his *Apollo and Daphne*, done in 1622-24 and now in the Borghese Gallery in Rome. Under the patronage of the Pope he received architectural commissions of great scope, and Rome is studded with mementos of his highly individual vision. Particularly beautiful is the Fountain of the Triton in Piazza Barberini, done in 1637. Without question his masterpiece is the magnificent and vast piazza in front of St. Peter's, where two great semi-circular arms of a colonnade partially embrace the enormous oval space. Inside the basilica the huge columns supporting the roof lead the eye to Bernini's great bronze canopy which rests over St. Peter's tomb, and directly beneath Michelangelo's incomparable dome.

BLAKE, WILLIAM (1757-1827).—English poet, artist and mystic. First trained as an engraver, Blake supported himself for many years in this craft, using both his own and the designs of others. He gained recognition as a poet when he published "Songs of Innocence" in 1789, and "Songs of Experience" in 1794, which he illustrated with hand-coloured engravings. Though Blake considered design of secondary importance to literature, his pictorial output was extraordinarily large. These illustrations have a very individual, visionary quality, depicting turbulent, symbolical forms in pale colours. His major works are the 21 large water colour illustrations for the Book of Job, produced in 1820, and the 102 illustrations for Dante's Divine Comedy. Blake was exceptionally individual in his creative work. Endowed with an awesome energy of mind and spirit, he produced out of himself, impulsively, and with virtually no academic training.

BOCCIONI, UMBERTO (1882-1916).—Italian sculptor, and the most significant of those belonging to the Futurist movement. Boccioni advocated the revolt from "the cult of the past", and lauded the by-products and subject matter associated with the mechanised age. He tried to represent in sculpture forms successive stages of movement, thus adding a time element to a hitherto static medium. *Single forms of continuity in space*, done in 1913, shows a human figure thrust forward in the act of walking. His work is best represented in the collection of the Museum of Modern Art in New York.

BONNARD, PIERRE (1867-1947).—French painter, illustrator and lithographer, the leader of the modern French *Intimiste* school. In his early work Bonnard was influenced by Japanese art and the paintings of Gauguin. After 1920 he began using gay, dissonant combinations of colours in a very personal manner, preferring to paint from memory in his studio, and taking only brief colour notes in sketches from direct observation of nature. For his subjects Bonnard chose villages, nude bathers, and peaceful scenes in sunny interiors. He produced many posters recalling the art of Toulouse-Lautrec, as well as a variety of etchings, lithographs for book illustration, and stage designs.

BORROMINI, FRANCESCO (1599-1667).—Italian architect of the Roman baroque. Along with Bernini, he was the greatest architect of the period, though he never enjoyed a comparable fame. Borromini used the means and vocabulary of the baroque with much greater freedom and style than did his rival. His buildings are rich in poetic fantasy, dynamic in their space and lighting, and however elaborate, all elements are carefully and inventively unified. *San Carlo of the four fountains* typifies his architectural genius with its fluid lines, undulating walls, and the profusion of spirals, pilasters and sculptures. Among his most important works are the façades of the Church of Sant' Agnese in Piazza Navona, Rome, done in 1653-57, and that of Sant' Ivo alla Sapienza, Rome, 1642-60.

BOSCH, HIERONYMUS (1450-1516).—Dutch painter of fantastic allegories. Bosch achieved a unique poetic quality in his weird landscapes heavily populated by monsters, animated malevolent objects and surrealist creations. Reflecting the religious tensions and upheavals of his day, he painted in a pessimistic and critical spirit, stressing the vices, stupidities and follies of the medieval world. The work of Bosch was greatly admired by the profoundly religious Philip II of Spain, who collected especially those paintings with a moralist tone. Thus such masterpieces as *The Seven Deadly Sins*, *The Cure for Madness*, *The Hay Wain* and many others, now hang in the Prado in Madrid. The bizarre subject matter contained in the paintings of Bosch frequently clouds the spectator's eye to the very admirable plastic qualities of his art. In the moving *Christ crowned with thorns* in the National Gallery in London, his use of clear, bright colours, boldly and simply composed is seen to fine advantage. In the same picture Bosch's relentless analytic view of mankind provides us with a vivid description of Christ's tormentors. Bosch was a pioneer in a little understood but much appreciated realm of art; he was much imitated by lesser artists, but had no worthy follower until Pieter Breughel.

BOTTICELLI, SANDRO (1444-1510).—Florentine painter and draughtsman, one of the greatest products of the Renaissance. He is thought to have been a student of Fra Fillipo Lippi, yet the most obvious influence in his early work is that of Pollaiuolo. Botticelli's prime concern is line. Colour and

space seem almost afterthoughts, but his sinuous and telling outlines are so exceptionally decorative and expressive that this element alone has given his works a place among the finest creations in the history of art. Especially memorable are his 96 drawings for Dante's Divine Comedy. His most famous paintings, both in the Uffizi Gallery in Florence, are *The birth of Venus* and the *Primavera*. In each of these the beautiful, melancholy figures stand delicately poised among leafy arabesques, or undulating wave patterns. By lengthening the normal proportions of the necks, limbs and fingers, and simplifying the features of the faces by delineation, Botticelli heightens the expressive mood of a decorative form. In his later works, the graver aspects of the artist's temperament appeared. The sharply defined, cold and assured figures in the *Nativity* now in the National Gallery in London, or those in the altarpiece *The vision of Saint Augustine* in the Uffizi in Florence, reflect an entirely different spiritual attitude. It is thought that these last works contain the oblique influence of the reformer-monk, Savonarola, who caused many of Botticelli's earlier works to be destroyed on the pyres which claimed to be burning human vanity.

BOUCHER, FRANCOIS (1703-1770). —French painter, called the perfect exponent of the rococo taste. Along with Fragonard and Watteau, Boucher typifies the 18th-century decorative spree in France. The protégé of Mme de Pompadour, he decorated her chambers at Versailles with charming and naughty scenes. Boucher also designed many tapestries, notably the series *Loves of the Gods*, and did illustrations for an edition of Molière's works. Rich, and the most fashionable painter of his period, his art declined in his later years. There are works by him in the National Galleries in London and in Edinburgh.

BRAMANTE, DONATO (1444-1514). Italian architect who developed the classical ideas of the late Renaissance known through the works and writings of his great forerunners, Brunelleschi and Alberti. His *Tempietto* of San Pietro in Montorio, in Rome, is a restrained building in the classic style, composed of perfectly balanced and contrasted architectural elements. In 1505 Pope Julius II commissioned Bramante to reconstruct the old basilica of Saint Peter's. His design had a magnificent simplicity, based on the plan of a Greek cross. As with the small temple, his purpose was to create a close harmony of parts, both inside and out. He died before his plans were carried out, and those who succeeded him so altered and revised his ideas that the building has virtually no relation to the original design.

BRANCUSI, CONSTANTIN (1876-1957).—Roumanian sculptor, and the most completely abstract of the modern school. His forms, usually of stone or metal and highly polished, express absolute shapes. All details are subordinated to heighten the drama of the simplicity and singleness of the piece. Brancusi worked most of his life in Paris.

BRAQUE, GEORGES (1882-1963).— French painter and sculptor. Braque began his career as an apprentice in his father's decorating business. He turned to painting and in 1905 was part of the Fauve group. In 1909 he began a collaborative work with Picasso, developing the branch of painting known as "analytical cubism". He was one of the first to experiment with "collage", using sackcloth and a great variety of materials and textures to obtain decorative and expressive effects. By 1920 he had exhausted his interest in synthetic cubism, and begun to develop a very personal interpretation of reality, especially in still-life and figure compositions. His palette is a particularly subtle one, mainly variations of browns, greys, greens and white. Braque produced some sculpture, largely reliefs in plaster, and also lithographs and etchings.

BREUGHEL, PIETER The Elder (1525?-1569).—Flemish painter of landscapes and, with Bosch, the greatest Netherland satirist. He travelled to France and Italy after passing his apprenticeship in Antwerp. The grand vistas of the Alps made a tremendous impression on him, as his subsequent landscapes with their jutting, fantastic mountains and deep spaces indicate. Often called the "Peasant Breughel", he delighted in portraying the gay simplicity of peasants at work and play. Like Bosch he was merciless in his criticism of superstition, but his regard for men was warmer and his comments less caustic. Breughel planned a great series of landscapes and scenes depicting the twelve months of the year. The cycle was never completed, though five exist, now in New York, Prague and Vienna. *The massacre of the Innocents*, now in the Prado in Madrid, is generally thought to be a protest against the Spanish subjection of the Netherlands.

BRONZINO, AGNOLO (Angelo?) (1503-1572).—Florentine mannerist painter. One of the most significant portrait painters of his period, Bronzino composed his pictures with a kind of icy calculation, arranging his sitters in formal, affected poses, and surrounding them with tight spaces and acid colours. He was a pupil of Pontormo and an admirer of Michelangelo.

BRUNELLESCHI, FILIPPO (1377-1446).—Italian architect and sculptor, called one of the "fathers of the Florentine Ren-

aissance". Brunelleschi began as a sculptor but after 1402, when he lost a competition for a design for the new doors to the Baptistery in Florence to the younger and lesser known Ghiberti, he turned to architecture. With his friend Donatello, he travelled to Rome and made exhaustive studies of the ruins and the building methods of the ancient Romans. Thereafter he developed his own theories of proportion and perspective, incorporating the ideas of classic architecture with the revolutionary ideals of his own day which glorified the individual. Basing his structural plans on mathematical proportions, he set the pace for the spirit of scientific enquiry, the keynote of the Renaissance. His masterpiece is the grandiose dome on the cathedral of Florence. His Capella de' Pazzi, also in Florence, is a handsome example of the harmony and intellectual discipline of his art.

BUFFET, BERNARD (b.1928).—French painter and illustrator. Buffet became famous in 1945 with his paintings of thin, melancholy figures, sparse still lifes, and sterile landscapes. He uses a very limited range of colours, concentrating on black, white and greys, and highly simplified forms outlined boldly in black. He has done stage designs, lithography, and book illustration.

CALDER, ALEXANDER (b. 1898).— American sculptor, inventor of "stabiles" and "mobiles". After taking an engineering degree, Calder began experimenting with metal structures, at first rigidly-fixed pieces of metal and steel wire, and gradually developing into the movable compositions of flat pieces of painted metal suspended by

Calder, *Pomegranate*. Mobile—sheet aluminium and steel wire and rods. 1949. Whitney Museum of American Art, New York.

wire. These latter sculptures move in space as a current of air strikes them, constantly creating new motifs and shadow patterns.

CANALETTO or Canale, ANTONIO (1696-1768).—Italian painter of *vedute*, or views. The son of a scene-painter, Canaletto worked with his father as a youth, then turned to painting the minutely detailed and accurate views of the buildings and canals of Venice. His clear, positive touch, and apt use of perspective are seen in hundreds of large canvases scattered in museums throughout the world. Canaletto's work was especially admired by the English travellers in Venice, who eagerly bought his work as fast as he could produce it. In 1746 he went to England and stayed several years painting views of London which, though similar in technique, are inferior in quality to his Venetian works. Canaletto frequently employed his pupil, Guardi, to paint in the small, lively figures which animate his paintings.

CANOVA, ANTONIO (1757-1828).—Italian sculptor, most renowned of the neo-Classical school. He idealised the human form, in accordance with neo-Classical theories, eliminating all natural and spontaneous movement. The cold and formal sedateness of his work was much admired by Napoleon, who commissioned him to do a number of works including Canova's most famous piece, Pauline Bonaparte Borghese as Venus, in the Borghese Gallery in Rome.

CARAVAGGIO, MICHELANGELO MERISI DA (1573-1610).—Italian painter, and one of the great revolutionaries in art. Caravaggio was by nature a tempestuous character and from the beginning of his career was in constant conflict with the authorities, both civil and aesthetic. In opposition to the reigning Mannerist painters, the Carracci, he embarked on a path of stark realism, using the costumes and attitudes of common people for his religious models, and exaggerating the effects of chairoscuro to the point of melodrama. Ultimately, after many rejections, and derision from fashionable painters, his dynamic style became popular and spread through Europe, particularly among the artists of Spain and the Netherlands.

CARRACCI, ANNIBALE (1560-1609).—Italian painter, and leading artist of the family who founded an academy in Bologna to train Mannerist painters. The school taught a conservative version of the baroque style, encouraging the study of Michelangelo, Raphael, and other Renaissance artists, but stressing illusionist and emotional effects. Carracci's major works are the frescoes in the Palazzo Farnese in Rome.

CASSATT, MARY (1845-1926).—American impressionist painter. She studied in Paris and became interested in the work of Courbet, Manet, and the new Impressionist group. After meeting Degas in 1877, she began to exhibit with the group, buying some of their paintings herself and encouraging American friends to do so. Her sensitive, tender style was not appreciated during her lifetime, though she is now one of the most famous American painters.

CELLINI, BENVENUTO (1500-1571).—Florentine goldsmith and sculptor of the Renaissance. Primarily influenced by Michelangelo and the elongated forms of the Mannerist school, Cellini created such elaborate and sophisticated pieces as the renowned salt cellar in Vienna, and the *Coppa Rospigliosa* in New York, both of gold. Despite his considerable skill in working metal, Cellini's greatest fame rests with his Autobiography, written in 1558-1562.

CÉZANNE, PAUL (1839-1906).—French painter and the most revolutionary figure in the development of modern art. Finding the contemporary Impressionist movement lacking in form and structure, Cézanne set off on a solitary course in the exploration of volume in space, and colour as a structural element. He experimented with an almost obsessive persistence, breaking down the natural form of objects into planes of colour, and finding means of causing those planes to recede in depth through tonal values. Thus Cézanne pointed the way to Cubism, for his forms, constructed of planes like the facets of jewels, each varied in hue, break down natural shapes into basic geometric solids— the cone, the cylinder and the sphere. Noting that warm colours, for instance yellow or orange, tend to push forward on the canvas, and that the cool colours like blue or green tend to recede in space, Cézanne used the principle in laying down his tonal values. In his still lifes, a pear painted yellow in the light and blue in the shadow, has the solidity of a rock. After 1886 Cézanne retired to Aix-en-Provence with a comfortable inheritance from his father, and devoted himself entirely to painting. Still lifes and landscapes were his favourite subjects, for so painstaking were his observations of nature that he often required a hundred sittings of a model; human beings, he declared, could not sit so well as apples.

CHAGALL, MARC (*b.* 1887).—Russian-born painter of brightly coloured fantasies. Chagall has spent most of his life in France and, for a while, experimented with Cubism, though he is primarily an Expressionist. His paintings embody memories of his childhood in Russian villages, folk tales and fables, as well as symbolic figures. During the last war Chagall was profoundly disturbed by the persecution of the Jews; his tragic paintings from this period tell of the suffering of Jews from the time of Christ until the advent of the Nazis.

CHARDIN, JEAN-BAPTISTE SIMEON (1699-1779).—French painter of still life and *genre* scenes. Chardin's choice of subjects, largely from middle-class sources, plus his delicate sense of colour and loving attention to detail, are in great contrast to the gay and frivolous paintings of his contemporaries. He delighted in portraying everyday events with complete honesty, neither sentimentalised nor dramatised. His technique was extremely subtle; texture is realised with the most delicate brushwork, impasto and scumbling. The solidity of objects and the precision of their placement in space is without peer; Chardin stands as one of the greatest painters of still life in history.

CHIPPENDALE, THOMAS (1718-1779).—English cabinet-maker, who in his furniture designs incorporated into the English style the forms of the French Rococo and of the "Chinoiserie". His furniture was mainly made of mahogany and was practical as well as comfortable. His catalogue "The Gentleman and Cabinet-maker's Directory" spread his style throughout England and Europe.

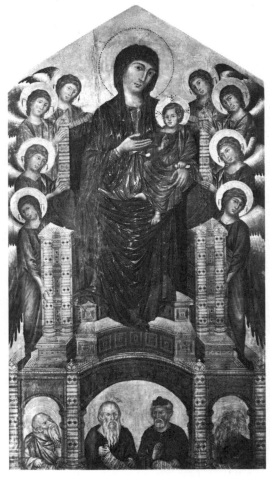

Cimabue, *Virgin and Child*. Uffizi, Florence. (Alinari).

CIMABUE (1240 - 1303?). — Florentine painter, considered the initiator of Renaissance painting. In his earliest work he followed the Byzantine tradition, with highly stylised and rigid figures placed symmetrically on gilded backgrounds. In time he developed his own very original approach, giving a profound solidity and reality to his religious subjects. Cimabue was claimed by Renaissance writers to have been the teacher of Giotto, and indeed his naturalistic treatment of the human figure was the starting point for Giotto, Masaccio, and the entire Florentine tradition. Surviving works attributed to Cimabue are the much-damaged frescoes, the *Crucifixion* and the *Deposition* in the transept of the Upper Church of Saint Francis at Assisi, and the *Sta Trinità Madonna* in the Uffizi in Florence.

CLOUET, JEAN (1486?-1540).—French portrait artist of Flemish birth, and the father of François. The greatest portrait painter of his epoch, Clouet was appointed court painter by Francis I of France in 1516. His style is typical of the Flemish-French tradition with its purity of line, precision of detail, and clear, rich colour. A fine example of his work is the *Portrait of Francis I of France* in the Louvre.

CONSTABLE, JOHN (1776-1837).—English landscape painter; with Turner, the greatest of the 19th century. Developing the style of the Dutch 17th-century landscape artists, Constable endeavoured to re-create atmosphere in all its cloudy, rainy and windy variations. He used a heavy impasto, often applying his colours with his palette knife. His exhibition in Paris in 1824 had an enormous success, and greatly influenced the Barbizon school.

COPLEY, JOHN SINGLETON (1738-1815).—American portrait painter. Copley was self-taught, and early developed a very forceful and direct style that was both realistic and personal. After leaving Boston in 1774 he settled in London where the popularity of Reynolds and West influenced and weakened his work.

COROT, JEAN-BAPTISTE (1796-1875).—French landscape and portrait painter. From his early painting and well through his career, Corot's softly-greyed, poetic landscapes brought him exceptional popularity. Because of his prolific output, his work may be seen in museums the world over. His emphasis on tonal effects rather than colour was ultimately enriched in his later period when he produced many portraits of serene, beautiful women in the manner of Courbet.

CORREGGIO, ANTONIO ALLEGRI (1489?-1534).—Italian painter whose soft and emotional style anticipates the Baroque art of the next century. Correggio's use of foreshortening in ceiling frescoes to create the illusion of open sky was much admired and imitated. He painted numerous religious themes, but his mythological series including *Antiope* in the Louvre, *Leda* in Berlin, and *Io* in Vienna, are considered his finest works.

COURBET, GUSTAVE (1819-1877).—French realist painter of landscapes and figures. Courbet made vehement protests against the classical and idealised schools of art, insisting that natural, uncomposed subjects were the noblest sources for the artist. His ideas reflect the social consciousness awakened in him by the European revolutions of the 19th century. This unequivocal honesty, represented in his paintings by bold colours, well-defined lights and darks, and completely unsentimentalised, not to say vulgar subject matter, shocked his contemporaries. Among Courbet's major works are the enormous pictures *Burial at Ornans* and *The Studio*, both in the Louvre.

CRANACH, LUCAS THE ELDER (1472-1553).—German painter, engraver, and designer of woodcuts. Cranach was an inventive portrait painter, and perhaps the first to do full-length portraits of individuals. His sinuous female nudes set against dark backgrounds, and painted in clear enamel-like tones, have a memorable grace and erotic character. He had two sons, Hans and Lucas II, both of whom painted in a manner quite similar to his own.

DALI, SALVADOR (b. 1904).—Spanish Surrealist painter. The most controversial and bizarre of contemporary Surrealists, Dali is also a notorious self-advertiser. In his paintings, real objects are distorted or juxtaposed to totally unrelated subjects, creating images which emanate from the artist's unconscious mind, and are frequently understandable only to himself. Dali's technique is one of exquisite perfection of detail, common to the early miniaturists.

DAUMIER, HONORÉ (1808-1879).—French lithographer and painter, and one of the greatest social and political satirists in history. He made over 4000 lithographs for various Parisian magazines including "La Caricature" and "Le Charivari", which depict the capriciousness, foolishness, humour and tragedy of life. His paintings illustrating "Don Quixote" have a remarkable boldness of light and shadow, and the same spontaneous, expressive line found in his drawings.

DAVID, JACQUES-LOUIS (1748-1825). —French painter and arbiter of artistic taste. David began painting according to Rococo tenets, but after a visit to Rome between 1775 and 1781 he abandoned his early attitudes for neo-Classicism. *The Oath*

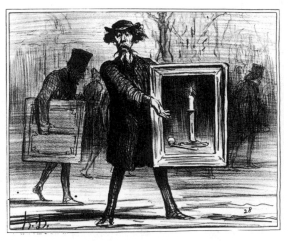

Daumier, "*And that they have turned down, the ignorant fools!*" 1859. Lithograph. Bibliothèque Nationale, Paris.

of the Horatii was the first and possibly the most important of French neo-Classical works; it represents the virile republican attributes which David discovered in the ancients, all the more starkly powerful for the cold light and lack of colour. During the French Revolution David became the official painter for the Republic and was later appointed by Napoleon to paint court portraits as well as large pictures commemorating the Emperor's victories. He had many successful pupils, among them Ingres and Gérard.

DAVIS, STUART (b. 1894).—American abstract painter. After painting in the successive styles of Impressionism, Expressionism, and Cubism, Davis arrived at an abstract poster style. His works represent scenes from contemporary life, often including words spelled out in large letters because, according to Davis, they "are part of an urban subject". His abstract motifs in pure brilliant colours are gay and decorative.

DE CHIRICO (b. 1888).—Italian painter, founder of the *Pittura Metafisica* movement. A subtle and semi-mystical sadness pervades the greater part of De Chirico's work, seemingly depicting a disenchanted fantasy world. Anticipating Surrealism, De Chirico furnishes his empty, panoramic spaces with incongruous objects such as classical statues, trains and abstract geometrical forms. The images are enclosed within classical architectural settings in which there is an overwhelming sense of silence and a lack of human activity. During the '30s De Chirico openly repudiated his previous work and turned to a conventional style.

DEGAS, EDGAR (1834-1917).—French Impressionist painter. Degas came from a well-to-do family and was trained in painting in the academic tradition under a pupil of Ingres. During the decade between 1860-70 he developed a characteristic, carefree style and manner of composing which gives a vivid sense of immediacy. He seemed to catch his subjects unawares, often placing

them to the side of the canvas. Every detail is carefully selected and highly significant. Focal points such as broad splashes of colour or precisely placed objects function to balance the asymmetric design. Unlike other Impressionists, Degas preferred indoor scenes, ballerinas in the rehearsal studio, or women bathing. For outdoor scenes he chose crowds of people, say at the racetrack rather than the atmospheric landscapes favoured by his fellow-artists. Degas was the only Impressionist who specifically aimed at portraying the psychological meaning of a scene. Due to his comprehensive knowledge of painting mediums and his lively spirit of enquiry, he produced a great variety of work ranging from pastels, etchings and oils, to sculpture.

DELACROIX, EUGÈNE (1798-1863). —French painter, leader of the Romantic movement in France. Delacroix was a passionate admirer of Géricault, who interested him in animal painting and English art. Both were outspoken rebels from the reigning classical style of Ingres and his followers. Delacroix studied Rubens, and like him, had a penchant for large canvases painted in a broad, free manner, full of brilliant colour and violent movement. He chose dramatic scenes from history and literature, such as *Dante and Virgil crossing the river Styx* and *The massacre of Chios*, both in the Louvre, as vehicles for his bold and unorthodox style. A trip to North Africa in 1832 further stimulated his interest in exotic subjects. Although sharply criticised by the official art world, Delacroix was the idol of the young painters who saw in him a

symbol of revolution and independence.

DELAUNAY, ROBERT (1885-1941).—French abstract painter, and leading representative of the "Orphism" movement which tried to free Cubism from its typical brown, grey and black gloom, and its dependance upon real subjects. Delaunay introduced a lyrical movement into the static technique of the Cubists, liberally using bright colours. His favourite subject was the Eiffel Tower, indicating his interest in mechanical forms.

DERAIN, ANDRÉ (1880 - 1954). — French painter, one of the original Fauves. Derain tried many styles, influenced by the "pointillism" of Seurat, by the broken planes of Cézanne, and by the verve and colours of Vlaminck and Matisse. His early work is his best; in later years he turned to a study of the old masters and painted in a conservative style. He also produced etchings, book illustrations, and stage designs.

DONATELLO (1386-1466).—Florentine sculptor, one of the greatest figures of the Renaissance. With Brunelleschi and Masaccio, Donatello ranks as the greatest innovator of the 15th century. After apprenticeship to Ghiberti, he worked on sculptural details for the Duomo and continued doing so, intermittently, for the next thirty years. Disdaining the formality and refinement of the international Gothic style, Donatello carved his figures on observations of real models. After travelling to Rome with his friend, Brunelleschi, and absorbing the spirit of classical art, Donatello returned to Florence and was commissioned by Cosimo de' Medici to execute a bronze *David*. This was one of the first independent nude figures to appear since antiquity and the advent of Christian art. Incorporated in its classically balanced proportions is a profound expression of the self-awareness of Renaissance man. The graceful, boyish David with Goliath's head at his feet seems more conscious of his own beauty and masculinity than of the feat he has accomplished. Donatello sculpted in wood, stone and bronze, works ranging from bas relief to equestrian monuments, in a form that was ever varied and vital. His influence on both sculptors and painters during the whole of the 15th century and afterwards was enormous. Mature works, such as the *Maddalena* and the *Pulpiti* in the Church of Santa Maria Novella in Florence are superb in their sense of movement and play of light.

DUCCIO DI BUONINSEGNA (1255-1319).—Sienese painter, the first great personality of the Italo-Byzantine tradition. Duccio's art is the sum and substance of the stylised austerity of the old Byzantine forms, and at the same time is imbued with a new.

vital naturalism. He is to the Sienese School what Giotto is to the Florentine; a pathfinder, though of modified proportions. In 1308 Duccio was commissioned to paint the vast *Maesta* for the Cathedral of Sienna. This is a two-sided altarpiece; the front, facing the congregation, shows the Madonna and Child enthroned and surrounded by angels and saints, while the back shows 26 scenes from the Passion and other panels from the Life of Christ. The back panels were visible only to the clergy, functioning as an instructive narrative, while the front painting could be viewed from a distance by those at prayer. Duccio employs a rich variety of colours and an elegant soft line against the gold-leaf backgrounds common to the Byzantine tradition. In addition, his *Maesta* shows an exceptional gift for story-telling.

DUCHAMP, MARCEL (b. 1887). — French painter, one of the original Dadaists. Duchamp's celebrated *Nude descending a staircase* shocked the American public when it was exhibited in the New York "Armory Show" in 1913, provoking violent criticism, and establishing his name in the art world. He executed various compositions in glass, giving them ridiculous titles like "To be watched, at close range, by one eye, for almost an hour". When, during the journey to an exhibition, one of his glass paintings was broken, Duchamp insisted that the

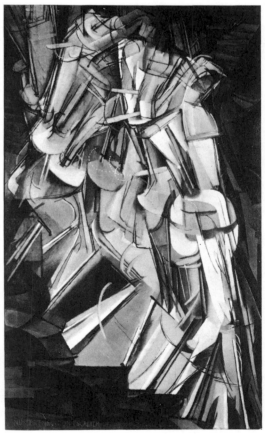

Duchamp, *Nude descending a staircase*. 1912. Philadelphia Museum of Art.

Derain, *Portrait of the Artist*. The Minneapolis Institute of Arts. Gift of Mrs. Elizabeth Bates Cowles.

271

composition had been planned on the assumption that it would be broken and placed it for showing as it was. Besides painting, he worked in abstract films and as a journalist.

DUFY, RAOUL (1877-1953).—French painter and decorator. Beginning his career with an Impressionistic style, Dufy turned to the more intense colours and simplified forms associated with the Fauves. He developed his own gay, light style which became widely popular, often choosing festive subjects like regattas and bathing beaches. He also designed ceramics, textiles, and tapestries.

DÜRER, ALBRECHT (1471-1528).—German painter, engraver, and designer of woodcuts. Extended visits to Italy, during which time he met and admired the aged Giovanni Bellini, gave Dürer a first-hand knowledge of the Italian Renaissance art, and the new theories of perspective and proportion. Synthetising this with his inherited Gothic forms, Dürer created a very personal expression of such broad scope that it became a major force in the introduction of Renaissance ideas to the north. A superb graphic artist, Dürer's finest work is in woodcut and copper engraving. There are relatively few paintings by him extant, which, though exquisitely detailed, are less inventive and moving than his graphic works. The latter are almost exclusively Biblical illustrations.

EAKINS, THOMAS (1844-1916).—American portrait painter. Influenced by the work of Manet during a visit to Paris, Eakins produced numerous portraits in a keen, realistic style. The body of his works is in American museums.

EL GRECO (DOMENIKOS THEOTOCOPOULOS) (1541?-1614).—Spanish painter born on the island of Crete. After early training in the rigid, formal style of Byzantine art, El Greco went to Venice and studied for a time under Titian. His major influence during his years in Venice, however, was Tintoretto's dramatic use of light and technique of swirling composition. In Rome he incurred disfavour among artists and patrons by claiming he could paint a better *Last Judgement* than that of Michelangelo in the Sistine Chapel. In 1577 he settled in Toledo, Spain, where the temperament of the people and their intense religious faith was suited to his own character. His remarkable talents were welcomed there, and he remained for the rest of his life, painting religious themes. His highly mystical vision produced an increasingly personal expression, the primary elements of which are elongation of his figures, a use of eerie light and brilliant, harshly contrasted col-

ours, and a writhing, nervous movement. His ideas were far in advance of his time; indeed, it is only in this century that his profoundly expressionistic art has found a deserved appreciation.

ENSOR, JAMES (1860-1949).—Belgian Expressionist painter. Ensor inherited certain grotesque and bizarre elements from Bosch and Breughel. At first glance his work, with its gay, light colours and rich texture, has a carnival air. Masked faces crowd the canvases, but rather than amusing, they are disturbing, an ironic comment on human falsity and frailty.

EPSTEIN, SIR JACOB (1880-1959).—American-born sculptor, but a British subject from 1906. In his earliest work, Epstein's sculpture was relatively abstract, but later he leaned towards realism. He is especially known for his portraits in bronze, which have a richly textured surface and Rodinesque quality. Many of his large-scale architectural sculptures decorate London's modern buildings.

ERNST, MAX (b. 1891).—German Surrealist painter. In his early period Ernst collaborated with Jean Arp in the Dada movement, constructing their series of extravagant collages called "fatagaga", made up of scraps of other paintings, drawings and writings. From 1924 he belonged to the Surrealist group, producing paintings, frescoes and stage-settings in which real objects are combined with dream images in fantastic scenes.

FEININGER, LYONEL (1871-1956).—American painter and graphic artist. In 1887 Feininger went to Germany to study music but turned instead to figurative art. For

some years he was an illustrator for the "Chicago Sunday Tribune", then from 1919 to 1924 taught at the Bauhaus at Weimar. Thenceforth his painting was tied to this school of aesthetics. His work is precisely composed, delicate and with a mathematical purity of form. Skyscrapers, boats and locomotives are frequent themes.

FIDIA, *see* **PHIDIAS.**

FOUQUET, JEAN (1415? - 1480). — French painter and miniaturist. The greatest artist in France during the 15th century, Fouquet travelled to Italy in 1445-1447 where he came in touch with the vital spirit of the Italian Renaissance. Thus, incorporated into his exquisitely detailed art in the Franco-Flemish tradition, is a marked plasticity of space and perspective typical of the Italian school. Many of Fouquet's canvases have architectural settings recalling ancient Roman monuments.

FRAGONARD, JEAN-HONORÉ (1733-1806).—French painter, one of the leading artists of the Rococo period. A student of Boucher, and an admirer of Tiepolo during his stay in Italy, Fragonard's gay and erotic compositions were popular in the frivolous days before the Revolution.

FRANCESCA, PIERO DELLA (1410?-1492).—Italian Renaissance painter of the Umbrian school, and today one of the most appreciated artists of the Quatrocento. Piero studied the new science of perspective from the Florentine master, Paolo Uccello, and from Domenico Veneziano he learned to use colour and light to create solid forms. The influence of Masaccio is also prominent in his work. He evolved a very individual expression in the fresco medium, remarkable

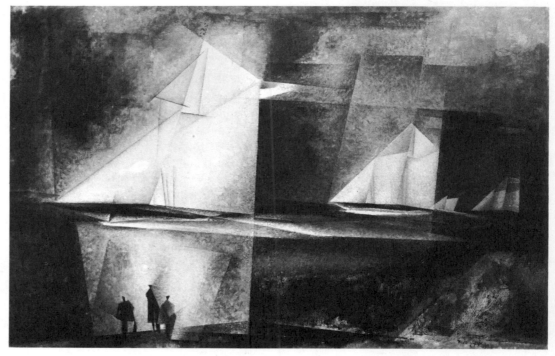

Feininger, *Glorious Victory of the Sloop "Maria"*. Courtesy of the City Art Museum, St. Louis.

for its classic serenity and almost mathematical organisation of space. In about 1492 Piero was commissioned to paint a cycle of frescoes on the *Story of the Cross* in the Church of San Francesco at Arezzo. This magnificent series is the best preserved of his frescoes, and the most celebrated of his works.

GABRIEL, JACQUES-ANGE (1710-1782).—French architect. In reaction to the capricious asymmetry of the Rococo taste, in fashion at the beginning of the 18th century, Gabriel returned to the Classicism of the previous century. The two "Ministries" in the Place de la Concorde in Paris, are among his works.

GAINSBOROUGH, THOMAS (1727-1788).—English portrait painter. Influenced by the elegant society portraits of Van Dyck, Gainsborough developed a subtle technique of depicting fine fabrics, delicate laces and shimmering silks, and often posed his subjects against lyrical landscapes. His work was much sought after and he became the chief rival to Sir Joshua Reynolds, whom he surpassed both in his ability to catch the likeness of his sitters, and his facility in the handling of paint.

GAUDÍ, ANTONIO (1852 - 1926). — Spanish architect. Gaudí began his career as an adherent of the neo-Gothic style, but developed one of the most individual and imaginative styles in the history of architecture. Typical works, such as the Church of the Holy Family (*Sagrada Familia*) and the *Casa Mila* in Barcelona, are fantasies of iron and stone, borrowing inspiration from the forms of nature. The latter is considered a masterpiece of curvilinear structure in the *Art Nouveau* style. His art was so highly personal that he has remained an isolated figure in architecture.

GAUGUIN, PAUL (1848 - 1903). — French post-Impressionist painter. Breaking from his family and his career as a stockbroker, Gauguin devoted himself to painting, and exhibited his works with the Impressionists, particularly influenced by Pissarro and Cézanne. During his wanderings from Paris to Brittany, Provence (where he stayed with Van Gogh), Martinique, Tahiti and the Marquesa Islands, Gauguin developed a penchant for exotic subjects and a daring use of colour which was spread in large areas over the canvas. Scorning the Impressionists' technique of tiny dabs of colours in combination to create the effect of volume, he used bright, unrealistic colours in flattened, slightly distorted forms. An introduction to Japanese art, primitive sculpture, and medieval art in 1888 led Gauguin to extend his ideas, turning further from representations of

nature, and ally himself with the Synthetists. This group attempted to express ideas and moods through decorative abstractions. Gauguin spent the final years of his life in the South Seas, poverty-stricken and ill, but continuing to paint the exotic women and landscapes which he preferred above all other subjects.

GELLÉE, CLAUDE, called Lorrain (1600 - 1682). — French landscape painter. Claude spent the greater part of his life in Italy where he had a wide reputation from the time he was 30 years of age. His poetic landscapes are inevitably planned to the Mannerist scheme dividing the picture into distinct areas: a darkish foreground; a lighter middle distance with a large mass, say of trees, counter-balanced by a smaller mass or feature; and a deep far-distance, often lit with a shining golden sun. The canvases are imbued with a sense of silence and serenity; human beings are sometimes represented in mythological or Biblical roles.

GÉRICAULT, THÉODORE (1791-1824).—French painter and lithographer, outstanding leader of the Romantic movement. Géricault's most celebrated work, *The Raft of the Medusa*, painted in 1819, introduced the Romantic movement to the public. The subject of the picture is the 15 survivors of a terrible shipwreck in which hundreds of French emigrants to North Africa perished, an event which was blamed on official negligence and had tremendous political repercussions at the time. Such a choice of subject matter and the realistic presentation of the survivors at a dramatic moment is typical of Romantic painting, and well illustrates the extent of Géricault's break from the balance and chill calm of the prevailing neo-Classical school led by David. Géricault's rebellion from the tenets of neo-Classicism led him to paint portraits of unsavoury characters and to draw many studies of animals from life.

GHIBERTI, LORENZO (1378-1455).—Italian sculptor and goldsmith. In 1401 Ghiberti was invited, along with other Florentine artists including Brunelleschi, to compete in the designing of a second pair of bronze doors for the Baptistery. He completed these in 1424 and immediately started work on another pair, which occupied him until 1452. The latter were described by Michelangelo as "The Gates of Paradise"—a name which has survived until today. Ghiberti stands as a bridge between the Gothic and the Renaissance eras. His contributions also include various writings—his autobiography is the first known record of an artist's life told by himself, and marks the beginning of a new respect for the artist as a creative individual.

GIACOMETTI, ALBERTO (b. 1901).—Swiss sculptor. Giacometti joined the Surrealist movement around 1930. He later developed his own very personal style, usually depicting elongated human figures, alone or grouped. The anonymous figures are surrounded by a vast empty space, as though to symbolise the insignificance of man in the modern world. Giacometti's sculptures in both bronze and plaster have a rough, corroded surface, investing them with a nervous vitality.

GIORGIONE, GIORGIO DA CASTEL-FRANCO (1476/77-1510).—Italian painter of the Venetian school. Giorgione was a pupil of Giovanni Bellini, and one of the most important innovators in the Venetian tradition. One of the earliest exponents of the easel picture, the "picture for pleasure" rather than for religious purposes, he had an enormous influence on his contemporary, Titian, whose early pictures bear a marked resemblance to his own. Volume in space is achieved by means of colour, used with incredible subtlety, and light is diffused through an atmospheric haze which softens contours and merges cool tones with warm. There is an indefinable mystery and silence lurking in Giorgione's portraits and landscapes. He died, quite young, of the plague; his authenticated paintings are few, perhaps a half dozen, an outstandingly beautiful example is *The Concert in the Park* in the Louvre.

GIOTTO DI BONDONE (1266?-1337). —Florentine painter and architect, considered to be, with Cimabue, the founder of modern painting. Dante, a contemporary of Giotto, immortalised him in the *Commedia* as the genius who freed himself from the enslavement of the "Byzantine manner" and gave the world a new vision. Breaking from the stylised formality which had dominated all Christian art for nearly a millenium, Giotto sought to humanise art, to express the nobility of the individual in accord with the credo of Saint Francis. Thus he added weight and mass to his figures, and set them in space. Unavoidably influenced by the Byzantine traditions to some extent, Giotto made an imaginative use of the decorative elements and formalities of the older art in his magnificent series of frescoes in the Upper Church of Saint Francis in Assisi. Later, between 1305 and 1307, he painted another series which entirely covers the walls of the *Cappella degli Scrovegni* in Padua. In these, his theories which in Assisi are tentative, have crystallised. The com-faces of the bystanders are turned towards a central subject in, for instance, the *Deposition from the Cross*. Thus, the sorrow-filled faces of the bystanders are turned towards

Christ, angels are poised overhead, and in the background the light strikes a diagonal line on the hill, all in such a way that the spectator's eye is forced to return again and again to the figure of the dead Christ. Giotto was responsible for the original designs for the Campanile which stands beside the Cathedral in Florence, however the bell tower was not finished until after his death, and was altered by succeeding architects.

GIOVANNI DA BOLOGNA (Giambologna) (1525?-1608).—French sculptor, a resident in Italy for the greater part of his life. One of the great Mannerist sculptors, Giambologna was the leading sculptor in Florence after the death of Michelangelo. In his most celebrated piece, *Mercury*, the principles of Mannerism are shown in full flower: the elongation of the figure, the delicate, tenuous balance, the affected pose.

GOGH, VINCENT VAN (1853-1890).—Dutch post-Impressionist painter. During his early period in Holland, Van Gogh painted many studies of miners, farmers and peasants, in dull, heavy browns and blacks. In 1886 he went to Paris where he met the Impressionists, Seurat, Pissarro, Degas, and also Gauguin. In this atmosphere he began to develop his very personal, vibrant style which he later developed in Arles in Provence. The sun entered his palette; he experimented with pure colours laid on the canvas with short, nervous strokes. The surfaces of his paintings took on the aspect of plastic relief, producing a tactile as well as visual response in the spectator. Van Gogh suffered from intermittent attacks of insanity and in 1890 killed himself. He produced a large body of work, much of which is in Holland, and was a major influence on the later Expressionists.

GONZALES, JULIO (1876-1942).—Spanish sculptor. Gonzales began his career working in his father's factory as an artillery-smith, and studied painting in the evenings at the Barcelona Art Academy. He turned to sculpture, working usually with wrought iron, and in an abstract vein. He was a great friend of Picasso's to whom he taught various techniques for working iron between 1929 and 1932.

GOTTLIEB, ADOLPH (b. 1903).—American Abstract-Expressionist painter. Gottlieb paints large pictographs, using symbols in the style of Klee and Miro. He has also painted murals, and designed the large stained-glass windows for the Park Avenue Synagogue in New York.

GOYA Y LUCIENTES, FRANCISCO JOSÉ (1746-1828).—Spanish painter, lithographer and etcher, one of history's great satirists and an equally great portraitist. Goya's earliest work was decorative, largely

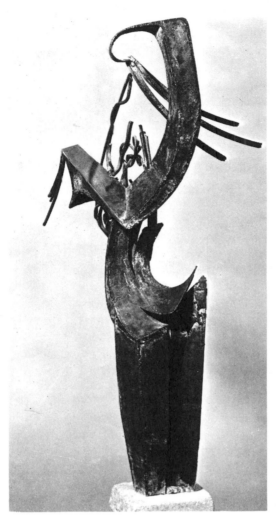

Gonzales, *Woman combing her hair.* 1936. Wrought iron. Museum of Modern Art, New York. Mrs. Simon Guggenheim Fund.

influenced by the frescoes of Tiepolo, and included many designs for tapestries. By 1799 he was Court Painter to the King, Carlo IV. His portraits of the Spanish court are remarkable not only for their technical freedom and perfection, but so caustic in their description of the arrogance and corruptness of the Bourbon monarchy that one wonders that Goya continued to receive commissions from them. Between 1796 and 1798 Goya produced a series of some 80 etchings called *Los Caprichos*, severely criticising the superstitions, customs and manners of the day. When the French troops of Napoleon took over Spain, Goya recorded the brutality of the conquerors in another series called *The disasters of war* which, in the whole of art history, remains the most moving documentary on man's inhumanity. In his last period Goya painted the group of so-called "black pictures" peopled with monsters and grotesque phantoms, and executed in heavy luminous dark colours in a bold expressionistic style. For the scope and content of his art, Goya has few peers; his influence on painting during the 19th century in France was tremendous.

GRAVES, MORRIS (b. 1910).—American painter. A profound interest in Oriental philosophy and art contributed to the development of Graves' delicate linear painting style. He paints almost exclusively in gouache and water colours, using birds, animals, rocks and trees to express the mystical and supernatural.

GRIS, JUAN (1887-1927). — Spanish painter and illustrator. Gris moved from Madrid to Paris in 1906, where he played a major role in the development of "Synthetic Cubism", as opposed to the "Analytical Cubism" associated with Picasso and Braque. Unlike the latter artists, Gris pursued his exploration of form through the principles of cubism until the end of his life. His art was impersonal and had little success until very late in his career. He illustrated many books and did some designs for the Diaghilev ballet.

GROPIUS, WALTER (b. 1883).—German architect, one of the leading figures in modern building. In 1919 Gropius founded the Bauhaus School at Weimar where painting, sculpture and architecture were taught as inter-related arts. Such men as Feininger, Klee and Kandinsky were among those teaching the concept that design and modern industry must function integrally. The school played an essential role in the development of the present-day international style. In 1925 Gropius designed the famous steel and glass palace of Denan. When Hitler assumed control of Germany, Gropius emigrated to the United States where he was appointed head of the architectural department at Harvard University.

GROS, ANTOINE JEAN "BARON" (1771-1835).—French painter, student of David whom he succeeded as leader of the neo-Classical school. Gros is best known for his large battle scenes in homage to Napoleon; his style was more active and dramatic than David's and thus his influence was important in the romantic movement.

GROSZ, GEORGE (b. 1893).—German painter and engraver. In his early period Grosz was associated with the Futurists and the Dadaists. Later he produced a series of masterful pen sketches expressing bitter social criticism of overstuffed militarists and middle class greed. In 1932 he moved to the United States. In latter years Grosz has devoted his attention to the nude and to landscape painting.

GRÜNEWALD, MATTHIAS (1460?-1528).—German painter. Grünewald's art reflects the vexed era of the Reformation in the hard style of 14th-century art in Germany. His paintings are intensely religious in theme and expression, functioning as strict and eloquent sermons on canvas. Following the tradition of northern medieval painting, the important religious figures are of a larger size than the others,

Grosz, *Die Räuber*. Mr. and Mrs. Bernard J. Reis, New York.

and given further prominence by the use of brighter colours and dramatic rays of light. Unlike his contemporary, Dürer, Grünewald rejected the ideas of the Italian Renaissance, preferring the powerful imagery of Gothic symbols.

GUARDI, FRANCESCO (1712-1793).—Italian painter of the late Venetian school, a student of Canaletto. Like his master, Guardi painted scenes of Venice almost exclusively, but his exceptionally lively line and sketchy brushwork betray a much closer allegiance to the work of Tiepolo, his brother-in-law. So adept was he at creating quick and effectively life-like figures, that Canaletto frequently hired him to fill in the figures in his views of Venice.

HALS, FRANS (1580?-1666).—Flemish portrait painter, a resident of Holland most of his life. Hals was one of the most facile of painters. With his sure eye and quick technique it was said he could paint a portrait in an hour. He placed his sitters in natural positions and, in a few brushstrokes, caught their happiest moods. The warm robust colours of his early period later changed to a restricted palette of greys, browns and black. Many of his works are in the Frans Hals Museum at Haarlem in Holland.

HARTLEY, MARSDEN (1877-1943).—American painter. Hartley's early works are largely landscapes painted in the Impressionist manner. After visiting Europe he turned to abstract art and exhibited, together with other painters of the "Blue Rider" group, in Monaco in 1913. Then, in 1918, he abandoned non-objective art for a violent Expressionism, using a palette of harsh and intense colours.

HECKEL, ERICH (b. 1883).—German painter and engraver. One of the founders of the German Expressionist group, "Die Brücke" (The Bridge), Heckel's art is unusually poetic and sensitive compared to the work of other members of the group such as Nolde or Kirchner.

HOFMANN, HANS (b. 1880).—German painter, long time resident in the United States. Abstract-Expressionism is Hofmann's milieu, but he is best known as a teacher of painting. From 1934 he taught in New York and Provincetown, Massachusetts.

HOGARTH, WILLIAM (1697-1764).—English painter and engraver. Hogarth's major works are three series of paintings: *Harlot's Progress*, *Rake's Progress*, and *Marriage à la Mode*. These are moral paintings, criticising the social order of his time, and influenced by the French Rococo art, with vivid colours and presenting his subjects rather like characters on a stage. He produced engravings of his paintings which were sold with great success to the public at very low prices.

HOLBEIN, HANS the Younger (1497-1543).—German painter and engraver. Holbein lived in Basle for more than a decade, where there is a large collection of his works in the Kunstmuseum. He then established himself in London, winning considerable fame as a portrait painter. Finally, in 1532 he was made Court Painter to Henry VIII, and also functioned as a goldsmith's designer and interior decorator for the king. His portraits are keen and realistic, painted with a studied detachment, becoming increasingly linear in style as time went on. His taste for symbolic objects is nearly always in evidence, as for example in the famous picture, *The Ambassadors*, painted in 1533 and now in the National Gallery in London.

HOMER, WINSLOW (1836-1910).—American sea and landscape painter. Homer lived on the rugged Maine coast of New England, and painted from direct observation, which endowed his works with a sharp reality. Two years in Paris and London as a student influenced his style towards Impressionism, and his later dramatic studies of the sea done in the manner of Courbet caused a sensation among American painters.

HOOCH, PIETER DE (1629-1684?).—Dutch *genre* painter. Hooch lived at the same time as Vermeer, and in the same city, Delft. Like Vermeer, he painted intimate domestic scenes in which the effects of light are a major preoccupation. A frequent composition shows a dusky interior with a doorway opening out into a sunny room. Light streams through a window and falls on the precisely recorded details of clean, ordered rooms with housewives and servants ab-

sorbed in some task. In his last period Hooch moved to Amsterdam, where his painting became rather pretentious and insincere.

HOPPER, EDWARD (b. 1882).—American painter and etcher. Following the style of the "Ashcan School" of social realism, Hopper paints the solitude and pathos of life in the towns and cities of America. Atmosphere is suggested simply, with few figures, bare houses, in areas of pure colours and clear light.

HOUDON, JEAN-ANTOINE (1741-1828).—French portrait sculptor of the late Rococo period. Notwithstanding the prevailing taste, Houdon sculpted in a classical style and enjoyed great popularity for his busts of statesmen, generals and scholars. He executed several portraits of Voltaire, one of which is in the Victoria and Albert Museum in London. In 1785 he travelled to the United States where he did a marble statue of George Washington.

INGRES, JEAN-AUGUSTE-DOMINI-QUE (1780-1867).—French painter, student of David, and leader of the neo-Classical school after David's death. Ingres lived in Italy for eighteen years from 1806, before returning to Paris to lead the opposition against Delacroix and the Romantic school. Portraits were his most successful works, though he preferred historical, mythological and exotic subjects. A major influence on his technique was the newly discovered photography. Thus his sinuous line was accentuated, forms modelled with utmost simplicity, and colour used rather as a tint than an integral part of form.

JONES, INIGO (1575-1652).—English architect. Jones first introduced the classical forms of Palladio into England. As architect to James I and Charles I, he designed the Queen's House at Greenwich and the Banqueting Hall in the Palace of Whitehall.

KANDINSKY, WASSILY (1866-1944).—Russian painter, teacher and art theoretician. Kandinsky was one of the founders of the German "Blue Rider" group which stressed colour and line rather than subject matter. In 1912 he published "The Art of Spiritual Harmony", an exposition of the principles on which his own, and modern art in general, is based. He was also one of the key teachers at the Bauhaus. The finest collection of his works is to be found in the Guggenheim Museum in New York.

KIRCHNER, ERNST LUDWIG (1880-1938).—German painter, sculptor and engraver. Kirchner was one of the founders of "Die Brücke", an off-shoot of Expressionism that emphasised the crueller aspects of life. This was in contrast to the principles of the "Blue Rider" group, which was less committed to specific commentary.

KLEE, PAUL (1879-1940).—German-Swiss painter. Klee developed his highly imaginative style after experimenting with the ideas of Cézanne, Van Gogh, Ensor, the "Blue Rider" group, the Dadaists and Surrealism. In an effort to "make memories abstract", he used a subtle sign language that has the charming effect of children's paintings. The curious hieroglyphics, together with his mastery of line, colour and textured materials, make his drawings and paintings both decorative and meaningful. Klee was among the teachers at the Bauhaus school.

KOKOSCHKA, OSKAR (*b.* 1886).—Austrian painter and teacher. Kokoschka's energetic approach to Expressionism is distinguished by swirling lines and vivid colours. The harsh, distorted features on his portraits depict the subjective aspect of his sitter's characters. He paints turbulent landscapes, usually of cities, and allegories based on ideological and political themes.

KOLLWITZ, KÄTHE (1865-1945).—German graphic artist and sculptress. Nearly all of the lithographs, etchings and engravings produced by Kathe Kollwitz are protests against suffering, hunger and pain in the life of the poor, and against the privations and separations caused by the two world wars. Her social criticism made her unpopular in Wilhelm II's era, and during Hitler's rule she was forbidden to work or exhibit her works. Among her prints are illustrations for Hauptmann's "The Weavers", Zola's "Germinal", and the series on *The Peasant Wars* executed between 1902 and 1908.

Kollwitz, *Seeds for Sowing Must Not Be Milled.* Lithograph. 1942. Courtesy: Galerie St. Etienne, New York.

KOONING, WILLEM DE (*b.* 1904).—Dutch painter living in America since 1926. De Kooning turned to Abstract-Expressionism in 1934, and is now one of the leaders in that field.

KUNIYOSHI, YASUO (1893-1953).—Japanese painter; lived in the United States from 1906. Kuniyoshi's early work was a mingling of Oriental and Western art traditions, but he was later absorbed into the mainstream of American art. His paintings have a conscious innocence, full of humour and imagination; one of his best known themes is the triangular cow. During the decade between 1920 and 1930 Kuniyoshi deliberately changed his style and began to paint with that subtle grey cloudiness that has made him famous.

LE BRUN, CHARLES (1619-1690).—French painter, head of the French Academy at the time of Louis XIVth. His major work was done at the Palace of Versailles where he executed the frescoes in the Hall of Mirrors, the designs for tapestries and sculptural decorations.

LÉGER, FERNAND (1881-1955).—French painter and designer. An early acquaintance with Braque and Picasso led to Léger's development of a particular form of Cubism in which appear the shapes of geometric and mechanical devices. Men are depicted as massive, robot-like creatures surrounded by machines and vast buildings. The forms are impressively simple and the compositions precise; the overall mechanical effect is accentuated by his use of large areas of primary colours with blacks and clear greys. Léger also designed settings for ballets, mosaics, ceramics, and in 1924 produced the first abstract film, "Le Ballet Mechanique" using actual objects instead of animated drawings. His influence on modern painting has been tremendous.

LEHMBRUCK, WILHELM (1881-1919).—German sculptor. Lehmbruck's highly personal style developed early, after he had visited Italy and Paris. His figures, usually in stone, are subtly elongated and have a melancholy, introspective air. Lehmbruck also produced etchings and lithographs, some illustrating the Bible and Shakespeare.

LEONARDO DA VINCI (1452-1519).—Italian painter, musician, scientist, military engineer and inventor. One of the most versatile minds in history. Leonardo is the epitome of the Renaissance ideal, the Universal Man. Yet so diverse were his interests, and so impatient his nature, that he rarely completed his projects. Despite voluminous notes and drawings, he left only a few paintings, and even these were left unfinished at the moment when Leonardo felt he had "solved the problem". One of his most important works, *The Last Supper*, on the walls of the Sta Maria delle Grazie in Milan, now in a sorry state of deterioration due to the untried methods used by Leonardo, is considered to be the first work of the High Renaissance. The painting depicts the reaction of his disciples to Christ's statement that one of them will betray him. Leonardo's subtle insight into the psychology of each individual is far in advance of his times. In all of his paintings we find the imprint of a keen, enquiring mind; Leonardo believed that in order to represent the exterior aspect of anything, he must understand its inner principles. Thus he studied and experimented with the fall of draperies, rock formations, the dramatic use of chiaroscuro, and pyramidal compositions. The finest collection of his drawings is at the Royal Library in Windsor Castle.

LEVINE, JACK (*b.* 1915).—American painter. Using the profusion of colours and the emotional intensity of the Expressionists, Levine paints social allegories on the complacency and injustice of modern man. A well-known example, *The Feast of Pure Reason*, is in the Museum of Modern Art in New York.

LIPCHITZ, JACQUES (*b.* 1891).—Lithuanian sculptor. In his early period Lipchitz applied the rigid forms of cubism to sculpture. As his style evolved, he used more rounded forms, giving greater emphasis to the modelling of the figure. Since 1941 he has lived in America, where he has produced a number of large pieces of sculpture for public buildings, among them *Prometheus and the Eagle* for the Ministry of Education in Rio de Janeiro.

LIPPI, FRA FILIPPO (1406?-1469).—Florentine painter. Although educated to be a monk, Lippi fled from the monastery and embarked on a life of adventure. He is reputed to have been a student of Masaccio, and the influence of Donatello is also evident, especially in his later work. He painted religious scenes, particularly those including the Virgin, whom he endowed with an appealing sweetness and humanity. He frequently used the *sacra conversazione* theme, with the Virgin and Child seemingly talking together.

LYSSIPUS (409-350 B.C.).—Greek sculptor. Lyssipus introduced new elements into classic sculpture, using informal poses and slender, supple figures in contrast to the formalised epic figures typical of the antique carvings. His *Apoxyomenos*, the original Roman copy of which is now in the Vatican, shows an athlete, his arm extended in space, caught in a momentary natural gesture.

MACKE, AUGUST (1887-1914).—German painter, member of the "Blue Rider" group. Essentially Macke's art is derived

Lysippus, *Apoxyomenos*. Vatican Museum, Rome. (Alinari)

from Cézanne, though his later work is influenced by Delaunay. His painting was almost entirely figurative, especially of women and children, with pleasant luminous colours.

MAILLOL, ARISTIDE (1861-1944).— French sculptor. Beginning his career as a painter, Maillol's style evolved from impressionistic to flat colours and large figures in the manner of Gauguin. From the age of forty he devoted himself to sculpture. His usual theme was the nude female figure, massive and solid, with smooth, harmonious forms and virtually depersonalised in the manner of early Greek sculpture.

MANET, EDOUARD (1832-1883).— French painter, one of the great pathfinders of the Impressionist school. Manet's first notoriety came with *The Absinthe Drinker*, painted in 1859 and now in Copenhagen. Here his dashing technique, much influenced by Goya and Frans Hals, is used with a great economy of means. Half-tones were reduced to a minimum and black dominated his palette. After 1870 he adopted the Impressionist technique, employing their use of colour and rejecting black. For the greater part of his life, Manet's work was under violent attack from the critics who objected to his free technique and the vulgarity of his subject matter in paintings such as *Olympia* and *Dejeuner sur l'herbe*, both of which are in the Louvre.

MANSART, FRANCOIS (1598-1666).— French architect. Mansart conferred a classical dignity on the architecture of his time in contrast to the fanciful style of the Italian Baroque. Maison-Lafitte, near Paris, was an early work in the manner which later came to be known as "Louis XIVth". The mansard roof was named after him.

MANTEGNA, ANDREA (1431-1506). —Italian painter. The adopted son of an archaeologist, Mantegna early developed a passionate interest in the ruins of Roman antiquity. This, together with the forceful influence of works by Donatello and the scientific ideas which marked the beginning of the Renaissance, prompted his concentrated study of the new techniques of perspective. His paintings are set in vast Roman structures which tower above the human beings and open out through arches or grand stairways into deep, barren landscapes. Most of his work was done in Padua and Mantua; in the Castello in the latter city, Mantegna's frescoes on the ceiling of the *Camera degli Sposi* show an early use of illusionistic tricks by means of perspective. Mantegna was married to a daughter of Jacopo Bellini, and exerted considerable influence on his brother-in-law, Giovanni Bellini.

MARC, FRANZ (1880-1916).—German painter. Marc, with Kandinsky, was a founder of the "Blue Rider" Expressionist group. He used colours symbolically, ignoring natural tones. Animals were his frequent theme. In 1912, influenced by Delaunay, Marc's paintings changed to a use of colour planes that intersected, in a fused background, with those in the foreground.

MARINI, MARINO (*b.* 1901).—Italian sculptor. Marini began his career as a painter, and his sculpture reveals his interest in surface texture. For a period between 1930 to 1940 he devoted his art almost exclusively to the subject of acrobats. Another favourite theme is the horse and rider.

MARSH, REGINALD (1898-1954).— American painter and illustrator. Marsh's most frequent subject is New York City's crowds, streets, bars and slums. His pictures dwell on the hypocritical aspects of mankind.

MARTINI, SIMONE (1284-1344).— Italian painter of the Sienese school. Martini's teacher and earliest influence was Duccio, though his style tended in the direction of French Gothic art. Exquisitely patterned surfaces and delicate linear treatments distinguish his work. Commissions from the French Court at Naples crystallised his tendencies towards courtly art and the decorative embellishments associated with northern Gothic art. The *Annunciation* in the Uffizi in Florence typifies the formal delicacy which made Martini famous. In 1340 he moved to Avignon where the Papal court was in exile. There his fragile and refined technique became highly influential in the development of the International Gothic style which spread throughout Europe.

MASACCIO (TOMMASO DI SER GIOVANNI DI MONE) (1401-1428).— Florentine painter, the first and considered by many the greatest master of the 15th century in Florence. In the course of his short life Masaccio revolutionised painting when he applied Brunelleschi's discoveries in the field of perspective to pictorial art. Masaccio was the first artist to contribute to Giotto's bold ventures in the creation of spatial depth, and his work was revered and studied by contemporary artists following his untimely death. There are regrettably few surviving works by Masaccio, the most important being the frescoes in the Brancacci Chapel of Sta Maria del Carmine in Florence. One of these, *The Expulsion from Paradise*, is a powerful interpretation of human guilt; a dramatic light falls almost ruthlessly on the realistically-drawn figures of Adam and Eve, while overhead an angel hurries them on. Another fresco, *The Trinity* in the Santa Maria Novella in Florence, expresses the new principles of perspective with a mathematical discipline. Christ appears against a background of barrel-vaulting, in a magnificently realised spatial depth.

MASTER OF NAUMBURG (13th century).—German sculptor, most famous for his work in the choir of Naumburg Cathedral. His works may be also seen in the cathedrals of Amiens, Rheims, Chartres, Strasbourg, Metz and Mainz. In the last named is a famous equestrian statue of *St. Martin*.

MATTISSE, HENRI (1869-1954). — French painter, sculptor and lithographer. One of the leaders of the "Fauve" group, Mattisse had earlier been influenced by Cézanne and the Impressionists. His daring joyful colour was given further impetus when, in 1910, he saw an exhibition of Far Eastern art. Thereafter his interest in flat patterns and pure contrasting colours in juxtaposition was uppermost in his work. Mattisse preferred flowers, women, and fruit as subjects for his highly decorative paintings. After moving to the south of France in 1914, his work took on a new subtlety of form and colour, permeated by the intense light of the Mediterranean. His last major work was designs for the stained glass windows of the small Dominican church in Vence, France; the decorations by Mattisse lend the church the fundamental characteristics of his art—simplicity, serenity, and joy.

MICHELANGELO BUONARROTI (1475-1564).—Italian painter, sculptor and architect. The most famous, and certainly one of the most gifted artists of the Renaissance, Michelangelo considered himself above all a sculptor. Nevertheless his greatest fame rests with the magnificent frescoes on the ceiling of the Sistine Chapel in the

Michelangelo, *Interior of Medici Chapel*, Florence. (Alinari)

Vatican, which are, in effect, compositions of statuesque figures presented pictorially. Whether in carved stone or in fresco, Michelangelo's figures are of heroic dimensions, hymns in praise of man's beauty, and as such, express the artist's profound religious faith. One of his greatest achievements is the Medici Chapel in Florence, including both the design of the building and the sculptured tombs of Giuliano and Lorenzo de' Medici. The figures of Night and Day, Dawn and Evening, symbolic of the active and meditative characters they honoured, are supreme works of expressive art. Constantly in demand by popes and princes, Michelangelo was never free to pursue the projects in sculpture which most interested him. It was against his will but for the greater glory of God that he accepted commissions for further frescoes, among them *The Last Judgement* in the Sistine Chapel, and designed and supervised the construction of the enormous dome of St. Peter's, Rome. The impact of Michelangelo's genius on succeeding generations was tremendous; not only did he sum up the Renaissance, but his later works incorporated many of the principles of Mannerism and Baroque art.

MIES VAN DER ROHE, LUDWIG (*b.* 1886).—German architect, with Gropius and Le Corbusier, one of the great creative minds in modern building. Mies' architecture is characterised by a use of glass and steel and by a strongly accentuated symmetry in the vertical and horizontal lines. He achieved international fame with the German pavilion at the 1929 Barcelona Exhibition, and a year later, with the *Tugendhat* house at Brno in Czechoslovakia. He taught at the Bauhaus until 1938, when he emigrated to Chicago. There he designed the skeleton-like pavilions in steel and glass for the Technological Institute of Illinois; later, the apartment houses along Lake Shore Drive in Chicago; and recently, the impressive bronze Seagram's building in New York.

MILLET, JEAN FRANCOIS (1814-1875).—French painter of rural life and landscapes. Millet was accused of Socialism when he first exhibited his peasant picture, *The Winnower* now in the Louvre. Today his work is generally regarded as being sentimental.

MIRÓ, JOAN (*b.* 1893).—Spanish painter, leader of the Abstract Surrealist Movement. Halfway between total abstraction and figurative painting, Miró uses vivid primary colours, curved lines and amoeboid forms. Though his paintings are often without definable meaning, they are fascinating and dream-like—sometimes full of joy and humour, and at others, poignant in their expression of solitude.

MODIGLIANI, AMEDEO (1884-1920).—Italian painter and sculptor. Modigliani moved to Paris from Leghorn at the age of 22, and there lived a troubled and tragic life in Montmartre where he died of tuberculosis. He met Brancusi who introduced him to primitive Negro art, which provided him with a major stimulus in the development of his own powerfully simple style, both in sculpture and painting. His portraits are outstanding for their purity of line and sensitivity of expression, comparable to those of Botticelli.

MONDRIAN, PIET (1872 - 1944). — Dutch painter. In Paris, between 1910 and 1914, Mondrian belonged to the Cubist group, but on returning to Holland he developed his own geometrical abstract compositions which are known as neo-Plasticism. In his book "Plastic Art and Pure Plastic Art", written in 1937, he defined his premises: 1. the whole of painting is based on line and colour, thus these must be reduced to their essence; 2. universality of expression requires simplified forms; 3. the purer the colour, the more universal the expression. Mondrian's pictures are experiments in equilibrium, using only the primary colours with black and white, with straight horizontal and vertical lines. His theories strongly influenced the Bauhaus teachings, and thus all modern architecture.

MONET, CLAUDE (1840 - 1926). — French painter. The leading member of the Impressionist group and the one who remained faithful to its tenets for the longest period. In 1872 he exhibited a painting called *Sunrise: an Impression*, which was derided by the critics and gave the young movement its name. Monet's consuming interest throughout his life was to reproduce the sensation of colour received by the eye, out of doors, under varying conditions of atmosphere and light. He saw the colour of an object not as a flat element, but as a combination of colours reflected from near-by objects. Likewise, shadows are not grey only, but permeated with the colours of the objects that project them. With his technique of a multiplicity of colour splashes, Monet's forms are often difficult to distinguish at close range, but emerge clearly when seen from a distance. His explorations are considered to be the starting point of Abstract Impressionism; the best known of his series is the *Water Lilies*, in the Paris Orangerie.

MOORE, HENRY (*b.* 1898).—English sculptor and painter. Moore is best known for his large figures in stone, wood and bronze, which stand mid-way between the real and the abstract. In an effort to realise the relationship between solid and empty space, he opens great holes in his material which he claims can have greater consistency than solid mass. His work has been related

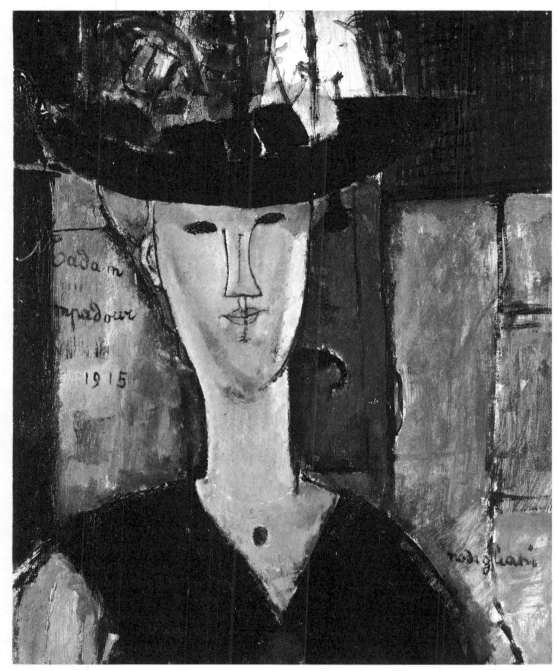

Modigliani, *Madam Pompadour*. 1915. The Art Institute of Chicago. The Joseph Winterbotham Collection.

antiquity; one, the *Discobolus*, is among the best known of all Greek sculptures.

NASH, PAUL (1889 - 1946). — English painter, designer and book illustrator. Nash's paintings were influenced by the "Fauves", the Cubists and the Surrealists. He was appointed official artist during both world wars, and in 1933 collaborated in the formation of Unit One, an *avant garde* group.

NEUMANN, BALTHASAR (1687 - 1753).—German Baroque architect. Neumann's designs added lightness and colour to the French Rococo tradition. Among his masterpieces are the *Wurzburg Palace* with its famous staircase, and the *Church of Vierzehnheiligen*.

NOGUCHI, ISAMU (b. 1904).—Japanese sculptor and designer, long-time resident in America. Noguchi studied with Brancusi in Paris between 1927-28, and was later influenced by Calder and Giacometti. He is well known for his large abstract basreliefs and his functional designs such as mobiles used in various ways, lamps which diffuse a pleasant, soft light and large compositions in stone for gardens.

NOLDE, EMIL (1867-1936).—German Expressionist painter and engraver. Nolde began painting in the manner of the Impressionists, but gradually his colour became more violent and his forms more grotesque. Profoundly religious, Nolde treated with terrifying harshness subjects inspired by the life of Christ.

O'KEEFE, GEORGIA (b. 1887).— American painter. Beginning as an abstract painter, O'Keefe modified her original manner in 1920 to an abstract realist style. Unlike other Cubist-realists, she was not interested in mechanical or industrial motifs but rather painted flowers, landscapes, and still-lifes in a crisp, linear style. Her compositions frequently suggest a poetic introspection, silence and loneliness.

OROZCO, JOSÉ CLEMENTE (1883-1949).—Mexican painter and lithographer. Orozco is most famous for his murals, executed with extraordinary technical virtuosity. His art has a strong political bias and was frequently commissioned by succeeding revolutionary governments. The macabre element in his subject matter is reminiscent of the religious practices of the Aztecs. A large share of the credit for Mexico's artistic renaissance was given to Orozco. He painted a number of large frescoes in the United States; at Dartmouth College, the New School for Social Research in New York, and at Pomona College in California.

PALLADIO, ANDREA DI PIETRO (1508-1580).—Italian architect of the late Renaissance. Palladio began as a stone-

to pre-Columbian and Egyptian art.

MORRIS, WILLIAM (1834 - 1896).— English painter, designer, and social reformer. Morris rejected the decline in taste which accompanied industrialisation and opposed the contemporary trend to separate art from utility. In 1861 he founded the firm of Morris and Company, producing furniture, wallpaper, carpets, tapestries and coloured-glass windows in designs done by himself and others, including Burne-Jones. In his Kelmscott Press, Morris revived the art of hand-printing and did much to improve the standards of book design. He wrote poems and other writings expressing his opposition to industrialisation and his support of handicrafts as a means of regenerating man.

MOSES, "GRANDMA" ANNA MARY ROBERTSON (1860-1962).— American painter. A *genre* painter of American rural life, "Grandma" Moses used

simple, unsophisticated designs and flat colours; her paintings are widely reproduced on cards and ceramic tiles.

MUNCH, EDVARD (1863-1944).—Norwegian painter and graphic artist. In his early years Munch spent considerable time in Paris and Berlin; the major influence on his art at the time was Gauguin. An exhibition of his work, in 1892, provided a strong impulse for German Expressionism. His brooding themes on death, sickness, fear and loneliness are dramatised by the use of patterns of lines and flat, often heavy colours. His woodcuts are perhaps his most effective and original works.

MYRON (middle of the 5th century B.C.). —Greek sculptor. Myron experimented with new techniques in the art of fusing bronze alloys. In this way he greatly extended the potential in composing metal statuary. His works were much admired and copied in

cutter in Vicenza, and became the most influential architect in Northern Italy in the 16th century. His major works are the Vicenza Basilica and the Villa Capra, called the *Rotonda*, in Vicenza. In 1554 he published a study of Roman antiquity and in 1570, his four famous volumes on architecture, *De Architectura*. The latter had a great influence on 17th-century French art, and on that of England and America during the 18th. In his long treatise, Palladio defined the laws governing proportion in architecture; the emphasis on proportion was characteristic of his own buildings, and those of his later followers, Inigo Jones in England, and Thomas Jefferson in the United States.

PARMIGIANO, FRANCESCO MAZZOLA (1503-1540).—Italian Mannerist painter and graphic artist. Parmigiano was a facile portrait painter whose slender-necked Madonnas, like the one in the Pitti Palace in Florence, were greatly appreciated for their brilliant, luminous colours and delicate features. Parmigiano did much to spread his fame by reproducing his own works in engravings and woodcuts, a rare art in that time.

PEALE, CHARLES WILLSON (1741-1827).—American portrait painter, inventor, and founder of a private museum of natural history. Peale's fame rests on his highly realistic portraits of George Washington, John Adams, James Madison, and other notables of his time.

PHIDIAS (490-*c*. 415 B.C.).—Greek sculptor of the classical era. Pericles, the great leader of Athens during her Golden Age, appointed Phidias to design the sculpture for the Parthenon on the Acropolis. With the help of other sculptors, Phidias carried out the designs of the metopes and the frieze, and supervised the completion of the entire project. His most celebrated work, the colossal statue of Athena, in bronze, was removed when the Christians took over the temple in the 5th century, A.D. Only a few of his original works from the Parthenon have survived.

PICASSO, PABLO (*b*. 1881).—Spanish painter, sculptor, graphic and ceramic artist. The most influential artist of our times, Picasso developed his incredible technical mastery at an exceptionally early age in Barcelona. By the time he made his first visit to Paris in 1900 he had already mastered such different techniques as those employed by Toulouse-Lautrec, Munch, and Renoir, to say nothing of more traditional art forms. He settled in Paris in 1901 and there set off on an artistic journey through a succession of different styles or "periods" which, through the years, have

revealed a creative imagination of extraordinary richness. The Blue Period extended from 1901 to 1905 and was dominated by a melancholy atmosphere peopled with emaciated beggars and sick children. In the Pink Period, 1905-1906, Picasso's subjects included dancers, animals and portraits. In 1907 he painted the *Demoiselles d'Avignon*, now in the Museum of Modern Art in New York, which was one of the first cubist pictures. The influence of Negro sculpture, so evident in the *Demoiselles*, was crucial in Picasso's effort to free himself from representational subject matter. With Braque, he began working out the principles of Analytical Cubism in which form is broken down into its essential masses and planes, then reconstituted as though seen from various angles simultaneously. Between 1920-25, Picasso painted female figures inspired by Greek sculpture, with straight noses and robust proportions; by 1930 these figures had developed into grotesquely distorted creatures moving through space in wild, dance-like gestures. Out of this same phase came his most famous single work, the *Guernica*, also in the Modern Art Museum in New York, a powerful protest against the suffering of the Spanish people during the Civil War. Since the second world war he has lived in the south of France, following no one style, but expressing his subjects according to his particular interpretation, in lithograph, ceramic, sculpture and painting.

PIRANESI, GIOVANNI BATTISTA (1720-1778).—Italian engraver and etcher. Piranesi was an architect from Venice whose greatest works were his many etchings of the ruins of ancient Rome. These are poetic versions, highly dramatised by the use of strongly contrasting light and shade. There is also a series called the *Carceri d' Invenzione* (Imaginary Prisons), which are forerunners of 18th and early 19th century Romanticism.

PISSARRO, CAMILLE (1830-1903.—French Impressionist painter. Pissarro was the most unwavering member of the entire Impressionist group, the best loved by the others, the moderator of their quarrels, and the one who took greatest pains to encourage the younger ones such as Degas and Gauguin. When Pissarro first arrived in Paris from the West Indies, he met, and was strongly influenced by Corot. Later he encountered Courbet, Manet, and Monet, and took part in the first and the succeeding Impressionist exhibitions. His production was unusually large and varied, including etchings, lithographs, pastels and gouache.

POLLAIUOLO, ANTONIO (1432-1498).—Italian painter, engraver, and sculptor. Antonio Pollaiuolo, together with his

brother, Piero, ran a workshop in Florence. Antonio is generally accepted as the more gifted, though certain identification is not always possible. His consuming interest was the human body in motion. *Hercules and Antaeus* illustrates his masterful treatment of the human body in motion. A late engraving, *The Battle of the Naked Gods*, anticipates Michelangelo in the expressive and dramatic use of the nude in movement.

POLLOCK, JACKSON (1912-1956).—American painter, a leading figure in the Abstract-Expressionist movement. Pollock's early pictures were influenced by Albert Ryder and Thomas Hart Benton. From 1942 he painted in his vigorous abstract style with its characteristic twisting, labyrinthian lines, which were dripped onto the canvas. To Pollock, the very act of painting was a form of expression.

POLYCLITUS (5th century B.C.).—Greek sculptor. The younger contemporary of Phidias, Polyclitus also attained great fame within his lifetime. Unfortunately none of his originals have survived, but a famous Roman reproduction exists of the *Doryphorus*, the statue of an idealised athlete, long used as a perfect model.

POUSSIN, NICOLAS (1594-1665).—French painter, long time resident in Italy. Poussin's greatest inspirations were Antique sculpture and the serene compositions of Raphael. His expression was a deviation from the flamboyant Baroque style popular in his time, and his mythological and historic moral themes were patronised largely by intellectuals, who appreciated the logic and discipline of his compositions, and his uncompromising use of colour patterns.

PRAXITELES (4th century B.C.).—Greek sculptor from Athens. The most famous work by Praxiteles is *Hermes with the infant Dyonisus*, now in the Olympia Museum in Greece. Many copies of the sculptor's works were made and have survived, especially those of his statues of Aphrodite.

PUCELLE, JEAN (works from 1327-1347).—French miniature painter. Pucelle was a leading member of a group of miniaturists gathered at the Court of Burgundy in Paris. His manuscripts, often of a profane nature, are distinguished by their brilliant, enamel-like colours and exquisite attention to detail.

RAPHAEL, SANZIO (1483-1520).—Italian painter, with Leonardo and Michelangelo, one of the leaders of the High Renaissance. Raphael studied with Perugino in his native city, Urbina, and from him learned the symmetrical composition of space and the serene beauty of his figures. One of his early pictures, *The Betrothal of the Virgin*, now in the Brera Gallery in Milan, is

very reminiscent of Perugino, but the pupil had already surpassed the teacher in the polish of his execution and composition. After moving to Florence in 1504 Raphael's work became more virile, his colour richer, and his composition less studied. So remarkable were his gifts that his fame spread far and wide; the "boy-genius" was called to Rome and commissioned to execute the frescoes for the Vatican Library and other rooms in the Palace, as well as the celebrated cartoons for the Vatican tapestries. Many of these cartoons are now in the Victoria and Albert Museum in London. Raphael also designed a number of buildings; the surviving works are few, although much discussed.

REDON, ODILON (1840 - 1916). — French painter, one of the principal Symbolists. Redon's fantasy paintings have a dreamlike quality with vaguely religious overtones. His delicacy of touch and luminous colours covered a range of subjects including phantoms, plants with human heads, and unidentifiable nightmarish images. He was also a fine graphic artist and produced many lithographs and drawings.

REMBRANDT, HARMENS VAN RYJN (1606-1669).—Dutch painter, one of the great portrait painters in the history of art. As an apprentice Rembrandt came in touch with the dramatic chiaroscuro of Caravaggio and the main elements of early Italian Baroque. With the completion of his painting the *Anatomy Lesson of Dr. Tulp*, his services were greatly in demand. He accepted commissions for both individual and group portraits, the *Syndics of the Drapers' Guild* being a famous example of the latter. These commissions brought him great wealth. His good fortune came to a sudden end with the so-called *Night Watch*, which was sharply criticised for not giving each

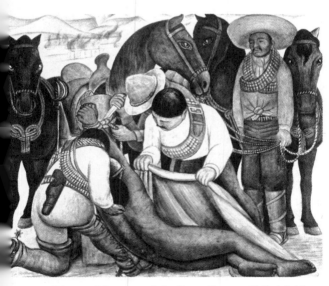
Rivera, *Liberation of the Peon*. Fresco. Philadelphia Museum of Art.

member of the group an equal prominence. During the same year, 1642, Rembrandt's beloved wife, Saskia, died. The years of prosperity were ended, and Rembrandt turned to religious themes profoundly moving in their emotional content. In portraits painted during his later period, the perception of the human being reached an unparalleled height, while colour, especially in the shadows, was enriched, and the brushwork used with unprecedented freedom. Throughout his career Rembrandt made etchings and drawings, using an economic and telling line. His entire production was enormous, and there are works in nearly every major museum in the Western world.

RENOIR, PIERRE-AUGUSTE (1841-1919).—French Impressionist painter, one of the great masters of colour. After working as a youth in a porcelain factory painting china, Renoir began art studies and came in touch with Monet and Sisley. Monet encouraged him to experiment with light-drenched colours and loose brushwork. Renoir's natural ease of draughtsmanship was an enormous advantage in his evolution from his early, basically impressionistic *genre* scenes in dance halls and on the riverside, as well as portraits, all from his "Blue Period". Travels in North Africa and Italy sharpened his sense of line and colour contrasts, and provided a stepping stone into his late "Red Period", in which he limited his subjects to nudes, flowers and landscapes, while making bold excursions in the problem of creating volume by means of colour. His last pictures are very nearly abstract, with amazingly subtle colour variations achieved by means of glazing.

REYNOLDS, SIR JOSHUA (1723-1792).—English portrait painter. The son of an educated family, Reynolds exemplifies the academic painter inspired by the Old Masters or classical art. His skilful portraits of aristocrats are inevitably grounded on an intellectual approach. Reynolds enjoyed great success, and was appointed the first President of the Royal Academy when it was founded in 1768.

RIBERA, JOSÉ (1591-1652).—Spanish painter. Ribera travelled in Italy and, in 1616, settled in Naples where he was strongly influenced by the dramatic chiaroscuro of Caravaggio. His compositions, almost entirely religious in theme, are intensely emotional and in his later years, have a brutal realism, probably influenced by the visit of Velázquez to Naples in 1630.

RICHARDSON, HENRY H. (1836-1886).—American architect, pioneer of modern architecture. Richardson's simple, severe structural style is reminiscent of

Roman building. His Allegheny County Jail in Pittsburg is an excellent example of this, but the building which most influenced the development of modern architecture in America is the Marshall Field warehouse in Chicago.

RIVERA, DIEGO (1886-1957).—Mexican mural painter. Rivera was living in Paris during the gestation period of Cubism, but he returned to Mexico and created his own boldly nationalistic style free from contemporary European trends. Rivera's subjects are chosen from Mexican history and the Mayan civilisation; in particular he dwelt on revolutionary events, emphasising their social and political significance. In Mexico and the United States, he executed many large murals on public buildings using the *buon fresco* technique practised in 14th-century Italy.

ROBBIA, LUCA DELLA (1399-1482). —Florentine sculptor. Luca's first important work was his marble *Singing Gallery* for the Cathedral of Florence, now in the Cathedral Museum. He was, however, more celebrated and successful for having discovered a process of applying coloured lead glazes to terra-cotta sculptures, thereby making them usable as architectural decorations. The most typical design, produced by himself and a long line of heirs, is a medallion wreathed in coloured fruits and flowers, showing heads or figures in white against a clear blue background.

RODIN, AUGUSTE (1840 - 1917). — French sculptor. Rodin's celebrated gifts produced a varied art which touched levels of great vigour as well as refinement. An early piece, *The burghers of Calais* is a powerful study of six characters in attitudes of despair. A copy of the group stands outside the houses of Parliament in London. His second, more emotional style is exemplified by *The Kiss* and *The Hand of God*. *The Thinker* was so popular that he made a number of copies of the same subject.

ROSSO, FIORENTINO (1494-1540).—Florentine painter. Influenced by the older Michelangelo, Rosso developed a dramatic mannerism, compressing a violent action into a constricted space. He was called to France in 1530 where he collaborated on the fresco decorations at Fontainebleau, exercising a great influence on subsequent French painting.

ROUAULT, GEORGES (1871-1958).—French painter and graphic artist. Rouault was apprenticed to a stained-glass craftsman before he studied painting. His first characteristic paintings appeared after 1904 and dealt with subjects such as prostitutes, clowns and judges. The stained-glass effect is powerful, and adds weight to the artist's very

pointed criticisms of hypocrisy and vice. Of his many etchings and lithographs, the series entitled *Miserere* is the best known.

ROUSSEAU, HENRI (1844 – 1910). — French painter, called *le Douanier* because of his service in the Customs offices. Rousseau's earlier military service in Mexico provided him with the material for many of his tropical subjects when, at the age of forty, he began to paint his charmingly naïve pictures, with flat colours and richly patterned backgrounds of foliage. His paintings, despite their apparent simplicity, are highly sophisticated in both content and composition.

RUBENS, PETER PAUL (1577-1640). —Flemish painter, one of the most talented and prolific artists in history. Rubens lived for several years in Italy where he was Court painter to the Duke of Mantua, and where he was greatly influenced by the work of Caravaggio. Subsequently, when appointed Court Painter to the Spanish Governor of the Netherlands, Rubens became the most famous painter in Northern Europe, and the greatest representative of the Baroque. His canvases were often vast, and teeming with movement and rich colours. A master of flesh-painting, Rubens delighted in luxuriously proportioned nude figures and so painted many mythological scenes, as well as battle scenes and commemorative portraits. So busy was his studio that he hired a large band of assistants to work from his sketches, touching up the final glazes with his own hand. His most personal pictures were done in later life, when sickness confined his activities.

RUISDAEL, JACOB VAN (1628-1682). —Dutch landscape painter, the most influential of the realist school among 19th-century European landscape painters. There is a brooding melancholy about Ruisdael's scenes, with ominous, cloud-filled skies, and the sun breaking through to fall on a patch of field or marsh. Other members of his family were well known as landscape artists, notably an uncle, Salomon van Ruysdael.

RYDER, ALBERT PINKHAM (1847-1917).—American painter, one of the major independent artists of the period following the Civil War. Ryder is particularly known for his romantic and very expressive marine pictures in which dark boats sail on moon-lit seas. His simple, bold shapes painted in dense colours are imbued with symbolic overtones, anticipating Munch and German Expressionism.

SAARINEN, EERO (1910-1963).—Finnish architect, long a resident of the United States. Saarinen's buildings aim to suggest the emotion implicit in function. His Chapel at the Massachusetts Institute of Technology is a starkly simple cylindrical stone building standing on low arches above a moat, the light entering the silent, darkened interior only as reflected rays from the water. Other notable projects include the shell-domed auditorium of the Massachusetts Institute of Technology, and the butterfly-shaped air terminal for Trans-World Airlines at Idlewild Airport.

SARGENT, JOHN SINGER (1856-1925).—American portrait painter. Sargent's great success in both the United States and Europe was due to the elegance of his technique, and his very able use of flattery. His murals met with considerably less success.

SARTO, ANDREA DEL (1486-1531).—Italian painter of the Florentine school. Andrea learned much of his line and modelling technique from Michelangelo's examples. His large frescoes at the Church of the Annunciation in Florence are the best works of the High Renaissance in that city. The *Madonna delle Arpie* in the Uffizi Gallery in Florence is classical in the manner of Leonardo and Raphael.

SASSETTA, STEFANO DI GIOVANNI (1392-1451).—Sienese painter. Sassetta's panels are painted in accordance with the strict formalities of his predecessors in Siena. His mystical nature endowed his religious themes with a compelling power, while technically, his use of space shows certain influence from Florence and the revolutionary experiments in perspective by Masaccio.

SCHÖNGAUER, MARTIN (*c.* 1435-1491). — German painter and engraver, whose art channelled the influence of Rogier van der Weyden and other Netherlandish painters into Germany. His only unquestioned painting is the *Madonna in the Rose-bower* in Colmar, but there are more than a hundred of his engravings extant.

SCOPAS (4th century B.C.).—Greek sculptor. Only fragments of Scopas' carvings have survived, but from these and from literary descriptions it is clear that his art had a particular emotional intensity and violence. One of the distinguishing marks is his technique of sculpting the eyes very deeply and shadowed. His influence on later Hellenic sculpture was marked, especially on works from the Pergamon school.

SEURAT, GEORGES (1859-1891).—French painter and colour theorist. Seurat studied contemporary literature on the science of colour and optics and, combining this with the lessons and discoveries of the Impressionists, he developed his own technique called "Pointillism". In this method, colour is applied in tiny dots, with shadow tones broken into complementaries of adjacent areas; the mixing of the colours takes place in the spectator's eye. In contrast to the Impressionists, Seurat created a formal type of composition, with all parts rigorously weighed against one another in relation to their size and shape. His celebrated painting, *Sunday Afternoon on La Grande Jatte*, now in Chicago, shows a number of figures in profile creating, with the trees, vertical rhythms contrasted to the horizontal rhythms of the shadows. The illusion of depth is thus calculated, but effective.

SHAHN, BEN (*b.* 1898).—Lithuanian painter and graphic artist, long-time resident of the United States. In the early part of his career, Shahn was apprenticed to a lithographer, and later became a news photographer. Both experiences influenced his art towards social themes executed in his characteristic style of flat planes and accented lines. During the years of the depression, Shahn's reputation was fostered on such themes as *The Passion of Sacco and Vanzetti*. His recent work is less concerned with a dissatisfied humanity than with a private mythology mingled with traditional Jewish lore.

Shahn, *Troubled Man.* 1958. Drawing. Courtesy: The Downtown Gallery, New York.

SHEELER, CHARLES (*b.* 1881). — American painter. After absorbing the influences of Post-Impressionism and Cubism, Sheeler became a photographer in New York. His art took on an objective character, presenting an almost photographic representation of reality. His series of paintings for the Ford River Rouge plant in Detroit, painted in 1927-1930, awakened his generation to the austere beauty of functional art.

SIGNORELLI, LUCA (*c.* 1450-1523).—Italian painter of the Umbrian school, said

to be a student of Piero della Francesca. Signorelli's masterpiece is the series of frescoes on the *Last Judgement* in Orvieto Cathedral. This daringly executed work confirms his knowledge of anatomy. The cycle is especially important for its influence on Michelangelo's fresco *The Last Judgement*, in the Sistine Chapel, where Signorelli also painted a fresco on one wall.

SISLEY, ALFRED (1839 - 1899). — French Impressionist painter of English descent. Sisley was almost exclusively a landscape painter, and with the exception of Monet, the painter most loyal to the tenets of Impressionism. Nonetheless he did not dissolve his forms in atmospheric mists of light and colour; his canvases are small, serene, and throughout preserve the realism of the early Impressionists.

SLUTER, CLAUS (active *c.* 1375-1406). —Dutch sculptor. Sluter was attached to the Court of Burgundy in the service of Philip the Bold at Dijon in France. The earliest realist of the 15th century, preceding even Jan van Eyck, Sluter made a daring departure from the Gothic conception of sculpture as a merely decorative complement to architecture. His masterpiece, *The Well of Moses* in the monastery of Champol, shows the six prophets, who foretold the coming of Christ, surrounding the well. Each figure is treated individually, especial attention having been given to their features and natural postures.

Sluter, *Well of Moses*, Abbey, Dijon. (Giraudon)

STEEN, JAN (1626-1679).—Dutch *genre* painter. Steen recorded, in humorous scenes, the lives of ordinary people, especially in taverns. His work, following as it does the styles of van Goyen and Brouwer, is neither original nor consistent.

STUART, GILBERT (1755-1828).— American portrait painter. After some training in England under the American painter, Benjamin West, Stuart returned to the United States where he enjoyed great popularity. His greatest fame rests with his various portraits of George Washington.

SUTHERLAND, GRAHAM (*b.* 1903). — English surrealist painter. Sutherland paints landscapes studded with restless forms; often thorny shrubs are used to express the mood of a place. He is equally famous for his Expressionist portraits of famous personalities.

TANGUY, YVES (1900-1955).—French painter, resident in the United States from 1939. Tanguy joined the surrealist school in 1925; his very subjective pictures burgeon with amoebic forms executed with great precision, often suggesting the ocean depths.

TIEPOLO, GIAMBATTISTA (1696-1770).—Italian painter, the last of the great Venetian decorators, and one of the finest of all Rococo painters. Tiepolo was a master of fresco, and his ceilings and walls are found in many palaces and churches in Venice as well as in the Würzburg Palace and the Royal Palace in Madrid. Probably the most impressive are those surrounding the entrances and grand staircase of the Würzburg Palace, where the Baroque architecture merges perfectly with the pale airy colours, the allegorical subjects, and the incredible facility of Tiepolo's brushwork.

TINTORETTO, JACOPO (1518-1594). —Venetian painter, one of the great innovators of Mannerist tenets. For a short time Tintoretto was a pupil of Titian, and a great admirer of Michelangelo. His prime aim was to incorporate Titian's rich colour with the heroic drawing of Michelangelo. The result was his intensely dramatic form, accentuated light, unusual perspectives and graceful, elongated figures. A profoundly religious man, Tintoretto painted relatively few portraits and mythological subjects, but concentrated on large Biblical scenes. One of his greatest achievements is the cycle of paintings in the *Scuola di San Rocco* consisting of enormous paintings, 12 to 16 feet high, depicting scenes from the life of the Virgin, the life of Christ, and scenes from the Passion. In these his mastery of narrative combines with his technical genius; light flickers and concentrates attention in startling ways. In *The Last Supper*, a boldly accented diagonal cuts through the composition, dramatising the space, yet giving the scene a powerful sense of reality.

TITIAN, VECELLI (*c.* 1487-1576).— Italian painter, leading exponent of the Venetian school, one of the most productive painters in history. Titian was a pupil of Giovanni Bellini, and more important, deeply influenced by Giorgione, with whom he is said to have collaborated, and several of whose paintings he completed when the latter suddenly died. During his exceptionally long and energetic career, Titian was the unchallenged leader of Venetian artists. His style progressed towards an ever greater freedom of brushwork, an ever richer and more golden palette, an ever more simplified treatment of composition. In his last period his use of light anticipates the Baroque, as in his *Rape of Europa*, while the freedom of brushwork blends colour and line in a decidedly impressionistic manner. Titian had a taste for mythological subjects, probably as they afforded him the opportunity of painting the female nude in a landscape, an art at which he had no peer until Renoir. He also painted many penetrating portraits, such as that of Philip II of Spain, and a great number of religious subjects.

TOBEY, MARK (*b.* 1890).—American painter. Tobey's form is a complex calligraphic abstractionism, treated in a lyrical manner and emotionally expressive.

TOULOUSE-LAUTREC, HENRI DE (1864-1901).—French painter and graphic artist. After initial art studies, Toulouse-Lautrec moved to Paris from his well-to-do family home in the country. There he was especially influenced by the work of Dégas and the Japanese prints which were the rage in *avant garde* circles. He remained relatively unknown until his first posters appeared in 1891, when he became immediately famous. Lautrec's favoured subjects were chosen for their innate spontaneity and included cabaret scenes, brothel life, and circus artists. His superb, quick line and keen sense of composition were admirably used in his posters and illustrations.

TURNER, JOSEPH MALLORD WILLIAM (1775-1851).—English painter and watercolourist. An extremely precocious talent, Turner began his studies at the Royal Academy at fourteen and held his first exhibition there two years later. Though he painted exclusively in watercolours until 1796, he then began painting in oils under the successive influences of the Dutch 17th-century landscapists, and Claude Lorraine. Critics berated him severely for the unfinished quality of such big works as *Crossing the Brook*, now in the National Gallery, London. Visits to Italy intensified his interest in the effects of light and dramatic colour; his later works are magical visions of forms dissolving in luminous atmosphere, anticipating the Impressionist manner.

UCCELLO, PAOLO (1396-1477).—Florentine painter, master of linear perspective. Uccello's earliest training was in the late Gothic style, a decorative influence which continued to mark his work throughout his career. The new scientific spirit of the Renaissance as seen in the work of Masaccio caught his imagination, and Uccello embarked on an exploration of perspective which, combined with his decorative impulse, produced a unique style of his own. Three fine examples of his mature work are the series, *The Battle of San Romano*, one of which is in the National Gallery, London, another in the Louvre, and a third in the Uffizi, Florence. Uccello was an important influence on the later works of Piero della Francesca.

UTRILLO, MAURICE (1883-1955).—French painter. The son of the talented painter, Suzanne Valadon, Utrillo was urged to paint by his mother as a distraction from his addiction to drink and drugs. His intimate scenes of Paris streets, done in delicate tones of white, greys and greens, have a realistic simplicity and naïveté. Utrillo's most original work was done between 1908-1916.

VAN EYCK, JAN (c. 1390-1441).—The major artist of the early Flemish school, Jan Van Eyck was a great intellectual in the medieval tradition yet fully committed to the Renaissance spirit. He greatly improved and helped to establish the technique of painting in oils, achieving in his pictures a realistic treatment of spatial depth, and wonderful effects of light and atmosphere. Together with his brother Hubert (c. 1370-1426) he painted the famous *Ghent Altarpiece*, completed in 1432. All the figures in his religious pictures are marked by a portrait-like naturalness, and are shown against real landscapes which stretch away into the distance. A fine example of his work is the *Madonna with Chancellor Rolin*, painted c. 1434, now in the Louvre.

VAN DYCK, SIR ANTHONY (1599-1641).—Flemish portrait painter, the most important assistant of Rubens. After his early success in the studio of that renowned Baroque master, Van Dyck travelled to Italy, where he soon obtained commissions from members of the aristocracy to paint their portraits. His deft technique, combined with a keen insight into character, plus an ability to present his sitters in languid and stylish poses, soon carried his reputation to England, where, in 1632, he was called to become Court Painter to Charles I. Although his finest work was produced in Flanders and Italy, his portraits of the English aristocracy established a tradition which was to be developed by Reynolds and Gainsborough.

VASARI, GIORGIO (1511-1574).—Italian painter, architect and art historian. Vasari's training in Florence was under Andrea del Sarto, and he was apprenticed for a time to Michelangelo whom he idolised. Although Vasari became official painter to the Medici's, it is generally agreed that he was a mediocre painter, a good architect, and an excellent talker. His design for the courtyard of the Uffizi Palace in Florence, is, with its exaggerated length, typical of Mannerist tendencies. Vasari's real masterpiece is his book, "Lives of the most famous painters, sculptors and architects", first published in 1550. This is not only a delightfully written series of anecdotes concerning the lives and works of Renaissance artists, but one of the most important reference books about the period ever compiled.

VELÁZQUEZ, DIEGO RODRIGUEZ DE SYLVA Y (1599-1660).—Spanish painter of Portuguese origin. Velázquez' earliest works showed a strong preference for realism, strong light, and subdued colour, in the manner of Caravaggio. His talent was such that already in 1623 he was appointed Court Painter, a position which he held for the rest of his career. Bound by his appointment, he painted many portraits of the royal family of Philip IV. During two extended visits to Italy, Velázquez astounded the art world with his remarkable portrait of Pope Innocent X, now in Rome. One of his finest works, from his later period, is *The Maids of Honour* ("Las Meninas"), in the Prado Museum. This charming composition of the Infanta Margareta Teresa with her maids is seen through a mirror and includes the re-reflection of Velázquez himself. In it the artist achieved a new high point in the presentation of expressive realism. The art of Velázquez had a profound influence on the much later painter, Manet.

VELDE, HENRY VAN DE (1863-1957). Belgian architect, decorator and educator. In his early period, van de Velde was working in the Art Nouveau style, but in 1900 he turned to robust, moulded architecture. Typical of this period is the art school at Weimar, using heavy mansards together with smooth white stucco walls. His masterpiece is the Werkbund Theatre in Cologne, built in 1914, with its characteristically curved walls and roof.

VERMEER, JAN (1632-1675).—Dutch painter of interiors, one of the greatest masters of light and colour in the whole of Netherlands painting. Vermeer painted with meticulous care, and was never a popular artist among his contemporaries. Only forty paintings have survived, and most of these show the same few rooms in the house where he lived, with the same women at their tasks

or leisure. In spite of these limitations, the jewel-like perfection of his surfaces, and the subtlety of the pervasive light which falls gently on carefully arranged objects endows Vermeer's pictures with a rare beauty.

VERONESE, (PAOLO CALIARI) (1528-1588).—Italian painter of the Venetian school. Veronese, though not so supreme a master as Titian, nor so boldly inventive as Tintoretto, combined their attributes with a Venetian splendour and pageantry. His frescoes in the Villa Maser near Vicenza are magnificent examples of his decorative genius, merging colour, subject and technique with the simple architecture of Palladio. The *Feast in the House of Levi*, now in the Accademia in Venice, is characteristic of his large canvases, crowded with gorgeous costumes, handsome architectural features, worldly abundance, and all seen from an angle which emphasises the grandeur of the whole.

VERROCCHIO, ANDREA DEL (1436-1488).—Florentine sculptor, goldsmith and painter. Verrocchio is thought to have been a pupil of Donatello, and became, after the latter's death, the most reputed sculptor in Florence. As the head of a prosperous workshop, Verrocchio executed commissions for paintings, and for goldsmith's work. Sculpture was his most vital medium; his *David* in the Bargello in Florence, and the equestrian statue of the General Colleoni in Venice are two of his finest pieces, rich in texture and imbued with dramatic tension.

VILLON, JACQUES (b. 1875).—French painter and engraver. Villon is the brother of three other French artists, the sculptor, Raymond Duchamp-Villon, and the painters, Suzanne Duchamp and Marcel Duchamp. Originally a poster and cartoon artist, he turned to painting, first in the manner of the Fauves, but in 1911 he became a Cubist. His painting in the latter trend is lyrical with soft, pleasant colour and unforced patterns.

VLAMINCK, MAURICE DE (1876-1958).—French painter and engraver. Vlaminck's highly diversified talents and enthusiasms are reflected in his vigorous paintings dating from his Fauve period. After 1907 his style changed, the colour darkened, and, under the influence of Cézanne and Courbet, the compositions grew more ordered. Gloomy landscapes in an Expressionist manner are his most typical and successful works.

VUILLARD, EDOUARD (1869-1940).—French painter and decorator. With his friend Bonnard, Vuillard was a member of the small *Intimiste* group, which focused on domestic interiors rather than landscapes. He painted relatively small canvases, producing

Villon, *Baudelaire with Pedestal*. Etching. Museum of Modern Art, New York. Gift of Victor S. Riesenfeld.

two-dimensional effects by the careful use of delicate colour shadings. The tastefully contrasted patterns of wallpapers, fabrics and furnishings recall the similarly complex patterns in Japanese prints.

WATTEAU, ANTOINE (1684-1721).— French painter, designer and engraver born at Valenciennes. A great admirer of Rubens, Watteau made many drawings in black or red chalk from Rubens' paintings, and thus established his own charming and intimate style. His experiences as a scene painter in a theatrical shop further moulded his style, and his later paintings often depict players from the French and Italian Comedies. There is a curious sobriety and meditativeness about his subjects which endows them, in their Rococo setting, with an unexpected awareness of their own frivolity.

WEBER, MAX (b. 1881).—Russian-born painter and graphic artist. His family emigrated in 1891 to the United States, where at the age of sixteen he attended the Pratt Institute in Brooklyn. In 1905 Weber went to Paris where he was taught by Matisse and was profoundly influenced by the Fauves. Back in America, in 1912 he began working in the Cubist idiom, from 1930 he returned to figurative art, using an abstract style and rather brooding Expressionist colours, often on social themes.

WEST, BENJAMIN (1738-1820).— American painter. West journeyed to Italy after his initial studies in America, and was much influenced by the reigning neo-Classical style. He settled in England where, under the protection of George III, he became a popular painter of portraits and historical subjects executed with an inaccurate, but highly appreciated, classical composition.

WEYDEN, ROGIER VAN DER (1399-1464?).—Flemish painter, with Van Eyck, the greatest Netherlands painter of the first half of the 15th century. Rogier was a pupil of Robert Campin, but introduced a powerful emotional impact into Campin's realistic tradition. Subordinating all effects of natural space to the essential religious intention of his compositions, Rogier created his intensely emotional studies of Christ in narrow dramatic spaces, much like sculptural reliefs. A fine example is his *Descent from the Cross* in the Prado, or the *Last Judgement* at the Hospice of Beaune.

WHISTLER, JAMES ABBOTT Mc NEILL (1834-1903).—American painter and etcher, long a resident of Paris and London. The major influences in Whistler's work were Courbet, Manet, and the popular Japanese prints. In reaction to the sentimentality and predominance of subject matter in the Victorian era, Whistler emphasised the aesthetic values of his paintings, frequently entitling them simply *Studies*, *Nocturnes*, or *Symphonies*. In 1877 he was involved in a sensational law suit against the art critic, John Ruskin, claiming that the latter had libelled him. He won damages of a farthing, and was obliged to go to Venice where he produced a series of etchings, his best work in this medium, in his effort to recoup his losses.

WREN, SIR CHRISTOPHER (1632-1723).—English architect, mathematician and astronomer. Wren's style was basically derived from that of Inigo Jones, tempered by his admiration for French architecture. After the Great Fire of 1666, Wren rebuilt many of the London churches, more than 40 between 1670 and 1714. Some of his small parish churches, such as St. Mary-le-Bow, are famous for their magnificent slender and beautifully proportioned spires. His masterpieces, St. Paul's Cathedral in London, with its imposing dome and vast dimensions, united the Palladian classicism of Jones with the more sculptural forms of the Baroque period.

WRIGHT, FRANK LLOYD (1869-1959).—American architect, one of the most individual talents and outspoken personalities of the century. A disciple of Louis Sullivan in his youth, Wright developed a very personal approach to architecture, contending that every structure must perfectly blend with the environment for which it was conceived. Using concrete, wood and natural stone, Wright attempted to create a relationship between outside and interior space. Some of his most famous buildings are "Taliesin West". at Scottsville, Arizona, the Kaufmann House, "Falling Water", cantilevered over a brook, near Pittsburg, and the Guggenheim Museum, in New York.

ZORACH, WILLIAM (1887).—Lithuanian sculptor, long-time resident in the United States. Zorach began as a painter, influenced in turn by Matisse and Cubism. Since 1922 he has devoted himself almost entirely to sculpture; his style derives essentially from primitive African, and archaic Greek and Egyptian art.

INDEX

Printed in Italy - Officine Grafiche Arnoldo Mondadori Editore - Verona